MICHELANGELO

HIS LIFE AND WORKS IN 500 IMAGES

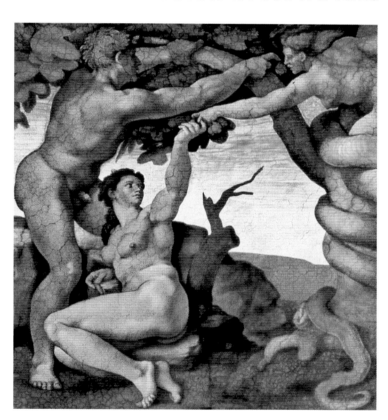

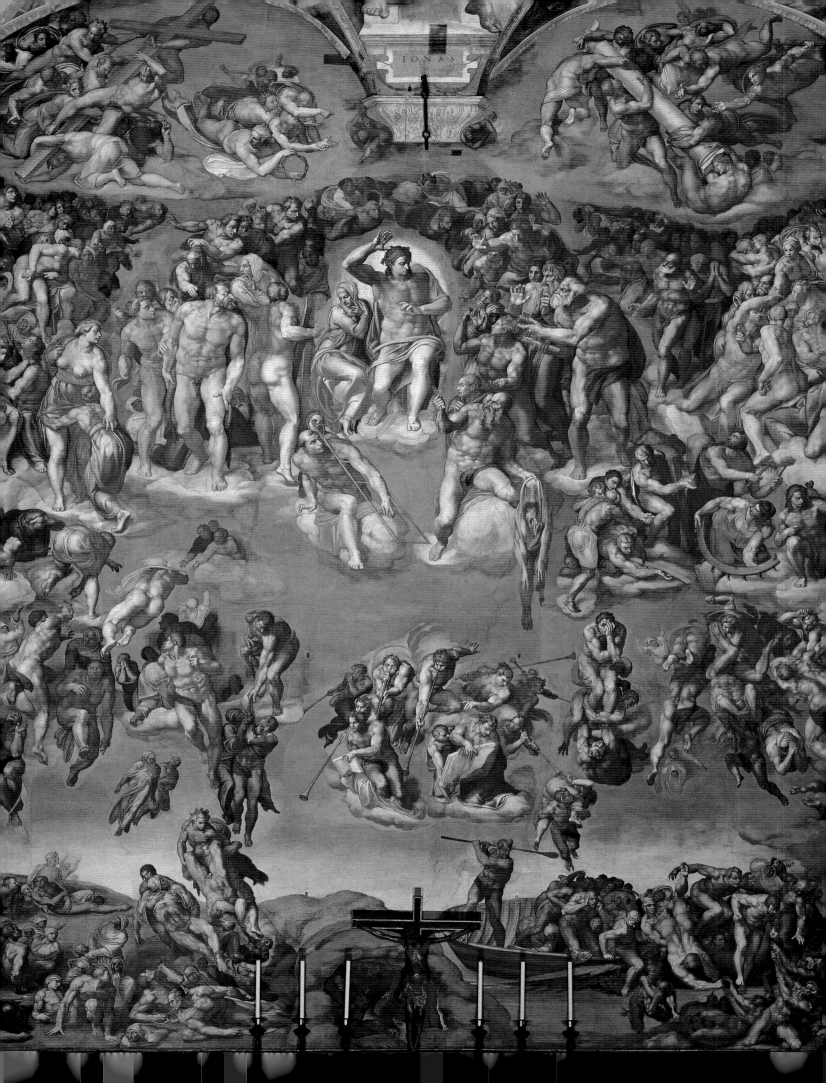

MICHELANGELO

HIS LIFE AND WORKS IN 500 IMAGES

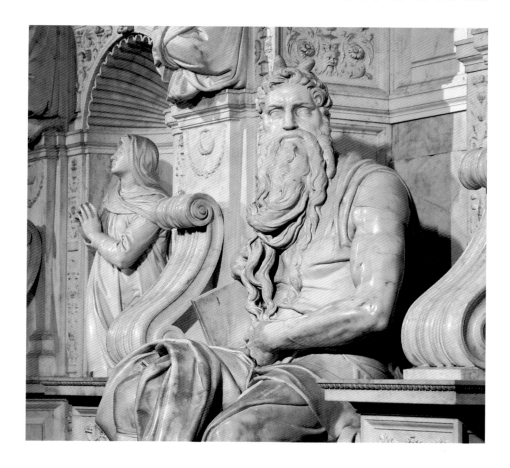

AN ILLUSTRATED EXPLORATION OF THE ARTIST, HIS LIFE AND
CONTEXT, WITH A GALLERY OF OVER 200 GREAT WORKS

ROSALIND ORMISTON

LORENZ BOOKS

This edition is published by Lorenz Books
an imprint of Anness Publishing Ltd
Hermes House
88–89 Blackfriars Road
London SE1 8HA
tel. 020 7401 2077
fax 020 7633 9499

www.lorenzbooks.com
www.annesspublishing.com

Anness Publishing has a new picture agency
outlet for images for publishing, promotions
or advertising. Please visit our website
www.practicalpictures.com for more information.

UK agent: The Manning Partnership Ltd;
tel. 01225 478444; fax 01225 478440;
sales@manning-partnership.co.uk
UK distributor: Book Trade Services;
tel. 0116 2759086; fax 0116 2759090;
uksales@booktradeservices.com;
exportsales@booktradeservices.com

North American agent/distributor:
National Book Network; tel. 301 459 3366;
fax 301 429 5746; www.nbnbooks.com

Australian agent/distributor: Pan Macmillan
Australia; tel. 1300 135 113; fax 1300 135 103;
customer.service@macmillan.com.au

New Zealand agent/distributor:
David Bateman Ltd; tel. (09) 415 7664;
fax (09) 415 8892

ETHICAL TRADING POLICY

Because of our ongoing ecological investment
programme, you, as our customer, can have
the pleasure and reassurance of knowing that
a tree is being cultivated on your behalf to
naturally replace the materials used to make
the book you are holding. For further
information about this scheme, go to
www.annesspublishing.com/trees

© Anness Publishing Ltd 2010

Publisher: Joanna Lorenz
Project Editor: Amy Christian
Proofreading Manger: Lindsay Zamponi
Editorial Reader: Penelope Goodare
Designer: Sarah Rock
Production Controller: Mai-Ling Collyer
Indexer: Ann Barrett

PUBLISHER'S NOTE

Although the information in this book is believed to
be accurate and true at the time of going to press,
neither the author nor the publisher can accept any
legal responsibility or liability for any errors or
omissions that may be made.

PICTURES

p1 *The Fall of Man and Expulsion from Paradise*, p2 *The
Last Judgement*, p3 *Moses*, p5 (L–R) *The Virgin and Child
with St John and Angels (Manchester Madonna)*, *Zenobia,
Queen of Palmyra*, *Dome of St Peter's Basilica, Rome*.

PICTURE ACKNOWLEDGEMENTS

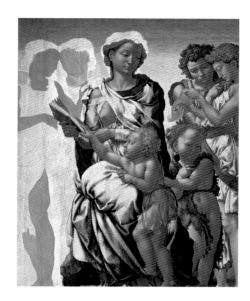
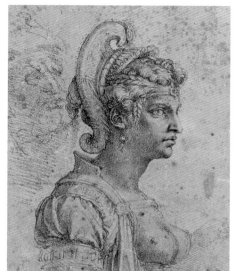
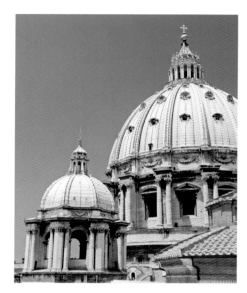

CONTENTS

INTRODUCTION

The history of the Florentine sculptor, painter and architect, Michelangelo Buonarroti, reveals a remarkable man who created an unsurpassed catalogue of works that has influenced artists, architects and historians from the 16th century to the present day.

The life of Michelangelo Buonarroti (1475–1564), sculptor, painter, architect and poet, allows a significant exploration of a unique period in art history – the High Renaissance in Italy. We learn much about it through Michelangelo the artist, and his substantial catalogue of work. We learn more about Michelangelo, the man, through the revealing letters he wrote to family, friends and patrons. In addition, his poetry gives insight into the private thoughts of a great man. Over three hundred poems survive. We know that Michelangelo venerated the Florentine poet Dante Alighieri (1265–1321), and some of his own sonnets are informed by Dante's prose, as is his dramatic fresco *Last Judgement* (1536–41) in the Sistine Chapel. The published works of two biographers, known to Michelangelo, greatly increase our knowledge of his life from birth until death. Giorgio Vasari (1511–74) included the 'Life' of Michelangelo in his book *The Lives of the Most Eminent Painters, Sculptors and Architects*, published in 1550 and updated in 1568. This publication and *The Life of Michelangelo Buonarroti*, 1553, by Ascanio Condivi (1525–74), fill in much of the historic background, the anecdotes and the essence of the 'divine' Michelangelo.

THE ITALIAN RENAISSANCE

There were different stages of the Renaissance. Pre-Renaissance is a term that refers to the 14th century in Italy. During this period the Florentine artist Giotto di Bondone (c.1266–1337), a pupil of Giovanni Cimabue (c.1240– c.1302), painted frescoes in the Upper Church of San Francesco, Assisi; in the Scrovegni Chapel, Padua; and in the church of Santa Croce, Florence, in a new style of remarkable naturalism. The Early Renaissance refers to the rebirth of interest in the literature, sciences, art and architecture of antiquity, in Florence in the early 15th century. The High Renaissance refers to a peak of artistic perfection centred on Rome, when Michelangelo, Donato Bramante (1444–1514) and Raphael (Raffaello Sanzio, 1483–1520) were working for Pope Julius II (1443–1513) at the Vatican. The late Renaissance concluded with the Sack of Rome, in 1527, by the troops of the Holy Roman Emperor, Charles V (1500–58).

RENAISSANCE BEGINNINGS

To appreciate the genius of the artist it is worthwhile to first consider the society into which Michelangelo was born in 1475. He was part of a Florentine society mainly dominated by patrician families whose wealth allowed them to commission the most innovative artists in Florence. It had not always been so. The Black Death, which ravaged the city in 1348, took the lives of three-quarters of the population. A new style of art,

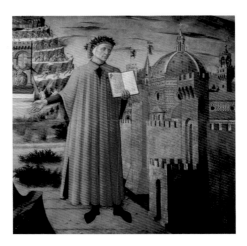

Above: Dante and The Divine Comedy *(detail) by Domenico di Michelino, 1465. The 13th-century poet is depicted before the dome of the cathedral of Santa Maria del Fiore, completed by Brunelleschi in 1436.*

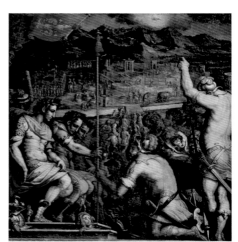

Above: The Founding of Florence, *by Giorgio Vasari, completed 1565. The city of Florence (Latin: Florentia – flourishing), was founded in 59BC by the Roman consul Julius Caesar.*

THE BLACK DEATH

Sweeping through Europe in 1348, the Black Death had originated from a Genoese ship that docked at the port of Messina in Sicily, in October, 1347. The plague, which crossed Europe in several epidemics, is estimated to have killed one-third to one-half of the population of the continent. Three-quarters of the population of Florence were killed by the pestilence that swept through the city from March until October 1348. One witness, Marchione di Coppo Stefani, wrote an account of it in the *Florentine Chronicle*, in the late 1370s–early 1380s. He reported a death toll of 96,000. The Tuscan-born writer Giovanni Boccaccio (1313–75) included an account of the devastation in the city of Florence in his work *The Decameron* (1349–52). He wrote that the number of fatalites was so vast that the death of a person warranted no more attention than that of an animal.

introduced by Giotto, remained undeveloped due in part to the terrible effect of the plague on the city of Florence. However, the parish churches of Florence did see a growth in their coffers, as money was left to them through the bequests of the dead. This pot of money would allow for new buildings and artworks when the city recovered. Eventually the religious and civic and private patrons of Florence were in a position to sponsor new buildings, from chapels to palazzos, as well as the artworks within them.

FLORENCE RECOVERS

One building to receive attention was the cathedral of Florence, Santa Maria del Fiore. It was built over the existing church of Santa Reparata, opposite the Baptistry. Arnolfo di Cambio (c.1232–1300), the first Master of the Works of the cathedral, had designed a new building in 1296. He planned a façade encrusted with green and white marble. He designed it with an expansive dome, even though at that time no one knew how to create it. Following Arnolfo's death in 1302, Giotto was appointed to oversee the work, designing its campanile (bell tower). The decorative detail of the bell tower would be a source of artistic inspiration for many of the artists emerging in the new Florence of the 15th century.

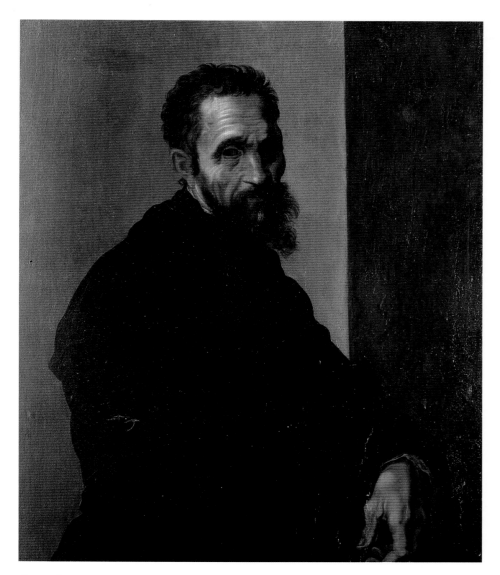

Above: Portrait of Michelangelo *by Florentine artist Jacopino del Conte, c.1535–40. The portrait shows Michelangelo at the age of 60–5 years.*

Below: View of Florence known as La Catena, *by Francesco Rosselli, 1471–82. Florence is considered the birthplace of the Italian Renaissance.*

FIORENZA

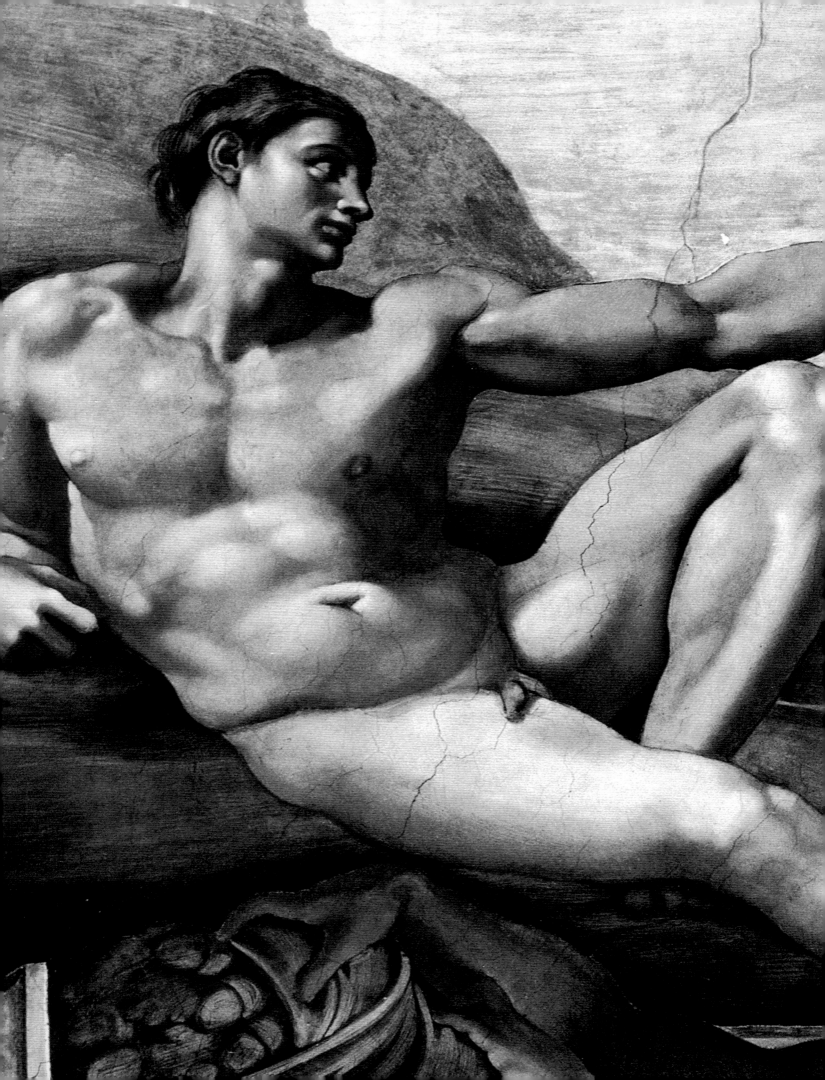

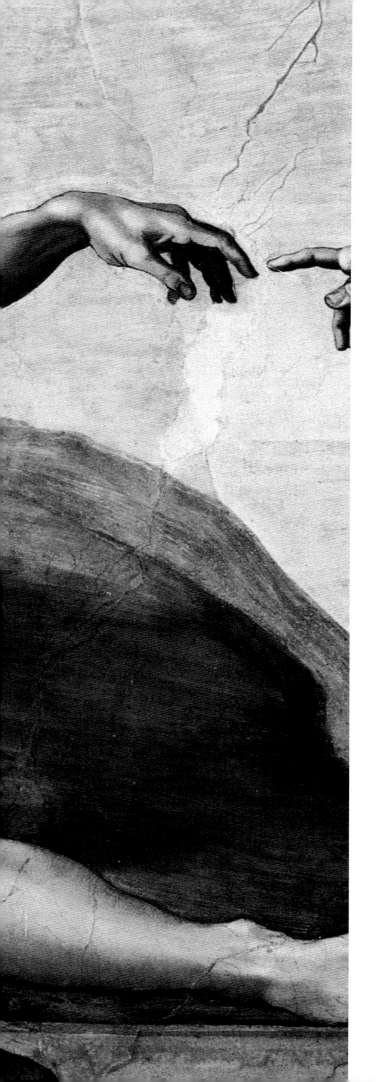

Michelangelo, His Life and Times

The life of Michelangelo Buonarroti epitomizes the Renaissance in Italy. His reputation as a sculptor, painter and architect was established in Florence and Rome. His early life at the Florentine court of the Medici introduced him to future princes and popes, and Humanism and Neo-Platonism. This knowledge, combined with his Christian beliefs, informed his work. Michelangelo's ability as a sculptor was recognized when he created a stunning marble *Pietà* (1499–1500) in Rome and a colossal sculpture of *David* (1501–4) in Florence. His fresco paintings on the vaulted ceiling of the Sistine Chapel in the Vatican (1508–12) confirmed his exceptional talent. He was hailed as a genius, an accolade he richly deserved.

Left: 'Adam' (detail), The Creation of Adam *by Michelangelo, 1508–12. To the right, the hand of God reaches toward the outstretched fingers of the reclining figure of Adam. The painting symbolizes the moment that God created Man.*

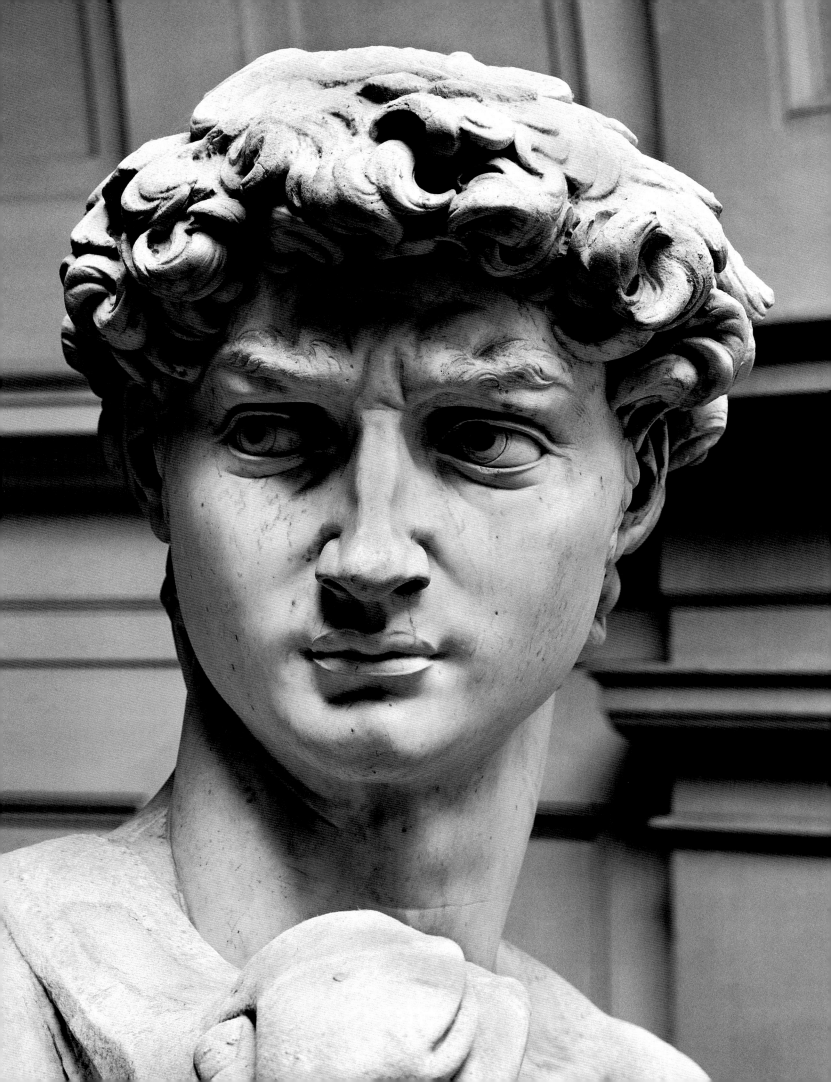

Florence
1475–1534

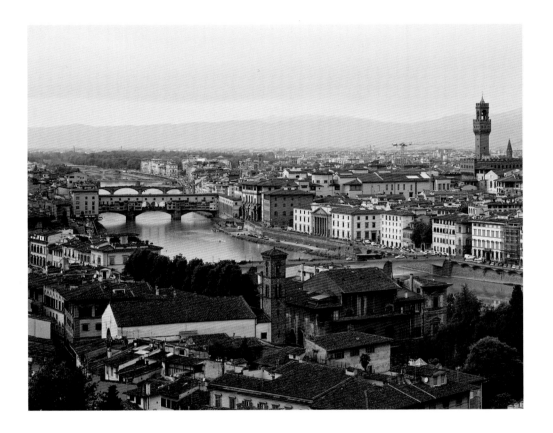

Michelangelo was born in 1475. At the time of his birth, the city of
Florence visibly displayed new architecture, painting and sculpture, which
related to the renewal of interest in ancient Greek and Roman texts and
to the art and architecture of antiquity. The study of Neo-Platonism
and Humanism flourished in the wealthy patrician society, and Florentines,
both patrons and artists, looked to their Roman heritage for artistic
inspiration. In the early 1400s the city streets of Florence were medieval in
appearance, with close-set houses and narrow alleys, but by 1475 Florence
was changing. The new dome of Santa Maria del Fiore symbolized the
city's bold innovative push toward an artistic renaissance.

Above: A view of the city of Florence with its famous bridge the Ponte Vecchio straddling the River Arno.
Left: David (detail of head), by Michelangelo, 1501–4. Placed outside the entrance to the Palazzo della Signoria
(Palazzo Vecchio), the marble sculpture of David symbolized the civic virtue of the city of Florence.

FLORENTINE ARTISTS

Florence in the 15th century was a hub of talented craftsmen, designers, architects, painters and sculptors. The patronage of the Church and wealthy Florentine families realized a profusion of new architecture, painting and sculpture.

The renewal of interest in ancient texts, and the poetry, prose, philosophy and science of ancient Greek and Roman writers inspired Florentines to look to their own Roman heritage. The Roman colony of *Florentia* had been established near the Arno river by Julius Caesar (100–44BC), in 59BC. The city grew in status under Emperor Augustus (27BC–AD14) and the population increased in the 2nd and 3rd centuries.

ANCIENT ROME REVISITED

In the 15th century not much of Roman Florence was left, but the city of Rome, just a few days' ride away, held many ancient buildings. In the early years of the 15th century the goldsmith Lorenzo Ghiberti (1378–1455), the goldsmith and architect Filippo

Brunelleschi (1377–1446), and the sculptor Donato di Niccolò di Betto Bardi (c.1386–1466), known as Donatello, journeyed to Rome to study its ancient buildings and seek out the sculptures, reliefs and other artworks that remained. Interest in the paintings and other art and architecture of antiquity had grown with intensity. Commissions were made for new façades for churches, new chapels and new town houses, all bearing a likeness to the buildings of ancient Rome. For example, in Florence the façade of Palazzo Rucellai (1446–51), designed by Leon Battista Alberti (1404–72), takes the structural elements of arches, stonework and pilasters from ancient Roman architecture. The classical orders on each storey – pilasters with capitals in

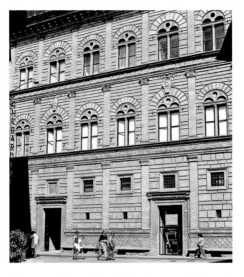

Above: Palazzo Rucellai, Florence, designed by Lorenzo Ghiberti, 1446–51. The façade of Palazzo Rucellai is influenced by the ancient façade of the Colosseum, Rome.

Above: David, by Donatello, 1408–9. A marble sculpture originally created for the Tribuna of the Cathedral of Santa Maria del Fiore, Florence.

Above: Santa Trinità (The Holy Trinity), by Tommaso Masaccio, 1427–8. An early Renaissance work using one-point perspective and foreshortening.

ROMAN FLORENCE REVIVED

The art and architectural form for new chapels was related to Florentine interest in antiquity. The presence of Greek philosophers living in Florence created a desire to replicate their past. John Argyropoulos (1415–87), a Byzantine philosopher, a Humanist and advocate of the revival of classicism, is known to have been in Italy in 1456. He tutored Piero de' Medici and Lorenzo de' Medici. Born in Constantinople, he spread knowledge of ancient Greek and Roman writers. The wealthy sought to own copies of ancient texts and agents were sent to the monasteries of Greece and elsewhere in Europe to seek out manuscripts. One such manuscript was the complete text of Vitruvius's *De Architectura*, a text on the history of Greek and Roman architecture, written c.30BC.

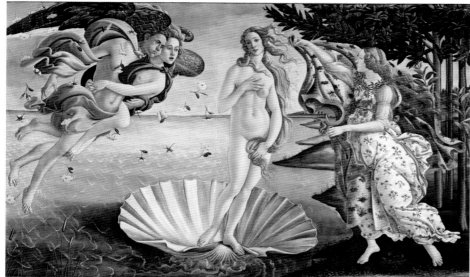

the Doric, Ionic and his own form of Corinthian style – are a visual reference to the exterior of the ancient Roman Colosseum (AD70–82). Alberti, a Humanist, an intellectual, a writer and an architect, had produced a contemporary version of *De Architectura* (*c*.30BC), by Roman architect and engineer Vitruvius (*c*.80–15BC). In his *De Re Aedificatoria* (On the Art of Building in Ten Books), completed in 1452 and published in 1485, Alberti discusses how buildings should be built and uses the architectural form of ancient Rome as his ideal.

THE INNOVATION OF MASACCIO

In the Florentine art of the early Renaissance, the free style of Giotto was taken up by the young artist Masaccio (1401–*c*.1428), and is visible in his stunning fresco, *Santa Trinità* (The Holy Trinity, with the Virgin and Saint John and donors), *c*.1425–8, in the church of Santa Maria Novella, Florence. The technique demonstrated in this painting, a masterful work showing Masaccio's awareness of one-point perspective, is considered to have been learned from his friend Brunelleschi's experiments in perspective for Santa Maria del Fiore. His perspective and foreshortening technique was copied by many artists, including Michelangelo. The naturalism

Right: A view of the classical arches of the Loggia of Ospedale degli Innocenti, Florence, by Filippo Brunelleschi, c.1420–4, a foundling hospital for orphans.

Above: The Birth of Venus, *by Sandro Botticelli, 1485. Botticelli's naked Venus is one the first non-religious nude depictions of the female body in Italian art.*

of the figures in Masaccio's frescoes was inspirational. Vasari writes that "he perceived that painting is nothing but counterfeiting all the things of Nature vividly and simply". Masaccio and Masolino da Panicale (1383–1447) had created frescoes for the Brancacci Chapel, Santa Maria del Carmine, Florence. Masaccio's frescoes were much copied by young artists (for figure-drawing practice). *The Tribute Money* and *The Expulsion of Adam and Eve* are two of Michelangelo's earliest drawings, which show his interest in Masaccio's style.

Above: The Sacrifice of Isaac, *by Lorenzo Ghiberti, 1401. This was a winning entry in a contest to make a series of reliefs for the doors of the Baptistry, Florence.*

Leonardo da Vinci (1452–1519) and Raphael were also inspired by his work. The mathematical precision in the paintings of Piero della Francesca (*c*.1415–92) shows an interest in linear perspective. The works of Fra Angelico (*c*.1387–1455), Fra Filippo Lippi (*c*.1406–69), Sandro Botticelli (*c*.1445–1510) and Domenico Ghirlandaio (1449–94), are all informed by the naturalism of Masaccio. Michelangelo was also aware of the new forms of sculpture created by Donatello and Andrea del Verrocchio (*c*.1435–88), favoured sculptors of the Medici family.

BIRTH OF A GENIUS

The infant Michelangelo spent the first years of his life living with a family of stone-cutters, among the stone quarries of Settignano. The experience left him with an insatiable interest in sculptural form and shaped his determination to become a painter and sculptor.

Michelangelo di Lodovico di Lionardo Buonarroti-Simoni was born on Sunday, 6 March 1475 in Caprese (now known as Caprese Michelangelo), a small village in the province of Arezzo, about 100km (62 miles) from Florence. He was named after the Archangel Michael. According to writer Ascanio Condivi, he was born under the sign of the planets "Mercury and Venus, in the second house of Jupiter", a very good omen for his future. Condivi, Michelangelo's biographer, associated Jupiter with creativity, which allowed "every undertaking but principally those arts which delight the senses, such as painting, sculpture and architecture."

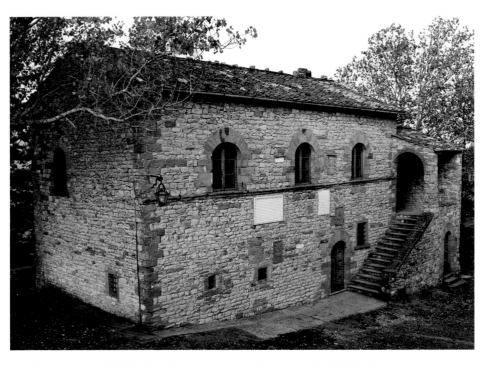

THE BUONARROTI FAMILY

Michelangelo was born the second son of Ludovico di Leonardo Buonarroti Simoni (1444–1531) and his wife Francesca di Neri di ser Miniato del Sera (1455–81). His elder brother was Leonardo (1473–c.1516) and three further brothers were to follow

him: Buonarroto (1477–1528), Giovansimone (1479–1548) and Gismondo (1481–1553). The boys' mother Francesca died at the age of 26 in 1481, when Michelangelo was just six years old. A family of ancient nobility, the Buonarroti were noted in Florence.

Above: In 1475, Michelangelo was born in the house of the mayor (podestà), in Caprese, during his father's one-year mayoral term of office.

Condivi stated that their lineage could be traced to the Counts of Canossa (in the region of Emilia-Romagna), although this has now proved incorrect. He states that the family connection to the devout noblewoman Countess Matilda of Tuscany (1046–1115) was through her inheritance of Canossa in 1052. At the time of Michelangelo's birth, her descendant family, the Buonarroti, were rather impoverished but nevertheless noteworthy citizens. Ludovico was holding a one-year position as *podestà* of Caprese, and Michelangelo was born in Casa del Podestà, the mayor's house. He was baptized in Caprese, in the 13th-century church of St John the Baptist (*Chiesa di San Giovanni Battista*) nearby.

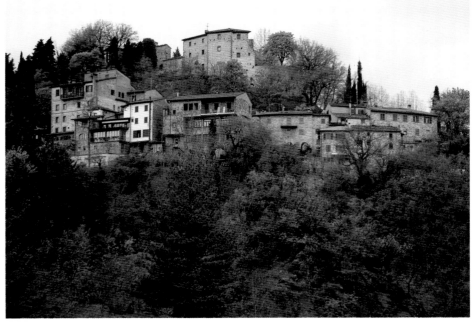

Left: Caprese Michelangelo, Toscana, Italy. The small hamlet where Michelangelo was born now bears his name.

Above: Florence from Settignano, *by Edwin Bale, 19th century.*

TO SETTIGNANO

One month after Michelangelo's birth the Buonarroti family returned to the house they shared with other relatives in the parish of Santa Croce, Florence, before going on to Settignano, a hillside village about 8km (5 miles) from Florence. It was here that Ludovico owned a farmhouse with his brother. The surrounding hills were stone quarries, and the village of Settignano was noted for its population of stonecutters. The sculptor Desiderio da Settignano (1428–64) and the Rossellino brothers, Bernardo (1409–64), who was also an architect, and Antonio (1427–79), came from the village. Francesca, in poor health, sent her new baby to a wet nurse in the village. It was common practice among the middle classes and nobility to obtain the services of a wet nurse, to care for babies from infancy through to early childhood. The wet nurse was married to a stonecutter and her paternal family were in the same business.

LEARNING FROM STONEMASONS

As Michelangelo grew up among a family of stone-cutters it is perhaps not surprising that he took an early interest in the craft. In Condivi's 1553 biography *The Life of Michelangelo* it is stated that it was not through formal apprenticeships that Michelangelo received his artistic inspiration for sculpture but from his mother's milk, that is, from the family of the wet nurse with whom he was sent to live. At the age of seven Michelangelo was sent to a grammar school in Florence to study under the tutelage of Maestro Francesco of Urbino. His studies of reading, writing, drafting letters, correspondence and legal documents were a regular curriculum for a Florentine school in 1482. The letters and poetry Michelangelo was to write in later life reveal a good education and an extraordinary gift for the written word; yet he did not want to pursue his academic studies, or to work in business.

AMBITION TO BE AN ARTIST

Michelangelo's biographer Giorgio Vasari tells us that during Michelangelo's years at school he was often reprimanded for time spent drawing when he was meant to be studying. His father Ludovico, a moneylender by profession, was dismayed at his son's apparent passion to become an artist; he and Michelangelo's uncles were said to beat the boy to try to make him concentrate on a business profession rather than art. However, he chose to neglect his academic studies, using his free time to practise his drawing skills and visit painters' workshops in Florence.

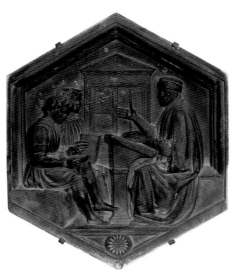

Left: Grammar, *by Andrea Pisano, c.1334–8. Decorative tile, one of a series depicting the Seven Liberal Arts, possibly based on designs by Giotto. Created for the Campanile of the Duomo, Florence.*

Right: Michelangelo carved the traditional symbol of a stonecutter on to the block of marble used for the Atlas Slaves, c.1519.

A GIFTED CHILD

Overcoming family pressure to take up a different profession, Michelangelo, with his father's agreement, joined the workshop of the respected artist Domenico Ghirlandaio in Florence as an apprentice, determined to achieve his ambition to be a sculptor.

In 15th-century Florence the rebirth of interest in the literature, sciences, art and architecture of ancient Greece and Rome had increased work commissions for painters, sculptors and architects, but at that time being a sculptor was not ranked as a worthy career for a middle-class boy such as Michelangelo, particularly as the Buonarroti family were not well off.

TRADE SKILLS
Moves were made for recognition of artistic practical skills but stone-cutting was considered a humble trade alongside butchers, tanners, cooks, smiths and joiners, and Michelangelo's father was hesitant for his son. That Michelangelo desired to be a sculptor, not a jobbing stonemason – and to Michelangelo there was a big difference – seemed to elude his father's understanding of the argument.

ORSANMICHELE

Orsanmichele, designed by Italian architect Arnolfo di Cambio in 1209, is one of the three most important medieval buildings in Florence. It was originally a granary, built on the orchard of the Convent of St Michael. It later became a market hall and then a religious building, assigned to the Guilds of Florence. The seven major guilds and five of the minor guilds were charged with decorating twelve niches with near life-size sculptures of their patron saints. The thirteenth niche was assigned to the Parte Guelfa and the fourteenth assigned to another guild at a later date. The life-size sculptures, which were created by the most talented sculptors in Florence, had a great influence on Michelangelo.

LEARNING FROM THE MASTERS
Much of Michelangelo's free time in Florence would be spent looking at the works of art in the chapels and churches of the city. To be surrounded by the artworks of Florence's finest sculptors, such as Verrocchio and Donatello must have assured him that his decision to become a sculptor was the right one. Florence contained the finest examples of the new form of naturalism in sculpture, whereby the position of the body was sculpted in the form known as *contrapposto*. It was visualized in the weight of the 'body' being placed on one leg, making the upper body twist, creating a natural movement in the figure. More importantly it imitated the sculptures of ancient Greece and Rome, which were well known to the artists. At the guildhall of Orsanmichele this 'new sweet style' is evident in the niche sculptures of saints, who express facial emotion and

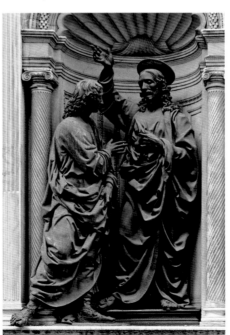

Above: Christ and Doubting Thomas, *Orsanmichele, by Andrea del Verrocchio, 1476–83. A niche double sculpture, which illustrates the* contrapposto *stance.*

Above: Self-portrait *(detail) from* The Adoration of the Shepherds *by Domenico Ghirlandaio, 1482–5. This portrait is part of an altarpiece painting created for the Sassetti family chapel.*

anatomical *contrapposto* movement, adding realism to the figures. The near life-size sculptures include the first bronze statues to be cast since antiquity.

APPRENTICE TO GHIRLANDAIO
With his father's agreement Michelangelo entered the workshop of the respected Florentine artist Domenico Ghirlandaio (1449–94) and his brother Davide (1452–1525). Domenico had made his reputation as a fresco painter. In 'The Life of Domenico Ghirlandaio', Vasari describes his work as full of vitality, naturalness, elegance and accuracy. A document of 28 June 1487 shows that Michelangelo began working for the Ghirlandaio brothers as an odd-job boy at the age of twelve. His three-year apprenticeship started on 1 April 1488. The signed agreement states that in return for working for the brothers, they would teach him to paint and enable him to practise that art, and pay him 24 florins in total: six in the first year, eight in the second year and ten in

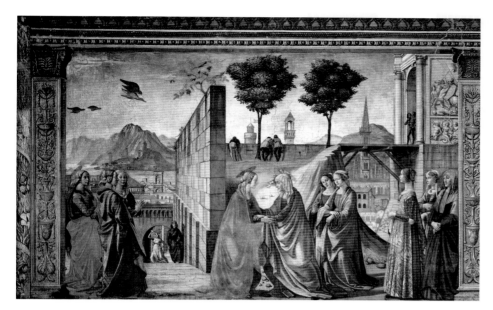

Above: The Visitation, 1486–90. A panel of the fresco cycle on the right wall of the Tornabuoni Chapel, created by Domenico Ghirlandaio and his workshop.

Above: The Temptation of St Anthony by Martin Schongauer, c.1470–83. Michelangelo was shown a copy of this work by the German artist and engraver.

the third year. His workshop tasks would include grinding pigments of paint and preparatory duties for the workshop commissions. Condivi says that Francesco Granacci (1469–1543), a young painter in the workshop, befriended Michelangelo, showing him engravings to copy. One of these was *The Temptation of St Anthony* (c.1470–83), by the German painter Martin Schongauer (c.1450–91).

OBSERVING THE MASTERS

Part of Michelangelo's apprenticeship would be spent observing paintings, sculpture and other artworks around

the city. The landmark works of the painter and architect Giotto were known to him. Masaccio's frescoes, c.1424, were to be seen in the Brancacci chapel of Santa Maria del Carmine church and Santa Maria Novella. The Dome of the cathedral of Santa Maria del Fiore, the Ospedale degli Innocenti, and the Nave and Sacristy (now called Old Sacristy) of San Lorenzo were just some of the

works by the talented architect Filippo Brunelleschi. The building of Orsanmichele held expressive sculptures in marble and bronze, including the works of Lorenzo Ghiberti, Verrocchio and Donatello. These were among the important Florentines whose works encouraged greater recognition for artists and spurred Michelangelo on to follow his dream.

Below: The Duomo, Florence. The octagonal double-walled dome was designed by the architect Filippo Brunelleschi and built 1420–36.

Right: Study of an Old Man wearing a Hat (Philosopher), c.1495–1500. In this drawing Michelangelo uses cross-hatching, which adds a sculptural quality to the figure.

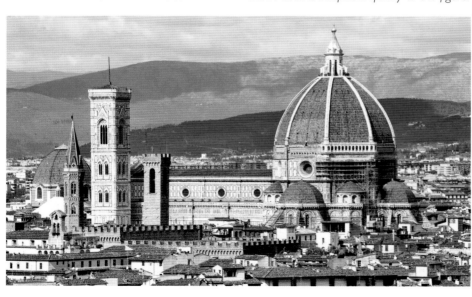

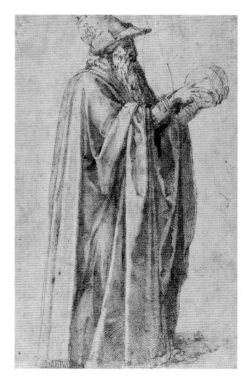

A NEW HOME WITH THE MEDICI

Michelangelo did not complete his apprenticeship in the workshop of the Ghirlandaio brothers. After a year an opportune offer, to study sculpture in a new Medici sculpture school, drew his interest. He was to become part of the Medici household.

Michelangelo's drawings from this period include a figure, c.1490, copied from Giotto's *The Ascension of St John the Evangelist* in Santa Croce, and a figure, c.1488–95, a detail of St Peter, copied from Masaccio's *The Tribute Money* c.1427 in the Brancacci Chapel. Each illustrates a superb attention to detail.

THE GHIRLANDAIO WORKSHOP

At the time of Michelangelo's apprenticeship Domenico Ghirlandaio was working on prestigious commissions, including frescoes of *The Life of the Virgin*, painted in the Sanctuary of Santa Maria Novella for the Tornabuoni family. This work includes *The Presentation of the Virgin* c.1489–90, on which he was assisted by his brother Davide, his brother-in-law Sebastiano di Bartoli Mainardi,

Below: Drawing of two male figures, by Michelangelo, c.1490, after Giotto. Michelangelo spent many hours studying the works of Giotto, copying figures in detail.

and apprentices, possibly including Michelangelo. It is clear that Michelangelo, even though he denied it later, learned much about fresco painting while working for Ghirlandaio during his apprenticeship.

Later, in 1508–12, Michelangelo's frescoes on the vaulted ceiling of the Sistine Chapel would prove his mastery of this exacting technique. The remarks of Ghirlandaio, recorded in Vasari's *Life* of Michelangelo, confirm that Michelangelo's talent for drawing was far superior to his other apprentices, and in many respects equal to his own work. He said that Michelangelo was spirited enough to alter other apprentices' drawings, which had been copied from the works of Ghirlandaio, in order to correct and improve them, to make them perfect. Vasari relates a story of how Michelangelo, while working for Ghirlandaio on the chapel frescoes in Santa Maria Novella, drew the scene before him: the scaffolding, the workmen and the tools and equipment

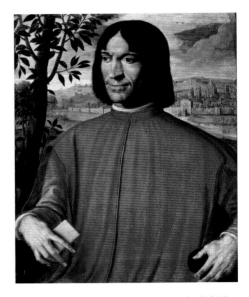

Above: Portrait of Lorenzo de' Medici 'the Magnificent' by Florentine School, 15–16th century. Lorenzo de' Medici is framed in a panoramic backdrop of Florence.

Below: The Ascension of St John the Evangelist (detail) by Giotto di Bondone, c.1311–20. Giotto was one of Michelangelo's favourite artists.

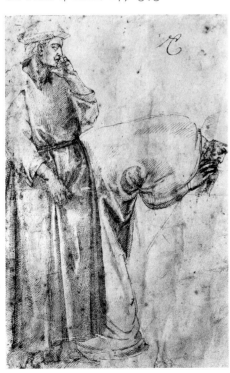

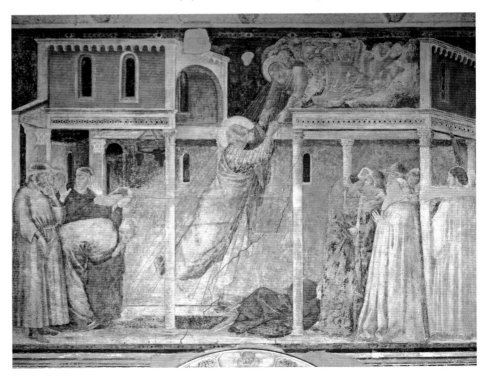

required to paint the frescoes. On Ghirlandaio's return he exclaimed: "The boy knows more than I do", and marvelled at the drawing.

A NEW OPPORTUNITY

Michelangelo is thought to have been working for the Ghirlandaio workshop for a year before an opportunity to be part of the Medici household presented itself. According to Vasari, Lorenzo de' Medici was concerned that there were not enough young sculptors in Florence learning the craft. The Florentine sculptors Nanni di Banco (d.1421), Lorenzo Ghiberti (d.1455) and Donatello (d.1466) were long dead. The gifted sculptor, painter and goldsmith Verrocchio, working at the court of Lorenzo, had recently died, in 1488. Where were the young Florentine sculptors to replace them? For this reason, Lorenzo wanted to start a school of sculpture. It would be located on his property near to the monastery of San Marco, in his sculpture garden, which contained a collection of sculptures and marble reliefs dating from antiquity. Lorenzo employed a Florentine sculptor, Bertoldo di Giovanni (1435/40–91), a former pupil and assistant to Donatello, to act as curator and custodian of the garden and the sculpture works. He would be available to guide and aid the younger sculptors in his charge. Bertoldi was noted for his sculptural reliefs in bronze. His apprenticeship with Donatello would have given him a vast knowledge of the technique of creating sculptures in wood, marble and bronze.

According to Vasari, Lorenzo approached Domenico Ghirlandaio to ask if he had any apprentices that would benefit from attending a sculpture school. It would aid the city of Florence as well as Ghirlandaio and the Medici. The most able of Ghirlandaio's pupils were put forward: Michelangelo and Francesco Granacci. For Michelangelo this must have seemed a stepping-stone on the way to the fulfilment of his ambition – to be given the chance to learn to be a sculptor, in the sculpture gardens of the Medici, surrounded by sculptures of antiquity.

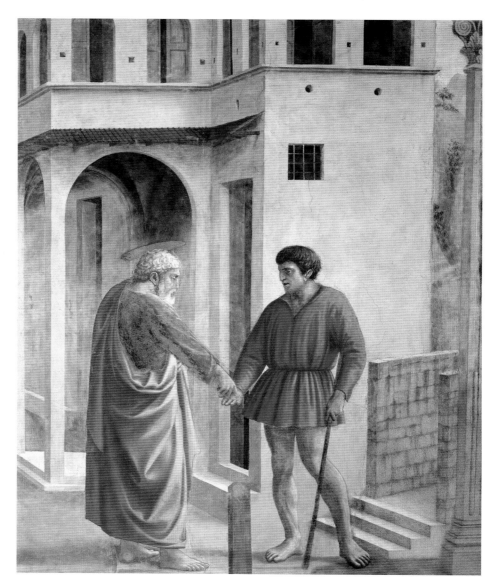

Above: The Tribute Money (*detail of St Peter*) by Tommaso Masaccio, c. 1427. The naturalism of these figures shows the new style of art emerging in Florence.

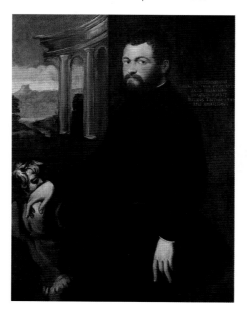

Below: Portrait of Jacopo Sansovino, *by Tintoretto (Jacopo Robusti), before 1546. A noted sculptor and architect, Sansovino attended the Medici sculpture school.*

THE SCULPTURE SCHOOL OF LORENZO DE' MEDICI

Lorenzo de' Medici's sculpture school was located in the gardens of a Medici property near to the monastery of San Marco, Florence. Many pupils of the school became noted sculptors, including Michelangelo, Baccio da Montelupo (1469–c.1523), Giovanni Francesco Rustici (1474–1554) and Jacopo Sansovino (1486–1570). The school closed down on the death of Lorenzo de' Medici in 1492.

LISTENING AND LEARNING

A meeting with Lorenzo de' Medici in the sculpture gardens of the Medici court initiated
Michelangelo's life-long association and friendship with members of the Medici family.
His father agreed to allow Michelangelo to reside in the Palazzo de' Medici.

As a keen draughtsman, more skilled than the other apprentices, Michelangelo would regularly criticize the other students' work. On one occasion, the apprentice Pietro Torrigiano (1472–1528), sketching with Michelangelo in Santa Maria del Carmine, was so angered at the scathing remarks that he punched him in the face and broke his nose. For this act of violence Torrigiano was banished from Florence. The sculptor and goldsmith Benvenuto Cellini (1500–71) met Torrigiano later, in 1518. In his autobiography (1559) Cellini related that Torrigiano recalled: "Clenching my fist I gave him so violent a blow upon the nose that I felt the bone and cartilage break…". Torrigiano added that Michelangelo would be wearing his signature for the rest of his life.

Below: Madonna of the Stairs, *by Michelangelo, 1489–92. One of his earliest examples of* rilievo schiacciato.

TO BE A SCULPTOR

Working under the guidance of sculptor Bertoldo di Giovanni, the pupils of Lorenzo's school learned from the superb specimens of original ancient Greek and Roman sculptures belonging to the Medici. They were used as templates for their own work. Michelangelo progressed quickly, and Lorenzo, noting his creativity, sent for his father and requested that the young sculptor be allowed to reside in the Medici household, and to join the family as one of his own. He agreed. It is recorded that Lorenzo offered Michelangelo's father any job he wanted. He accepted, choosing a low-wage position in the customs house. Perhaps the munificence of Lorenzo's patronage of his son was enough for him.

Below: Donatello's Madonna and Child (Pazzi Madonna), *1420–30. An earlier depiction, again in* rilievo schiacciato.

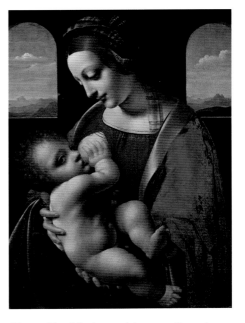

Above: The Madonna Litta, *attributed to Leonardo da Vinci, 1490. Leonardo perfectly captures the intimacy of an infant suckling his mother's breast.*

A COMPARISON OF STYLES

Michelangelo stayed in the Medici household for four years, until Lorenzo's death in 1492. Two works produced during this time show Michelangelo's mastery of sculptural relief. *Madonna of the Stairs, c.1491* is created through a technique known as *rilievo schiacciato*, a term for 'flattened' relief work in marble or bronze. In Florence the technique had been perfected by Bertoldo di Giovanni's tutor, Donatello. Comparing Donatello's *Madonna and Child (Pazzi Madonna)*, 1420–30, with Michelangelo's *Madonna of the Stairs*, one can see the influence of Donatello at work. Both versions of the Madonna exemplify humility. There is an informality in the relationship between mother and child. The infants are touchable, huggable babies, distinct from many portrayals in earlier periods, which

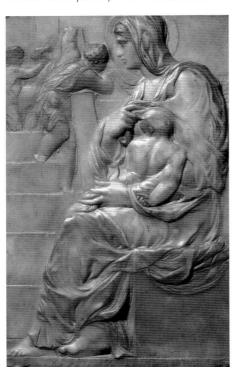

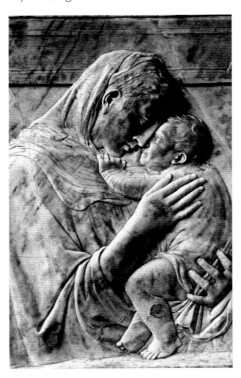

Right: Battle of Nude Warriors, *by Antonio del Pollaiuolo, 1470–5. This is one of the most well-known prints from the Renaissance period.*

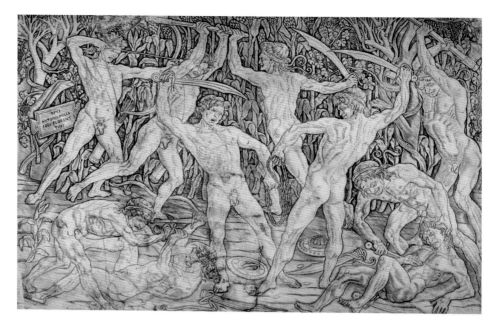

depict the Christ Child as a tiny adult. Depictions of the 'Madonna del Latte' (*Madonna of the Milk*), were popular commissions for artists at this time. Leonardo da Vinci's painting the *Madonna Litta*, c.1490, tempera on canvas, is a stunning example.

In Donatello's work there is a real sense of the intimacy of the scene, as the mother embraces her

THE FAUN

A story is told by Vasari and Condivi that soon after arriving at Lorenzo's school, Michelangelo implored to be given tools and a piece of marble to copy one of Lorenzo's pieces, an ancient marble sculpture, the head of a Faun (a grotesque head; half man, half goat). He copied it, emulating the old face, wrinkled nose and gaping, laughing mouth, but added teeth to his version. Passing through the garden, Lorenzo saw his work and remarked that good as it was, an aged person such as the Faun would not have all his teeth. Michelangelo set to work to remove one of the teeth, drilling into the gum to show that it had fallen out, as an old person's would. That was the moment that Lorenzo, impressed at his creativity, offered him residence with the Medici.

The faun's head that was made by Michelangelo is lost. A copy in terracotta and a drawing are all that we have left to consider one of his earliest sculptures in the round. The incident is however depicted in a later fresco by Giovanni Mannozzi (1592–1636), showing how by that time the tale had been exalted into the myths surrounding each of the two men.

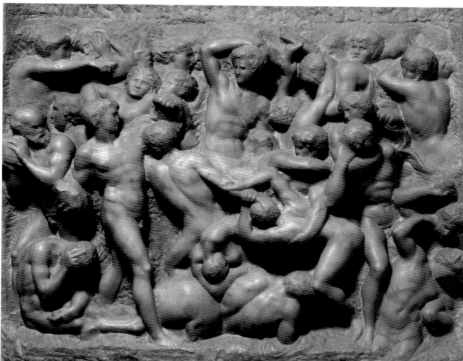

son, their heads touching as they gaze into each other's eyes. So too, in Leonardo's painting, as the Madonna, looks down fondly at her infant son whilst he suckles at her breast. The Christ child looks out at the viewer, who witnesses the tender moment of informality between mother and child.

The second relief from this period which demonstrates Michelangelo's blossoming creativity is *Battle of the Centaurs*, c.1492. A couple of years earlier Bertoldo di Giovanni had produced *Battle between the Romans and Barbarians*, c.1490, and although

Above: Battle of the Centaurs, *by Michelangelo, c.1492. Michelangelo's second marble relief depicts an intense mythological battle scene, possibly informed by Roman sarcophagi and the works of Giovanni Bertoldi and Antonio del Pollaiuolo.*

Michelangelo's work is not directly taken from his tutor's, both show a passionate battle scene. The juxtaposition of Michelangelo's figures may have been influenced by an engraving by Antonio del Pollaiuolo (1433–98), *Battle of Nude Warriors*, c.1470.

LORENZO DE' MEDICI

Lorenzo de' Medici, known as 'Il Magnifico', followed Michelangelo's sculptural progress with great interest. Deeply impressed, he became Michelangelo's first patron. Lorenzo's support and encouragement firmly set the ambitious sculptor on a path to excellence.

The brief four years that Michelangelo spent in the Medici household set him on a path to prominence. Here he was living among a patrician family of merchants who held high office in influential positions. Michelangelo knew the younger members of the family well and later, as cardinals and popes, they would request his service, and favour him with commissions.

A MEDICI 'SON'

It was as if Michelangelo were an honorary member of the Medici family. For this privilege he had to thank Lorenzo de' Medici, his first patron and supporter.

At this time Lorenzo was the most powerful man in Florence. The city had bestowed on him the title of 'Il Magnifico' that is, 'the Magnificent', an honour reserved for very few.

Lorenzo, like his grandfather Cosimo de' Medici (1389–1464), was a patron of the arts and actively sought to beautify the city of Florence with new architecture, sculpture and painting. He was respected by Florentines for his patronage of the city, not only in the arts but through bequests and aid to groups and individuals. His kindly act toward Michelangelo is just one example of his generosity.

THE CHURCH AND HUMANISM

Michelangelo was aware of the power struggle between the patrician families and between the Church and the Medici. The study of Humanism clashed with the teachings of the Church. To believe in the words of ancient philosophers such as Plato and Aristotle (384–322BC) was an acknowledgement of pagan superiority. Michelangelo was allowed

Above: Lorenzo de' Medici surrounded by artists admiring Michelangelo's 'Faun', *by Giovanni Mannozzi (Giovanni da San Giovanni), c.1616. Lorenzo and friends discuss Michelangelo's 'antique' marble faun.*

access to the many learned men – philosophers, writers and scientists – who frequented the Medici residence. Philosopher and theorist Marsilio Ficino (1433–99) had created an 'Academy' for the Medici, loosely based on the ancient Lyceum of Athens. The Medici circle of intellectuals was interested in Humanism and in Neo-Platonism, following the ancient tradition.

CHOOSING THE RIGHT PATH

This must have been difficult for Michelangelo. He had been allowed access to Lorenzo's magnificent library and the antique texts within it.

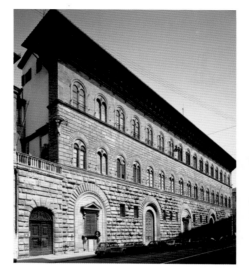

Right: Exterior view of the Palazzo Medici-Riccardi, Florence, by Michelozzo di Bartolomeo, c.1444.

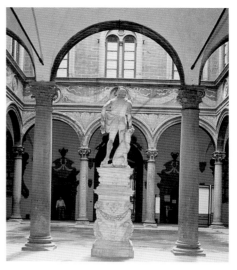

He sat at table with the family, at times taking his seat next to Lorenzo. From his biographers we know that he was treated with respect and encouraged to be part of the family household. Studying at the sculpture school and absorbing the literary and philosophical culture of the Medici household had educated Michelangelo to a high standard, as demonstrated by his letters and poetry of later years. As his knowledge and interest in Humanism and Neo-Platonism increased, it began to conflict with his fervent religious beliefs, a problem that would continue into adult life.

Below: Portrait of Lorenzo de' Medici, 'the Magnificent', by Giorgio Vasari, 1534. Vasari paints a sympathetic portrait of Lorenzo Il Magnifico, a passionate patron of the arts in Florence.

Above: Interior view of the Sculpture Court, Palazzo Medici-Riccardi, Florence. The sculpture court, based on the architecture of ancient Rome, contained sculptures from the Medici collection.

NEO-PLATONISM

The subject of Neo-Platonism is complex. Platonism at its simplest is the study and debate of the various arguments put forward by the Greek philosopher Plato (428/7–348/7BC). The philosopher Plotinus (AD204–270) is considered to have founded Neo-Platonism, linking Christian and Gnostic beliefs to debate various arguments within their doctrines. One strand of thought linked together three intellectual states of being: the Good (or the One), the Intelligence and the Soul. The Neo-Platonic Academy in Greece was closed by the Emperor Justinian (AD483–565) in AD529. During the early Renaissance, texts on Neo-Platonism began to be reconsidered, translated and discoursed. Of primary importance to the growing popularity of Neo-Platonism were two men: Marsilio Ficino and Pico della Mirandola (1463–94). Ficino produced Latin translations of Plato's *Dialogues*, the *Enneads* of Plotinus, and numerous other works. 'Five Questions Concerning the Mind', an essay by Ficino, is a summary of Neo-Platonic doctrine.

UNREST IN FLORENCE

The death of Lorenzo de' Medici in 1492, and the sermons of Fra Girolamo Savonarola, a zealous Dominican friar of San Marco, unsettled Florence and the Church of Rome. As a Medici supporter Michelangelo was caught in the middle.

Lorenzo de' Medici died overnight on 8/9 April 1492 in his villa at Careggi, in the Florentine hills. This villa had been the centre of his Platonic Academy. It was a fitting last resting place for a gifted poet, author, patron of the arts and statesman of Florence. At the time of his death he was 43 years of age and had been ill for some time. At his side was his priest, the Dominican monk Fra Girolamo Savonarola (1452–98) of San Marco, who may or may not have given him absolution. Michelangelo was devastated at the death of Lorenzo, who had been like a father to him. According to Vasari and Condivi, at this time Michelangelo travelled back home to stay with his own father for some time.

PIERO DE' MEDICI

Following his father's death, Lorenzo's eldest son, Piero de' Medici (1472–1503), was now head of the family at twenty-one years of age. He and Michelangelo were well acquainted and it was clear that Medici patronage of the sculptor would continue. Condivi states that Michelangelo was invited again to live in the Medici household. Vasari writes that Piero would often ask for Michelangelo's advice when buying antiquities. However, the only commission recorded during the brief two-year period that Piero was in Florence after the death of his father is one for a snow sculpture for the centre of the courtyard at the Medici palace. The idea presented itself to Piero after Florence received a prolonged, heavy blizzard of snow in January 1493; heavy snow was very unusual in Florence. Tantalizingly, neither biographer tells us any more: what it looked like, how big it was, or how long it lasted, one has to guess. Vasari simply states that Piero "caused him [Michelangelo] to make in his courtyard a statue of snow, which was very beautiful."

CHRIST ON THE CROSS

A wooden crucifix in the Church of Santo Spirito, Florence is an extant work from this period. Long debated over and associated with Michelangelo, it is now tentatively accepted by art historians to be one of his early works. The youthful figure of Christ, in painted wood, is thin and naked. The head hangs down gently on to the chest. It is a forlorn image. In terms of the style of the work, the thin arms and legs and the emaciated torso of the body are realistic. The body is striking in its anatomical detail, with the skin taut over the ribcage. It is known that the Prior of the Church of Santo Spirito allowed Michelangelo to dissect the bodies of the dead in the mortuary, to increase his knowledge of human anatomy. This was a great privilege that needed approval from the civil authorities of the city.

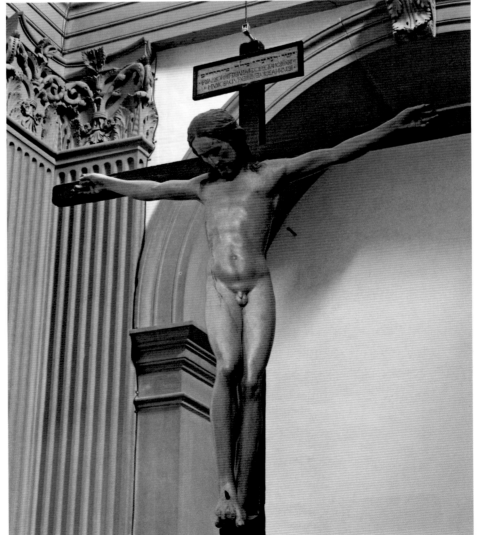

Left: Crucifix, c. 1492. The significance of Michelangelo's early sculpture in wood is that he depicts Christ naked. A sign above the figure of Christ reads "Jesus of Nazareth, King of the Jews".

PIERO FLEES FROM FLORENCE

Unfortunately Lorenzo's son Piero was neither a charismatic nor strong leader. In 1494 his gamble to remain neutral in a dispute with the French King Charles VIII (1470–98) found Florence besieged and Piero and senior members of the Medici family forced to flee the city. The action re-established the Republic of Florence, after 70 years of Medici rule, but it left the city open to a new leader, the fiery churchman Fra Girolamo Savonarola. The Dominican priest was Prior of San Marco (from 1491–98), a Dominican convent which had been funded by Cosimo de' Medici, Piero's great-grandfather. Savonarola imposed a sombre, less robust, more devout way of life for Florentines. During this period Michelangelo spent time in Venice and Bologna and only returned to Florence intermittently. For Florentine artists it was a bleak time unless they wanted to paint images of the Holy Family. No sculptures or works based on antiquity would be tolerated. For Michelangelo this was not work. He considered painting pictures to be work for women, of little skill and even less value.

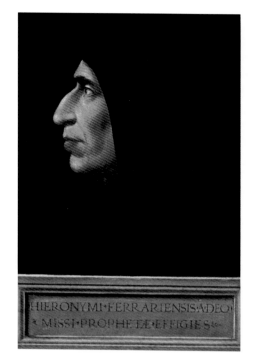

Above: Portrait of Girolamo Savonarola, *by Fra Bartolommeo, 1499–1500. Savonarola's rule of Florence heralded a low period in arts patronage in the city.*

Below: Execution of Savonarola in Piazza della Signoria, Florence, *anonymous, c.1498. Dominican preacher Girolamo Savonarola was executed in front of the Palazzo della Signoria on 23 May, 1498.*

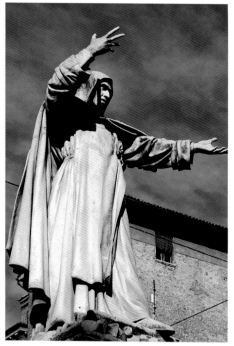

Above: Figure sculpture of Girolamo Savonarola, *by Stefano Galletti, c.1875. This life-size sculpture of Savonarola is displayed in Ferrara, where he was born.*

SAVONAROLA

At the expulsion of the Medici from Florence in 1494 Fra Girolamo Savonarola, the Dominican Prior of San Marco, became leader of the republican city. In 1496 he inaugurated a religious carnival at which the wealthy gave their finest possessions and money to the poor. At the following year's festival he ordered the wealthy to burn 'corrupt' paintings and books and festival masks, on a bonfire of the 'vanities', in the Piazza della Signoria. This was perhaps a step too far, for he lost the support of the Florentine Republic. The Church of Rome took away his power and in 1498 he was tried for heresy against the Church, found guilty and excommunicated. He was tortured and burnt at the stake in the Piazza della Signoria in Florence, alongside four other men – who were all zealous members of his fraternity.

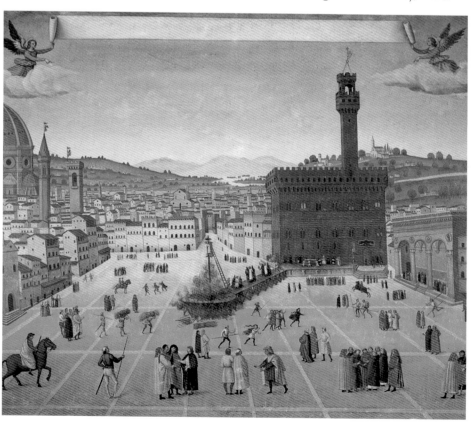

A MASTERFUL SCULPTOR

His unexpected departure from the Medici household in Florence saw Michelangelo look to other patrons in other cities for professional commissions, ever eager to continue working as a sculptor. He travelled to Bologna and Venice to seek patrons and work.

A change in circumstances increased Michelangelo's determination to pursue his career. More than anything else he wanted to prove himself to be a master sculptor. In 1493, before the expulsion of the Medici from Florence, we are informed that Michelangelo was working on a small statue of Cupid and a colossal marble sculpture of Hercules (the half-mortal, half-divine son of the Olympian god Zeus and the mortal Alcamene).

A NEW PATRON?

Both Vasari and Condivi suggest that Michelangelo had purchased the marble himself and carved the Hercules sculpture at his own home. Current historians debate whether he could have afforded such a piece of marble, even though it was not in the best condition. How would he transport the sculpture, once finished, and would he even attempt to create such a large work without a buyer? There is the possibility that he was given the marble by somebody to create the piece. But was it for Piero de' Medici or a new patron?

It is known that Michelangelo was well-acquainted with the wealthy Strozzi family at this time. He had long been a friend of the young Strozzi brothers Lorenzo (1482–1549/51) and Filippo (1489–1538), Filippo in particular. On completion *Hercules* was transported to the Strozzi property in Florence. One of Michelangelo's younger brothers worked for the Strozzi in their woollen business – all three younger brothers took an active interest in the woollen industry. With all these connections it could be argued that a Strozzi, perhaps Selvaggia, widow of Filippo Strozzi the elder, and mother of Lorenzo and Filippo, was Michelangelo's patron.

MICHELANGELO GOES MISSING

What is less easy to establish is the reason for Michelangelo's disappearance from Florence in the autumn of 1494. He is known to have left for Bologna and Venice on 10 or 11 October of that year, prior to the threat of the French king's invasion of the city. Perhaps he expected reprisals for his close association with the Medici. Condivi writes that Michelangelo was made afraid by an

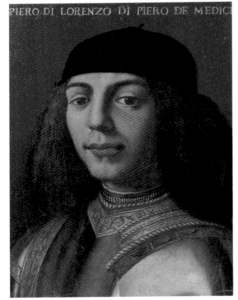

Above: Portrait of Piero di Lorenzo de Medici, by Agnolo Bronzino, 16th century. Piero 'the Unfortunate' fled from Florence in 1494, after ceding vital fortress towns to Charles VIII.

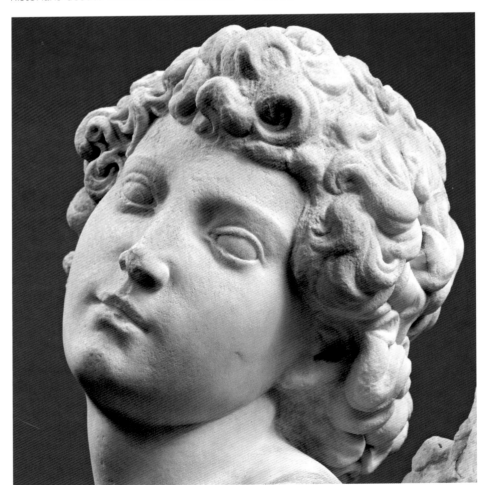

Left: 'Manhattan' Cupid (detail of head), by Michelangelo, c.1494–6. The creation of this 'Cupid' underlines Michelangelo's interest in the sculpture of antiquity.

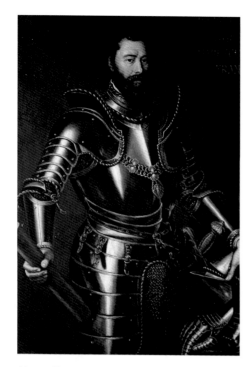

Above: Portrait of Filippo Strozzi, *Italian School, 16th century. Michelangelo possibly accepted a commission from the Strozzi family in Florence.*

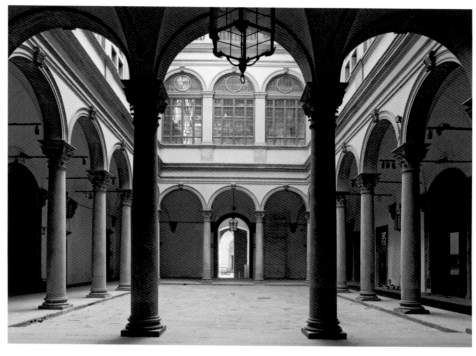

Above: Palazzo Strozzi, Florence. One of the finest Renaissance buildings in Florence, it was commissioned by Filippo Strozzi, a wealthy Florentine merchant.

omen interpreted by courtier Andrea Cardiere, that Piero de' Medici would be banished from the city. Piero, his friend and patron, when he found Michelangelo gone, made his disappointment clear. The Medici were banished in November 1494, when Piero ceded vital fortress towns to Charles VIII. It is likely that the combination of popular support for Savonarola and the demise of the Medici were the deciding factors in Michelangelo's departure.

BOLOGNA AND VENICE

Michelangelo left Florence with two companions and headed north toward Venice, travelling via Bologna, which would have been a two to three-day journey. According to his biographers, he ran out of money just two days after leaving Florence. As visitors entering the city of Bologna, they failed to comply with a local law created by Giovanni Bentivoglio (Lord of Bologna, 1462–1506) that compelled foreigners to have one thumbnail stamped with red sealing wax, so that they could be identified. For this, Michelangelo and his companions were taken to the tax

office to be fined fifty *bolognini* lire. Fortunately a Bolognese gentleman, Gianfrancesco Aldovrandi, on hearing that Michelangelo – a sculptor in the circle of the Medici – was to be fined, persuaded the authorities to set them all free. Michelangelo was then invited to stay at the home of Aldovrandi. He reluctantly accepted the invitation, after giving his friends what money he had. Condivi states that Michelangelo stayed "*pochi giorni*" (for four or five days) before travelling on to Venice.

Although still a young man, just beginning to follow his chosen career path, the fact that Michelangelo was known as an 'honorary member' of the Medici household in Florence held weight with noble and mercantile families in other Italian cities. Gianfrancesco Aldovrandi had welcomed Michelangelo into his home in Bologna for that reason. The Medici name opened doors, even by association. It was perhaps for this reason that Michelangelo often suppressed his Republican values concerning the city of Florence, in order that he might continue to be supported by wealthy patrons – whether in Florence, Bologna or Rome.

THE LOST HERCULES

Michelangelo's *Hercules*, c.1493, was lost or destroyed. The piece, at 2.3m/7½ft in height, was colossal. Vasari states that the *Hercules* was an admirable work, which stood for many years in the gardens of the Strozzi Palace in Florence. He adds that it was removed during the siege of Florence and sent to King Francis I of France (1494–1547) in 1529. However, it is possible that it was moved to a Strozzi property in France and later sold to King Francis I, or given to his son King Henri II of France (1519–59) in 1546, as stated by the 19th century curator of the Medici archives, Gaetano Milanesi (1813–95). It is known that Henri IV of France (1553–1610) placed the statue in the Jardin d'Estaing at Fontainebleau, Paris, in 1594 and that the garden was destroyed in 1713. The circumstances surrounding the statue's creation may be unclear, but it was certainly unusual for an 18-year-old to be working on such a large sculpture.

BOLOGNA

Michelangelo's visit to Venice did not result in any commissions. His style of work was influenced by the Florentine revival of interest in antiquity, which was an undesirable concept to Venetians at this time. He returned to Bologna.

Michelangelo returned to Bologna at the end of October 1494 and stayed for many months with Aldovrandi. By coincidence it was to Bologna that the Medici family and their followers fled after their expulsion from Florence in November 1494. They resided at the house of the Rossi, a wealthy patrician family. As Condivi points out, Cardiere's omen – that Piero de' Medici would be expelled from the city and not return to it – had been fulfilled. Piero eventually drowned in 1503, while attempting to cross the river Garigliano, fleeing a battle skirmish.

TOMB OF ST DOMINIC

The months spent as a guest of Aldovrandi must have been pleasurable for Michelangelo after the unrest in Florence. Condivi writes that he would read from Dante, Petrarch and Boccaccio in 'lingua vulgare' (colloquial Italian) to his host and in turn Aldovrandi took Michelangelo on excursions of the city, to see the buildings of Bologna. At the Basilica of San Domenico, the city's cathedral, Aldovrandi showed Michelangelo the tomb of St Dominic, the founder of the Dominican monastic order. The marble sarcophagus had been created in 1265–7 by sculptor Nicola Pisano (1220/25–c.1284) and his workshop. Work had then continued in the late 1460s with the addition of an ark, 'arca', above the tomb, to be decorated with freestanding figures. Niccolò dell'Arca (1435/40–1494) had been under contract since 1469. Condivi reports that the marble edifice was missing two marble figures: one of a kneeling angel and one of St Petronius. In fact, it lacked three figures, the third being that of St Proclus. Michelangelo's host

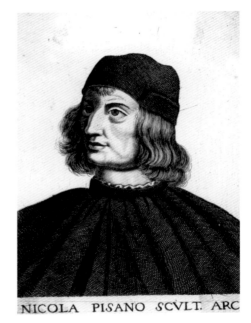

NICOLA PISANO SCVLT. ARC

Above: Portrait of Nicola Pisano, artist unknown, c.1258–78. Pisano was one of the most respected Italian sculptors of the 13th century.

Aldovrandi, one of 'The Sixteen' of Bologna – officials elected to protect the city from the Papal States – invited Michelangelo to create the missing figures, a commission he accepted. Condivi states the sculptor was paid 18 ducats for the marble St Petronius figure and 12 for the marble angel. He omits to mention St Proclus, the third figure. Later, in 1535, a Bolognese writer, Leandro Alberto, confirmed that all three figures had in fact been created by Michelangelo.

KNEELING ANGEL

The *Kneeling Angel* placed on the right above the sarcophagus complements the kneeling angel sculpted by Niccolò dell'Arca on the left side of the tomb.

Left: Basilica of San Domenico, Bologna, built 1219–51. The basilica was consecrated on 17 October 1251 by Pope Innocent IV.

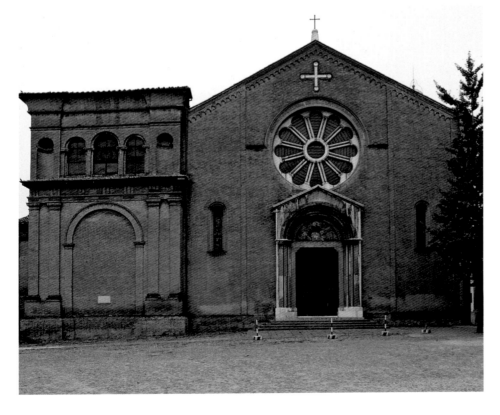

Right: Tomb of St Dominic, Basilica of San Domenico, by Nicola Pisano, 1265–7. The marble tomb was viewed by Michelangelo during his stay in Bologna.

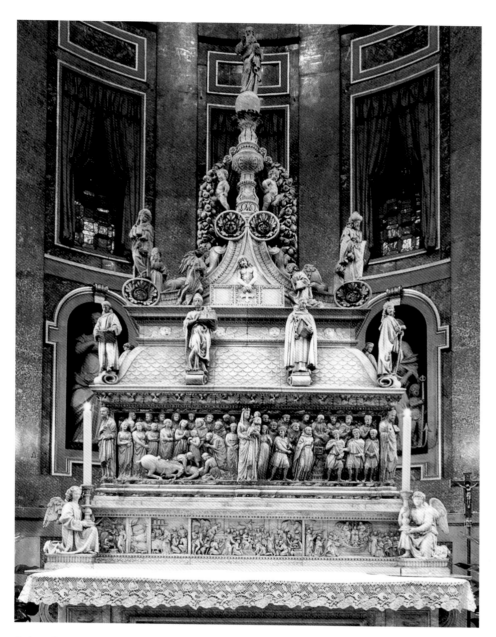

Both figures, each around 50cm/20in in height, hold a giant candelabra, but are quite different in style. Niccolò uses the refined gothic medieval style, popular in the northern cities. Michelangelo creates a calm, fulsome young figure with rounded face and contemporary hairstyle with a fluid bodyline clearly visible through the robes.

ST PETRONIUS

Patron saint of Bologna, St Petronius was elected and consecrated Bishop of Bologna in AD432 and died before AD450. A church was built in his honour in Bologna. When working on his St Petronius (64cm/25in), Michelangelo must have considered the sculpture of the saint by Jacopo della Quercia (c.1374–1438), placed above the entrance to the church of St Petronius in Bologna. While della Quercia places a model of the city in one hand, Michelangelo firmly places it in both hands. His is a squat, blocky depiction of Bologna. The city's recognizable high towers of ancient brick are reduced in height. The main buildings are enlarged in size. The shape and dimension of the city model is easily seen from afar, which highlights the figure of the saint aligned with other sculptures.

ST PROCLUS, A SELF-PORTRAIT

Michelangelo's figure of *St Proclus* (58.5cm/23in), a martyr of Bologna, was possibly inspired by the Niccolò dell'Arca sculpture of *San Vitale* (1469–94) on the same monument or by Donatello's *St George* (1415–17). The sculpture is said to be a self-portrait of Michelangelo. The face is defined by a deeply furrowed brow and staring eyes. This confrontational look can be seen in his later works of sculpture: on the face of his colossal statue of *David* (1501–4), and in *Moses* (1513–16) and *Brutus* (c.1540).

Below: Saint Proclus (detail of the upper body), by Michelangelo, 1494–5. Possibly a Michelangelo self-portrait.

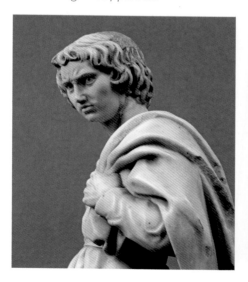

Below: St George by Donatello, c.1416. This marble figure was created for a niche in Orsanmichele, Florence.

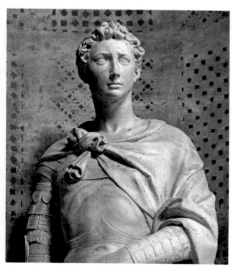

COMMISSION FOR A BACCHUS

Michelangelo worried that other sculptors were jealous of his success. Fearing for his safety in Bologna he returned to Florence, hoping to find new commissions. He received a warm welcome from the younger members of the Medici household.

In 1495 Michelangelo returned to Florence for six months. Some of the younger members of the Medici family had not left Florence; their sympathies lay with the Republic. Michelangelo was welcomed by them and invited to live in the household once again. During his time in Florence he created two marble sculptures, both now lost.

FAKING ANTIQUITY
One of these sculptures represented a young John the Baptist, possibly commissioned by Lorenzo di Pierfrancesco de' Medici (1463–1503). The other was *Sleeping Cupid* (80cm/ 32in), which may have been based on an antique sculpture of a sleeping Eros (the Greek name for the Roman Cupid) in the Medici sculpture garden, given as a gift to Lorenzo de' Medici by King Ferdinand I, Holy Roman Emperor (1503–64), in 1488. The *Sleeping Cupid* became a source of both scandal and fame for Michelangelo. Condivi writes that Lorenzo di Pierfrancesco suggested to Michelangelo to artificially age it: "If you were to treat it artificially, so as to make it look as though it had been dug

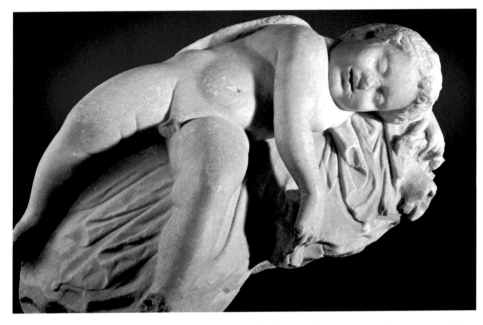

Above: Sleeping Eros, *artist unknown, copy of a Hellenistic sculpture, c.330–10BC.*

up, I would send it to Rome; it would be accepted as an antique, and you would be able to sell it at a far higher price." Whether Michelangelo agreed to this is not recorded, but it was sold through Lorenzo to Baldassare del Milanese, an art dealer in Rome, for the low price of

30 ducats. It was then sold to a notable collector of antiquities, Raffaele Sansoni Galeoti Riario (1461–1521), Cardinal of San Giorgio in Velabro, for a much higher price of 200 ducats.

ANGER IN ROME
The vast difference in the two costs suggests that the Cardinal did indeed believe the piece to be an archaeological find. When he discovered that it was actually a new work, he sent for Michelangelo to meet him in Rome. Soon afterward Michelangelo wrote an informal letter to Lorenzo on 2 July 1496, beginning, "This is only to let you know that we arrived safely in Florence", informing Lorenzo that the matter of the fake was resolved and the Cardinal had his money returned. Michelangelo wanted the sculpture back, but he informs Lorenzo in the letter that Baldassare, the art dealer, was determined to keep it, threatening

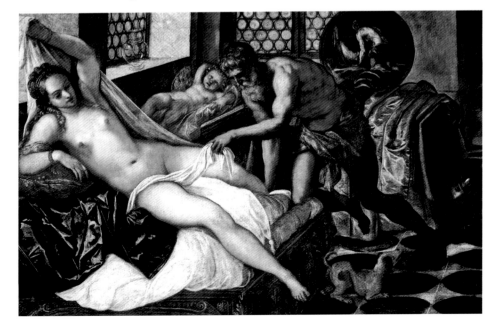

Left: Vulcan Surprising Venus and Mars, *by Tintoretto, c.1555. The image of the infant Mars in his cradle is said to be similar to Michelangelo's (now lost) marble Eros.*

"he would sooner smash it into a hundred pieces; that he had bought the cupid and it was his". The sculpture fell into the hands of the family of the Dukes of Mantua and is said later to have been owned by the English King Charles I (1600–49) and placed in his residence, Whitehall Palace in London. The palace was destroyed by fire in 1698.

A LIFELIKE BACCHUS

The outcome of the meeting in Rome between Michelangelo and Cardinal Riario was fortuitous. They got on well and the Cardinal invited Michelangelo to stay in Rome, working for him. The unrest in Florence, due to Savonarola and his clamp-down on cultural pursuits, had left many artists seeking work elsewhere. Michelangelo, aware that many potential patrons were living in Rome, chose to stay. The Cardinal employed Michelangelo for his knowledge of antique sculpture, to aid with the buying of antiquities for his collection. While Michelangelo was residing at the house of the Cardinal's banker Jacopo Galli, the Cardinal offered Michelangelo 150 ducats to create a full-size marble sculpture of Bacchus, the mythological god of wine, to complement the antique collection which was destined for his new palace. Michelangelo started work on *Bacchus* in July 1496. He chose to sculpt a naked Bacchus, wine cup to his lips, standing with a small satyr (a mythic half-human, half-goat creature) hiding behind him. Michelangelo suffered one setback: the large piece of marble purchased by the Cardinal was of poor quality. This was a lesson to him. In future he would insist that his clients paid for only the best quality marble.

Bacchus was completed by July 1497 but the Cardinal thought it inferior to his other pieces and left it at Galli's house. A drawing (c.1532–7) by the Dutch artist Maerten van Heemskerck (1498–1574) shows it standing in Galli's garden, with right wrist, hand and goblet missing. In 1572, eight years after Michelangelo's death, Galli sold it to Francesco de' Medici. It was respectfully positioned next to a Bacchus of antiquity, to prove Michelangelo's superior skill at an early age.

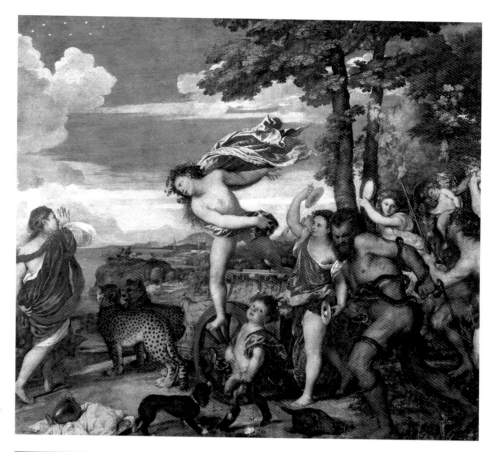

Above: Bacchus and Ariadne, *by Titian (Tiziano Vecellio; c. 1490–1576), 1520–3. Titian depicts the Roman god of wine Bacchus with Ariadne, followed by Bacchanalian revellers, including a small satyr and wild animals.*

Left: The Drunkenness of Bacchus, *by Michelangelo, 1496–7. The marble sculpture portrays Bacchus, lifting a dish of wine to his lips, accompanied by an impish satyr.*

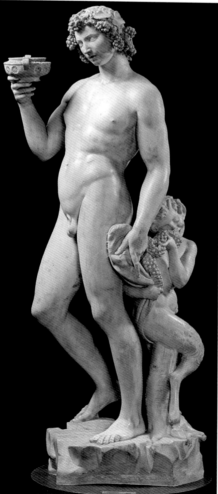

AN ENVIOUS TALENT

Throughout his life Michelangelo found that his superior talent as an artist created envy among his peers. He did not stay long in Bologna after completing the statues for the tomb of St Dominic. It was rumoured that he was fearful of his life from other sculptors in the city who were angry that he should get the privilege of such a commission. It would be the first of many times that he thought others, envious of his talent, were trying to kill him.

THE ARTIST MAKES HIS MARK

An opportunity to create a full-size group sculpture – a religious work commissioned by the French Ambassador in Rome – allowed Michelangelo to prove to himself and to prospective patrons that he was a master of sculptural figure-work.

In Rome, the *Sleeping Cupid* (1496) and the *Bacchus* (1496–7) created a surge of interest in Michelangelo, and his friendship with the banker Jacopo Galli proved useful once again. Cardinal Jean Bilhères de Lagraulas, the French ambassador of King Charles VIII at the papal court in Rome, was also one of Galli's clients. He wanted a *Pietà* for his proposed tomb in Santa Petronilla, Rome, the style of it "…showing a Virgin robed with the dead Christ nude in her arms". The figure of Christ was to be as "large as an actual man".

GALLI ACTS AS GUARANTOR

The Cardinal signed the contract for the sculpture on 29 August 1498 although it had been agreed at a much earlier date. Michelangelo had been looking for the right piece of marble in the mountain quarries of Carrara as early as November 1497. Jacopo Galli signed the contract on Michelangelo's behalf and stood as guarantor that the work would

be completed. The fee would be 450 ducats, a worthy amount of money. The delay between agreement and contract was normal procedure as the fee could not be finalized until all the costs, including the cost of the marble, were known. Michelangelo's trips to Carrara would last months. He eventually found the piece he wanted in the quarry at Polvaccio, assisted by Domenico di Giovanni da Settignano, the stone-cutter known as *Topolino* (little mouse). Michelangelo must have been greatly at ease among the stonemasons and quarrymen, a reminder of his early childhood in Settignano. At this time he wrote infrequently to family and associates, but it is known that he had set up a workshop in Carrara to prepare the stone for its transportation to Florence.

A SUBLIME PIETÀ

The finished *Pietà* was a masterpiece. It was to establish Michelangelo's reputation as a great artist. The figure

of the young Virgin is seated. The body of Christ is placed across her lap. She cradles the limp body of her dead son in her arms, holding him for the world to see. Her face is turned down, as she looks at him. Vasari and Condivi write fully about the contract and the reaction to the finished work. For many, the face of the Virgin showed a woman too young to be the mother of Christ, and also perhaps too beautiful. Michelangelo rebuked these challenges. For him it was the timeless and innocent soul of a virgin that was mirrored in her face, not mortal age. One can sense Michelangelo considering the Neo-Platonist ideal of the human soul mirroring the face of God, earthly beauty mirrored by divine, spiritual beauty.

Below: Carrara is a source of the world's finest marble. Michelangelo preferred the quality of marble from Carrara for his sculptures.

CARRARA

The town of Carrara, in the province of Massa-Carrara in Tuscany, Italy, lies about 120km (75 miles) north-west of Florence. Carrara was established in the 11th century, but for over 2,000 years the stone mountains close to it have been quarried to supply the finest white and blue-grey marble stone.

Workshops at the mountain bases were set up for the quarrymen, stonemasons and architects. It was the stone of choice for Michelangelo, who wanted only the finest quality. Carrara marble continues to be quarried today for its fine quality and durability.

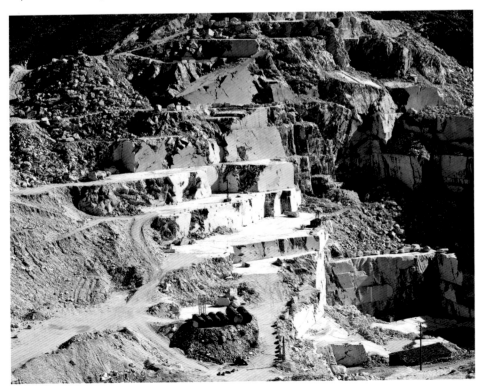

Right: Pietà, *by Michelangelo, 1498–1500. The marble* Pietà *is the first major work by Michelangelo, which established his career as a professional sculptor.*

A SIGNATURE MARK

Shortly after the sculpture had been installed, Michelangelo signed the sculpture across the torso of the Virgin. Vasari and Condivi write that Michelangelo overheard visitors from Lombardy saying the work was by 'Our Gobbo from Milan', referring to sculptor Cristoforo Solari (c.1460–1527). He said nothing but decided to make his mark on the piece. As Vasari tells us, one night Michelangelo brought his chisels and carved the words: 'MICHELANGELUS BUONARROTUS FIORENTINUS FACIEBAT', 'Michelangelo Buonarroti, Florentine, made this', on a sash across the Virgin's torso. The style of words is a throwback to the signature style of artists in ancient Rome. It may also have related to the episode of the *Sleeping Cupid* (1496), which had been passed off as an antique. Michelangelo wanted to confirm who had made the work, his Florentine roots and his family patronymic of Buonarroti.

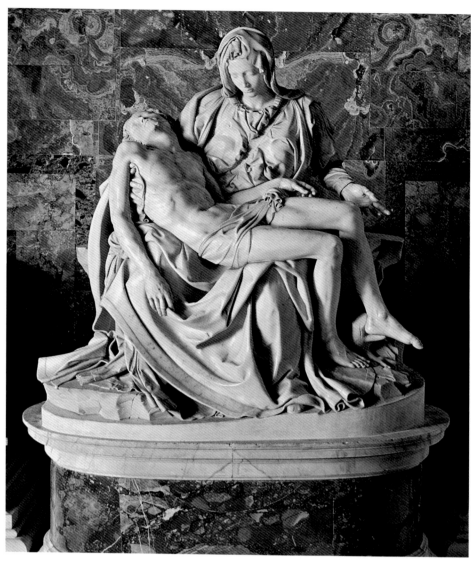

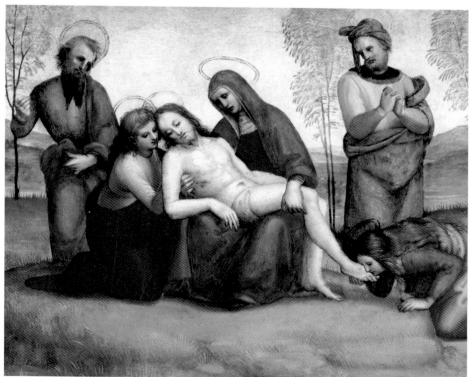

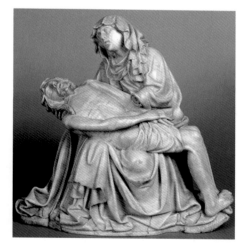

Above: Pietà, *German School, c. 1430. An alabaster sculpture illustrates the traditional depiction of the* Pietà.

Left: Lamentation for a Dead Christ, *by Raphael, 1504. Raphael's depiction of the figure of Christ replicates Michelangelo's* Pietà.

A PRESTIGIOUS REQUEST

Michelangelo returned to the city of Florence with an undisputed reputation as a master sculptor. Eager to engage his services, the Guild of Wool Merchants, patrons of the cathedral works, commissioned a statue of 'David', a civic symbol of the Republican city.

The success of the *Pietà* of 1498–1500 had conferred a new status on Michelangelo. He returned to Florence a recognized genius of his craft. While Florence remained a republic, the death of Savonarola had revived interest in the arts. New commissions were available, including one for a sculpture of *David*, for the cathedral of Santa Maria del Fiore.

A SCULPTOR FOR *DAVID*

The Arte della Lana (the Guild of Wool Merchants), patrons of the cathedral works, wanted to revive an earlier project for sculptures to be placed on the cathedral buttresses. It was a prestigious contract and Michelangelo accepted it, although he was unhappy with the second-hand piece of marble that the Church commissioners allocated to the project. It had already been blocked out, partly worked, by previous sculptors, namely Antonio Rossellino (1427–79), and earlier Agostino di Duccio (1418–81), who had bought the inferior marble in 1466. Michelangelo's contract of 1501 states that the stone was "badly roughed out". This wording was perhaps included to ascertain in advance that the sculptor might find it problematic to work with. The stone had been exposed to the elements for 35 years in the cathedral courtyard, and had deteriorated during that time.

With regard to the figure outline of Michelangelo's David, it is possible to see similarities with Nicola Pisano's

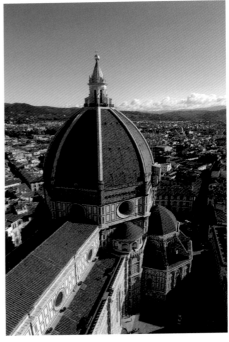

Above: Originally, Michelangelo's sculpture of David was to be placed on a buttress of the Cathedral of Santa Maria del Fiore.

half-life-size marble sculpture *Fortitude*, c.1260, a near free-standing figure, decorating the Pulpit of the Baptistry of Pisa Cathedral. Pisano's figure is considered to have been the first nude sculpture since antiquity. The right arm is raised toward the shoulder; the left is close to the side of the body, a pose that bears a striking resemblance to Michelangelo's later *David*, with left arm raised and right arm at the side of the body. Fortitude and courage were heroic virtues recognized in David and his mythological counterpart Hercules.

According to Vasari, Michelangelo accepted a fee of 400 ducats to make his David, paid over a two-year period. During that time he took on other commissions too. In May 1501, while waiting to receive the final draft of the David contract, he accepted a commission from Cardinal Francesco

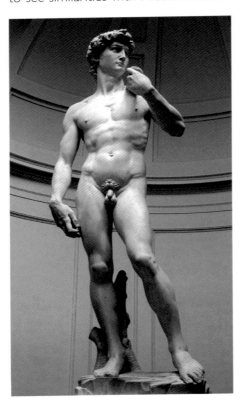

Above: Fortitude by Nicola Pisano, c.1260. This half-life-size sculpture shows early use of the contrapposto. *It is part of the decoration of the pulpit in the Baptistry, Pisa.*

Above: The original sculpture David now resides in the Galleria dell'Accademia, Florence. A copy is in its original location, outside the Palazzo Vecchio.

Todeschini Piccolomini (1439–1503), later Pope Paul III. This was to create 15 sculptures for the Piccolomini tomb in Siena Cathedral. In form they are similar to the sculptures created in Bologna. For the Piccolomini contract Michelangelo would receive 500 ducats. He completed four of the sculptures before he became too busy; his fame was bringing in better offers. The dispute over the Piccolomini payment for the unfinished contract was to haunt Michelangelo for decades to come. His nephew finally returned 100 ducats to the Piccolomini family after Michelangelo's death.

PALAZZO DELLA SIGNORIA

In 1504 the over-life-size sculpture *David*, a symbol of the civic virtue of Florence, was finished. It looked like a Roman god. By this time the patrons of the cathedral works had decided that the statue was too good for the buttresses and wanted to display the *David* right in front of the Palazzo della Signoria (now

Right: Palazzo della Signoria, by Arnolfo di Cambio, from the late 13th century. Michelangelo's David was placed outside the entrance to the building in 1504.

the Palazzo Vecchio), where all official ceremonies were held and religious ceremonies concluded; it was a huge honour. A special cart had to be made to pull the sculpture through the streets. It was heavily guarded before the unveiling. Records show that some people tried to destroy it by hurling stones at it. This may have been because Donatello's beautiful bronze *Judith and Holofernes* (1460), a popular symbol of the Republic of Florence, had to be moved to make way for the *David*. Michelangelo apparently told Vasari that Piero Soderini (1450–1522), the *Gonfalonier* (mayor), standing beneath the statue as it was put into place, remarked to Michelangelo that "the nose of the figure was too thick". Michelangelo, seeing that Soderini was standing below the statue, played a trick. He climbed

up, and with a chisel and a handful of marble dust, proceeded to pretend to chisel at the nose, sending the dust down, asking Soderini if it was improved, to which the reply was: "I like it better, you have given it life".

Above: David by Donatello, c. 1440. This bronze statue of David is the first nude freestanding sculpture in modern history.

Above: David by Andrea del Verrocchio, 1473–5. The bronze freestanding sculpture of David depicts the young shepherd the moment after he has slain Goliath.

DAVID

In the Old Testament, David the shepherd boy was guardian of his flock, a fitting sculpture for the Arte della Lana to commission. The city of Florence identified itself with the character of David in the story of David and Goliath; it was a small city, yet powerful against its bigger adversaries. Other notable sculptures of *David* were present in Florence, including a marble *David*, 1415/16, by Donatello made for a niche of Orsanmichele. Donatello's superb bronze *David* made in the 1450s was naked except for a shepherd's hat and greaves (knee to ankle armour). Donatello had created it for the Medici private collection and it stood in the courtyard of the Palazzo Medici in Florence. An equally superb bronze *David* by Verrocchio, c.1473–5, was perhaps also commissioned by the Medici.

BATTLE OF ARTISTIC GIANTS

Leonardo da Vinci and Michelangelo walked separate paths until the early 1500s. Leonardo had been working in Florence, Rome and Milan; Michelangelo in Bologna, Rome, Siena and Florence. In Florence they would create artworks for the Signoria.

Leonardo da Vinci (1452–1519), born in Vinci, 47km (29 miles) from Florence, was older than Michelangelo by sixteen years. Leonardo had been an apprentice in Florence to the sculptor Andrea del Verrocchio (c.1435–88), but his major commissions were for paintings. He was respected as an artist, sculptor, architect, military and civic engineer and scientist. As part of a committee of Florentine artists, Leonardo, along with 29 others, had decided on the final placement of Michelangelo's colossal *David* (at a meeting on 25 January 1504).

SKILLED ARTISTS

Drawings and sketches created by Leonardo da Vinci and Michelangelo reveal that both closely studied the artistic works of Florentine artists such as Giotto, Masaccio and Donatello. From an early age Michelangelo's ambition was to be a sculptor, not a painter. Leonardo's interest lay in science and engineering more than art. Both spent time as apprentices in the workshops of notable Florentine artists. Leonardo spent several years in the workshop of Andrea del Verrocchio, learning techniques from fresco painting to bronze casting. In contrast, Michelangelo spent only a short

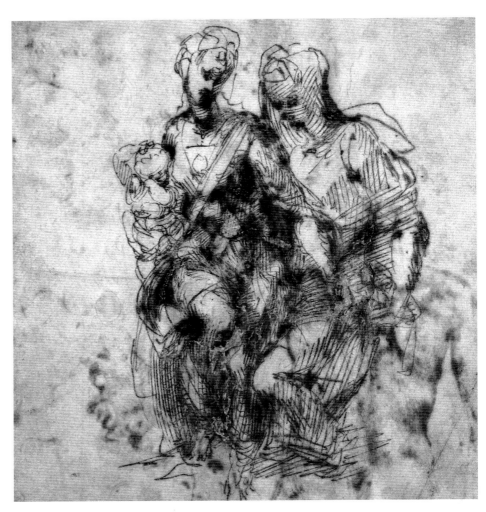

Above: A study of the Virgin and Child with St Anne, *after Leonardo's cartoon, which was on display in Florence for a short time. Michelangelo created many sketches such as this one, purely for pleasure.*

time at the workshop of Ghirlandaio, leaving to attend the new Medici sculpture academy. He professed never to have been 'trained' in a workshop. The surprise perhaps is Leonardo, the 'trained' artist, and his experiments with new painting techniques, which often led to the deterioration of important works such as *The Last Supper*.

Some of Leonardo and Michelangelo's drawings and sketches are copies of each other's work. For example, Leonardo

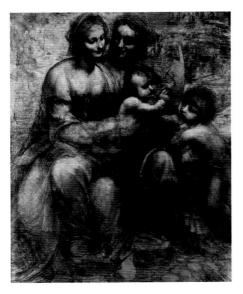

Left: The Virgin and Child with SS Anne and John the Baptist, *by Leonardo da Vinci, c.1499–1500. This preparatory full-size cartoon drawing is possibly a commission for a painting for King Louis XII of France.*

sketched Michelangelo's colossal sculpture of *David*, and Michelangelo drew a copy of Leonardo's *Virgin and Child with SS Anne and John the Baptist* cartoon. This brings to light an acknowledgement of interest in each other's commissions. However, it is recorded that Leonardo said that on greeting Michelangelo in the street in Florence the young man slighted him and turned away. It is possible that Michelangelo considered Leonardo his artistic rival.

Above: The Last Supper (L'Ultima Cena),
*by Leonardo da Vinci, 1495–8. Leonardo's
fresco painting, created for the refectory
of Santa Maria della Grazie, Milan,
illustrates his attention to figural composition.*

FURTHER CONTRACTS

Leonardo and Michelangelo were to
work together for the first time on a
project for the Salone dei Cinquecento
in Florence, but Michelangelo had other
commissions which needed to be
completed first. During his creation
of the colossal *David* (1501–4),
Michelangelo had signed a contract (on
16 August 1502) to create a *David* in
bronze. The work remained unfinished
when he was summoned to Rome in
1505 and was completed by the sculptor
Benedetto da Rovezzano (1474–1552/4)
in 1508. In addition, Michelangelo created
the beautiful *Virgin and Child* (known
as the 'Bruges Madonna'), 1503–5, in
marble, for two Flemish merchants,
Jean and Alexander Mouscron.

Within the Buonarroti family,
Michelangelo finding fame as a
professional sculptor coincided with
his eldest brother taking Holy Orders.
This meant that Michelangelo was
now considered the eldest son and
expected to provide support for his
father and younger brothers. His father
had remarried in 1485, four years after
the death of Michelangelo's mother, but

Ludovico's second wife Lucrezia
Ubaldini died in 1497. From this time
correspondence between father and
son increased and Michelangelo's letters
to his father are kind and full of care for
his well-being. Many letters ask his father
to do small errands for him. It is clear
that his father keeps him in touch with
family matters. In one letter Michelangelo
writes of receiving "a letter from a nun
who says she is an aunt of ours… she
says she is very poor… for this purpose
I am sending you five broad ducats…"
(Rome, August 1499). Four and a half
ducats were for the nun and one half
for his father to purchase half an ounce
of varnish. On a filial level Michelangelo's
letters illustrate his intention to provide
income for the family. His father's letters
offer paternal advice, and it is clear that
there is an extremely strong bond
between father and son.

TWO UNFINISHED PAINTINGS

*The Madonna and Child with Saint John
and Angels* ('The Manchester Madonna'),
mid-1490s, and *The Entombment*,
1500–1, which remained unfinished – we
have no record as to why they were not
completed – show Michelangelo's artistic
capacity in tempera and oils for the first
time. As an apprentice in Ghirlandaio's
workshop he possibly painted part of the
frescoes in the Tornabuoni chapel in
Santa Maria Novella, Florence, but his

contribution, if any, remains unidentified.
A third painting, which he did complete,
was the *tondo* (round) painting of the
Holy Family with St John the Baptist for the
Doni family, *c.*1503, which illustrates his
masterful use of colour and composition.
The youths in the background of this
work are linked to sculptures of antiquity.
Even here, he is incorporating a
sculptural quality into a painted work.

LEONARDO DA VINCI

Leonardo da Vinci was a highly
respected and established artist.
An early work, *The Annunciation*,
1472–3, underlines his gift for
portraiture, arrangement and linear
perspective. He is recognized
for his exceptional portraits, for
example the *Madonna and Child*,
*c.*1476. In Milan, at the court of
Duke Ludovico Sforza (1452–
1508), he completed a large wall
painting, *The Last Supper* (*L'Ultima
Cena*), 1495–8, in tempera on
gesso, pitch and mastic – his own
paint formula – in the refectory of
Santa Maria della Grazie. It was an
astounding work of realism and
depth. In 1503 he began painting *La
Gioconda* (*c.*1503–6), known to us
as the Mona Lisa.

SALONE DEI CINQUECENTO

Prestigious commissions given to Michelangelo and Leonardo da Vinci to create murals
of the Battle of Cascina and the Battle of Anghiari for the Salone dei Cinquecento
should have brought together two artistic giants.

In Florence, the *Gonfaloniere* (chief citizen) Piero Soderini (1450–1522) wanted to utilize the talents of two of the city's most worthy artists: Leonardo and Michelangelo. The Salone dei Cinquecento (Hall of Five Hundred) was the vast room on the first floor of the Palazzo della Signoria (now Palazzo Vecchio) where the council of Florence held meetings.

TWO MURALS

The two long walls of the rectangular room were to be decorated with murals depicting scenes from victorious Florentine battles. On the north wall Michelangelo was to paint the Battle of Cascina, fought against Pisa in 1364, which according to Vasari was a subject of Michelangelo's own choosing. On the south wall Leonardo was to depict the Battle of Anghiari, fought between the Florentines and Milanese in 1440. The theme of both murals was intended to highlight the civic virtues of the Florentine Republic.

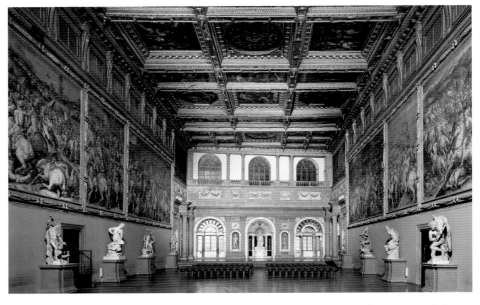

BATTLE OF ANGHIARI

Niccolò Machiavelli (1469–1527), secretary of the Second Chancery, a respected position in the Florentine Republican government, signed Leonardo's contract on 4 May 1504. As was the custom, work had already begun prior to this date. On 24 October 1503

Above: The Salone dei Cinquecento, Palazzo della Signoria, Florence. The two long walls were intended to display The Battle of Anghiari *and* The Battle of Cascina.

Leonardo had settled himself into the Sala del Papa in the convent of Santa Maria Novella, a space allocated to him for preparatory drawings, cartoons and layouts. On 6 July 1505 he began to paint in the vast hall. It is from the initial drawings and from copies of it made by visiting artists (for example, Raphael made a copy of it in 1505) that we have our understanding of the work. The painting itself soon began to deteriorate due to the paint formula Leonardo used. Later it was either removed or covered up, and replaced. A large mural by Vasari now decorates the wall. The painting *The Battle of the Standard* (1603) by Peter Paul Rubens (1577–1640) is itself a copy of a copy of Leonardo's battle scene, based on an engraving made by Lorenzo Zacchia in 1558.

Left: The Battle of the Standard, *after Leonardo, by Peter Paul Rubens, c.1603. We know of the composition of Leonardo's painting from this copy by Rubens.*

Right: Fight study for The Battle of Cascina *by Michelangelo, 1504. The pen and ink on paper drawing highlights Michelangelo's ability to portray a violent, dramatic conflict.*

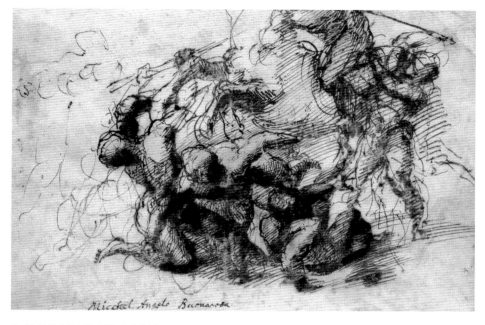

BATTLE OF CASCINA

The commission for *The Battle of Cascina* came at the end of 1504. Leonardo had left for Piombino in the capacity of military architect, leaving the Salone dei Cinquecento free for Michelangelo. Vasari states that Michelangelo was given a room in the dyer's hospital at the Convent of San Onofrio, where he began a large cartoon, allowing no one to see it. His work never got beyond the finished cartoon. Vasari describes how the drawing depicted nude figures bathing in the Arno. Hearing a battle cry, they leap from the water to put on their battle dress. One old man struggles to put his stockings on to his wet feet. Others are shown putting on armour, others are on horseback. The composition allowed Michelangelo to depict the bodies twisting and writhing. It was a similar expression of movement to that seen in his earlier *Battle of the Centaurs*. A copy of Michelangelo's cartoon was made by Aristotile da Sangallo (1481–1551).

A SUMMONS TO ROME

By 1505, Pope Julius II had called Michelangelo to Rome. The Pope, a Humanist with an interest in Neo-Platonism, was a notable collector of ancient Roman and Greek sculptures. He wanted to create a new St Peter's and a new Papal Palace. To this end he surrounded himself with the most gifted professionals in art, sculpture and architecture. It was fitting that Michelangelo was summoned for his talent, but it meant that he had to abandon commissions he was undertaking at the time, which left some patrons dissatisfied. The cartoon for *The Battle of Cascina* was kept safe for him to continue work at a later date. In a letter from Rome dated 8 July 1508 Michelangelo asks his father to give a young Spanish artist, coming to Florence to study painting, the keys to see the cartoon.

Below: The Battle of Cascina, *after Michelangelo, by Aristotile da Sangallo, 1542. This study of Michelangelo's cartoon gives insight into the original work.*

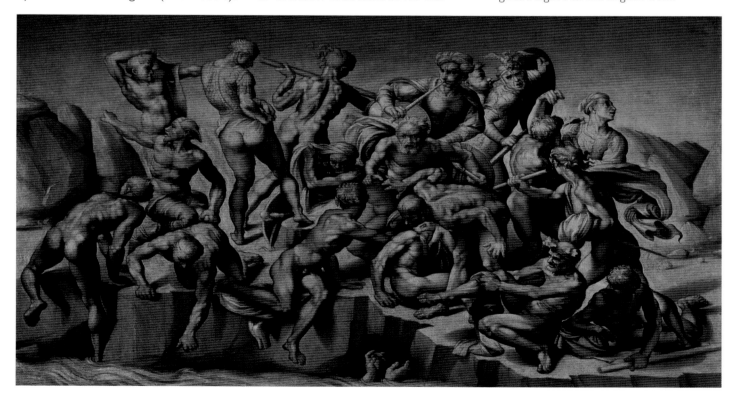

PATRONAGE OF POPE JULIUS II

Pope Julius II stands out as one of the most remarkably accomplished popes in history:
a politician, a military leader, a Humanist and a patron of the arts. To renew the
Vatican complex he chose the best artists in Italy.

To appreciate the motivations behind
Pope Julius II's desire to create a new
city of Rome and a splendid new
Basilica of St Peter's, it is worth
looking briefly at the history of the
city and its status in 1503, when
he took papal office. At this time,
the ancient city, the modern city
and the Vatican complex were all
in desperate need of renewal.
Various plans had been considered
and rejected by previous incumbents
of the papal chair.

A NEW ROME

In 1503 the buildings of the ancient
city of Rome mostly remained buried
or half-buried under the earth.
The demise of the ancient buildings
had started in AD330 when Emperor
Constantine I (AD275–337) moved
the powerbase of his empire from
Rome to Byzantium, which he
renamed Constantinople (now
Istanbul). The exodus left large arenas
like the Colosseum under-used. Its
status as a killing ground for gladiatorial
contests had ended around AD435
and wild beast entertainments were
halted in AD523.

DESTRUCTION AND LOOTING

By the 6th century the central arena
of the Colosseum contained a small
church and cemetery. The vaulted
spaces were used as shops and
warehouses until the 12th century.
Ancient temples, unless put to use for
a different purpose, were destroyed
or closed down, and pagan sculptures
were vandalized when public pagan
worship was banned in AD346. The
city that remained was depleted when
the Visigoths sacked it in AD410,
looting and destroying its fabric. Few
ancient buildings survived intact – they
were plundered for building materials.
One major building, the Roman
Pantheon, a circular pagan temple with
a Greek temple portico, had survived
due to its conversion to a Christian
church in AD609.

From a city of half a million people
in the 4th century AD, in the early 15th
century it had a population of perhaps
no more than 25,000. The population
increased with European and Eastern
pilgrimages to holy sites in the 11th
century – Rome, as the burial place of
Saint Peter, and with the Basilica itself,
was a major destination.

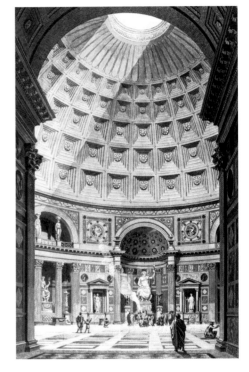

*Above: The Pantheon, an ancient Roman
temple, survived destruction through its
change of use to a Christian church,
St Mary ad Martyres, in AD609.*

A MOVE TO AVIGNON

In the modern era the status of
the city as the spiritual centre
of the Roman Catholic Church was
weakened when the Papal Curia
moved to Avignon on election of
Pope Clement V in 1305. Rome
suffered a serious earthquake in
1349 which saw the collapse of
many buildings. Its revival commenced
when the papacy returned from
Avignon in 1377. From that time
visitor numbers increased and the
city grew in size to accommodate
the vast numbers of pilgrims to the
city. In the mid-1450s the Florentine

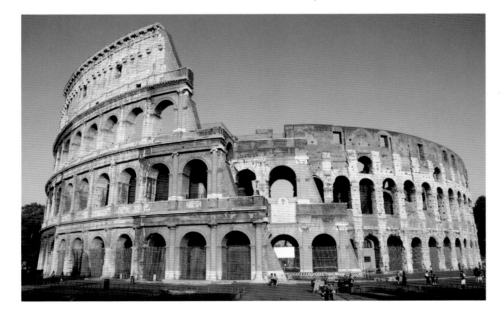

*Left: The under-used Colosseum (Flavian
amphitheatre) in Rome was part of
the papal plan to record and preserve the
buildings of the ancient city.*

Humanist, theorist and architect Leon Battista Alberti, working as secretary to Pope Nicholas (1397–1455), was elected Inspector of Ancient Monuments, to record the extant ancient buildings. The purpose of this was to encourage preservation and aid understanding of the building techniques and materials of the ancients. His treatise *De Re Aedificatoria*, 1452 (published thirty years later), create a renewed surge of interest in the architecture and art of antiquity. This interest in antiquity carried through to the papacy of Julius II.

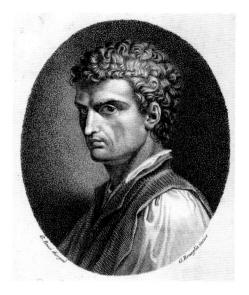

Below: Pope Sixtus IV installs Bartolommeo Platina as Director of the Vatican Library, *by Melozzo da Forlì (1438–94), c.1477. The fresco, transferred to canvas, includes an image of Pope Julius II.*

Above: Leon Battista Alberti, *artist unknown, 1560. The Italian architect Leon Battista Alberti wrote the first modern treatise on architecture,* De Re Aedificatoria, *in 1452.*

Above: The Apollo Belvedere, *artist unknown, c.250–25BC. The marble Roman copy of a Greek 4th-century BC bronze was part of the collection of Pope Julius II, placed in the Belvedere Palace, Vatican.*

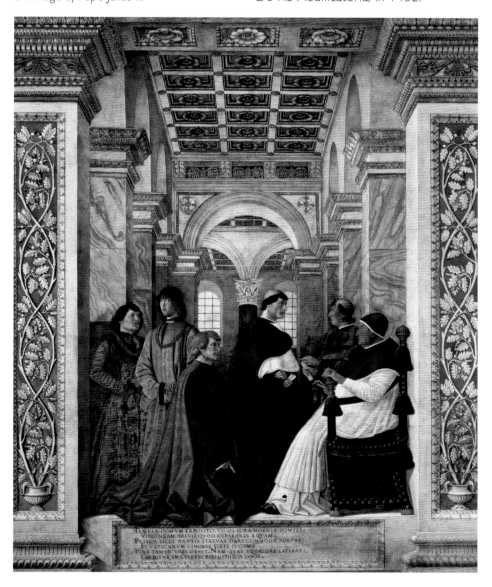

POPE JULIUS II

On the first day of November 1503 Cardinal Giuliano della Rovere was elected Pope Julius II. His ten years as Pope were remarkable. In political terms his papacy is marked by his friendship with the King of France and the Holy Roman Emperor, joining their forces to suppress the expansion of the Venetian Republic. In military terms he was a ruthless ruler, spending most of his reign at war with Italian city states. A Florentine historian once said it was only the vestments and title that showed him to be Pope. In 1506, in full armour with sword in hand, he showed his military prowess leading papal troops successfully into battle to free Bologna and Perugia from despotic tyrants. As a Humanist and Neo-Platonist, his interest in antiquity included a notable collection of sculptures, among them the Hellenistic or Roman marble known as the *Apollo Belvedere*, c.250–25BC. Once elected as Pope he lost no time in assembling the best architects, sculptors and artists to aggrandize Rome, befitting its ancient past.

SUMMONED TO ROME

In 1505 Michelangelo was called to Rome by the new pope, Julius II. There he found himself at the Papal Court in the company of respected artists and architects, including the formidable Donato Bramante and his Urbino counterpart, the young Raphael Sanzio.

Julius II planned to employ the most gifted painters, sculptors and architects to create a new Rome, starting with the Basilica of St Peter's and the Vatican. Michelangelo's most formidable competitor in Rome at that time was the architect Donato Bramante (1444–1514), who had arrived in the city in 1499.

BRAMANTE: A RIVAL

In 1502 Bramante had been commissioned by the Spanish monarchs Ferdinand II of Aragon (1452–1516) and Isabella I of Castile (1451–1504) to design a memorial temple in the courtyard of the cloister of San Pietro in Montorio, Rome. The martyrium was intended to mark the site of the martyrdom and crucifixion of St Peter in AD64. On the election of Pope Julius II Bramante was engaged by the Pope to renew the complex of the Vatican.

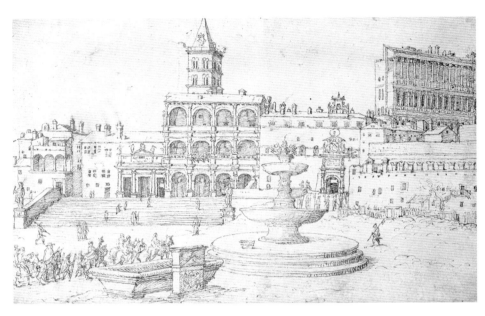

Above: Old St Peter's, *by Maerten van Heemskerck, 16th century. Pen and ink drawing of the old building and piazza of St Peter's.*

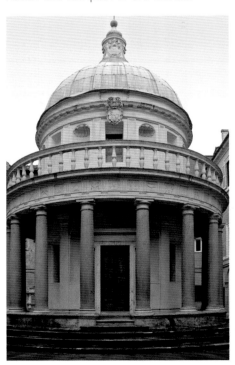

Above: Tempietto, *by Donato Bramante, c.1502–10. The Tempietto, a martyrium for St Peter, was built in the internal courtyard of San Pietro in Montorio, Rome.*

Above: Portrait of Donato Bramante, *English School, 1833. An engraving of the architect Donato Bramante from* Gallery of Portraits, *published in 1833.*

THE TOMB PROJECT

In 1505 the Pope gave Michelangelo a stupendous commission, his own mausoleum project. Michelangelo envisaged a monolithic marble structure adorned with 40 life-sized sculptures, which would serve as a vast memorial for the Pope. However, in a letter dated February/March 1506, Michelangelo wrote to his brother Buonarroto in Florence that there were problems concerning the money for the marble. Buonarroto, pleading for funds for the family, was told that Michelangelo owed a substantial amount of money – "one hundred and forty broad ducats" – on a piece of marble worth four hundred. "I haven't a quattrino," he explained. In the same letter Michelangelo responded kindly to his brother's request for help finding a position in Rome. The letter ends with a note for his childhood friend, Granacci. These private letters reveal Michelangelo, at the age of 31, to be a good son, a supportive brother and one who maintained his close friendships.

JULIUS II HALTS THE PROJECT

Vasari tells us that the problem with the payment for the marble accumulated as the Pope became anxious about the cost and timing of the project. Michelangelo fled Rome for Florence. In a letter dated 2 May 1506, Michelangelo wrote to his friend in Rome, Giuliano da Sangallo (c.1443–1516), an architect to Pope Julius II, to explain his actions. He states that he had overheard the Pope say he would pay not "one baiocco more" (a tiny amount) for large or small stones for the project. Michelangelo asked the Pope for an advance on a further part of the work, but the Pope refused him and continued to do so, avoiding his request for an audience. He was told by the Pope's attaché to leave. One can see from his letter Michelangelo's desire to continue the project. He writes that he will return to the Pope and the tomb commission if it is agreed that he has five years to complete it and when it is finished it is set up in St Peter's at a place of the Pope's choosing. Michelangelo promises that there will be nothing in the world to equal it. With the dispute temporarily settled, Michelangelo returned to Rome. Many raw pieces of marble had arrived from Carrara and were laid out in the piazza in front of the old St Peter's, to the amazement and awe of city residents.

Right: Medals depicting Pope Julius II and the Basilica of St Peter's, probably by Cristoforo Caradosso Foppa, 1506. These were struck to commemorate the commission for the rebuilding of St Peter's, and show Donato Bramante's design.

Below: Michelangelo appears before Pope Julius II in Bologna, by Anastasio Fontebuoni, 1620–1. The painting visualizes a meeting between artist and patron.

MICHELANGELO AND THE JULIUS TOMB

The many years he spent at the court of the Medici had accustomed Michelangelo to the company of princes, intellectuals and future popes. In March 1505 Michelangelo received a welcome commission from Pope Julius II to design and create the Pope's tomb. The sculptor planned a colossal edifice, which would be decorated with 40 life-sized marble sculptures, based on Christian iconography. The interior walk-in space would hold the sarcophagus of Julius II. The Pope was delighted with the prospect of such a laudable building, which far outweighed other memorials to any earlier popes. With the agreement made, Michelangelo spent from April until the end of November 1505 in Carrara, quarrying the best marble for the tomb structure and the sculptures. He was at his happiest in the marble mountains.

BRAMANTE AND RAPHAEL

Three men who encapsulate the High Renaissance in Rome are notably the architect Donato Bramante, the sculptor Michelangelo, and the artist Raphael Sanzio. Each vied for the attention of the Pope, in order to create masterpieces to the Pope's satisfaction.

The first decade of the 16th century finds Donato Bramante, Michelangelo and Raphael Sanzio in Rome working on projects for Pope Julius II. Bramante was employed by the Pope from 1503, Michelangelo from 1505 and Raphael from 1508. All three continued to work on papal projects after the death of the Pope in 1513. Bramante remained overseer of all works relating to the Vatican complex, including the design and building of the new St Peter's and the restructure of the Belvedere gardens and the Papal Palace.

DONATO BRAMANTE

Before Bramante arrived in Rome in 1499, his architectural projects in Lombardy demonstrated his knowledge of the buildings of antiquity. On his arrival he worked, according to Vasari, as under-architect to Pope Alexander VI

(1431–1503), who was pontiff in 1492–1503. In 'Bramante of Urbino, Architect' (*Lives…*), Vasari writes that Bramante spent much time taking the measurements of all the ancient buildings of Rome, including the Villa of Hadrian at Tivoli, doing the same further afield, in Naples. The Tempietto, 1502, was his plan for St Peter's in miniature. Pope Julius II appointed him in charge of all the design and building works. Rivalry between Bramante and Michelangelo may have stemmed from Pope Alexander VI persuading Michelangelo, during his earlier stay in Rome, to draw up plans for the rebuilding of St Peter's. On the death of Bramante in 1514, the choice of overseer of the new St Peter's fell to the youngest of the three artists, Raphael, as Michelangelo's work commitments for the tomb of Julius II precluded this position.

Above: Self-portrait, *by Raphael, 1508–12. Raphael's self-portrait is to be found in his fresco* School of Athens, *in the Stanza della Segnatura, Vatican.*

RAPHAEL SANZIO

Born in Urbino, Raphael was a pupil of Pietro Perugino (c.1445–1523). In 'Raphael of Urbino, Painter and Architect' (*Lives…*), Vasari describes Raphael as a "gift to the world". He extols his sweet nature, gracious manner, modesty, beauty, and boundless kindness to others. Raphael's religious portraits explore the humanity of the Holy Family in enchanting portrayals. His drawings and paintings reveal the influence of Leonardo and Michelangelo, whom he followed, focusing on their draughtsmanship and composition. In 1508, his commission from Pope Julius II was to decorate the Pope's private apartments in the Vatican with substantial frescoes. The content and composition of the work was groundbreaking in its use of perspective,

Left: Pope Julius II ordering Bramante, Michelangelo and Raphael to construct the Vatican and St Peter's, *by Emile Jean Horace Vernet, 1827.*

colour and combination of pagan and Christian subject matter. On the death of Bramante in 1514, Raphael became overseer of the building of the Vatican complex and the new St Peter's. The early death in 1520 of this much-loved, greatly revered artist at the age of 37 was profoundly mourned. Vasari states that Pope Leo X wept bitterly at the news of his death.

ST PETER'S BASILICA

The architecture of the new St Peter's is based on Classical Roman examples. Under the mantle of Pope Julius, Bramante put forward a plan to demolish part of the old basilica and build a dome above the tomb of St Peter. The presence of Michelangelo in Rome may have worried him. To this end, the story told by Vasari and Condivi is that Bramante as overseer of all the new works originally suggested a vast tomb for the Pope, the style of which would complement the new classical building of St Peter's. Later, the expense of the tomb and the Pope's bond with Michelangelo, its designer, caused rivalry as the two artists competed for the Pope's attention. Vasari records that Bramante and Raphael, both being born in Urbino and therefore colleagues, "persuaded his Holiness… he should cause him [Michelangelo] to paint in memory of his uncle Sixtus the vaulting of the chapel that he had built…" Vasari intimates that this was a plan by Bramante to keep Michelangelo away from the marble tomb, the project closest to the Pope's heart.

Right: Study of 'David' after Michelangelo, *by Raphael, early 16th century. A pen and ink study of Michelangelo's statue of David.*

Below: Laocoön, *artist unknown, c. early 1st century. Discovered in Rome (1506), the* Laocoön *group is a marble Roman copy of a 2nd century BC Hellenistic bronze statue.*

THE LAOCOÖN

In Rome in 1506, a remarkable discovery was made on the Esquiline Hill, in the ruins of the palace of the Roman Emperor Titus (AD39–81). An ancient sculpture, known to us as the *Laocoön* group, was unearthed. The life-size marble of Laocoön, a Trojan priest of Apollo, and his two young sons, Antiphantes and Thymbraeus, depicts them being killed by sea serpents, an event described in Book Two of Virgil's *Aeneid.* The sculpture was known to Pliny the Elder (AD23–79), who stated it was a marble copy of a second century BC Hellenistic bronze, made by Athenodorus, Hagesandros, and Polydoros of Rhodes c.1st century BC. From the moment it was unearthed in 1506, it was regarded as a superlative accomplishment in ancient art, a pinnacle of creativity. Michelangelo and his friend the architect Giuliano da Sangallo were present when the ancient sculpture was uncovered, and it would go on to influence much of Michelangelo's own work.

ROME, FLORENCE, BOLOGNA

From the years 1506 to 1508, Michelangelo led a fairly nomadic existence, travelling
between Florence and Rome, with a year spent in Bologna, in the service of the Pope.
It was a period of uncertainty that led to his acceptance of Pope Julius II's demands.

The Tomb of Julius II, commissioned
in 1505, would take 40 years to
complete. Designed to be decorated
with 40 life-sized sculptures, and
regarded by Michelangelo as his
life's work, escalating costs led to a
downsizing of both Pope Julius II's ego
and the original design for the tomb.

A CHANGE OF PLAN

Barely a year after the Pope's initial
exultation at the marble 'walk-in' tomb of
colossal size and intricate design, the cost
and size of the tomb had persuaded the
Pope to change his ambitious plans. His
eagerness to have the tomb positioned in
the new Basilica of St Peter's faltered too.
Michelangelo submitted a new design but
by April 1506 he had left Rome for

Florence, unhappy with the change of
plans. The Pope, angered that he had left
the Papal Palace, sent for him. Eventually
and most hesitantly, in November 1506
Michelangelo journeyed from Florence
to Bologna, where the Pope had just
overthrown the city with great success.
Julius II forgave Michelangelo his ill-
manners for leaving Rome unannounced,
and authorized a new task. Michelangelo
was to design and make a life-size bronze
statue (later destroyed) of Julius II, for the
city of Bologna. This commission would
take him over a year to complete.

*Below: View of Bologna. In November
1506 Michelangelo met Pope Julius II in
Bologna, to apologize for his untimely exit
from the Papal Palace in Rome.*

*Above: Gold coin with a portrait of
Pope Julius II. During his papacy, Julius II
commissioned many artworks featuring his
own image, including medals and coins.*

Right: Pieces of the lower storey of the Julius tomb, by Michelangelo, 1518. The drawing, in brown ink on paper, is a graphic inventory of the architectural elements of the Julius II tomb. On the reverse is a sketch of the elevation of the lower storey.

LETTERS HOME

Michelangelo's letters, written during his year in Bologna, interspersed with trips home to Florence, show how much he involved his father with the everyday happenings in his life and the time that he spent advising the family. One letter to his father (19 December 1506) begins with a vexed tone regarding a patron who wanted him to make a knife blade: "for one thing it is not my profession; and for another I haven't got time to attend to it". One can almost hear the frustration in his voice. He goes on to discuss a shop his brother wants to open in Florence: "I think he ought to wait another few months and do it with a flash and a bang all in one go." With regard to money for the enterprise he explains his position thus, "... as yet I have nothing to send you from here, because I cannot count on the small payment I am getting for the work I'm doing, and anything might happen to shatter my world." He goes on to give an insight into the discomfort of his day to day circumstances: "I'm living in a mean room for which I bought only one bed and there are four of us sleeping in it." A year later, writing to his father in

February 1507, Michelangelo's words show that relations with the Pope are still uncertain: "I expect to be ready about mid-Lent to cast this figure of mine, so pray God it may go well for me, because if it goes well I hope to have the good fortune to be in favour with this Pope."

The task was completed by February 1508, and he returned to Florence, but before the month was out the Pope once more summoned him to Rome.

A NEW COMMISSION

Perhaps it was Bramante who warned the Pope that the exorbitant costs of the palatial tomb were attracting unwanted attention from senior members of the Church. Whether as a result of Bramante's warning or not, a new commission to decorate part of the Sistine Chapel ceiling was offered to Michelangelo, as the tomb project was on hold. Could Michelangelo have walked away from the painting project if he had wanted to? He had always maintained he was a sculptor, not a painter. Perhaps he agreed to it because the Pope had not cancelled the tomb contract, merely delayed it, and one did not say no to Julius II.

Left: Pope Julius II (detail), from The Mass at Bolsena, *by Raphael, 1511–12, from the Stanza dell'Eliodor, Vatican, Rome.*

THE SISTINE CHAPEL CEILING

In 1508 Pope Julius II commissioned Michelangelo to design and paint the vast ceiling of the Sistine Chapel. It was a commission the sculptor did not want to undertake, but he had no choice. From a visibly shaky start, the finished result was sensational.

The commission, more a command, from Pope Julius II to Michelangelo to paint the ceiling space of the Sistine Chapel, was not a job the sculptor wanted, but his relationship with the Pope had been tested in the previous two years. On Pope Julius's list of renovations was the redecoration of the ceiling of the Sistine Chapel.

PAINTING THE SISTINE CEILING

Michelangelo tried to persuade the Pope to choose Raphael, whom he had met in Florence in 1504–5. At the very least, if Michelangelo refused it would harm his close relationship with the Pope, and if he accepted he was sure to be unsuccessful; his rivals knew that he was not a skilled colourist on a large scale.

Above: Fresco ceiling in the Sistine Chapel, Vatican, Rome. Michelangelo took four years to complete the ceiling decoration.

THE DESIGN PLAN

The initial agreement was for the lunettes (crescent-shaped openings or surfaces) of the upper wall to be decorated with portraits of the 12 Apostles and some additional ornamentation. For this, Michelangelo was to be paid 3,000 ducats. The resulting design looked poor and the Pope decided to increase the fee by another 3,000 ducats and give Michelangelo the freedom to design the whole of the ceiling vault, as far as the wall paintings below, and however he wished. Bramante, as overseer of Vatican works, was enlisted to create the scaffolding. Vasari tells us that Michelangelo was angered at the large

Left: A drawing of the decoration of the Sistine Chapel, artist unknown, late 15th century. Prior to the 1508 renovation, Pier Matteo d'Amelia (c.1450–1503/8) had decorated the ceiling with a celestial blue sky.

ceiling holes gouged out by Bramante's workers for a hanging scaffold, which would have to be refilled when the work was finished. Instead, Michelangelo created an innovative free-standing scaffold, which could be moved as the work progressed.

MICHELANGELO SENDS FOR HELP

Vasari's account states that Michelangelo wrote to several friends in Florence asking them to come to Rome to help with the ceiling, specifically to advise him on technique and colour. He names six painters, including Michelangelo's

THE SISTINE CHAPEL

The Sistine Chapel in Vatican City is the Pope's chapel and the place where the papal enclave meet to elect a new Pope. In 1477–80, Pope Sixtus IV (pontiff 1471–84) built the *Cappella Sixtus* (Sistine Chapel). It is a rectangular room, measuring 40.9 x 13.4m (134.3 x 44ft), with a ceiling height of 20.7m (67.9ft), the exact dimensions of the Temple of Solomon in the Old Testament. It has a barrel-vaulted ceiling. Six long windows on each side punctuate the north and south walls. The floor is made of exquisite inlaid marble. The Pope employed the best Italian artists to decorate it. Perugino directed the works with Botticelli, Ghirlandaio, Cosimo Rosselli (1439–1506), Luca Signorelli (1445–1523) and others. In the ceiling vault Pier Matteo d'Amelia (c.1450–1503/8) painted a starry blue sky. The lower walls were decorated with trompe l'oeil painted curtains and the upper walls with portraits of the popes and frescoes of stories from the Old Testament and New Testament. In 1504 the building works of St Peter's caused cracks and structural faults in the chapel, which then needed restoration. In 1508, Pope Julius II, nephew of Sixtus IV, as part of this restoration programme, asked Michelangelo to paint the Sistine ceiling.

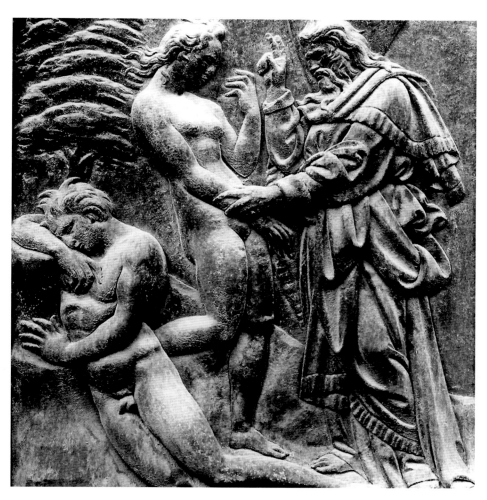

Above: The Creation of Eve, *by Jacopo della Quercia, 1425–35. The relief located in the Basilica of San Petronio, Bologna, possibly influenced Michelangelo's portrayal of the 'Creation of Eve' on the Sistine ceiling.*

Below: The Expulsion from the Garden of Eden *(detail), by Tommaso Masaccio, c.1427. Masaccio's style influenced Michelangelo, who portrays a comparable 'Adam and Eve' on the Sistine ceiling.*

boyhood friend Granacci. Vasari also relates that Michelangelo then sent them away again because the work they produced was not up to his high expectations. Current research confirms that Michelangelo did use assistants on the Sistine frescoes, which is to be expected given the large amount of paint and wall preparation involved.

Michelangelo's depictions of scenes from the Old Testament show a combination of the traditional narrative fused with a new naturalism. One can see images informed by the work of Jacopo della Quercia in Bologna, particularly in the depiction of the creation of Eve and the expulsion of Adam and Eve from Paradise, much like Masaccio's illustration in the Brancacci chapel, Florence, where the pain of departure is etched on their faces.

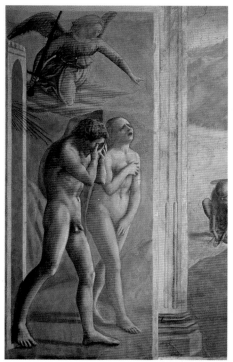

THE TRIUMPH OF MICHELANGELO

Four back-breaking years of work painting the Sistine ceiling produced a triumph of praise for Michelangelo. The ceiling frescoes would confirm him as the *capo maestro* of art, a title he did not want to acknowledge. Sculpture remained his primary interest.

Central to Michelangelo's layout of the Sistine ceiling were nine scenes from the book of Genesis: three triads (sections) further separated into three. The order of the images places the creation of Adam and Eve and their expulsion from Paradise in the second triad, between earlier and later events. The first triad relates to the story of Noah, the second to the creation of Adam, the third to God creating the Universe: the land and seas, the sun and moon and planets, day and night. To either side of the central panels are the thrones of the seers with seven Prophets and five Sibyls. Eight triangular spandrels (triangular spaces between the exterior curve of an arch and the surrounding rectangular moulding), and the lunettes, higher up, contain images of Christ's ancestors, taken from a list of 40 generations named in the Gospel of St Matthew. There are a total of over 300 figures.

PROBLEMS

Vasari reports that Michelangelo, after rejecting initial help from friends, worked alone. He was a solitary person, dedicated to his work, even painting, which he never enjoyed as much as sculpture. He would allow no outsiders, even the Pope, to enter the chapel to see the work in progress. This was not unusual; he preferred no criticism before the completion of any work. The task itself was fraught with problems. The physical exhaustion of standing with his head thrown back, looking up to the ceiling, working at close range for months on end affected his posture, and his body, neck and head ached. Another problem Michelangelo encountered was the cold winter air, which was slowing the paint-drying process and affecting the salt content in the lime-based paint pigments. Vasari states that Michelangelo told him that by the time he had painted a third of the ceiling vault a certain "mouldiness"

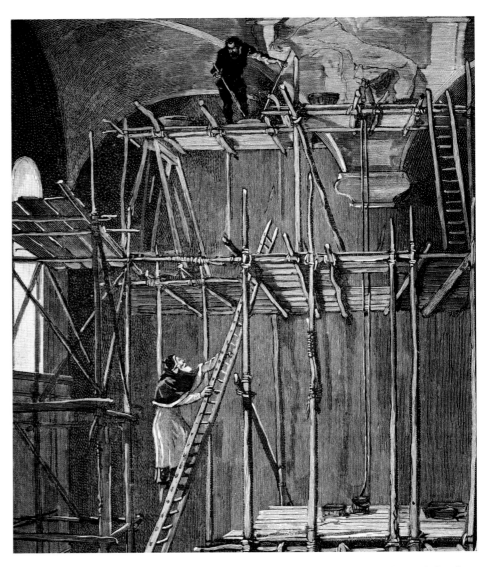

appeared on it. The biographer explains that this was due to Roman lime being white and made of travertine. It left an efflorescent white residue if it was wet for too long. Michelangelo wanted to abandon the project but Pope Julius sent for an expert, their mutual friend Giuliano da Sangallo, who showed Michelangelo how to avoid the problem.

THE POPE AND THE ARTIST

After providing this help the Pope was allowed to join Michelangelo on the scaffolding to view the work in progress. However, the Pope's impatience caused

Above: Michelangelo and Pope Julius II on the scaffolding in the Sistine Chapel, *artist unknown, 19–20th century. Julius II examines Michelangelo's frescoes.*

the work to halt when it was only half done. The scaffold came down and the chapel was opened for invited visitors to view it. According to Vasari, the magnificence of Michelangelo's work, even half finished as it was, inspired all who saw it, particularly Raphael. At this time a letter from Michelangelo to his father (September 1510) refers to a quick trip home because his brother

Buonarroto was ill, but he worries: "…he [the Pope] has gone away and has left me no instructions… if I leave without permission, I'm afraid the Pope might be angry." He asks his father to keep him posted: "if Buonarroto is still ill, let me know at once, since men are worth more than money." This is a reference to the money he is owed for the ceiling. Buonarroto recovered. This letter reveals how tied to the Pope Michelangelo was, not daring to leave Rome. In the meantime, Bramante, unhappy that Michelangelo was receiving even more acclaim, suggested to the Pope that Raphael continue with the second half of

Right: Study for the Creation of Adam, by Michelangelo, 1508–12. This pencil on paper drawing shows Michelangelo's attention to muscular detail.

Below right: The Creation of Adam (detail), by Michelangelo, 1508–12. Adam is created through the touch of the hand of God, symbolized in Michelangelo's fresco.

THE CREATION OF ADAM

As part of the pictorial narrative of the story of the Creation, God's creation of Adam shows the beautiful image of a naked muscular Adam reclining with an arm, hand and fingers outstretched. The position of the body lends itself to comparison with an earlier depiction by Jacopo della Quercia in Bologna. In Michelangelo's version the fingers of the celestial father and earthly son reach to touch each other. It is a sublime portrait. In a material sense the figures of Adam and God could be considered as highly idealized portraits of Michelangelo and Pope Julius II, coming together to create a masterpiece in the Sistine Chapel. In 16th-century Italy this would have been a blasphemous suggestion but Michelangelo and many artists of his time were known to insert self-portraits and cameos of patrons and fellow artists in their works.

the ceiling. At this point Michelangelo exploded with anger, referring to Bramante's shortcomings, particularly his destruction of part of the old St Peter's. The Pope listened. He ignored the advice of Bramante and asked Michelangelo, whom he greatly respected, to continue. Vasari remarks that the Pope was convinced of Michelangelo's genius.

As the ceiling neared completion the Pope became impatient for it to be finished. Vasari reports a heated argument between Michelangelo and the pontiff, Michelangelo saying it would be finished "when I shall have satisfied myself in the matter of art". The Pope was angered and threatened to have him thrown out. Instead of reacting rashly Michelangelo finished the work, thus allowing the scaffolding to be removed and the chapel readied for opening. The ceiling was finished. Vasari reports that the Pope ventured to ask why the figures on the ceiling were not enriched with gold. Michelangelo replied, "Holy Father, in those times men did not bedeck themselves with gold, and those that are painted were never very rich but holy men who despised riches". His remark was perhaps aimed at the worldly Julius II. The Pope inaugurated the chapel on the Feast Day of All Saints, 1 November 1512.

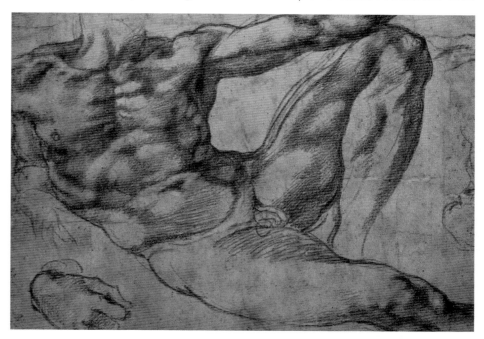

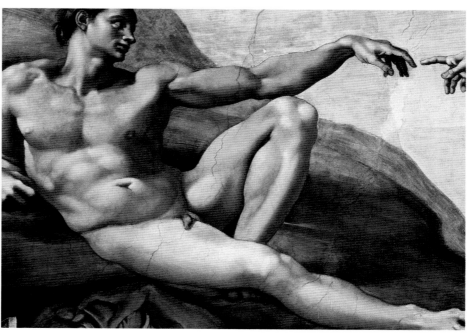

NEO-PLATONISM

Pope Julius II was not the first theologian to link Neo-Platonist thought with Christian doctrine. Saint Augustine (AD354–430), born of a Christian mother and pagan father, had preached both simultaneously.

Pope Julius II, with the help of Michelangelo, Bramante and Raphael, enjoyed a revival of classical antiquity within the confines of the Vatican. Raphael's painting *Portrait of Pope Julius II*, 1511–12, portrays Julius II as an elderly man. Julius was nearly 70 when it was painted. He looks worn and tired, a shadow of the warrior he once was. His beard, not normally permissible by canon law, was retained from June 1511 to March 1512, as a sign of mourning for the Papal States' loss of Bologna, a city he had fought for, and wrested from tyrants in 1506.

Back then, on 18 April 1506, he had laid the foundation stone for the new Basilica of St Peter's, designed by Bramante to resemble an ancient Roman temple. The architecture of the tomb, to be made for him by Michelangelo, combined elements of Christianity with pagan ideology, particularly in its use of the classical 'ideal' nude figure.

THE STANZA DELLA SEGNATURA

The Pope had shown great interest in the content of Raphael's fresco for the Stanza della Segnatura. This was his personal library (later a room for signing official documents). A vast painting, Raphael's *The School of Athens*, 1510–11, filled one wall. In it the most famous philosophers of antiquity, including Plato and Aristotle, converse within a temple building that resembled Bramante's new plan for part of St Peter's. The Humanist element brought together the revered names of the past with those of the present. Raphael depicted Leonardo da Vinci in the guise of the Greek philosopher Plato (429–347BC), Raphael himself as the Greek painter Apelles (c.4th century BC) and Michelangelo is represented as the pessimist philosopher Heraclitus (c.535–475BC), who preferred his

Left: Portrait of Pope Julius II, *by Raphael, 1511–12. Vasari wrote, "And at this time... he also made a portrait of Pope Julius in a picture in oils, so true and so lifelike, that the portrait caused all who saw it to tremble as if it had been the living man himself."*

Below: The Sistine Madonna, *by Raphael, 1513. The Madonna and Child was commissioned for the Tomb of Julius II.*

Above: The School of Athens, *by Raphael, 1510–11. Created for the private apartment of Pope Julius II at the Vatican.*

Right: St Matthew, *by Michelangelo, 1503–6. This unfinished marble sculpture reveals Michelangelo's working method.*

own company (perhaps Raphael's view of Michelangelo at work). The figure work shows the influence of Michelangelo's Sistine ceiling, which had been uncovered when the work was half completed.

Today the imagery of *The School of Athens* may seem to be simply a taste for antiquity, but at the time many saw it as a promotion of pagan philosophy at the heart of the Catholic Church. However, the work so pleased Julius II that he commissioned all four rooms of his apartment to be designed and painted by Raphael. The painting on the wall opposite *The School of Athens* is *La Disputa*, the theological dispute between the Church Militant (on Earth) and the Church Triumphant (in Heaven), on the origin of all things. It brings together Christian and Humanist philosophy in the same room.

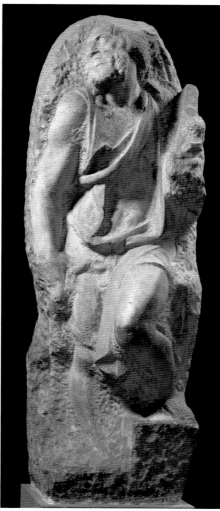

NEO-PLATONISM IN ART

Michelangelo's interest in Humanism and Neo-Platonism, which he first studied in the household of Lorenzo de' Medici, was explored in his sculpture portrayals of the human body. In Renaissance Italy a revived interest in the works of Plato, Aristotle, Virgil and other notable Greek and Roman writers led to the study of Humanism and Neo-Platonism, which placed Man at the centre of the Universe. In painting, sculpture and architecture it created a demand for works in the style of the ancients. For ancient Greeks the perfect embodiment of the 'ideal' figure was the male nude, which was portrayed to perfection in sculptures. Michelangelo's interest in Humanism and Neo-Platonism, studied in the household of Lorenzo de' Medici, is reflected in many of his early works: the naked body of the dead Christ in the *Pietà*, 1499; the nude statue of *David*, 1501–4; and St Matthew, 1503–6.

THE TOMB OF JULIUS II

At the end of 1512, Michelangelo, exhausted from his four-year commission to paint the Sistine Chapel ceiling, returned to his family home in Florence. There, he hoped to continue working on the design for a free-standing tomb chapel for Pope Julius II.

Michelangelo wrote many letters to his father during the summer of 1512, and promised to be with his family by All Saints Day (1 November). In October he wrote, "I have finished the chapel I have been painting; the Pope is well satisfied." With these words, four years of work painting the Sistine ceiling were at an end. He was celebrating with a brief visit to his family in Florence.

FIRST COMMISSION CONTINUES

Apart from the physical pain of spending nearly four years with his neck bent, working at close range to the Sistine ceiling, 20 metres (65 feet) up on scaffolding, Michelangelo also felt pain in the subsequent delay in his work on the tomb. The opening of the Sistine Chapel and the reaction to Michelangelo's stupendous work should have placed him in a strong position to

continue. One of the planned colossal figures, the seated *Moses*, was nearing completion. The Pope allowed him to continue to work on designs for the walls of the tomb chapel, but two months later, in February 1513, Pope Julius died. Michelangelo would have to rely on the generosity of the new Pope to give him time to get it completed. One might imagine that the death of Pope Julius would push forward plans for his tomb memorial. Unfortunately, unless the succeeding pope was from the same family this was highly unlikely. Each pope wanted to stamp his own dynasty on Rome.

THE FIRST CONTRACT 1513–16

In 1513 the new pope, Leo X (1475–1521), temporarily gave his blessing for Michelangelo to continue the work in Florence; a contract was

Above: Copy of the Belvedere Torso. *The original Greco-Roman marble torso, documented in Rome from the 1430s, was acquired by the Vatican c.1530.*

drawn up with Francesco della Rovere, Duke of Urbino and nephew of the deceased Pope Julius. The tomb would be decorated with 40 sculptures but as a three-sided wall tomb, not a free-standing chapel, as originally planned. The fee rose from 10,000 to 16,500 ducats and the new timeline was seven years. The della Rovere family stipulated that Michelangelo would take on no other work during that time. This was very good news to him as the tomb sculptures were the only project he wanted. He began with *The Rebellious Slave* and *The Captive Slave*, reminiscent

Left: The Wrestler, *artist unknown, copy of a Greek sculpture, 3rd century* BC. *The marble sculptures of antiquity informed Michelangelo's sculptural technique.*

Left: Pope Leo X with Two Cardinals, *by Raphael, 1518. Cardinal Giovanni de' Medici was elected Pope Leo X in 1513.*

Below: Tomb of Pope Julius II *(figure of Moses), by Michelangelo, 1513–16. The sculpture of Moses was one of the first to be created for the Julius tomb.*

of the powerful sculpture of the *Laocoön*. The form of each was close in style to the *Ignudi* (20 athletic, nude males) that Michelangelo had painted on the Sistine ceiling. Vasari refers to the bound slaves or prisoners as personifications of the provinces subjugated by the Church.

THE SECOND CONTRACT 1516–22

Freedom to design, carve and complete the sculptures did not last. By 1514, Leo X wanted Michelangelo to draw up a design for the bare façade of San Lorenzo Church in Florence, the Medici parish church. The Tomb contract had stipulated no large commissions, and perhaps the Pope did not consider it to be such, but Michelangelo had to spend

months in Carrara obtaining marble for the San Lorenzo façade. By 1516 relations between the della Rovere family and Pope Leo X had soured. The Duke of Urbino had refused to side with the Pope against the French. The Duke was excommunicated and the tomb contract negated. It was then that a second contract was drawn up for a much smaller monument with half the number of figures. Two further years were added to the original seven, which made the completion date 1522. The fee remained at 16,500 ducats, a generous decision by the della Rovere family. The family also assigned a house in Macello de' Corvi, Rome, to be made available for Michelangelo to live in and to work on the project.

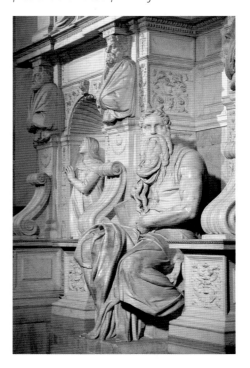

A RETURN TO FLORENCE

To strengthen links between the papacy in Rome and the Medici in Florence, the Medici
Pope Leo X planned to aggrandize the family's properties, starting with the church of San
Lorenzo, Florence. His chosen architect was his childhood friend, Michelangelo.

In 1419, Giovanni di Bicci de' Medici
(1360–1429), the founder of the
Medici banking empire, had begun to
rebuild the San Lorenzo church in
Florence. Since that time the front of the
church had been left with its rough stone
exterior (still in place today), waiting for
a façade to complete it. This was not
unusual for churches in Italy. The façade
of the *Duomo*, Santa Maria del Fiore, was
not completed until the 19th century.

LEO X AND MICHELANGELO

Pope Leo X knew Michelangelo like a
brother. He was the second son of
Lorenzo the Magnificent, and he and
Michelangelo, both the same age, had
spent time together in their youth living
in the Medici household in Florence.
After his investiture as pontiff, the Pope
lost little time in utilizing Michelangelo's
skills. His consent to the della Rovere
family for Michelangelo to continue the
Julius tomb meant little; he had his own
agenda for the aggrandizement of the
Medici parish church in Florence. Condivi
writes that it was a "very great sorrow"
for both Michelangelo and Pope Julius's
heirs to have to leave the tomb project.

*Above: Scale model in wood of the façade
of the Church of San Lorenzo. The model
shows Michelangelo's design and elevation
for the façade in 1519.*

A COMPETITION

According to Vasari, in 1514–15 Pope
Leo held a competition among leading
artists to create a marble façade for the
Basilica of San Lorenzo. Michelangelo's
design was chosen perhaps partly
due to his partnership with the
respected Florentine architect Baccio
d'Agnolo (1462–1543). A drawing and
a wooden model of the façade show
that Michelangelo designed a classical
Roman front with Corinthian columns
and pilasters decorating an upper and
lower section. He returned to Florence
to begin work. The Pope had sweetened
the request, saying that Michelangelo
could work on the tomb sculptures
while in Florence, but this did not
happen. Conversely Condivi writes

that "Michelangelo weeping abandoned
the tomb and went away to Florence."
The commission would require the
sculptor to journey to Carrara too, to
choose the stone.

CARRARA AND PIETRASANTA

Condivi writes that when Michelangelo
had finished the preparation for the
church façade he travelled to his
favourite quarries in Carrara to choose
the best stone for it and the Julius
tomb. Pope Leo X, who was a true
Medici merchant under his papal
robes, had heard that the marble in
Pietrasanta, 84 kilometres (52 miles)
from Florence, was just as beautiful as
Carrara marble, perhaps even better,
and the quarry was under Florentine
jurisdiction. Michelangelo was deeply
frustrated. He had signed contracts with

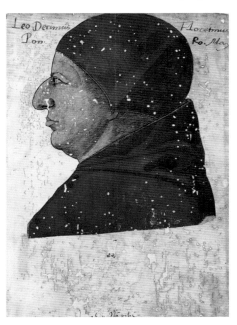

*Left: Portrait of Leo X, 16th century, Italian
School. Pope Leo X, Giovanni di Medici
(1475–1521) was a childhood friend of
Michelangelo. His plan was to aggrandize
the Florentine church of San Lorenzo, using
Michelangelo as architect and sculptor.*

the Carrara quarries and he did not want to start again, searching for stone in a quarry without a proper road leading to it. Condivi records that Michelangelo informed Pope Leo that the stone from Pietrasanta was much harder to work with and a road would need to be built to the quarry. It would be a massive undertaking. The Pope was undeterred. Condivi states that the Pope listened to his advisors instead of Michelangelo, and he commanded Michelangelo to use Pietrasanta marble. The road to the quarry was built at great expense and time delay.

BASILICA OF SAN LORENZO

The Basilica of San Lorenzo holds a special place in Florentine history. The basilica of St Zenobius, the earliest church in Florence, originally stood on the site. It was consecrated by St Ambrose of Milan in AD393. The church was named after Zenobius (AD337–417), the first Bishop of Florence. It had been the city's cathedral until Santa Reparata was built in the 7th century. The present-day church was rebuilt in 1425–46 at the instigation of Giovanni di Bicci de' Medici, the founder of the Medici family banking empire. Filippo Brunelleschi, the architect of the Ospedale degli Innocenti (Hospital of the Innocents), was commissioned in 1420 to re-design San Lorenzo's nave and to build a sacristy for the Medici family tombs. Brunelleschi's masterful design for the nave, Corinthian columns in Pietra Serena stone (a dark granite stone), drew on the architecture and heritage of ancient Rome. The resting place of Cosimo de' Medici, grandfather of Lorenzo the Magnificent, lies in front of the altar, beneath the dome. Three grilles in the stone floor mark the place with a simple plaque reading 'Pater Patriae' or 'Father of His Country'.

Above: Portrait of Filippo Brunelleschi (1377–1446) from Vasari's 'Life' of the sculptor and architect, in Lives of the Artists, *first published in 1550.*

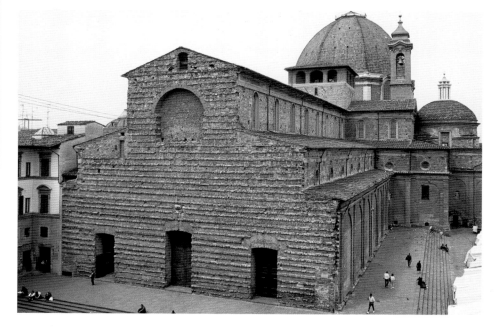

Below: The Church of San Lorenzo, Florence, renovated by Filippo Brunelleschi, 1425–46. The façade of the church was never completed.

A NEW SACRISTY

Michelangelo's close associations with the Medici family made him the sculptor and architect of choice when a new sacristy, to hold the tombs of the Medici family, was planned c.1520. His aim was to create a neo-Roman temple to house the tombs.

A new memorial chapel was needed to hold Medici family tombs and Cardinal Giulio de' Medici (1478–1534) may have been the first to initiate a plan for a new sacristy. Michelangelo was briefed to design and build a marble memorial to four of the Medici: a double tomb memorial to the assassinated Giuliano de' Medici (d.1478) (father of Giulio), and to Giuliano's brother Lorenzo the Magnificent (d.1492), Giulio's uncle and adopted father.

CONSTRUCTION BEGINS

Giuliano de' Medici, Duke of Nemours (1479–1516), and Lorenzo, Duke of Urbino (1492–1519), were the last male direct-line descendants of Cosimo de' Medici (1389–1464), the eldest son of Giovanni de' Bicci (1360–1429), founder of the Medici bank. The significance of their heritage might have been a reason for the chapel's creation soon after the death of Lorenzo in 1519. The new sacristy building would adjoin the right transept of the church, symmetrical to the earlier sacristy designed by Brunelleschi 100 years before, in 1420.

The construction of the chapel building started before the design for the tombs was finished. It was then discovered that the interior space was too small to hold the large free-standing tomb that Michelangelo had planned. He changed the design and reverted to wall tombs, so that stepping inside the chapel, the visitor would be enclosed within an architectural structure – as though inside a free-standing tomb. Michelangelo possibly turned his original design inside out.

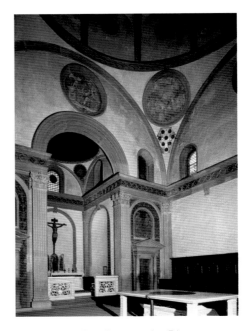

Above: The Old Sacristy, by Filippo Brunelleschi, 1420–9. The Old Sacristy and the New Sacristy were designed 100 years apart.

Below: Tomb memorials to Lorenzo and Giuliano de' Medici, New Sacristy, c.1520–34. Michelangelo created memorial wall tombs for the Medici brothers.

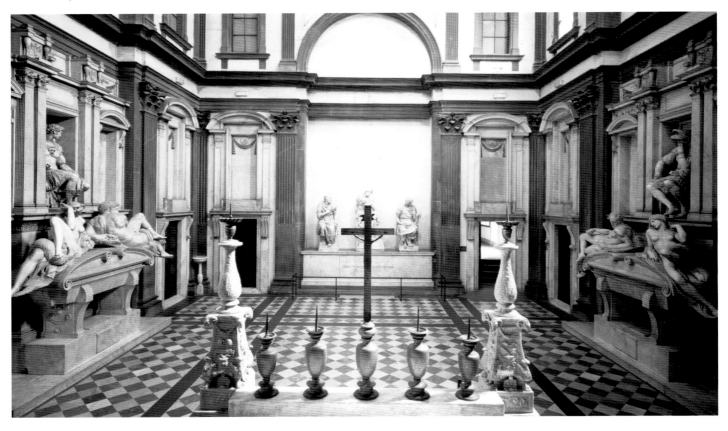

The order for a Pietra Serena stone to build the architectural framework of the room was in progress by 1520. The stone would harmonize this interior with that of the church nave and the Old Sacristy. By April 1521 Michelangelo was in Carrara choosing the marble for the figure sculptures.

FIGURE SCULPTURES

Condivi writes that the double tomb of the elder Lorenzo and Giuliano was to face the altar of the chapel. According to Michelangelo's drawing it was to have many figures. The sarcophagus of the younger Giuliano was to be decorated with two over-life-sized reclining figures, a young woman as 'Day' and a bearded muscular male figure as 'Night'. The younger Lorenzo was to have two reclining figures, a bearded muscular male symbolizing

'Dusk' and a female figure to symbolize 'Dawn'. All four sculptures were symbolic of the passage of time. Condivi writes that although the statuary in the memorial chapel was decoratively similar, each piece was quite different. Each piece contributed to a unified memorial within the architectural framework of the room.

A CALL TO ROME

For the memorial statues of the younger Giuliano and Lorenzo, Duke of Urbino, Michelangelo depicts them in the armour of ancient Romans. The figures are seated with their heads turned toward the place where the wall tomb of the elder Lorenzo and Giuliano was to be placed. The sculptures in the chapel, including figures of the Virgin and Child, St Cosmas and St Damian, were started before the Siege of Florence in

1529 and continued when it finished in 1530. The rear sections of the symbolic figures reclining on the tombs remained unfinished, as Michelangelo eventually left for Rome in 1534, to work for the Pope once more.

The Medici bookkeeping system and expense accounts for the Medici chapel illustrate the money spent on creating Michelangelo's masterpiece. The chapel was completed in Michelangelo's absence. Although the rear sections of some of his sculptures remained unfinished, they were left in place, to complete the sculptural effect of the chapel space, a temple to Medici power. The building was yet another physical symbol of the control the family held over the city, albeit sporadically fractured by the rule of Girolamo Savonarola in 1494–8 and the Sack of Rome in 1527, which led to the siege of Florence.

Right: Design for the Medici Chapel in the Church of San Lorenzo, by Michelangelo, c.1520. A double tomb design was originally planned for the New Sacristy.

THE NEW SACRISTY

There are two sacristies in the Basilica of San Lorenzo. The Old Sacristy is a room adjoined to the left transept of the nave of the church. It was designed by Brunelleschi in 1420–9, and includes decorative detail by Donatello. It was the first part to be rebuilt when the church was refurbished in the 1420s. Commissioned by Giovanni Bicci de' Medici (died 1429), it holds his remains and those of his wife Piccarda Bueri, in a sarcophagus in the centre of the room. The side walls hold the sarcophagi of their sons. The New Sacristy was designed by Michelangelo from 1520 as a pendant to the earlier chapel. The interior decoration builds on the architectural framework of the Old Sacristy. In the two wall tombs Michelangelo emphasizes the power, the fame and the legend of the Medici.

ARCHITECTURAL POETRY

The flowing movement of the stairway leading to the Laurentian Library highlights Michelangelo's artistic licence to fuse sculpture and architecture to create innovative new forms of spatial interpretation.

In 1524, Pope Clement VII commissioned Michelangelo to build a new library at San Lorenzo, Florence. Michelangelo's response to the Pope's request for a library building shows that his interest in architectural commissions was not a priority. He wrote to his agent in Rome, "it's not my profession," but agreed to do what he could with the space available.

ARCHITECTURAL INNOVATION

In 1517, Michelangelo had restructured an exterior corner of the Palazzo Medici (now Palazzo Medici-Riccardi) to enclose two entrances to an interior courtyard. He walled up the doorway arches and placed a pediment window frame in each sealed arch. The placements of two large stone brackets under each window, reaching to nearly street level, were referred to as 'kneeling'

windows by Vasari. This design is carried through to the Medici chapel and the library vestibule.

THE LAURENTIAN LIBRARY

Michelangelo's new library had to fit into an already quite full site where the convent of San Lorenzo stood. At first he considered building the library where the enclosed garden courtyard stood, directly to the side of the church. It was an obvious free space but building it there would have removed the contemplative atmosphere of the cloisters surrounding the courtyard. He turned his attention toward the area above one cloister. Here he built on an extra floor, choosing lighter-weight materials to preserve the lower building. Work on the project began in 1524. Most of it was completed by 1527.

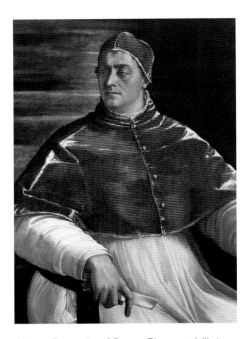

Above: Portrait of Pope Clement VII, by Sebastiano del Piombo, c.1526. Giulio de' Medici, Pope Clement VII, commissioned a new library at San Lorenzo.

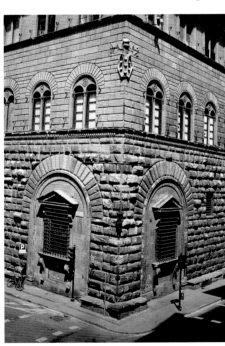

Above: Palazzo Medici, Florence, by Michelozzo di Bartolomeo, after 1444. Michelangelo restructured one corner of the building in 1517.

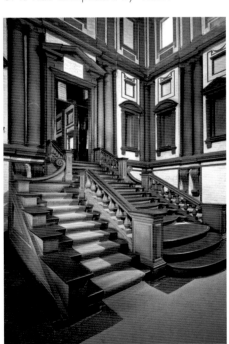

Above: The vestibule of the Laurentian Library, by Michelangelo, from 1524. The staircase remained unfinished until 1559.

THE MEDICI LIBRARY AT SAN LORENZO

Pope Clement VII's plan for the San Lorenzo complex included the creation of the Biblioteca Medicea Laurenziana (Laurentian Library) to house the Medici collection of rare manuscripts, books and papers, which were kept at the Palazzo Medici and other Medici properties. The Pope wanted them to be on public display. In a letter of 2 January 1524, the Pope requested drawings and measurements from Michelangelo, for separate Greek and Latin libraries and an entrance vestibule. The Pope gave Michelangelo freedom to spend whatever he needed. Today the Laurentian Library is open to scholars, holding 4,500 manuscripts and over 11,000 rare books.

VESTIBULE AND STAIRCASE

The architectural structure of the inner walls and staircase of the vestibule continues to fascinate architects and historians. Michelangelo created an architectural façade for the inner walls, as in the Medici Chapel. The result is an overpowering sense of architecture in sculptural form. This was one of the earliest examples of the style that came to be known as Mannerism.

The design of the stairway leading to the reading room is intriguing. Extant drawings of the stairway show three sets of stairs, to the side and centre, which run up toward the reading room entrance. The central stairs are oval in shape. The Pope had expressed his preference for one staircase but this must have proved difficult. Building of the staircase was not yet under way when Michelangelo left for Rome in 1534. His plan was put aside, perhaps because the Pope still wanted a design for one staircase, or it was expected he would return to finish it, which he did not. Twenty-five years later the Medici decided to revive the original plan. In January 1559 Michelangelo sent his original drawings and dimensions to sculptor and architect Bartolommeo Ammannati (1511–92), who created the staircase in stone. Michelangelo later informed him that he had intended it to be made in wood to relate to the wood furnishings, ceiling and doors of the library reading room.

MICHELANGELO IN FLORENCE

The amount of work involved in the Medici building programme at San Lorenzo allowed Michelangelo to stay in Florence for long periods from 1523 until 1534. During this time his interest in the poetry of Dante developed and he began writing sonnets himself. It is possible that during this time he instructed a young man, Andrea Quaratesi (1512–85), a member of a wealthy family of bankers, in the art of drawing. *The Portrait of Andrea Quaratesi, c.1528–32*, is the only surviving portrait that was drawn

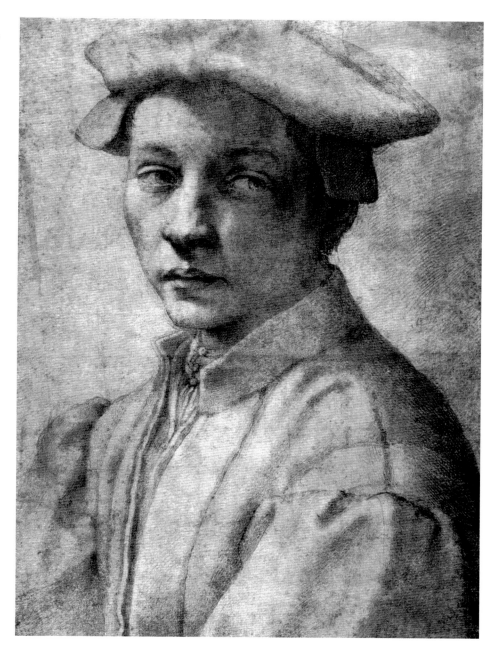

Above: Portrait of Andrea Quaratesi, *by Michelangelo, c.1532. It is possible that Quaratesi was instructed in drawing by Michelangelo.*

by Michelangelo. In it the youth wears contemporary dress with a flat cap. Vasari writes that the artist mostly refused to draw portraits unless the subject was of outstanding beauty. During this period he also completed a marble sculpture of a youth crouching, *Crouching Boy, c.1530–4*.

The intensity and depth of Michelangelo's poetry at this time reveal the soul-searching of a solitary man. Although he had good friends, he was an independent person, and his work dominated his life. The death of his father in 1531 had suddenly taken away his closest friend, the person to whom he confided the most trivial and the most serious

matters. It was his father who had constantly kept him in touch with family news. In 1531, at the age of 56, he was the protector rather than intimate of his remaining family.

To gain insight into Michelangelo Buonarroti the man, it is in letters from Michelangelo to his father that one should look. In addition, Michelangelo's poignant poems, written for himself and close friends, can help us to discover the artist and the real Michelangelo.

A BUILDER OF FORTIFICATIONS

The Sack of Rome in May 1527, by mercenary troops of the Holy Roman Emperor
Charles V, led on to the siege of the city of Florence in 1529 and the expulsion of the
Medici. Michelangelo was the architect in charge of the Republican city's fortifications.

Michelangelo was one of the few artists
to remain in Rome during the sack of
the city, but he returned to Florence
soon afterward. In May 1527, following
the Sack of Rome, the city of Florence
became a Republic. The Medici family
were expelled but using their allies they
plotted to return. For Michelangelo the
city without the Medici meant a halt to
his contract for the New Sacristy and he
stopped work on the Medici chapel
tombs in April 1527.

THE SIEGE OF FLORENCE 1529
Michelangelo found himself once again
in the difficult position of being a friend
of the Medici but a supporter of the
Republic. He was now in his fifties and a
respected senior citizen of Florence. In
January 1529, Michelangelo was elected
to the Nove della Milizia, the 'Council
of Nine for the Militia', and by 6 April
he was appointed Head of City
Fortifications, the Governor and
Procurator General. The citizens of
Florence had sided with France during
the Sack of Rome. However, the French
army had been defeated at Naples and
Landriano, which led to their submission

and that of Rome and Venice to
Emperor Charles V. It left Florence
isolated and fighting on all sides. The city
expected retaliation and it was in their
interest to create fortifications.

Michelangelo's many drawings reveal
the extent to which he was involved
in the fortifications. The artists of the
Renaissance wore many professional hats.
Here he was to act as military architect.

*Above: The Siege of Florence in 1530,
by Jan van der Straet, 1563–5. A fresco
illustrates the siege of the city of Florence
by Imperial and Spanish soldiers.*

*Below: Pope Clement VII Is Held,
Besieged by Charles V, High in
Hadrian's Tower, Italian School, 1527.
The pope was held hostage during the
Sack of Rome, 1527.*

A DEATH WARRANT

Emperor Charles V and Pope Clement VII began their attack. (As a Medici it was in the Pope's interest that his family return to the city.) Michelangelo, although he was in charge of the fortifications, left Florence in September and went to Venice. His absence angered the Florentine militia, and he returned in November, soon after the siege started on 24 October 1529. A large army of Imperial and Spanish soldiers serving under the French prince, Philibert of Chalon (1502–30), surrounded the city. Their aim was to overthrow the Republic and return the Medici. The siege continued for nearly ten months until Florence was captured on 10 August 1530. The Papal commissioner Baccio Valori ordered a death warrant for Michelangelo due to his military capacity as the Governor and Procurator General, in charge of Tuscan fortifications, and because he had fought on the side of the Florentine Republic, and not the Medici.

IN HIDING

While in danger, Michelangelo hid in the basement rooms of the Medici Chapel. There he spent his time creating wall drawings which are still visible today. Within a few months the death sentence had been withdrawn. Michelangelo was too talented to kill, and Medici building projects were still unfinished. A papal brief, issued 21 November 1531, forbade Michelangelo working for anyone other than the Pope. The young Alessandro de' Medici (1510–37) was installed as ruler of Florence in 1531 and created Duke of Florence in 1532. The metamorphosis of the Medici from merchant bankers to hereditary princes was now unstoppable.

THE SACK OF ROME, 1527

On 6 May 1527 the disgruntled mercenary troops of the Holy Roman Emperor Charles V, not having received their wages for many months, sacked the city of Rome to show their displeasure and to materially compensate their loss of earnings. Italian, German and Spanish mercenaries pillaged and looted houses and churches, including the Vatican. The Pope, Clement VII, was swiftly moved from the Vatican to the relative safety of nearby Castel Sant'Angelo. The Emperor's troops massacred nearly all of the Swiss Guard, the Pope's personal bodyguards. During the massacre the Pope escaped along an 800-metre (½-mile) *passetto*, a fortified secret corridor, which linked the two buildings. He was to remain a 'prisoner' in the castle until the mutinous troops left. Over 1,000 defenders of the city were murdered. A month later the Pope paid a vast ransom to save himself and gave obeisance to Charles V from then onward. The city had been wrecked. Vatican treasures were stolen, sold on, melted down, or destroyed. The Sack of Rome marked the end of the High Renaissance.

Below: Conservators at work in basement rooms of the Medici Chapel in 1975. Drawings created by Michelangelo were discovered in the chapel.

Bottom: Wall drawing of a nude figure, by Michelangelo, c.1530. These drawings may have been created at the time of the siege of Florence, 1530.

WRITER AND POET

The extraordinary beauty of Michelangelo's paintings and sculptures can be compared to the beauty of the words of his poetry: his interpretations of love, loneliness, and death. Influences on his style were Plato and Petrarch, and the Florentine poet Dante Alighieri.

Whether Michelangelo was working as a painter or sculptor, or military strategist, he continuously put pen to paper to write poetry. He produced over three hundred sonnets, poems and madrigals during his lifetime. Like many poets, Michelangelo was a perfectionist and would often rewrite his poems many times over, perhaps just changing a single word.

PLATO, DANTE AND PETRARCH

Certain lines of Michelangelo's poetry are reworkings of phrases by Plato, Dante, Petrarch and other poets that he admired. His poems date from 1503 to 1560. Some mirror the content of his letters (over 460 extant), which reflect his day-to-day life, his working environment, his domestic problems, his money, his servants, his friends, colleagues, patrons and family, and love and death. "How will I ever have the nerve/without you, my beloved, to stay alive…" were the first lines of

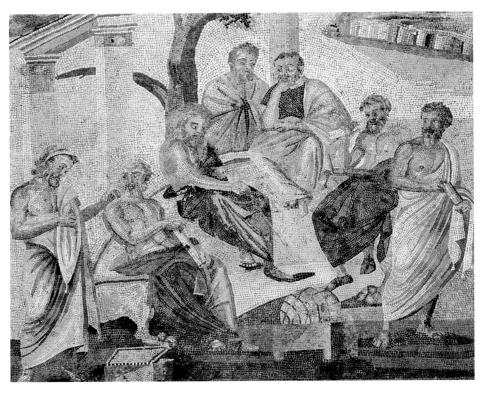

Above: Plato's Academy, *Roman mosaic from the House of T. Siminius, Pompeii, c. 1st century BC.*

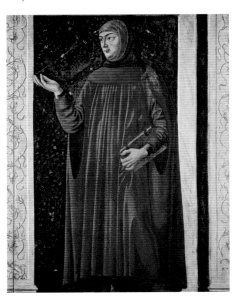

Above: Petrarch, *by Andrea del Castagno, c.1450. The Italian scholar Francesco Petrarch (1304–74) is known as the 'Father of Humanism'.*

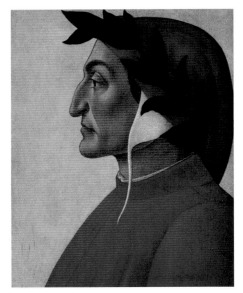

Above: Portrait of Dante, *by Sandro Botticelli, c.1495. Michelangelo revered the works of the Florentine poet Dante Alighieri (c.1265–1321).*

a poem he wrote c.1513. The poem was then set to music and published as a madrigal by the Italian composer Bartolommeo Tromboncino (c.1470–1535) and performed on stage in 1518.

HIDDEN MESSAGES

Beware the patron who crossed Michelangelo. He may not have been able to voice his opinion too loudly in the Papal Palace but on paper, in poetry, who could stop Michelangelo writing what he felt? "I am and long have been your faithful servant/I gave myself to you like the rays of the sun; /but you don't suffer or care about my time/and the more I exert myself, the less you like me…'. The poem was written c.1511, and probably refers to Pope Julius II. The message, barely coded, "…heaven is the one that scorns all virtue… and then it wants us/to go and pluck fruit from a tree that's dry."

Right: Autograph sonnet, 16th century, Michelangelo's poetry was informed by the works of Plato, Dante and Petrarch.

LOVE AND DEATH

Many of the poems focus on love or death. "Love, your beauty is not a mortal thing;/there is no face among us that can equal/the image in the heart…" This poem, written c.1530, has the undertones of Neo-Platonic theory, where beauty, the soul, reflects the image and likeness of man. Death and weariness are evident too. One poem concludes: "Cruel mercy and merciless grace/left me alive and cut you off from me/breaking but not extinguishing our bond…" The dating of the poem, to c.1528, coincides with the death of Michelangelo's brother Buonarroto. A madrigal, c. 1536–46, written by Michelangelo in tribute to his friend Vittoria Colonna, reveals his modest opinion of himself: "I can't help seeming to lack talent and art/to her who takes my life… what I can do leaves me unworthy of her/This lady, full of grace." The good nature of his friend left Michelangelo bereft of words to show the depth of love he had for her.

ON THE DEATH OF HIS FATHER

The death of Michelangelo's father in 1531 followed soon after the capitulation of Florence in 1530. At the death of his father Michelangelo was overcome with grief. Ludovico had been the constant support in his life, in spite of Michelangelo being the chief wage earner. Letters from father to son reveal intimacy and love, often shrouded in requests for payments, or problems with siblings. For Ludovico he wrote his longest poem. A few lines here express the essence of the whole: "There is no cloud that can obscure your light/the successive hours have no power over you… Oh my dear father, and in my thoughts I see you… where, God willing, I presume and believe you are/and where I hope to see you… the highest love between father and son/increases in heaven, where every virtue grows." The poem of 68 lines remained unfinished, yet the words seem to encapsulate what Michelangelo felt.

Throughout his hardworking life, Michelangelo appears to have used his poetry as a means of expressing emotions, in a way that complemented his creativity in sculpture and painting.

Left: Autograph letter, dated 18 October 1524. A copy or draft written by Michelangelo, relating to the New Sacristy, San Lorenzo, commission.

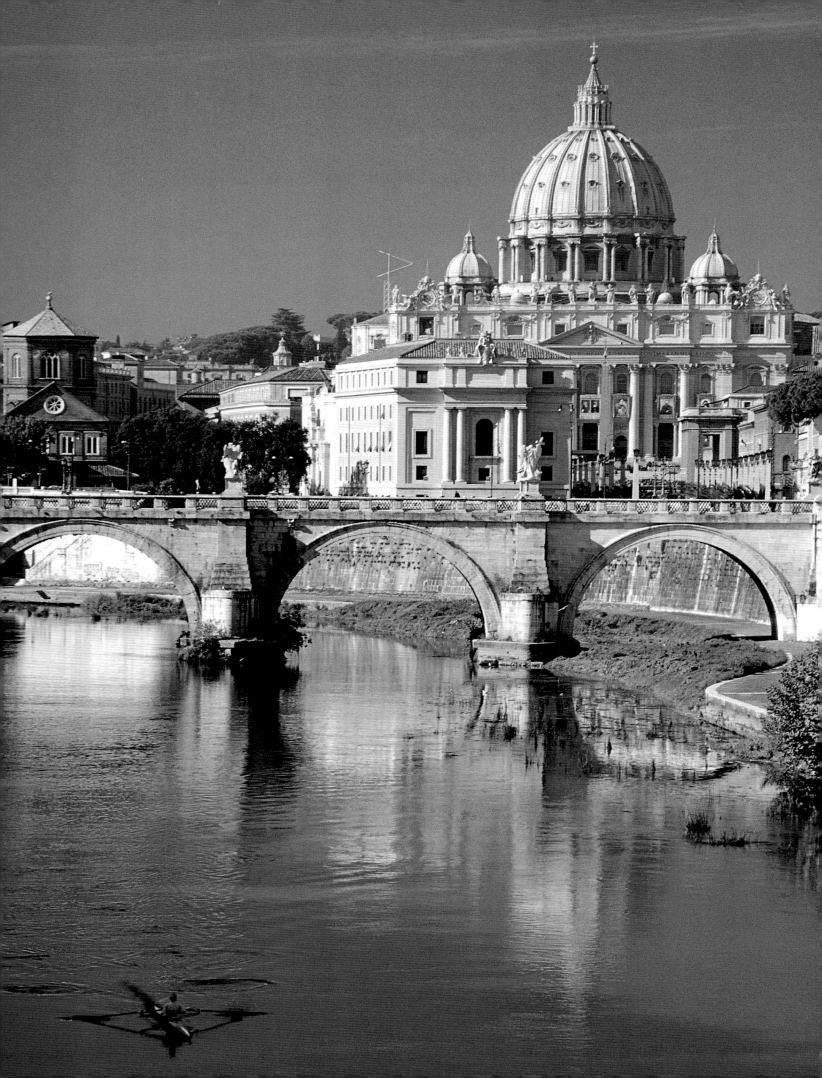

Rome
1534–1564

In 1534 Pope Clement VII invited Michelangelo to Rome to create
another large-scale fresco for the Sistine Chapel. Michelangelo left
Florence, never to return until his death. In 1537 he was made an
honorary citizen of Rome and spent the remaining years of his life in the
city. The first of the papal commissions was the *Last Judgement*
(1536–41), a colossal fresco painted on the altar wall of the Sistine
Chapel. On its completion the new Pope, Paul III, commissioned two
large frescoes (1542–9), for the Pauline Chapel in the Vatican.
During this period Michelangelo was honoured with the position of
chief architect to St Peter's Basilica and worked on further architectural
projects around the city. In 1550 and 1553 biographies of Michelangelo
were published which revealed his life, his work, his ego and his genius.

*Above: The Vatican Museum and the Sistine Chapel, Rome. The remarkable fresco
of the Last Judgement is painted on the altar wall of the Sistine Chapel.
Left: St Peter's Basilica, Rome. Michelangelo's magnificent dome crowns the Basilica.*

THE *LAST JUDGEMENT*

Pope Clement VII's invitation to Rome involved a major painting project, which would take the reluctant Michelangelo years to complete. Clement VII would not live long enough to see it commence, but the new pope, Paul III, insisted that the work continue.

The move to Rome must have produced mixed emotions for Michelangelo. Once more he had left his family and the familiar surroundings of Florence. His prime hope for relocating to Rome was to be given more time to work as a sculptor. Pope Clement VII was a good friend and his request for a large fresco of the Last Judgement on the east wall of the Sistine Chapel would have been difficult for Michelangelo to ignore.

DEATH OF POPE CLEMENT VII

At 60 years of age Michelangelo had not painted any large-scale works since the Sistine ceiling, 30 years before. However, the Pope insisted on it and gave him complete freedom to paint the biblical scene from Revelation 20:11–24 in whatever way he felt appropriate. Michelangelo initially argued against the commission, but then wearily agreed. But he was stubborn – he pretended to be making the cartoon for the fresco while secretly working on the

Julius Tomb sculptures. On the death of Pope Clement VII in September 1534 the work on the New Sacristy and Laurentian Library at San Lorenzo in Florence stopped. It freed Michelangelo from his obligation to create a staircase for the Laurentian Library, which was still at the drawing stage, and to work on any further sculptures for the Medici Chapel. All the major work had been completed. If time allowed in Rome, he wanted to concentrate wholly on the Julius sculptures, if he could only rid himself of the *Last Judgement* commission.

LAST JUDGEMENT GOES AHEAD

The installation of Pope Paul III (1468–1549) in October changed nothing. Fearing he would have no time to continue the Julius sculptures,

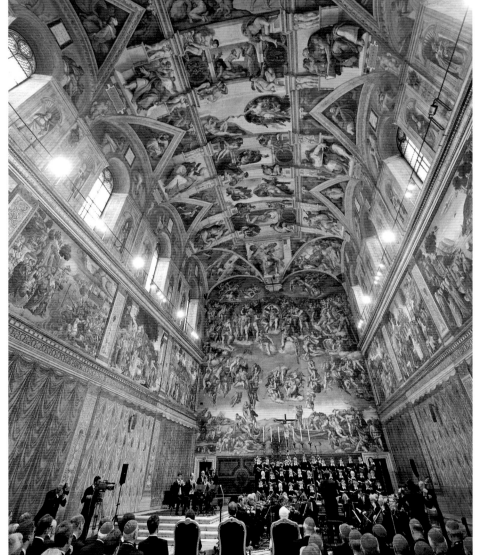

Left: A recent view of the Sistine Chapel interior, showing Michelangelo's fresco of the Last Judgement.

THE *LAST JUDGEMENT* (1536–41)

Michelangelo captures the moment before humanity's final judgement. He divides the event into five parts. The central scene of the painting depicts seven angels with long trumpets. The sounding of the trumpets calls the dead to judgement from all the four corners of the Earth. In the lower left section the dead are rising from their graves. Two angels hold open the *Book of Life* where the dead read of their past. The dead are in various forms from skeletal bones and shrouds to fleshy half naked figures. On the left the saved souls recover their bodies and rise to heaven; on the right the damned descend.

A VIEW OF THE *LAST JUDGEMENT*

The *Last Judgement* is a remarkable representation of a strongly worded narrative. Some historians believe that Michelangelo's interpretation is based on the *Inferno* (1308–21) by the Florentine poet Dante Alighieri. Michelangelo was an expert on Dante's works. In the *Last Judgement* the body of Christ and other prominent figures are bulky and misshapen. There is a tension in the painting brought on by the expressions of horror on the faces of the damned. The muscular bodies are in the style of Mannerism, which Giulio Romano (c.1499–1546), Raphael and Michelangelo had instigated two decades earlier. It was a reaction to the 'ideal' figure of classical antiquity.

In the *Last Judgement* most figures (with the exception of the mother of Christ) were originally depicted naked. Prior to the unveiling in 1541 the Pope and the Master of Ceremonies, Biagio da Cesena, viewed the fresco. Vasari states that Biagio was alarmed. He thought the nude figures suitable only for taverns and certainly not fitting for such an 'honoured place'. The Pope would not hear of any changes being made. Michelangelo made fun of Biagio by including in the painting a portrait of him with the gross body of Minos. Michelangelo also features in the painting, in the image of St Bartholomew holding his own skin. The face on the skin is said to be a self-portrait.

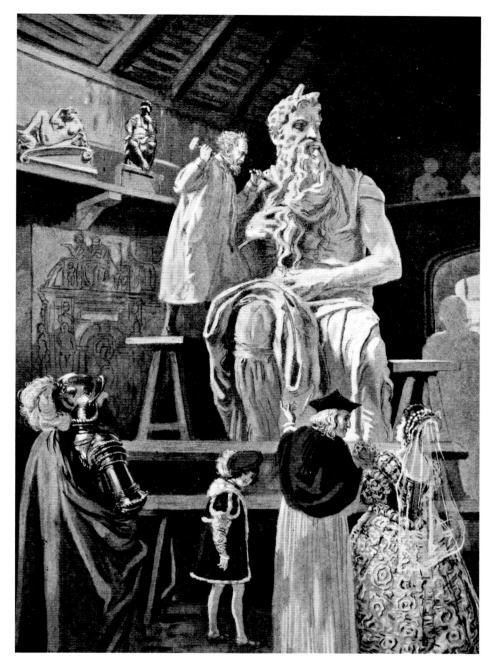

Above: Michelangelo creating the colossal statue of Moses, *English School.*

Michelangelo made plans to go to Genoa to his friend the Bishop of Aleria. According to Condivi he sent one of his servants ahead to buy a house and land for the purpose of completing the contract. Pope Paul brought a large group of cardinals (Condivi states eight cardinals, Vasari states ten) to Michelangelo's house in Rome and demanded to view the cartoons for the fresco and all the sculptures for the Julius Tomb. The Cardinal of Mantua, on seeing the *Moses* sculpture, commented that it would be enough for the tomb on its own. This did not please Michelangelo. According to Condivi, the Pope said that he would speak to the Duke of Urbino to get an amicable agreement from him that the three sculptures already completed would suffice, thereby freeing Michelangelo from the contract. The Pope firmly added that the three remaining sculptures for the tomb would be made from Michelangelo's models by other sculptors.

Right: Last Judgement *(detail, Christ, the Virgin Mary and St Bartholomew). The face on the human skin, held by St Bartholomew, is possibly a self-portrait of Michelangelo.*

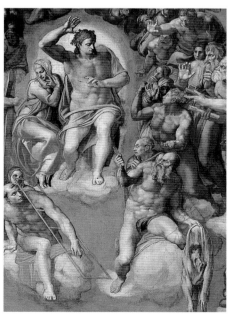

FRIENDSHIPS IN ROME

As a young man Michelangelo had been totally committed to his art: sculpture and painting. It left little time for personal relationships. His circle of friends had been formed through his professional network of patrons. In Rome he found new friends and companions.

Vasari relates that a few months before he finished painting the *Last Judgement* Michelangelo fell from the scaffolding, badly injuring his leg. He refused treatment until his friend Maestro Baccio Rontini, a physician, visited him. He found Michelangelo in great pain, severely injured. Rontini insisted on looking after him until his leg had healed. The story highlights Michelangelo's reluctance to attract the attention of others, or seek any help, even of a medical nature. Rontini's kindness is an example of the depth of feeling his friends had for this solitary man.

TOMMASO DEI CAVALIERI

The Roman nobleman Tommaso dei Cavalieri (c.1509–87) was 23 when he met Michelangelo toward the latter part of 1532. He had an estate in Florence and was known

Below: The Fall of Phaeton, by Michelangelo, 1533. The allegorical pencil drawing contains a message for Tommaso dei Cavalieri at the bottom of the page.

to everyone as 'Messer Tommao'. In about 1538 he married into the family of Cardinal Andrea della Valle, and fathered two children, born c.1540 and 1550. In a letter to Michelangelo (autumn/winter 1532) he describes himself as a mere baby, "as ignorant as can be". Cavalieri had perhaps requested a meeting to purchase drawings or commission a work. Michelangelo's letter to Cavalieri, dated 1 January 1533, is chatty and light-hearted. It is clear that Michelangelo had an interest in Cavalieri beyond showing drawings to him. A portfolio of drawings in red and black pencil of "ideal head" portraits was sent with the letter. From this beginning, a close friendship developed. Six months later, in a letter dated 28 July 1533, in response to a letter from Cavalieri, Michelangelo writes with strong affection, saying he has not forgotten the young man; that his name alone "nourishes the body and soul…" and "he who loves has a retentive memory".

INSPIRED POETRY

Michelangelo was inspired to write several poems for Tommaso. The content of the sonnets shows a deep longing for that which was impossible to attain. The words are intimate, sensual and deeply personal. Michelangelo is known to have been homosexual, but there is no supporting evidence that his friendship with Tommaso was other than platonic. One sonnet for Cavalieri declares that, if to be happy means to be chained and conquered, then he [Michelangelo] will remain the prisoner of an armed cavalier. The last line 'resto priogio d'un cavalier armato' is considered to be a play on Cavalieri's name. Dating the poem is difficult. It may have been written

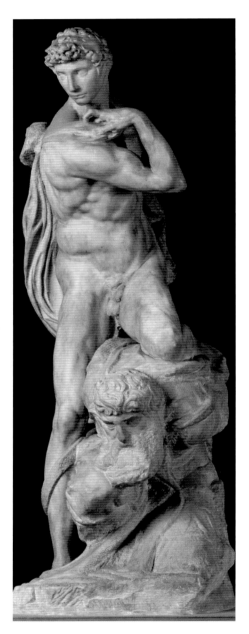

Above: The Genius of Victory, by Michelangelo, 1520–5 and 1532–4. The head of the marble sculpture is considered to be modelled on Tommaso dei Cavalieri.

close to the time that Michelangelo made the drawing of *The Punishment of Tityos* (1532–3), when he met Tommaso. Cavalieri is known to be the model for the head of *The Genius of Victory*, c.1532–4, one of the

Right: Portrait of Vittoria da Colonna, *by Girolamo Muziano, c.1540s. Michelangelo's letters and poems reveal his respect and love for Vittoria da Colonna.*

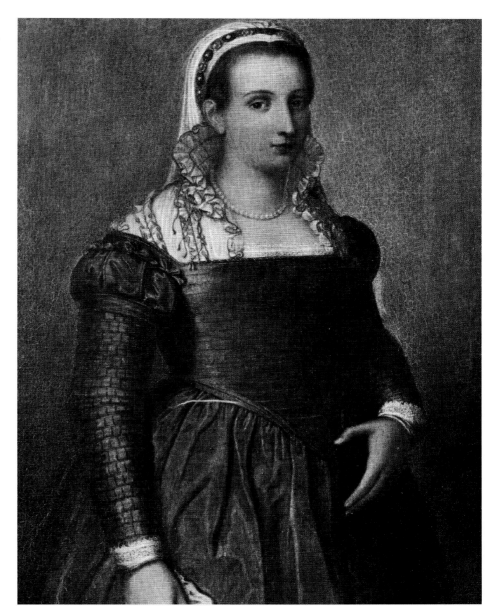

sculptures intended for the tomb of Julius II. The bearded man that 'Victory' stands astride is considered to be a portrait of Michelangelo. The two men were friends for 30 years and shared a mutual interest in music, literature, sculpture, architecture and art. Cavalieri openly spoke of his fortune to be allowed to be a friend to Michelangelo and was with him in the final hours of the sculptor's death.

VITTORIA DA COLONNA

On the death of her husband in 1525, Vittoria da Colonna had turned to the Church and to poetry for consolation. She spent years staying in convents, and many of her poems are written in memory of her husband. Meeting Michelangelo changed many things for her and for him. Both needed companionship, and both channelled their love through the written word. It is clear that they shared an interest in Neo-Platonism from the content of Michelangelo's sonnets to her. He combines spiritual and sensual love – for him earthly beauty is a reflection of a higher divine spiritual beauty. At her death in 1547 he was inconsolable: 'Earth holds in its embrace/thy lovely limbs, thy holy thoughts the skies…' She had awakened a passion in him that he had perhaps never felt for a woman before.

Vittoria da Colonna's death would inevitably leave a void in Michelangelo's life. He had confided much to her and trusted their platonic relationship. His Roman friends and colleagues, including Tommaso dei Cavalieri, rallied round.

From the time of Vittoria and Michelangelo's first meeting in 1536 he was involved with major Vatican projects, notably the painting of the *Last Judgement*, completed in 1541. Michelangelo's hope was that he could continue with the Julius Tomb sculptural programme and his own projects. It was not to be. The pope had his own plan for Michelangelo.

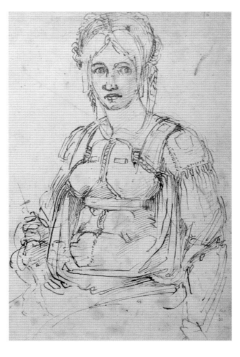

Left: Drawing of a Seated Woman, *1525. Possibly a 'teste divine' drawing, which Vasari records Michelangelo creating for special friends.*

SPECIAL FRIENDSHIP

The Marchioness of Pescara, Vittoria da Colonna (1490–1547), and Michelangelo were involved in a friendship that was deeply spiritual. On Michelangelo's part it was passionate too. They met in 1536 in Rome. Their strong friendship was maintained through much time spent together and the poetry they wrote for each other. His sonnets to Vittoria are some of the finest he ever wrote.

THE DELLA ROVERE SCULPTURES

Michelangelo revealed to his biographers Giorgio Vasari and Ascanio Condivi his personal sadness at the mishandling of the Julius Tomb project. It amounted to decades of mismanagement and delay. Michelangelo called it 'the tragedy of the tomb'.

During 1535–41 Michelangelo had worked hard on the *Last Judgement* in the Sistine Chapel, in spite of signing a contract in 1532 with the della Rovere family to produce six sculptures for Julius's tomb.

NEW CONTRACTS

Pope Paul III planned for Michelangelo to paint two frescoes for the Pauline Chapel. He was unconcerned about the della Rovere contract. The Pope's wishes overrode the family of a pope long deceased. Julius's heirs agreed reluctantly to have the remainder of the work, with the exception of two sculptures, *Leah* and *Rachel*, completed by Michelangelo's assistants, Urbino (Francesco di Bernardino d'Amadore da Urbino) and Giovanni de' Marchesi da Salteri. The sculptor Raffaello da Montelupo (c.1505/6–66/7) was contracted for a *Sybil*, *Prophet* and *Virgin*. The *Moses* sculpture had previously been finished by Michelangelo, which completed the six sculptures for the wall tomb. The statues of *Leah*, *Moses* and *Rachel* would be placed at ground level, and the *Sybil*, *Prophet* and *Virgin* on the upper level. It was a quite different prospect to the 40 life-sized sculptures initially visualized by Michelangelo, and desired by Julius II.

ANOTHER DISPUTE

The architectural frame for the sculptures was to be made by Michelangelo's assistants Urbino and Giovanni. This should have been a straightforward task but nevertheless a dispute arose. Michelangelo, in a letter written in May 1542 to a

Right: Tomb of Pope Julius II, by Michelangelo, 1505–45. The completed marble wall tomb is in the Church of San Pietro in Vincoli, Rome.

colleague, Luigi del Riccio, in Rome, asked for advice on handling the situation. Michelangelo berates Urbino and Giovanni for being unreasonable. They could not agree on who would do what. Michelangelo's amusement and frustration are evident: "this difficulty has arisen between them, which might lead to a serious quarrel or death. Should such a thing happen to either of them, I should be sorry about Messer Giovanni but much more

so about Urbino, because I have brought him up." He adds, "Messer Luigi, I have made this statement in writing… [because] to make it in front of those fellows by word of mouth completely exhausts me…".
Michelangelo wanted Riccio to cancel the assistants' contract and place the work back in Michelangelo's hands. It would seem from the tone of the letter that he did not want the job but did not want "their stupidity" to be his ruin.

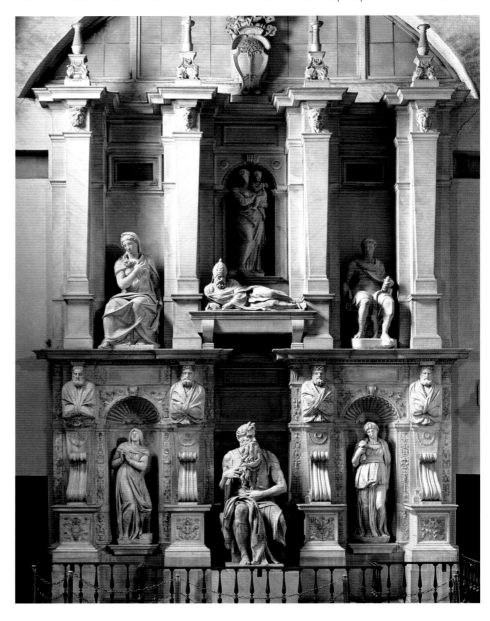

Right: View of Rome with the Convent of San Pietro in Vincoli, *by Hendrik van Lint, 18th century. The wall tomb of Julius II was placed in his titular church of San Pietro.*

Eventually the problems were resolved when another contract was drawn up on 1 June 1542, and under Michelangelo's guidance the architectural frame was made and erected on site. The tomb did seem blighted from the outset but at least completion was in sight.

At long last, in 1545, the tomb was completed. Condivi writes that Michelangelo was deeply upset that the tomb was a shadow of the original concept. The family erected it in San Pietro in Vincoli, the parish church of Pope Julius II. His body lay in the Basilica of St Peter.

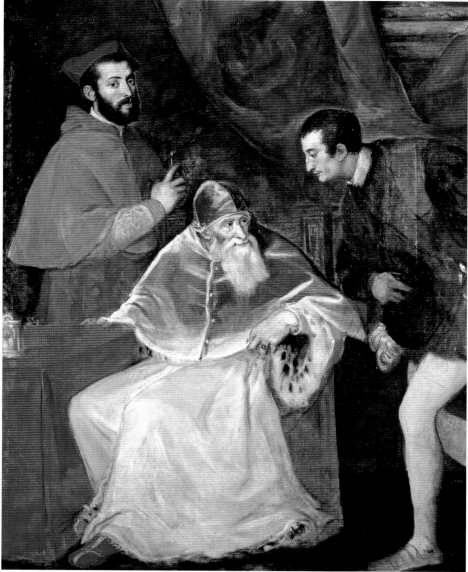

THE 'TRAGEDY' OF THE TOMB

At this time in Michelangelo's life his dream to create a masterpiece for Julius II was finally over. He called it 'The Tragedy of the Tomb'. One has to consider the stages that led to his loss of contracts and the waning friendship and patience of the della Rovere family. Following Michelangelo's completion of the Sistine Chapel ceiling in October 1512, he wanted to continue the sculptures for Julius's tomb. A letter to his father in Florence, dated October that year, explains that he was waiting for the Pope to tell him what to do.

However, following the death of Julius II in February 1513, each pope that succeeded him, from Leo X to Pius IV, had their own agenda for Michelangelo, which did not include the creation of a substantial tomb to a previous pope.

Left: Portrait of Pope Paul III and his Nephews, *by Titian, 1545. This oil on canvas painting depicts the elderly pope with his nephews.*

MASTERFUL FRESCOES

In 1541, Pope Paul III commissioned Michelangelo to paint two large frescoes for the Pope's private chapel, the Cappella Paolina in the Vatican, which had recently been built. The artist reluctantly agreed to do it, having no power to refuse a papal command.

In 1542, Michelangelo began work on the two frescoes for the Pauline Chapel. At the age of 67 he must have found the task more difficult than in his younger years. The commission would take eight years to complete. One fresco was to depict the conversion of St Paul (the Roman soldier Saul) on the road to Damascus; and the other the crucifixion of St Peter in Rome. Both saints were relevant to Pope Paul III. The first was his papal namesake, and the second, St Peter, was the first pope of the Roman Catholic Church. Rome was the place of St Peter's martyrdom and his burial.

NEW MASTERPIECES

Two letters written by Michelangelo to his nephew Lionardo in August 1541 reflect his discontent – "things are not going as I wish" – possibly a reference to the Pope assigning him the Pauline Chapel frescoes on completion of the *Last Judgement*. He never wanted to be a painter and now the work was physically tiring him.

Letters from this period also reveal Michelangelo, the man. Lionardo and a friend wanted to visit Michelangelo the following month in September but he put them off: "I'm so busy… [and] Urbino, my assistant, is going to Urbino in September… [and for me] to have to do the cooking for the two of you would be the last straw…wait until next Lent…"

DEATH OF A YOUNG FRIEND

Michelangelo's letters were now addressed mainly to his nephew Lionardo in Florence or to his brothers. At this time (1542) he had to organize the architectural frame for the Julius Tomb. His assistants Urbino and Giovanni di Marchesi were meant to work on

Above: The Conversion of St Paul, *by Michelangelo, 1542–5. The Roman soldier Saul of Tarsus is temporarily blinded by the light from Heaven.*

Below: The Conversion of St Paul, *by Taddeo Zuccari, mid-16th century. The painting by Zuccari is comparable to Michelangelo's fresco composition.*

THE PAULINE CHAPEL

The *Cappella Paolina*, known also as the Pauline Chapel, was designed by Antonio da Sangallo the Younger (1484–1546). The construction took place in 1537–41, for Pope Paul III. It is part of the Apostolic Palace of the Pope. The chapel has never been open to the public. The frescoes of *The Conversion of Saul* and *The Crucifixion of St Peter*, painted by Michelangelo between 1542–9, are vast in size and flank each side of the narrow chapel.

Right: The Crucifixion of St Peter, *by Michelangelo, 1546–50. Historians debate whether the face of St Peter is a self-portrait of the artist.*

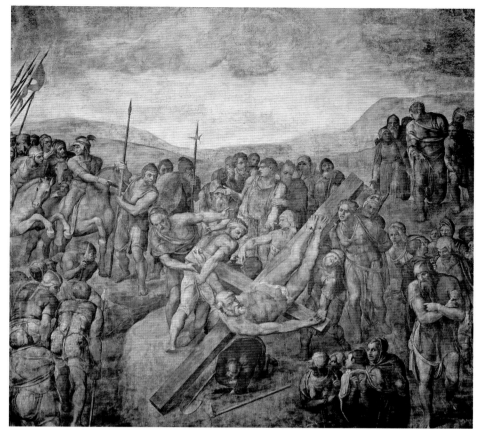

it together but fell out, negating the contract. Michelangelo organized a second contract for 1 June 1542.

In January 1544, one of Michelangelo's assistants died suddenly at the age of just 16. This was Cecchino de' Bracci, the nephew and adopted son of his financier Luigi del Riccio. Urbino was set the task of making the memorial stone. Michelangelo was taken with grief. He wrote 48 orations and epitaphs mourning the loss of a beautiful friend. He was deeply saddened: "Bereft of handsome eyes, and jaunty air…whom I embraced, in whom my soul now lives."

Michelangelo then became ill himself, which delayed the work. (He suffered occasional bouts of ill health, mainly due to kidney stones.) On this occasion he rested at the Palazzo Strozzi in the care of Luigi del Riccio.

ST PAUL

The frescoes in the Pauline chapel were to be placed on the wall either side of the altar. The figures in each show the extent to which the style of Mannerism had taken hold of Italian art at this time. Here there were no idealized Greek or Roman gods to immortalize the faces of St Peter and St Paul or even the crowds of soldiers and onlookers. In *The Conversion of Saul* (1542–5) the depiction of St Paul captures the moment when, as the Roman soldier Saul, he is temporarily blinded by the vision of God appearing to him in the sky above. The composition and figure work bear a similarity to the *Last Judgement*, with its bulky figures.

ST PETER

In the second fresco, *The Crucifixion of St Peter* (1546–9), the representation of St Peter is of a strong man willing to be crucified for his beliefs. Michelangelo follows the Bible narrative – Peter is about to be crucified on an inverted cross, deeming himself unworthy of being crucified upright as Christ had been. In the background Michelangelo captures the landscape and hills of Rome, giving the event context to the city of Rome. The composition of the work places the onlooker at the scene, which took place not far from the Vatican. The penetrating look on Peter's face stares out to question the onlooker. The face is familiar. Could it be Michelangelo? In recent years the deaths of many close friends and relatives had wearied him. He had lost his father, a brother, the young boy Cecchino, and in 1547 his devout friend Vittoria da Colonna.

Left: The Crucifixion of St Peter, *by Filippino Lippi, c.1484–8. A comparison with Lippi's painting highlights the raw energy of Michelangelo's depiction.*

CHIEF ARCHITECT, ST PETER'S

On 1 January 1547, Michelangelo was officially appointed Chief Architect of St Peter's Basilica, Rome, an honour bestowed on him by Pope Paul III. After Bramante, Raphael and Sangallo, Michelangelo would, at last, control the plans for the new basilica.

Michelangelo was 71 years of age in 1546. His late appointment as Chief Architect of St Peter's Basilica in Rome may have been due to his on-off relations with Rome and the papacy, particularly during the siege of Florence, or more probably due to his popularity as a painter and sculptor.

ARCHITECT OF ROME

Whatever the reason for the delay, Michelangelo retained the position until his death, a term of 17 years. The job of Chief Architect must have been an enjoyable experience, for Michelangelo – it linked professionally to his friend Tommaso dei Cavalieri's position in the Conservators' Palace, as one of the overseers of public architecture works in Rome. His chief duty during this time was to oversee the structural building of St Peter's. He had opinions on how the basilica should be designed. His concern was to return to Bramante's design for a centrally planned church. Whatever Michelangelo's personal view of Bramante, in a letter to his friend

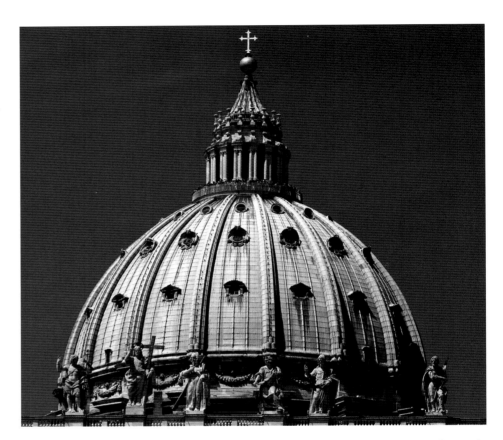

Above: Exterior view of the cupola, St Peter's Basilica, Rome. The cupola of Michelangelo's dome was completed in 1593.

Below: Engraving of Michelangelo's project for St Peter's, by Etienne Dupérac, 1568.

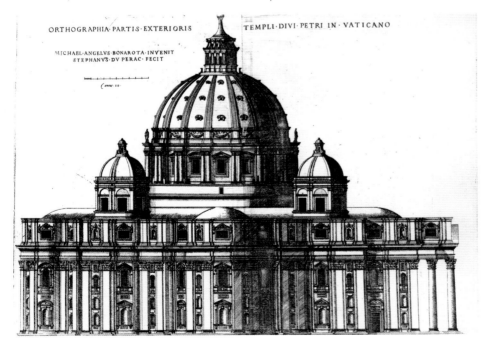

Bartolommeo Ammannati in 1555 he wrote that he preferred Bramante's original basilica plan, designed on Pythagorean principles of harmony and proportion through mathematical ratio. For Neo-Platonists the harmonious geometry of the circle and the square, both perfect forms, was a symbol of the microcosm of man and the macrocosm of God. Michelangelo wanted to remove all adjustments made by other architects. His own design plan would follow that of Bramante.

CONSTRUCTION CONTINUES

Michelangelo's major contribution to St Peter's was the vast central dome, still uncompleted at his death in 1564. The project continued after his death,

and the dome was eventually completed 30 years later in 1590 by Giacomo della Porta (1533–1602) assisted by Domenico Fontana (1543–1607).

In 1603 the papacy appointed Carlo Maderno (1556–1629) as Chief Architect. Maderno altered Michelangelo's Greek cross design and elongated it to a Latin cross, extending the nave. He added a sumptuous, richly decorated Baroque façade to the building, which was completed in 1612. The Basilica was eventually consecrated in 1628.

Right: The marble Baroque façade of St Peter's Basilica was completed in 1612.

Below: View of the interior of the dome of St Peter's Basilica, Rome. Light floods in through the circle of windows in the dome.

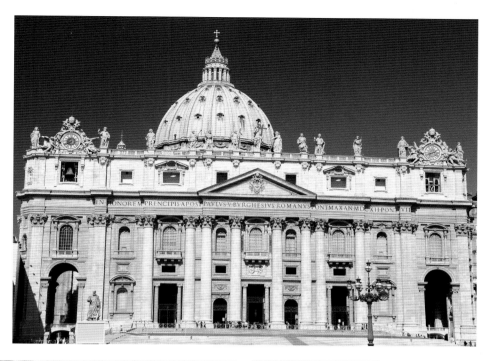

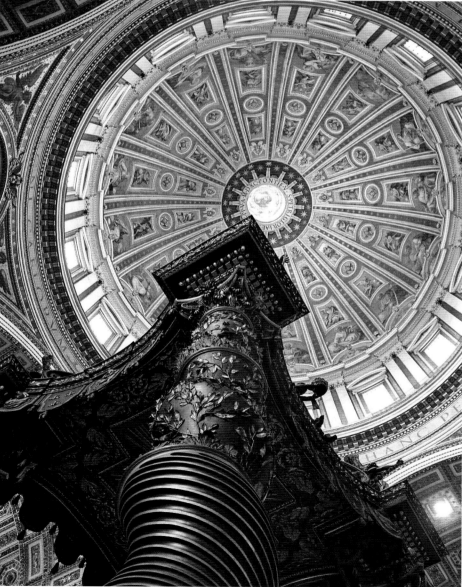

CHIEF ARCHITECTS

1505 can be said to be the year when the old St Peter's, falling into decay, was assigned to history and a new St Peter's was devised by Donato Bramante. Working under the instruction of Pope Julius II, he became Chief Architect. Bramante's area of expertise was to renovate and replan old buildings. There is no evidence to suggest that he planned to destroy the whole of the old St Peter's. His design was for a Greek cross plan with a large dome over the crossing. The first cornerstone of four giant piers was laid in April 1506, the same year that the central plan was altered to include a nave. On the death of Pope Julius II in 1513 and Bramante in 1514, a less expensive building plan was actioned by Pope Leo X. His architects were Raphael, Giuliano da Sangallo, and Fra Giovanni Giocondo (1433–1515). From 1523 Pope Clement VII had 60 experts working on the project. Antonio da Sangallo the Younger worked continuously on it from 1520 and became Chief Architect in 1536. Following Sangallo's death, Michelangelo was appointed Chief Architect of St Peter's Basilica on 1 January 1547.

A GEOMETRIC MASTERPIECE

The Piazza Campidoglio on the Capitoline Hill is at the heart of the ancient city of Rome.
A planned visit to Rome in 1536 by the Holy Roman Emperor Charles V instigated
Michelangelo's commission to renovate the piazza and create a vibrant new city space.

A planned visit to the city of Rome by the Holy Roman Emperor Charles V in 1536 prompted Pope Paul III to consider where to terminate the Emperor's triumphal entry into the city. The medieval city, which had grown from the ruins of the ancient one, had no obvious focal point and, in fact, had hardly recovered since the Sack of Rome, nearly nine years before. The Pope chose the Campidoglio (Capitoline Hill).

RENEWAL OF THE CAMPIDOGLIO

In ancient times many triumphant entrances to the city had climaxed at this same point. However, this area and the medieval buildings on the hill needed restoration, and Emperor Charles's visit was less than spectacular. Following the Emperor's visit, the Pope decided to restore the Capitoline Hill as a symbol of the new Rome. Michelangelo made an initial plan for its redesign, but this was not carried through. In 1538 he created a second plan,

and from this we can see that he considered the buildings on site, the open space between them and the rough earth road down the hill as one complete unit. The Pope requested that the equestrian bronze statue of Emperor Marcus Aurelius (AD121–180), which had previously stood outside the Lateran Palace, was moved to the Capitoline Hill. Michelangelo did not approve, but his oval design for the statue's pedestal actually shaped the whole piazza design.

Historians agree that it is possible that Michelangelo designed the Campidoglio layout after considering two earlier schemes for urban redevelopment. Both imposed geometric harmony in a confined urban space. One was Bramante's

Below: View of the Piazza del Campidoglio, Rome, leading toward the 'Cordonata' steps, designed by Michelangelo for the triumphal entry of the Emperor Charles V in 1536, and completed after the artist's death. To the right Palazzo Nuovo.

plan (c.1505) for the Belvedere Court at the Vatican. From a hillside area Bramante had created a dramatic series of stepped courtyards, which had brought together various buildings of the Vatican complex as one unit. Michelangelo may also have considered the town plan of Bernardo Rossellino for the central piazza and buildings of Pienza, an urban development scheme commissioned in 1459 by Pope Pius II (pontiff 1458–64).

GEOMETRIC HARMONY

On the Capitoline Hill, Michelangelo unified a site which had five different entrances through a complex geometric pattern. The slightly convex paved area was trapezoid in shape, which pulled together the buildings

THE CAPITOLINE HILL

Rome was officially founded on 21 April 753BC. The most important temple in ancient times stood on the Campidoglio (Capitoline Hill), dedicated to Jupiter Optimus Maximus. All Roman Triumphs (a triumphant march of heroes returning from battle) paraded through the Roman Forum and ended at the steps of this temple.

In the Middle Ages the Forum, leading from the Capitoline toward the Colosseum to the south, was overgrown. The new city spread in a northerly direction. The civic area of the Capitoline Hill, which had a Senate House, and a Conservators' Palace built into the foundations of the old temple, consisted of dirt roads and mismatched buildings.

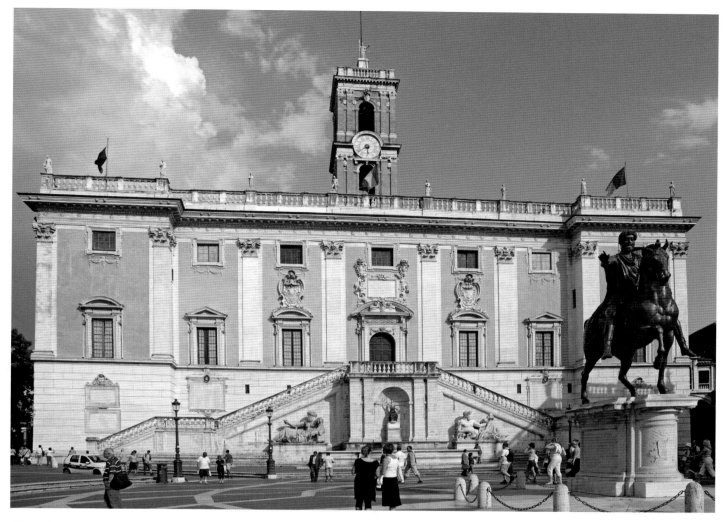

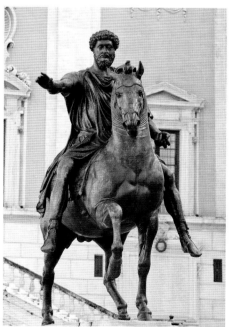

Above: Piazza del Campidoglio, Rome, with exterior view of the Palazzo Senatorio. Near right, the equestrian statue of Emperor Marcus Aurelius.

on site. He linked this to a grand staircase ramp running down to the base of the hill. In addition, he designed similar new façades for the existing Senators' Palace (completed 1600) and the Conservators' Palace (completed 1584), to unify their outward appearance. He included plans for a third building, the Palazzo Nuovo (built 1603–54), for no other reason than to unify the architectural 'room' he had created. The piazza would be enclosed on three sides by the 'walls' of the buildings.

The focal point of the outdoor 'room' was the bronze equestrian statue of Emperor Marcus Aurelius. The bronze was one of the very few statues not to be melted down when Christianity replaced paganism as the

official religion of the Roman empire in the 4th century AD. Michelangelo designed a marble oval pedestal for the statue. He favoured the oval shape and mirrored it in the trapezoid design for the whole piazza, an unusual choice and the first in Renaissance architecture. The statue was chosen as a symbol of the civic power of ancient Rome, linked across time to Rome in 1536. In addition, Marcus Aurelius was greatly admired for his humanist beliefs. However, Michelangelo and others believed it to be a statue of Aurelius's father, Emperor Antonius Pius (AD86–161), and the inscription written on the pedestal declares it to be so. At its conclusion, and long after the death of Michelangelo, the unity imposed on the stunning Piazza Campidoglio, this once shambolic mix of dirt roads and decaying buildings, shows Michelangelo's supreme skill as an architect.

Above: Equestrian statue of Emperor Marcus Aurelius, artist unknown, 2nd century. The bronze equestrian statue of Marcus Aurelius unites the ancient city of Rome with its Renaissance renovation.

PALAZZO FARNESE

The Palazzo Farnese in Rome, initiated by the young Cardinal Alessandro Farnese in 1515, needed further embellishment when he was elected as pontiff, and became Pope Paul III. In 1546, Michelangelo was commissioned to work on the project.

Above: Palazzo Farnese, Rome. In 1546, Michelangelo designed a colossal roof cornice to complete the impressive façade.

The Palazzo Farnese, or Farnese Palace, has been called the most imposing Italian palace of the 16th century. The elevation of Cardinal Alessandro Farnese to Pope Paul III in 1534 turned his attention to the house as a symbol of the Farnese dynasty, an outward sign of its immense wealth and power. Vasari explained that the Pope felt that Sangallo should now be building a palace fit for a Pope, not a Cardinal. After 19 years of work on it, the Pope wanted to embellish the design.

MICHELANGELO'S DESIGN

In 1546, at the time Michelangelo was commissioned, the building work was in an advanced stage and so he was limited in what he could add. His first task was to complete the façade, before finishing the sides and rear of the building. In essence the construction was still to Sangallo's design but with the addition of Michelangelo's artistic flair. His brief was to complete the third

level (the ground floor and first floor, the *piano nobile*, were in place) and reconsider the plan for the courtyard. To accentuate the height and width of the palace and emphasize its presence Michelangelo added a colossal cornice for the roof, which projected far over the building's façade. Its presence accentuated the horizontal alignment and repetitive pattern of three floors of regular windows. To compensate for the substantial dimensions of the cornice – a design idea borrowed from ancient Roman architecture and used to aggrandize Renaissance palaces such as the Palazzo Rucellai and the Strozzi Palace in Florence – Michelangelo altered the dimensions of the windows on level three, the attic storey, to mirror those on the lower floors (the attic windows were often smaller in size). The addition of pediments above each window frame accentuated the design rhythm of the façade. A colossal rusticated entrance pierced the centre

of the façade and a 'papal' balcony was sited directly above the entrance, on the *piano nobile*. On the wall above the balcony between the second and third level, a gigantic crest of the Farnese coat of arms, combined with the insignia of the Papal Tiara, completed the aggrandizement of the façade.

A REVIVAL OF ANCIENT ROME
The façade of the inner courtyard of the Palazzo Farnese was embellished with Doric, Corinthian and Ionic columns, used in ascending order on each level, informed by the decorative architectural design of the ancient Colosseum in Rome. This style was initiated by Leon Battista Alberti on the façade of the Palazzo Rucellai (1446–51) in Florence, and by Bernardo Rossellino on the façade of the Palazzo Piccolomini in Pienza (1459–64). The exterior deference to ancient Rome mirrored the decoration of the interior rooms, which were to be frescoed with allegorical depictions and mythological stories, including the labours of Hercules.

Right: Sala dei Fasti Farnesiani (Hall of the Splendours of the Farnese), by Francesco Salviati and Taddeo Zuccari, 16th century, Palazzo Farnese. A detail of the frescoed trompe l'oeil wall decoration.

Above: Michelangelo's commission for the Palazzo Farnese included a redesign of the inner courtyard.

A BRIDGE TO PALAZZO FARNESINA
On the garden side of the building, which ran down to the river Tiber, Michelangelo planned a bridge across the Via Giulia and across the river to link the Palazzo Farnese to the family's villa in Trastevere, the Palazzo Farnesina, used as a private

Above: The Farnese archway on Via Giulia. Only one arch of the bridge across the Arno was built.

residence and for entertaining. Michelangelo completed the first arch of the bridge across the Via Giulia, which still remains in place today. The rest of the bridge scheme was unrealized. The Farnese family decided against the idea for some reason.

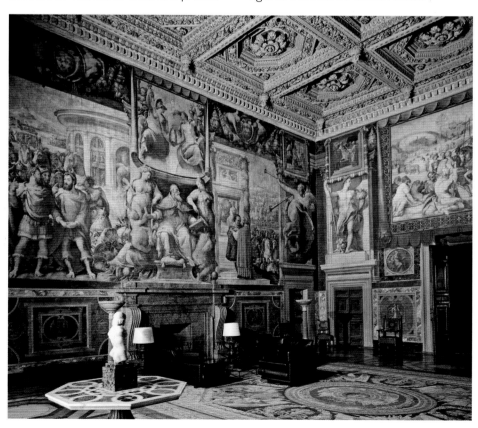

VASARI AND CONDIVI

In addition to the many letters Michelangelo wrote to patrons, professional colleagues, friends and family, two contemporary biographies of the artist, written by Giorgio Vasari and Ascanio Condivi, seek to reveal the true 'life' of Michelangelo Buonarroti, the man.

As well as writing to family and his few close friends, Michelangelo also wrote to work colleagues and to papal officiates. One letter, written on 1 August 1550, is addressed to 'Messer Giorgio Vasari, painter and special friend in Florence', written at the time of Vasari's publication of *Lives*. The letter discusses the delay on a project for a chapel planned for San Pietro in Montorio in Rome, which would involve them both. He goes on to thank Vasari for his last three letters, of which his pen is 'incapable of replying to such high praises'.

GIORGIO VASARI

Vasari idolized Michelangelo and for a short time worked with him. In the 1550 edition of *Lives*, Michelangelo was the sole living artist included. The idea of writing the *Lives* was suggested to Vasari by Cardinal Alessandro Farnese. Vasari was a regular guest at the court of the Farnese in Rome. The two-volume work was dedicated to the Grand Duke Cosimo I de' Medici, one of his patrons. It took seven years to write and it chronicles the lives of eminent artists from Cimabue (c.1240–c.1302) onward. Because of this publication Vasari is now referred to as the 'father of art history'. Following Condivi's biography of Michelangelo, published in 1553, Vasari heavily revised the *Lives* of 1550 and republished it in 1568.

ARTIST, ARCHITECT AND AUTHOR

Vasari was a respected artist and architect as well as an author. Painting in the Mannerist style he was commissioned by Cosimo I de' Medici to create the wall and ceiling paintings in the Salone dei Cinquecento, in the Palazzo Vecchio in Florence, completed in 1565. The ceiling paintings depicted episodes of the history of Florence. The wall panels of battle scenes, painted by Vasari (and assistants), were begun in 1566 and finished by 1571. One of the scenes is said to cover over Leonardo's lost *Battle of Anghiari* (c.1506).

Above: Portrait of Michelangelo (detail), by Giorgio Vasari, c.1550. Vasari published his 'Life' of Michelangelo in 1550, the sole living artist to be included in the comprehensive collection of Italian artists' biographies.

Vasari's skill as an architect is apparent in the Uffizi loggia, and its covered corridor, which he designed and built in five months in 1565. This walkway begins in the house of the Medici (now the Uffizi Museum), crosses the Ponte Vecchio and is carried above the streets of Florence, through houses and a church to end in the Palazzo Pitti, the private home of the Medici. The corridor was built to protect the family.

ASCANIO CONDIVI

Unlike Vasari, who had many skills, Ascanio Condivi would be a forgotten man if it were not for his friendship with Michelangelo. The result of their

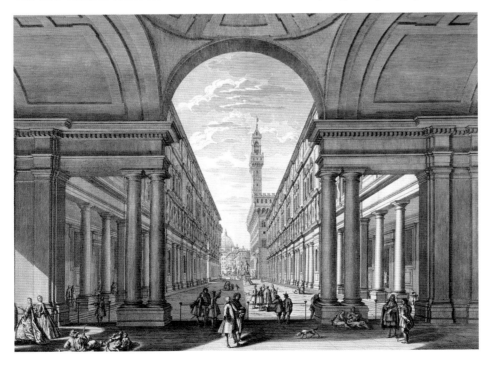

Left: The Uffizi and Palazzo Vecchio, Florence, by Giuseppe Zocchi, 1757. The engraving shows the classical colonnades of the Uffizi, designed by Giorgio Vasari.

friendship was his book *Vita di Michelangelo Buonarroti* (The Life of Michelangelo Buonarroti), published in 1553. Condivi was a minor pupil of Michelangelo and it seems that Michelangelo, not totally happy with Vasari's 1550 account, suggested to Condivi to write another, aided by Michelangelo's own memory of events. This 'life' is the account that reveals the fears and vanities of the artist, as well as his ability to manipulate the biographer. For example, Condivi wrote that Michelangelo had never been an apprentice; that his skill as an artist was God-given; and that his ability as a sculptor was imbibed from the milk of his wet-nurse. It does not acknowledge the period Michelangelo spent as an apprentice, in the workshop of Ghirlandaio brothers. Both authors reveal Michelangelo to us in different ways.

Above: A drawing of the façade of the Palazzo degli Uffizi, *by Vincenzo Scamozzi, 1580. Designed by Vasari c.1560.*

Below: Giorgio Vasari, *self-portrait, 1566–8. Vasari was an accomplished Florentine artist, architect and biographer.*

MICHELANGELO – MARRIAGE BROKER

The substantial collection of letters that Michelangelo wrote to his family and friends reveals his day-to-day routines, his concerns, his work ethic and his health. In the 1540s, when work commissions saw him immersed in large-scale frescoes for the Pauline Chapel, and architectural plans for the Basilica of St Peter, the Palazzo Farnese and the Piazza Campidoglio, his letters reveal him to be a marriage broker, helping to find a suitable wife for his nephew Lionardo. Many letters give insight into his small pleasures. In a letter of thanks to his nephew (2 May 1548), he writes of his pleasure at receiving a barrel of 86 pears, 33 of which he gave to the Pope, who "thought them excellent". Some letters concern the buying and selling of properties and land, carried out by Lionardo on his behalf. They give details too of the work projects he liked and those he would have preferred not to take on.

AT ONE WITH ANCIENT ROME

Architectural commissions in Rome, from the vast Basilica of St Peter's to the Porta Pia gatehouse, as well as his sensitive handling of new projects, proved Michelangelo's enduring concern for the city of Rome, which he had made his second home.

Around 1509, a competition to design a church for the Florentine community in Rome had been held. Some said that the reason for the contest was the desire of Cardinal Giovanni de' Medici (later Pope Leo X) to show the superiority of Florence over Rome.

SAN GIOVANNI DE' FIORENTINI

Jacopo Sansovino (1486–1570) won the contract to design San Giovanni de' Fiorentini (St John of the Florentines). It was to be built at the northern end of the new Roman avenue, Via Giulia, close to the river Tiber, an enclave of the large Florentine community. Other architects followed Sansovino in working on the project, including Antonio da Sangallo the Younger, who laid the foundations in 1519. In 1559 Michelangelo was one of five men given charge of its construction. Duke Cosimo I de' Medici was to partly finance the project. A letter written by Michelangelo to the Duke

Above: City view of Porta Pia, Rome, by Michelangelo, from 1561. In 1561, Pope Pius IV commissioned a new road, Via Pia, and new city gate, the Porta Pia.

in Florence, dated 1 November 1559, thanks the Duke for permission to take the contract and encloses one of his approved designs, which he refers to as "the most imposing". The five extant drawings show that he intended a centrally planned church, following an ancient Roman precedent. This would be his chance to construct a new building, rather than add to an older one. Michelangelo's assistant Tiberio Calcagni (1532–65) made two models of the church and a presentation drawing but the plan was dropped when the Duke withdrew his support.

FUNERARY CHAPEL

From 1560, Michelangelo provided designs for a funerary chapel for Cardinal Ascanio Sforza. At this time, Michelangelo would draw plans

Left: The external façade of the Porta Pia was completed in 1869 from original plans.

but delegate the model making and actual organization of the construction to his assistants. Tiberio Calcagni was given charge of the work until his death in 1565. The chapel was completed in 1573, possibly to Michelangelo's original design.

HONORARY CITIZEN

Michelangelo was made an honorary citizen of Rome on 10 December 1537; his official title on a list of foreigners given Roman citizenship was 'Master Michelangelo, sculptor'. By 1546, with the Tomb of Julius II at an end, his skills were now in demand as an architect rather than as a sculptor. He received new architecture commissions from both private patrons and public authorities. Of the many projects few were for new buildings. Every project was a continuation of work in progress, such as St Peter's or the Palazzo Farnese; or an alteration to an existing building such as the Church of Santa Maria degli Angeli, created within the ancient Baths of Diocletian.

PORTA PIA

The Porta Pia gatehouse was commissioned by Pope Pius IV in 1561. It was to be a focal point of a newly straightened street, the Via Pia. The gatehouse was a monumental exit rather than a defence barrier. Unusually it was the inner city façade rather than the outer city entrance which was given most importance. Michelangelo considered the gatehouse in relation to the surrounding city walls and medieval streets. In drawings it appears from a distance to be an ancient triumphal arch. His design is a fusion of classical and medieval iconography. An early drawing is close to a theatrical garden portal of a grand villa. The faux-castle medieval façade in brick is decorated with classical detailing. The central portal is a classical arch with a grand pediment. A Latin inscription within the pediment records the construction of the gatehouse and the Via Pia by Pope Pius IV. The arch is dressed with Tuscan Doric pilasters and extended capitals. The roof line is topped with faux crenellation, which unexpectedly fits into the whole scheme of the design. It is a masterfully staged piece of theatrical embellishment, which paves the way for the flamboyant Baroque

Above: Basilica of Santa Maria degli Angeli, Rome, by Michelangelo, 1564. An interior section of the ancient Baths of Diocletian (AD306) was used to create the church.

architecture of the 17th century. The inner Porta Pia was completed in 1565.

BASILICA SANTA MARIA DEGLI ANGELI

The Basilica of Santa Maria degli Angeli is contained within the ancient Baths of Diocletian, which date from AD306. The commission was given to Michelangelo to convert the vast central hall of the ancient building into a church for the Carthusian monastery, which was situated on the site. Work began in 1563 and stopped in 1566. Michelangelo's innovative interior was later altered by the architect Luigi Vanvitelli (1700–73), and it is hard to envisage Michelangelo's original design, which had included a lengthy nave. Michelangelo placed the entrance to the church where the south transept now is. Eight colossal columns of red granite, original to the ancient building, were left in place, showing Michelangelo's consideration for the ancient Roman interior.

PORTRAIT OF A MAN

During Michelangelo's 30 years' residence in the city of Rome, it was customary to see him riding on horseback in the city during the late afternoon or early evening, to visit friends or colleagues, to pass time in their company. It was one of his great enjoyments.

Michelangelo's knowledge of horse anatomy was first hand. He regularly rode, even attempting to do so in the final days before his death. Horses had featured in Michelangelo's work: from the *Battle of Cascina*, which featured writhing horses mounted by soldiers called to battle, to the startled horses in *The Conversion of Saul* in the Pauline Chapel.

A KEEN HORSEMAN

Fittingly, one of his last designs was for a colossal equestrian monument in bronze, dedicated to King Henry II of France. It had been requested by Queen Caterina de' Medici, widow of the king. She wrote to Michelangelo in 1559, asking him to take the commission. He designed the monument but delegated the work to his assistant, the artist Daniele da Volterra (1509–66). At the age of 85, it was not in his physical power to do any more. The bronze horse was the only part of the monument completed when it was sent to France. It did not survive the French Revolution (1789–99).

AN ACCURATE PORTRAYAL

According to Vasari, the artist remained in good health for most of his life and riding would have kept him in good shape. However, Michelangelo's letters to his nephew chronicle some bouts

of ill health due to kidney stones. Vasari records that from the 1550s, when his first edition of *Lives* was published, he got to know Michelangelo well. He had sent him a first edition of the book. In the 1568 edition Vasari includes selected letters from Michelangelo to him and a few of his sonnets. The biographer venerated the 'divine Michelangelo'. From his 'Life' of the artist we can picture the physique of the sculptor in later life.

Left: Obverse of silver medal of Michelangelo Buonarroti, by Leoni Leone, 1560–1. In March 1561, Leone sent Michelangelo four copies of the medal, two in silver, and two in bronze, as a gift.

Above: Portrait of Michelangelo, English School, 18–19th century. Raphael, Jacopino del Conte, Giorgio Vasari, and Leoni Leone created portrayals, copied by others, which recorded Michelangelo, the man.

Vasari records that he was of medium height with a strong, sinewy, muscular body. He notes that the artist's manner of dress and habits were unusual and curious. For example, that he was in the habit of wearing buskins (open-toed calf-length boots) of dog skin, next to his skin. These would be worn for months on end without being removed. When they did get taken off his skin would often come off at the same time. To ward off damp and cold he

Right: Portrait of Michelangelo, *a copy of a c.1546 print (engraving) made by Giulio Bonasone. Giorgio Vasari's description of Michelangelo, with a face wide at the brow, an angular chin with a wispy beard, and furrowed wrinkles on his forehead, fits this late portrait.*

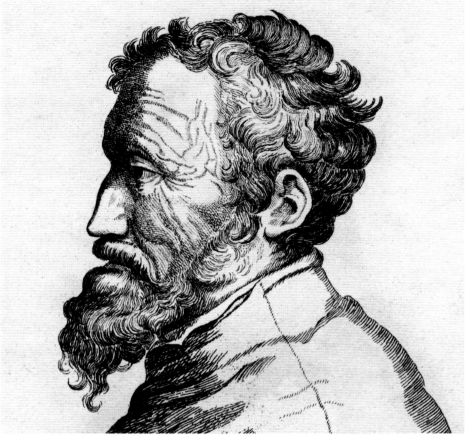

wore stockings and cordovan (high-quality horse leather) boots with inner fastenings. Condivi adds that Michelangelo would sleep in his clothes and boots and forget to eat or drink.

A RELUCTANT SITTER

According to Vasari, there were only four contemporary portraits of Michelangelo in existence, which says much about Michelangelo's reluctance to sit for others. The artists capture a man who is pensive, even melancholy. *Portrait of Michelangelo,* painted after 1535, is attributed to the north Italian painter Marcello Venusti (1512–79). The sitter looks out to the onlooker and the painter with an air of resignation; a dignified distance remains between the viewers and viewed. Michelangelo's self-portraits suggest a man who is uncomfortable in his own skin. His own

Below: Michelangelo on Horseback, Visiting an Artist, *by Federico Zuccaro, 16th century. Michelangelo was a keen horseman, continuing to ride even when his health was failing.*

sculptures constantly strove to reveal the inner person, the spiritual persona rather than the outer shell. Through the external appearance of the young and old, which he portrayed in marble and in frescoes, he tried to show the inner soul. The Florentine *Pietà* (c.1553), which Vasari claimed was for Michelangelo's own tomb, depicts Joseph of Arimathea,

possibly a self-portrait of Michelangelo, supporting the dead Christ. Recent cleaning of *The Crucifixion of St Peter,* in the Pauline Chapel, has revealed a secret self-portrait of Michelangelo (discovered July 2009). His features are visible on the face of one of three horsemen. He wears a colourful turban of lapis lazuli blue.

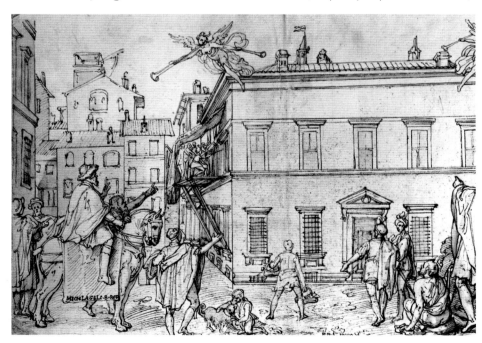

A PORTRAIT OF MICHELANGELO

Giorgio Vasari's description of Michelangelo's physique is written from the perspective of the superb portrait painter that he was; it is accurate and discerning in detail. He describes Michelangelo, now aged, with a face that is wide at the brow, with large ears and an angular chin, a square brow lined with several furrows, eyes that are small and dark and a mouth that is thin, fuller at the bottom lip than the top. His short black hair was streaked with grey and his sparse beard rather unruly.

A PEACEFUL DEATH

Michelangelo's final days saw him weakened through insomnia and the effects of a possible stroke. As his body deteriorated he wrote to his nephew Lionardo in Florence to come to him. Surrounded by his dearest friends Michelangelo's life drew to its close.

The decline in Michelangelo's health accelerated in the last few months of his life although he was determined to continue his daily ride on horseback.

In a pleasant letter to his nephew Lionardo written on 28 December 1563, thanking him for a seasonal gift of 12 *marzolini* (cheeses), Michelangelo had informed his nephew that he could no longer use his hand to write and would be getting others to do so.

LAST DAYS

By January 1564 a congestive ailment prevented him sleeping and he would spend much of his time sitting in a chair rather than going to bed. However, on 12 February 1564, he is recorded as having spent the whole day working on his *Pietà*. Two days later he had a fever yet he still went riding. It is possible that he suffered a stroke or seizure on that day. Michelangelo's assistant Tiberio

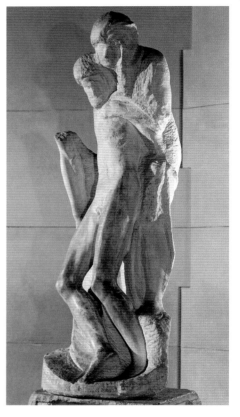

Above: Rondanini Pietà, *by Michelangelo, c.1555–64. Daniele da Volterra records Michelangelo working on this marble sculpture up to six days before his death.*

Calgani (1532–65) reported to Lionardo that Michelangelo had been seen in a bad state wandering around outside his house. Calgani had found him in the rain, speaking incoherently. "I left him on his feet clear headed and in good spirits but heavily weighed down with somnolence." Michelangelo hoped that the exertion of riding would tire him and allow him to sleep, but his legs gave way, and he had to take to his bed.

Left: Pietà (detail), *by Michelangelo Buonarroti, 1553. The face of Joseph of Arimathea (or Nicodemus) is possibly a self-portrait of Michelangelo.*

Left: Pietà (the Colonna Pietà), *by Michelangelo, early 1540s. The study, in black chalk on paper, was created for Michelangelo's friend Vittoria da Colonna.*

His servant Antonio and his loyal companions Tommaso dei Cavalieri, Daniele da Volterra and Diomede Leoni were present. Vasari records that in his final moments Michelangelo made his will, spoken in three sentences, "committing his soul into the hands of God, his body to the earth, and his substance to his nearest relatives; enjoining upon these last, when their hour came, to think upon the sufferings of Jesus Christ."

The same day Diomede Leoni wrote again to Lionardo telling him of his uncle's death and his peaceful end. The close friendship between Michelangelo, his friends, physicians and family is clear. Before his death Michelangelo asked Volterra to stay in the house until Lionardo arrived, which he did. That evening the body was taken to the Church of SS Apostoli.

MICHELANGELO THE PERFECTIONIST

Vasari reports that before his death Michelangelo destroyed "a large number of his own drawings, sketches and cartoons so that no one should see the labours he endured and the ways he tested his genius, and lest he should appear less than perfect." Perfectionism ran through his personal life, along with a devout religious belief and a total dedication to his work that in many ways fuelled his inner fears and influenced his desire to lead a solitary life. One quality for which his work was admired by contemporaries was its *terribilità*, a word meaning 'action in repose'. It could be a word to describe the man himself. However much he sought solitude in his final days, his friends paid tribute to his fiery spirit and stayed with him until his end.

SUMMONED TO ROME

In a letter of 15 February 1564 to Lionardo in Florence, dictated to sculptor Daniele da Volterra (1509–66), Michelangelo asked Lionardo to come to his house in Rome. He felt that the end of his life was drawing closer. Michelangelo signed the letter himself and Volterra added a postscript describing his worsening symptoms of somnolence, difficult breathing and stomach pains. A covering letter from Michelangelo's friend Diomede Leoni described Michelangelo's condition but advised Lionardo not to come post-haste because the roads were treacherous; and not to worry, because his uncle was in the company of his faithful servant Antonio, Volterra, Tommaso dei Cavalieri and himself.

FINAL HOURS

When the end came just before five o'clock on the afternoon of 18 February 1564, Michelangelo was surrounded by friends. Gherardo Fidelissimi and Federigo Donati were his physicians but also friends. To soothe him they gave him potions of honey and vinegar mixed with sea water and crushed almonds.

A FLORENTINE HOMECOMING

Before Michelangelo's nephew Lionardo left Florence for Rome he asked permission
from Duke Cosimo I de' Medici to bring the dead body of his uncle back to Florence.
Michelangelo's wish was to be buried without fuss in his beloved birthplace.

Lionardo was too late to reach Rome before Michelangelo died. As Michelangelo had not left a will his possessions became the property of Lionardo as sole heir. According to Vasari's version of events, Lionardo and some of his uncle's close friends wrapped up the coffin of Michelangelo "like merchandise" in an attempt to get it out of the city without disturbance. (This is recorded in Vasari's amended edition of his *Lives*, published in 1568, four years after Michelangelo's death, thus superseding Condivi's earlier 1553 account.)

Below: The Church of Santa Croce, Florence. The Franciscan church was the parish church of the Buonarroti family.

A SECRET PLAN

Lionardo was obliged to stay in Rome to complete the official business of his uncle's estate, and the coffin journeyed from Rome by mule over the Apennine Mountains to reach Florence. There it was taken to the Customs House, as a package addressed to Vasari. Instructions from Lionardo were carried with the coffin. Lionardo wanted a dignified and quiet arrival for his uncle. He asked that the body be transported to the church of Santa Croce, where it would await burial until he returned. It was not to be.

THE ACADEMY

A fledgling academy of Florentine painters, sculptors and architects, the Accademia del Disegno, had been set up by Giorgio Vasari in 1562. It had opened in 1563, with the approval and patronage of Duke Cosimo I de' Medici as President. According to Vasari, at its formation Michelangelo had been unanimously elected '*capo, padre et maestro di tutti*' – the first academician and chief of them all. (Vasari had written to tell Michelangelo this on 17 March 1563.) The motivation for the formation of the Academy was to give to other artists, sculptors and painters the same respect afforded to Michelangelo by popes and princes. They wanted recognition as arts professionals, not manual labourers. The members unanimously agreed that the return of Michelangelo's

BURIAL IN ROME OR FLORENCE?

On arrival in Rome, Lionardo's aim was to take the body of his uncle back to Florence. It had been Michelangelo's wish too. For thirty years he had lived in Rome, but he wanted to be laid to rest in his native soil near to his father. According to Vasari, Michelangelo had only stayed away from Florence because the climate was injurious to his health and the weather in Rome suited his health. However, after giving Michelangelo honorary citizenship in 1537, the Romans considered him one of them. It was thought that Pope Pius IV, who greatly favoured Michelangelo, wished him to be buried with honours in the city. It was not to be. Before leaving Florence, Lionardo had requested permission from Duke Cosimo I de' Medici to bring his uncle's body back to Florence. The Duke agreed.

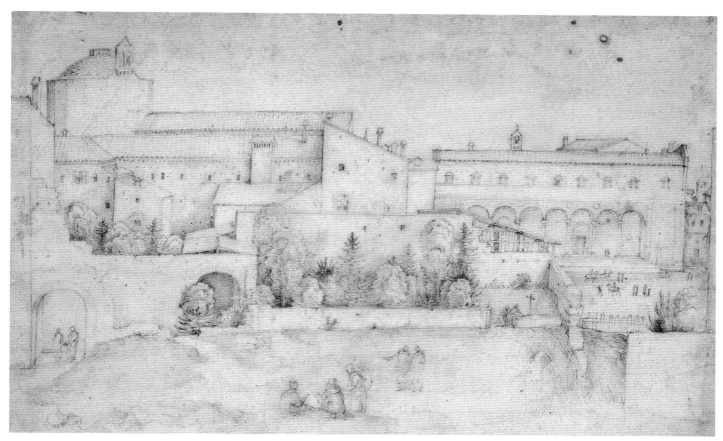

Above: View of the Church and Convent of Santa Croce, Florence, *by Fra Bartolommeo, early 16th century. The Church of Santa Croce was the chosen burial place for Michelangelo.*

body to their city was the perfect occasion to show appreciation of him as an artist and fellow professional and highlight their cause.

A PROCESSION

Vasari writes that Michelangelo's coffin arrived in Florence unexpectedly on Saturday, 11 March. From the Customs House it was moved to the room of the Company of the Assumption, near San Piero Maggiore. On the Sunday morning, 32 academy members met and agreed to carry the coffin to Michelangelo's family church, Santa Croce, after sunset. It was only a short distance away. They brought a velvet cover with golden fringe to cover the coffin. A crucifix lay on top. After sunset the academicians gathered around the coffin. Some of the older men carried lighted torches, and the younger men lifted the bier. It was to be a short, low-key procession through the streets of Florence to Santa Croce, but Vasari reports that word had spread and a huge crowd formed outside to follow the procession. The monks who had prepared the sacristy of Santa Croce for the arrival of the coffin were appalled by the huge mob that had gathered. It was neither what Lionardo had requested, nor what Michelangelo, a very private man, would have wished.

SANTA CROCE

Even at the late hour, Santa Croce was filled with people who had come to see the great Michelangelo. Some were near hysterical. The friars had to forget the sacristy plan and receive the coffin in the church to perform the funerary rites. Vicenzo Borghini, vice-president of the Academy, against the family's wishes, requested that the coffin be opened. This had to be done by a customs official, as Vasari had had the coffin sealed after its arrival. It has been written that all the academicians present touched the dead Michelangelo's face. Vasari and others recorded that Michelangelo's body showed no signs of

Above: The Genius of Victory, *(detail of head), by Michelangelo, 1527–8. The features of the face and head are considered to be Michelangelo's self-portrait.*

decomposition 25 days after death and had no bad smell, and that his features were retained except that he was pale and he appeared to be sleeping. Even though it was late a throng of people stayed to pass by the body before the coffin lid was eventually closed.

A PRINCELY FUNERAL

The imposing funeral and memorial service created for Michelangelo Buonarroti was to take place in San Lorenzo, the Medici parish church. To the people of Florence, Michelangelo was a princely son of Florence, who would be mourned by every citizen.

The academicians sought Duke Cosimo I de' Medici's permission to hold a public funeral in San Lorenzo, the Medici parish church, which would effectively give Michelangelo the rank of Medici nobility. The Duke put aside rules of etiquette and granted the dispensation, normally reserved for princes of Medici blood. Vasari writes that the Duke offered to pay all costs with no expenses spared, but records show he was slow to complete the payments. Further, it was agreed that four renowned members of the academy would be responsible for the funeral obsequies: two sculptors, Benvenuto Cellini (1500–71) and Bartolommeo Ammannati, and two painters, Vasari and Agnolo Bronzino (1503–72).

DELAYS

The ceremony was arranged to take place after Easter, as the Easter period was a time when the Medici family would be at the church for many religious services. It was further delayed due to Lionardo being detained in Rome (he returned to Florence in May). In-fighting between the four supervisors led to further delays, and Cellini withdrew from the group. Letters show that he wanted a low-key, modest service and disagreed with the choice of the large Basilica of San Lorenzo as the venue, preferring the smaller Laurentian Library or San Lorenzo's Chapter House on site. The acrimony between the academicians over matters of decoration show how the perceived hierarchy of the arts of painting and sculpture was hotly disputed. Cellini verbally attacked Vasari and Borghini for planning to

place an allegory of painting higher than one of sculpture on the catafalque. The Duke created further delays through non-payment for the many paintings planned to decorate the church for the ceremony. It meant that no canvases could be bought, and

Above: View of the interior of the Church of San Lorenzo, Florence. Michelangelo's memorial service was held in the church on 14 July 1564.

Below: Portrait of Cosimo I de' Medici, by Agnolo Bronzino, 1559.

Right: Portrait of Benvenuto Cellini, illustration from 'Memoirs of Benvenuto Cellini, a Florentine Artist'. Engraving by Hinchcliff, after Giorgio Vasari.

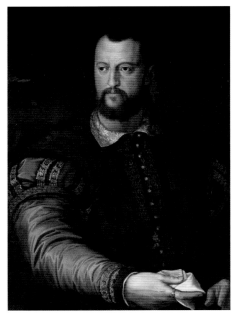

eventually Ammannati paid for them on a promise that he could keep the paintings if the Duke did not pay. The money owed was finally paid to Ammannati on 1 July 1564, two weeks before the service.

14 JULY 1564

At last, five months after Michelangelo's death, his funeral obsequies took place in the magnificent setting of the Church of San Lorenzo on 14 July 1564. The interior of the church was furnished in mourning black. Scenes from Michelangelo's life were depicted in paintings. Michelangelo's catafalque was decorated with allegorical figures of painting, sculpture and architecture. At the base were two over-life-sized sculptures representing river gods, one the Arno and the other the Tiber, to symbolize Michelangelo's affiliation to the two cities of Florence and Rome. The funeral oration was given

Right: Bronze bust of Michelangelo, *by Daniele da Volterra, 1564.*

by the Florentine poet and historian Benedetto Varchi (c.1502–65). Neither Duke Cosimo I de' Medici nor his son Francesco attended, but Varchi's oration, which had already been printed for the ceremony, included them as being present.

A NOTABLE ABSENCE

There were several possible reasons why the Medici were not present at the funeral ceremony. Duke Cosimo I de' Medici was not in good health and was expected to retire from office soon, handing over to his son Francesco. He had also suffered the loss of his wife and two of his sons in 1562. Another possibility is that

he felt slighted by Michelangelo's continual refusal to return to work on the façade for San Lorenzo. In a letter to his ambassador in Rome written on 5 March 1564, a few weeks after Michelangelo's death, the Duke's main concern was the retrieval of any drawings Michelangelo had made of the planned façade. He was furious to learn that Michelangelo had burnt the majority of his drawings and papers; he was bemused by the artist's actions and disappointed in him. To placate the Duke, Vasari had suggested to Lionardo to offer him the few drawings and pieces of sculpture that remained at the time of his death.

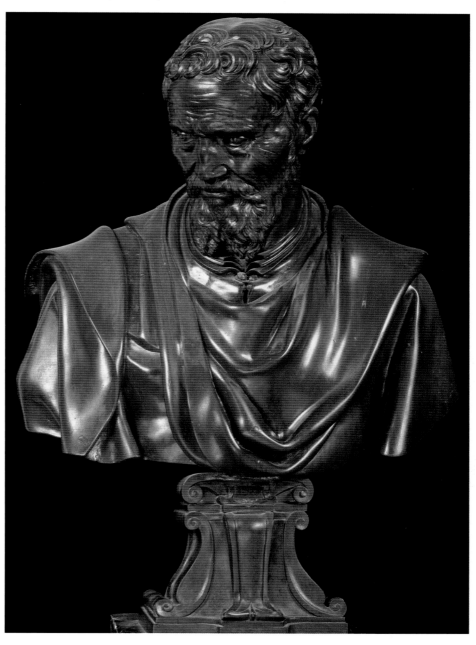

A FUNERAL TO PROMOTE THE ARTS

The day after the coffin had been carried to Santa Croce the members of the academy began their preparations for the funerary memorial service. On 21 February, soon after Michelangelo's death, Vasari had received a letter from the academy vice-president Vincenzo Borghini, an advisor to Duke Cosimo on art and literature. It suggested that it would be commendable if an "imposing funeral service" could be held at which someone could speak a few words "in praise and in honour of the arts", to inspire younger men. Vasari understood. In the hands of the academy the funeral service could be a spectacular celebration of their chief academician, *primo Accademico e capo*, an exemplary model of the arts, as a sculptor, painter and architect.

MICHELANGELO AND FLORENCE

In Florence there are many reminders of the 'divine' Michelangelo. Cultural tourists flock to view his tomb monument in the Church of Santa Croce, and his masterpieces in the Galleria dell'Academia, the Bargello, the Uffizi and the Casa Buonarroti.

Casa Buonarroti at Via Ghibellina, 70, in Florence is an unassuming palazzo dedicated to Michelangelo. The existing 17th-century house was built on the site of three former houses which combine to make Casa Buonarroti. Michelangelo bought the properties in 1508–16. They were inhabited by his nephew Lionardo. The three houses were eventually made into one, to a plan drawn up by Michelangelo.

A TRIBUTE TO MICHELANGELO

In 1612, his great-nephew Michelangelo Buonarroti the Younger, a cultured and well-respected citizen of Florence, decided to commemorate his venerated relation by refurbishing the building. He chose the theme 'Michelangelo's Life and Apotheosis' for a cycle of paintings created for him by contemporary artists, including Artemisia Gentileschi (1593–c.1653), Pietro da Cortona (1596–1669), Francesco Furini (c.1600–46), Giovanni da San Giovanni (1592–1636), and Jacopo Vignali (1592–1664). Each

room-decoration relates to his great-uncle Michelangelo. Casa Buonarroti houses some of Michelangelo's earliest works, notably the sculpture reliefs *Madonna of the Stairs* (c.1491) and *Battle of the Centaurs* (c.1492). *The River*

Above: Moving Michelangelo's 'David' from Piazza della Signoria, artist unknown, 1873.

God, c.1524–7, on display is an unfired clay model for one of the four river gods planned for the bases of the two Medici chapel tombs, abandoned when Michelangelo left for Rome. Their placement within a house which was once owned by Michelangelo himself lends an aura of intimacy to the surroundings. Added to this, a shopping list kept at Casa Buonarroti reveals Michelangelo's sense of humour. He has listed different foods, illustrated with ideograms, c.1518.

Far left: Casa Buonarroti, Florence, owned by Michelangelo, now houses a museum dedicated to him.

Left: Three Different Lists of Foods, by Michelangelo, c.1518. The 'shopping list' in ink on paper, is illustrated with small sketch drawings.

Right: Wall tomb of Michelangelo Buonarroti, by Giorgio Vasari, Santa Croce, Florence.

STATUES OF MICHELANGELO AND DAVID

Visitors walking through the Uffizi courtyard in Florence will find a statue of Michelangelo, created in 1845–50, made from Carrara marble by the Florentine sculptor Emilio Santarelli (1801–86). It stands in a niche under the Uffizi loggia, looking down on the throng of Florentines and tourists below. At Michelangelo's feet are the tools of his trade. In addition, the many millions of visitors to the city will without fail crowd around the 5.17 metre (17ft) marble replica of the colossal statue of *David*, standing at the site of the original statue's position, at the main doors of the Palazzo Vecchio in the Piazza della Signoria. This copy was created in 1910. Casa Buonarroti has a model of the wagon used to transport the original statue from the piazza in 1873, when it was moved to protect it from deterioration.

PALAZZO DEL BARGELLO

The Bargello in Florence, a medieval fortress built in 1255, was originally the Palazzo del Popolo, the seat of Florentine government. It became a museum in 1859. Here are Michelangelo's early masterpieces: the *Bacchus* sculpture, c.1497, owned by Jacopo Galli in Rome for 50 years; the *Pitti Madonna*, a tondo of the Madonna and Child and St John, c.1503; and the marble bust of *Brutus*, c.1540, one of the first figureheads to incorporate the dress of Imperial Rome (and Michelangelo's only portrait bust). Included in the collection is the small *David* (Apollo). These are just a few of the many sculptures, drawings and paintings that remain in Florence, at the Uffizi, Galleria dell'Accademia and Casa Buonarroti, which bring Michelangelo to life in his native city.

Right: Michelangelo Buonarroti, 1845–50, by Emilio Santarelli, Galleria degli Uffizi courtyard, Florence. The marble sculpture is one of 28 statues of famous Florentines placed around the courtyard.

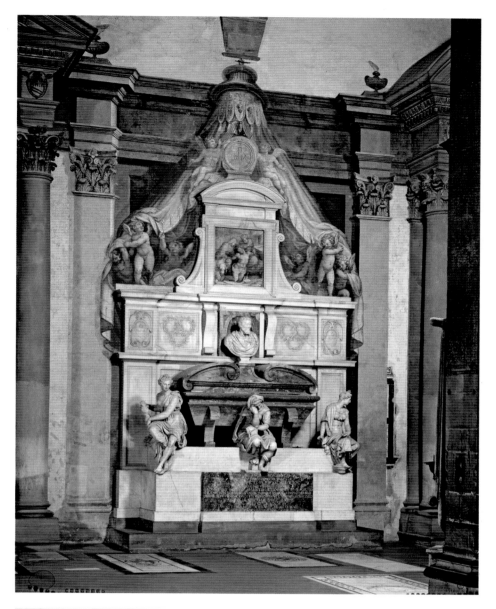

MICHELANGELO'S TOMB

In the Church of Santa Croce is Michelangelo's tomb, installed 11 years after his death. It was created by the Accademia del Disegno to a design by Giorgio Vasari. Before his death, Michelangelo had discussed with Vasari what his memorial should contain. There are three life-sized sculptures perched on the marble ledge below his sarcophagus. These are female personifications of painting, sculpture and architecture, fitting symbols of his life's work. Their demeanour and facial expressions reveal sadness at his death.

THE LEGACY OF MICHELANGELO

Michelangelo's outstanding contribution to the disciplines of painting, sculpture and architecture is his legacy. He is the *capo maestro* and his genius continues to be an inspiration to artists, sculptors and architects throughout the world.

Just before his death Michelangelo had discovered that his major paintings in the Sistine Chapel were to be censored and 'covered up' to preserve the blushes of visitors. The renaissance of the 'ideal' classical nude was at an end.

A 'LAST JUDGEMENT'

In 1563, the year before Michelangelo's death, a ruling was made by the Council of Trent (the 16th-century Ecumenical Council of the Roman Catholic Church) that nude imagery was not to be tolerated in religious artworks. Michelangelo was aware of this and thought it nonsense. A year after his death Pope Pius IV commanded Daniele da Volterra to paint drapery on the nude figures of Michelangelo's vast fresco, *Last Judgement*. For this Volterra was teasingly nicknamed the 'breeches' painter. The alterations to the fresco did not stop artists flocking to Rome to copy it.

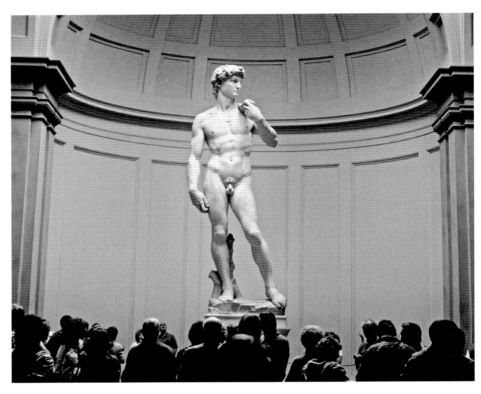

Above: Since 1873 visitors have viewed Michelangelo's 'David' in the Galleria dell'Accademia.

THE BASILICA OF ST PETER'S

The magnificent Dome of St Peter's Basilica, Michelangelo's contribution to the church building programme, was completed in 1593 to his design. Today it stands out on the skyline of Rome. At 136.5 metres (448ft), its height balances the heavy Baroque façade designed by Carlo Maderno (1556–1629) in 1614. The design was to go on to be a model for the dome of the new St Paul's Cathedral in London in 1675. Since the completion of St Peter's, both its interior and exterior have inspired architects and encouraged artists to come to Rome from all over the world to paint its splendour.

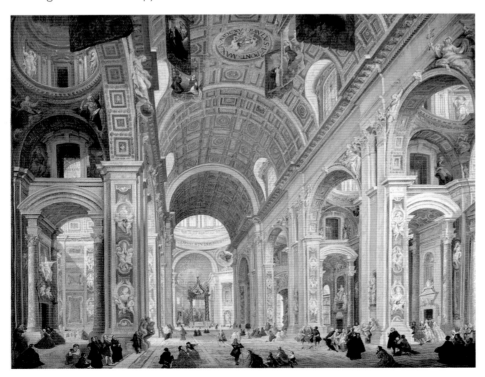

Left: Interior of St Peter's Basilica, Rome, by Giovanni Paolo Panini, 1754. Eighteenth-century artists, architects and 'Grand Tourists' flocked to Rome to view the Basilica and Michelangelo's dome.

Right: The Cast Court Collection, Victoria and Albert Museum, London. In the mid- to late 19th century, plaster casts of Michelangelo's Moses, Slaves and David were created, to aid study of his work.

GALLERIA DELL'ACCADEMIA

Since 1873, visitors to Florence have headed to the Galleria dell'Accademia to see Michelangelo's original *David,* created in 1501–4. It stands at the end of a fine room, which displays the *Quattro Prigioni* (four prisoners/slaves), the unfinished works for the Tomb of Julius II. Here too is the unfinished *St Matthew,* one of the statues for the Duomo cycle of apostles.

The Accademia is linked to Vasari's Accademia del Disegno of 1563. It was the inspiration for the Académie Royale de Peinture et de Sculpture, founded in 1648 by Jules Mazarin (1602–61) in Paris, under the patronage of King Louis XIV, and also for the Royal Academy of Arts in London, founded by Sir Joshua Reynolds (1723–92) in 1768 under the patronage of King George III. All three academies, although two hundred years apart, revered the first academician, their chief '*capo maestro*', Michelangelo.

FOLLOWERS OF MICHELANGELO

In the 17th century many Italian sculptors and painters looked to Michelangelo's work. Gianlorenzo Bernini (1598–1680) was a man recognized as the 'Michelangelo' of his era, and one who studied his works. Bernini's sculpture *St Lawrence on the Grill,* 1617, echoes Michelangelo's depiction of Adam in

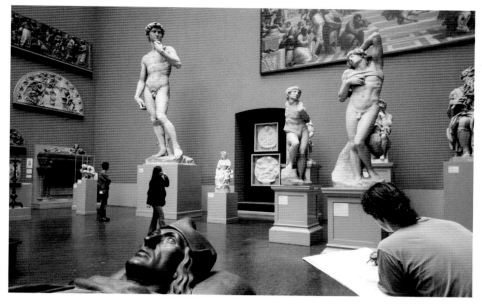

The Creation of Adam on the Sistine chapel ceiling. During this period and on into the 18th century, Grand Tourists, particularly from Britain, descended on Florence and Rome for months, sometimes for years, to study Renaissance art and architecture, and most importantly, the works of Michelangelo.

19TH TO 21ST CENTURIES

The Italian sculptor Antonio Canova (1757–1822) and the French sculptor Auguste Rodin (1840–1917) were just two of the many artists who were enlightened by the works of Michelangelo in this period.

Below: St Lawrence on the Grill, by Gianlorenzo Bernini, 1617. Bernini was influenced by Michelangelo's marble sculptures, which informed his own works.

Rodin's epic work in bronze, *The Gates of Hell* (1880–1917), depicts a scene from Dante's *Divine Comedy.* Rodin 'borrowed' the layout from Michelangelo's *Last Judgement.* In 1850s England the newly formed Art and Design schools learned from cast copies of works by Italian Renaissance artists, particularly Michelangelo. In the 21st century, these casts, moulded from the original pieces in Florence and Rome, continue to inform students and visitors to the Victoria and Albert Museum, London, where they reside. Michelangelo's exalted reputation and influence have never diminished.

MICHELANGELO'S INFLUENCE

The 'divine' Michelangelo was venerated as an artist during his lifetime and continues to be revered today. His work in sculpture, painting and architecture is a benchmark by which other artists are judged. His works profoundly affected the many artists and architects who followed him. The list is long and includes many of Michelangelo's fellow Italians, such as the architect Andrea Palladio (1508–80), the sculptor and architect Gianlorenzo Bernini and the Neo-classical sculptor Antonio Canova (1757–1822).

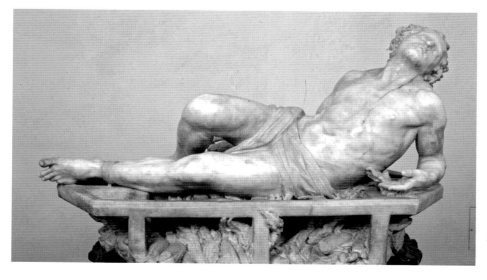

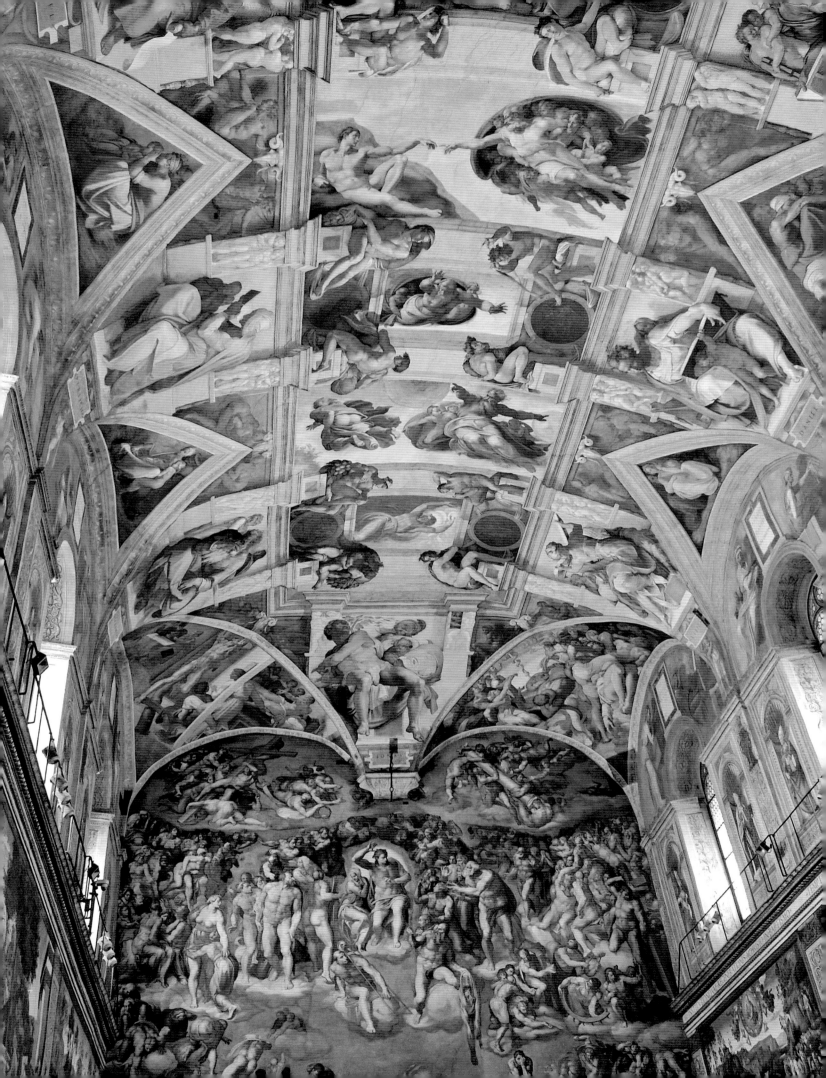

The Gallery

The gallery is divided into four sections: sculpture, paintings, architecture and drawings. A close examination of each discipline highlights unique artistic skills, clearly defined in such a supremely talented, ambitious man. From a young age Michelangelo knew that he wanted to be a sculptor – the very best sculptor in Florence, in Italy and in Europe. From a substantial beginning, he produced a masterful freestanding sculpture, the *Pietà,* and a colossal marble *David,* but his 1505 sculpture commission, to create an immense marble tomb for Pope Julius II, faltered when the Pope commanded him to decorate the vast ceiling of the Sistine Chapel in 1508. Michelangelo's adaptation to painting in fresco showed him to be a true master of the art of painting. The Sistine ceiling, unveiled in 1512, confirmed his genius as an artist. From the death of Julius II, in 1513, Michelangelo's fate was held in the hands of each succeeding pope, all of whom used him to create masterpieces of sculpture, painting, and, in his later years, architecture, all for their enjoyment. In the final section of the gallery, Michelangelo's drawings add an extra dimension, revealing his lucid, economic approach to design.

Left: Sistine Chapel, Vatican, Rome (interior detail). The ceiling and upper walls of the chapel are decorated with spectacularly colourful frescoes, painted by Michelangelo, 1508–12. The artist received a further commission in 1536, to paint the biblical Last Judgement *on the vast altar wall.*

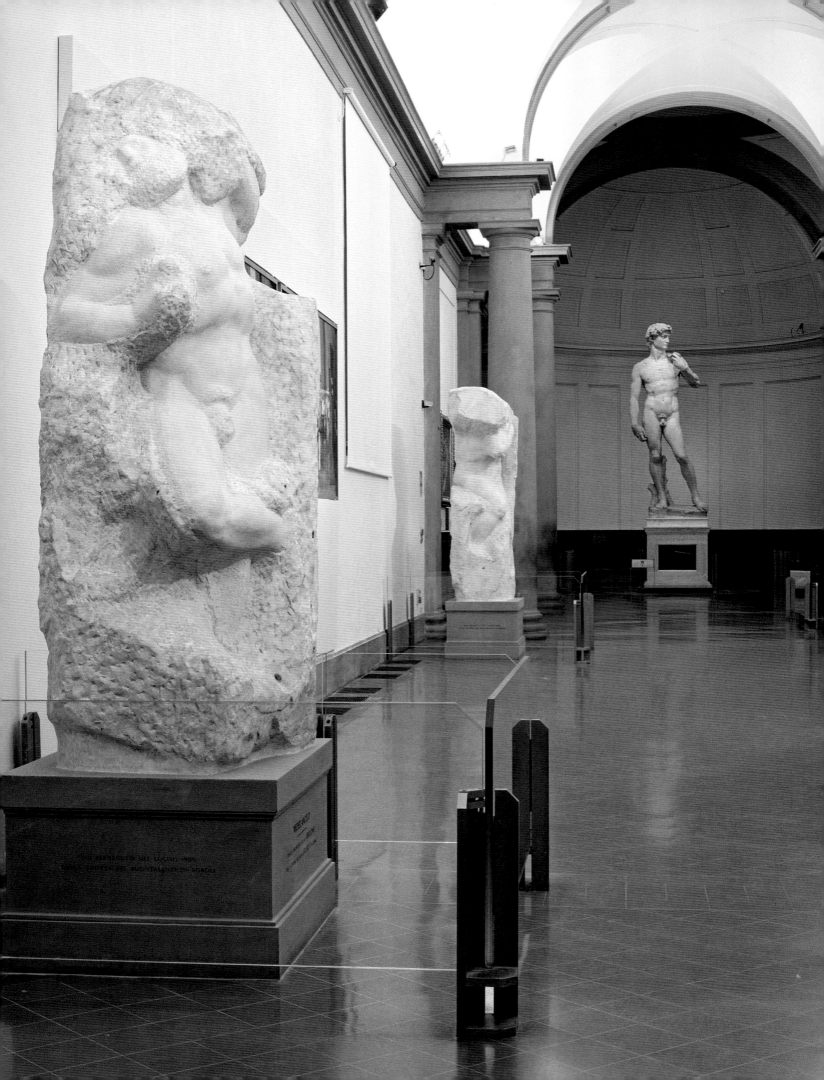

Sculpture

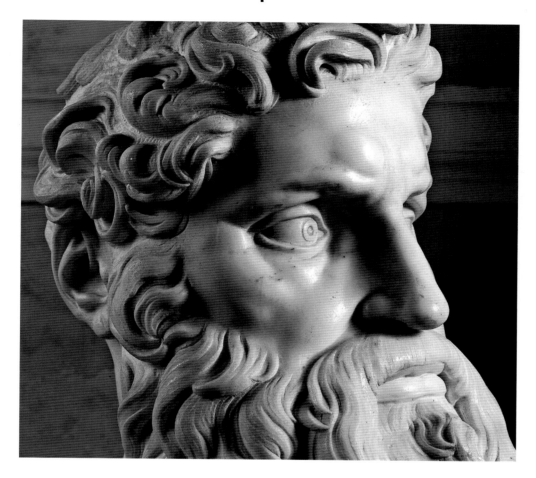

The small marble relief of *Madonna of the Stairs*, created by Michelangelo in 1489–92, foretold the talent of the young sculptor. Large freestanding sculptures soon followed and confirmed his gift for design, expression, and creative skill. The sculptures of *Bacchus* (1496–7), the *Pietà* (1499–1500), and an over-life-size *David* (1501–4), brought public attention and the clamour of papal patrons. In his lifetime Michelangelo achieved much in his chosen discipline of sculpture. The memorial tombs within the New Sacristy of the Medici Chapel, in San Lorenzo, Florence, reveal his interest in, and knowledge of, the heroic ancient past of Roman Italy. The architectural framework of the sacristy and the vestibule of the Library of San Lorenzo acknowledge the architectural poetry of his sculptural technique.

Above: A detail of the face of Moses on the over-life-size marble sculpture of the biblical prophet, created by Michelangelo for the tomb of Pope Julius II.
Left: The Galleria dell'Accademia in Florence preserves Michelangelo's giant sculpture of David, originally positioned outside the Palazzo della Signoria, and the unfinished slaves planned for the tomb of Pope Julius II.

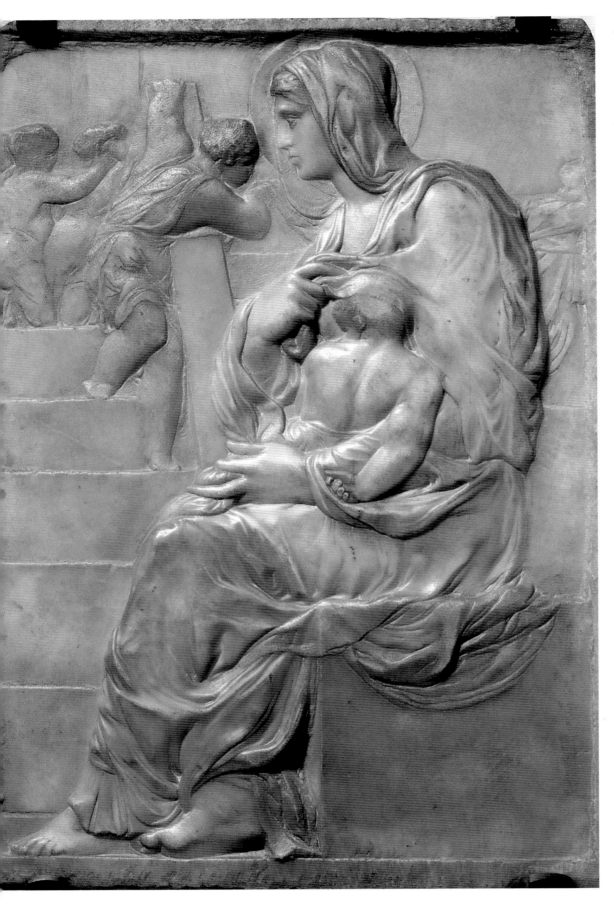

Madonna of the Stairs
(*Madonna della Scala*),
1489–92, marble, Casa
Buonarroti, Florence, Italy,
57.1 x 40.5cm (22.5 x 16in)

The marble relief *Madonna of the Stairs* was created from a piece of creamy-yellow marble. The *rilievo schiacciato* (flattened or squashed) low-relief technique, which follows the style of Donatello, creates a visual impression of depth. The Madonna is seated to the right on a rectangular base. She holds the infant Christ on her lap and close to her body. In left profile, she looks beyond a series of steps, where infants play. One child, midway on the stair, reaches out to clutch the end of a winding cloth, a reference to the Passion of Christ. The other end of the cloth is held by another child, behind the Madonna's head. The image of the cloth represents the bond between mother and child. The Madonna lifts the mantle of her drapery to allow her infant to suckle her breast. The infant Christ nestles into his mother's body with his right arm behind his back. This is one of Michelangelo's earliest works in marble. It was first mentioned in Giorgio Vasari's 1568 edition of *Lives*. The relief remained in Michelangelo's own collection until his death.

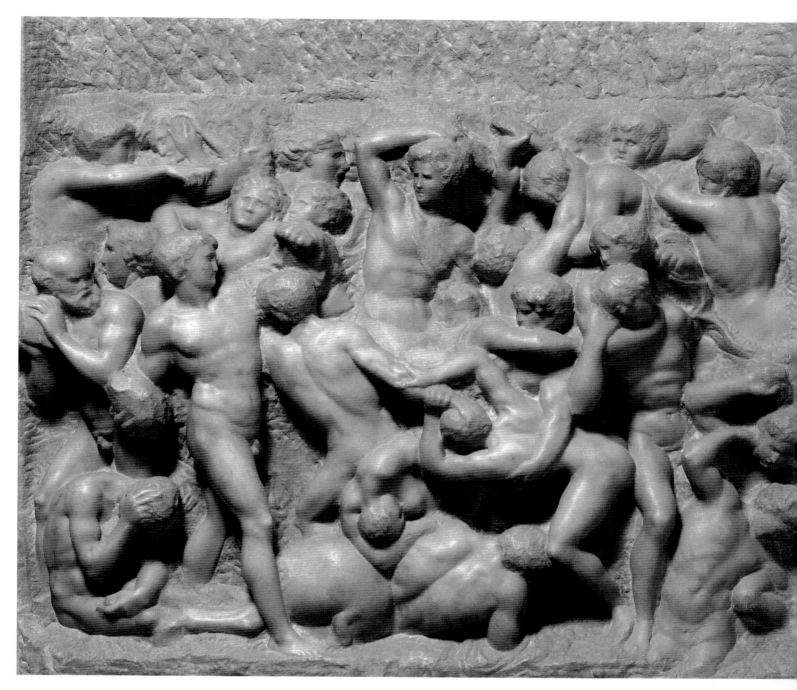

Battle of the Lapiths and Centaurs, 1490–2, marble, Casa Buonarroti, Florence, Italy, 80 x 90.5cm (31.5 x 35.6in)

The narrative of this unfinished marble relief focuses on an episode from the Greek and Roman myth of the war between Centaurs and Lapiths, related in texts by Homer and Ovid. The naked Centaurs and Lapiths are depicted in the thick of battle, where their writhing bodies twist and turn, expressing intense passion and anguish without visibly committing any act of violence. The bodies writhe as they fight for control. Michelangelo has created in miniature a scene of mayhem; a Neo-Platonic interpretation of the material and spiritual battle of the soul. At the centre of the marble relief a twisting figure with right arm raised is a forerunner of the central figure of Christ in the *Last Judgement*.

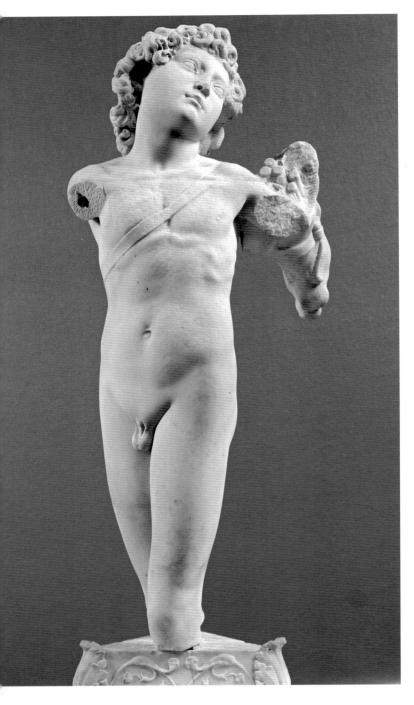

The 'Manhattan' Cupid, c.1494–6, marble, Musée du Louvre, Paris, France, 80.5 x 88cm (31.7 x 34.6in)

Little is known about the early provenance of this marble statuette, which depicts the Roman boy-god of love, Cupid. It is considered to have been part of a collection of marble statuary in Villa Borghese – known then as Casino Borghese – collection in Rome, in 1650. It is listed in a guidebook, written by Jacomo Manilli, who places it in the Borghese private garden. At that time it had legs and feet (now broken off at the knees) and arms (now lost), a quiver of arrows, and was 'leaning' on a marble vase (now lost), which supported the statue.

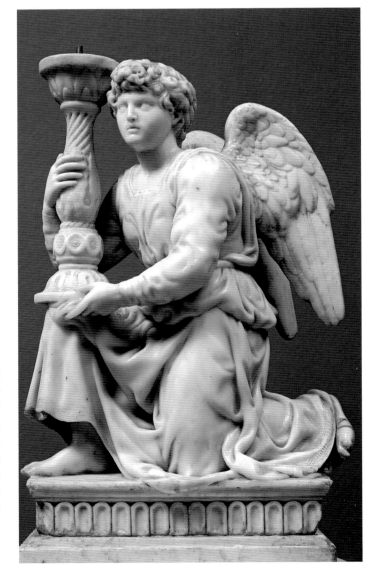

Kneeling Angel Holding a Candelabrum, 1494–5, marble, tomb of St Dominic, Cathedral of San Domenico, Bologna, Italy, 51.5cm (20.3in)

The marble statuette of the *Kneeling Angel Holding a Candelabrum* is placed on the lower level of the tomb of St Dominic. It is a companion piece to the earlier marble *Angel* by Niccolò d'Arca. The winged angel kneels on its left knee, resting a tall and elaborately carved candle-holder on the right knee. The fluid draperies of the angel's clothing reveal the outline of the body beneath the clothing.

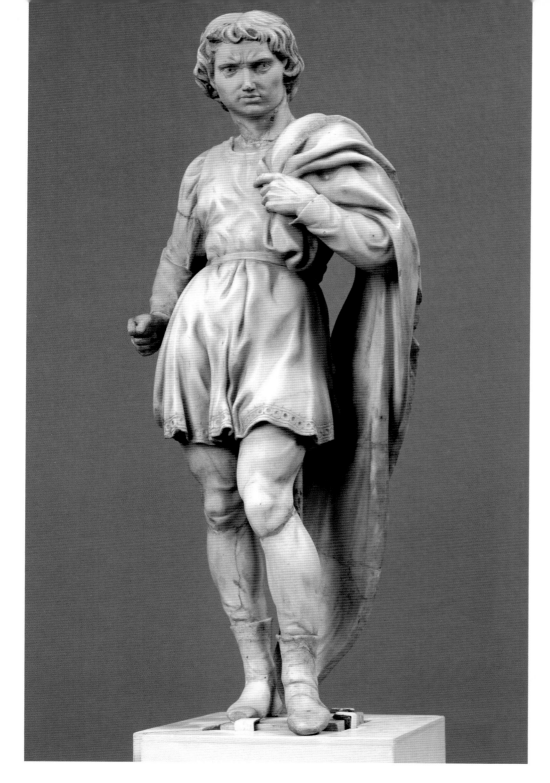

St Proclus, from the Arca di San Domenico, 1494–5, marble, tomb of St Dominic, Cathedral of San Domenico, Bologna, Italy, 64cm (25.2in)

The marble figure is of *St Proclus* (d. AD446–7), a patron saint of the city of Bologna. It is situated on the tomb of St Dominic in the cathedral of San Domenico, Bologna. The figure, in a *contrapposto* position (with the weight on one foot), strides forward. With his left hand he holds on to a long cloak thrown over his left shoulder. His right hand is clenched to hold a metal lance (now lost).

St Proclus, detail of face and head

This possible self-portrait of a young Michelangelo as St Proclus depicts an earnest face with furrowed forehead, piercing eyes and determined expression, similar to that of the colossal *David,* 1501–4, and *Moses* 1513–16. *St Proclus* is one of three marble figures created for the shrine (the others are the figure of an angel and St Petronius). Proclus was a Roman military leader and a Christian, subsequently martyred for his actions.

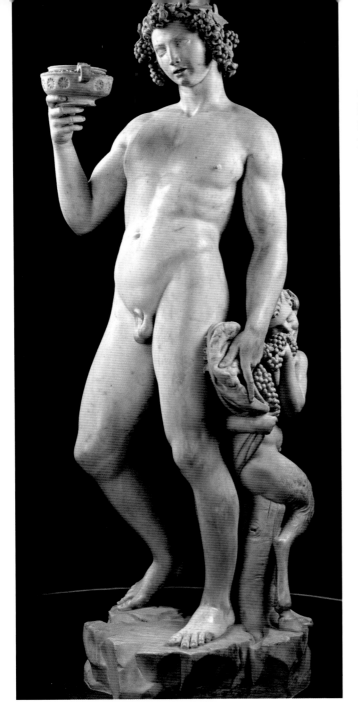

Bacchus, 1496–7, marble, Museo Nazionale del Bargello, Florence, Italy, 203cm (80in)

Bacchus is a superb masterpiece by Michelangelo. The ancient Roman god Bacchus (Dionysus in Greek mythology) was the son of Zeus and Semele. He is the god of wine and the cult of the Bacchanalia, a frenzy of dancing, drinking and debauchery. Michelangelo depicts a full-size Bacchus naked, standing in the *contrapposto* position. In his right hand he holds a wine cup. He is accompanied by a small satyr that stands to his rear left. Bacchus stares ahead with his mouth open, about to drink from the wine cup he holds. His head is wreathed with small bunches of grapes interwoven with vine leaves. Condivi considered the expression on the face of Bacchus to be that of drunkenness. The open mouth and vacant eyes perhaps show the god's state of inebriation. The eyebrows are raised and the eyes look up and toward the right. They would seem to be unfocused, perhaps, as Condivi says, 'wandering and wanton'.

Bacchus, detail of satyr

In ancient Roman mythology a satyr (half-human, half-goat) is a lustful woodland creature with goat-like ears, small horns, legs and a tail. The statue cleverly disguises the inner support for the figure of Bacchus. The satyr firmly clutches the tiger skin in his right hand while eating from a large bunch of grapes held in his left hand.

The pert smiling face of the young satyr draws attention to him. He hides behind Bacchus and peers out with laughing eyes toward the viewer. Is he delirious? Is he feasting with Bacchus? Is his pose one of sexual provocation? The large bunch of ripe grapes that he holds in his left hand symbolize his association with the god of wine and wanton Bacchanalian revelry.

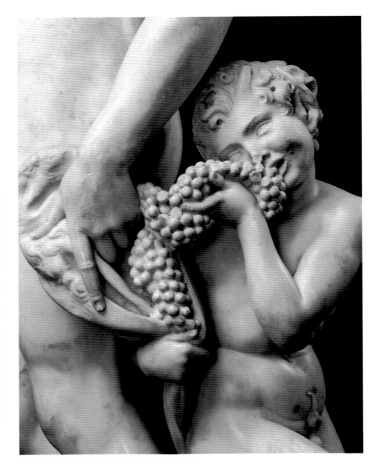

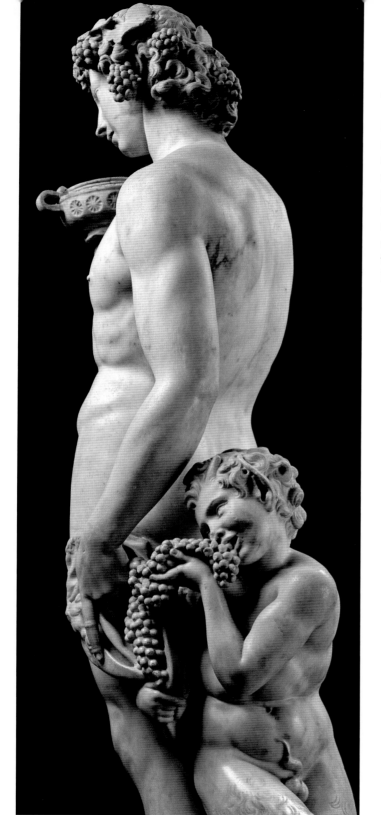

Bacchus, rear view

Michelangelo has carefully sculpted a small satyr to accompany the figure of Bacchus. The satyr positioned to the side of Bacchus, to the left, encourages the viewer to circle the statue in order to see the angle of Bacchus's head, which dips forward. Bacchus has a youthful body with solid, muscular shoulders and a strong back. The piece was commissioned by Cardinal Raffaele Riario in Rome in 1496, to complement his collection of antiquities. It is possible that Michelangelo based the Bacchus figure on an antique sculpture owned by the Cardinal.

Bacchus, detail of the tiger's head and satyr's foot

The Roman god Bacchus was often portrayed wearing a tiger's or panther's skin on his body. Here, Michelangelo drapes the animal skin between Bacchus and the satyr, with the animal's head resting at the cloven feet of the satyr.

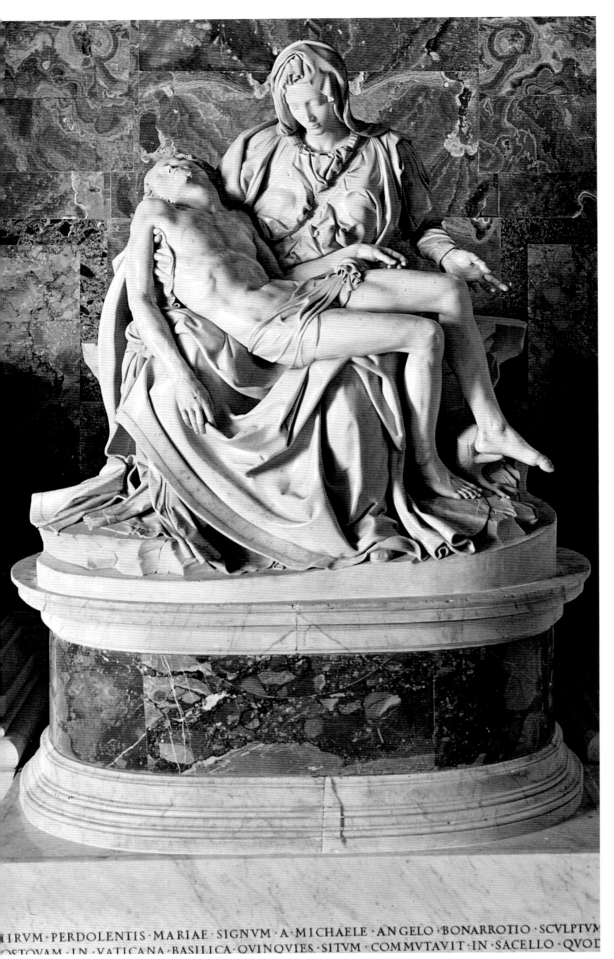

Pietà, 1499, marble, The Basilica of St Peter, Vatican, Rome, Italy, 174 x 195cm (68.5 x 76.8in)

The *Pietà* is Michelangelo's second masterpiece, commissioned by Cardinal Jean Bilhère de Lagraulas, French ambassador of King Charles VIII at the papal court in Rome. Michelangelo was asked to make a life-size marble Pietà, depicting the Virgin holding the naked dead Christ in her arms. The highly polished figure group was carved from a single block of marble and intended for the Cardinal's tomb. Michelangelo has supremely captured a moment of contemplation and sadness. The limp upper body of Christ rests across his mother's lap. His head rests on her right arm. The weight of his body is depicted in the tension that is evident in the Virgin's right hand and fingers. The lifeless right hand of the figure of Christ bears the mark of the penetration of the nail that held his body to the crucifix. The veins are raised. Between his fingers the drapery of the Virgin's gown is enclosed. Christ's right foot rests on the Virgin's gown. It bears the marks of the nail, which has been hammered into the foot for the crucifixion. The left foot hangs in mid-air and between the feet is a severed tree stump, a symbol perhaps of a life cut short. Michelangelo's depiction of Christ reflects not only the corporeal body of the son of God but the immortal beauty of his soul – a Neo-Platonic interpretation.

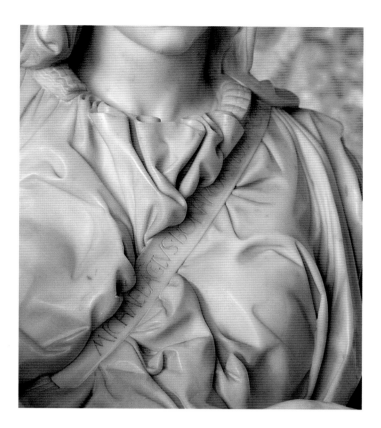

Pietà, detail of Michelangelo's name

The thin sash that is displayed diagonally across and on top of the Virgin's clothing has the wording in Latin 'MICHELANGELUS BUONARROTUS FIORENTINUS FACIEBAT' (Michelangelo Buonarroti, Florentine, made this). Vasari explains that the reason Michelangelo clearly signed the piece in this way was to make sure that others recognized it as his work. Apparently Michelangelo had overheard visitors looking at the sculpture referring to it as the work of another sculptor.

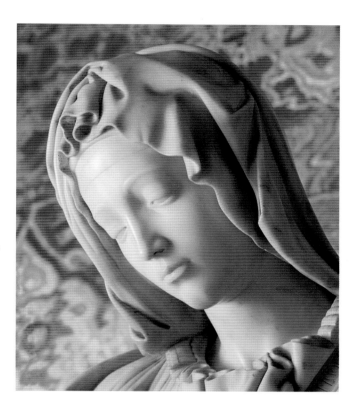

Pietà, detail of head of Madonna

The beauty of the Virgin is evident in her unlined face. She looks down in silent contemplation at her dead son. Critics of the piece focused on the youthfulness of her features. Michelangelo snubbed the criticism, referring to her beauty as virginal and a reflection of the purity of her soul, not her material body. The Virgin is with her son at his final hour, a pictorial symbol of a mother's continuing love.

Pietà, detail of Christ's head and upper body

The face and head of Christ depict the human image of the son of God. The muscular right arm of the figure of Christ hangs limply, and has fallen to his side. The ribcage and chest sag; the last breath of his human life has been expelled from his body. He rests in his mother's arms, her left hand open-palmed in a gesture of disbelief. The face of the dead Christ is in repose, as if in quiet slumber. He is at peace. His features are relaxed and his expression serene. His eyes are closed. His hair frames his handsome face. Condivi records that Michelangelo wanted the figure of Christ to reflect his humanity and the physicality of his human body, as an ordinary man, living on Earth as the son of God.

The Piccolomini Altar, 1501–4, marble, Siena Cathedral, Siena, Italy

The Piccolomini altar, created in 1481–3 by the sculptor Andrea Bregno (1418– 503), is in Siena cathedral. It was commissioned by Francesco Piccolomini (1409–1503), who briefly acted as Pope Pius III (September–October 1503). The commission included 16 sculptures. Michelangelo originally intended to create more than the four figures attributed to him (Saints Peter, Paul, Pius and Gregory). Money owed to the Piccolomini family for non-completion of the contract was repaid to them after Michelangelo's death.

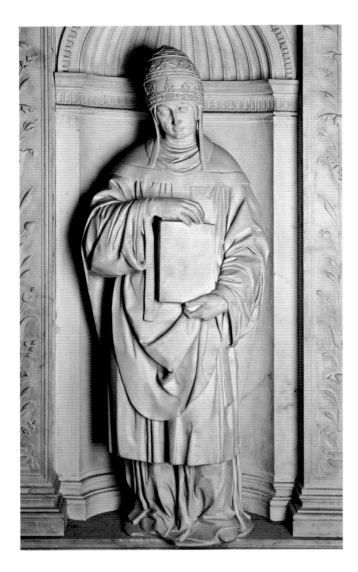

Piccolomini Altar, detail: *St Gregory*

St Gregory (c.AD540–604), also known as Pope St Gregory I, and Gregory the Great, was Pope from AD590 until his death. He is one of the Latin Fathers of the Church. He is noted for his writings, including *Dialogues* and *Letters*. Michelangelo depicts the figure of St Gregory holding a book supported with both hands.

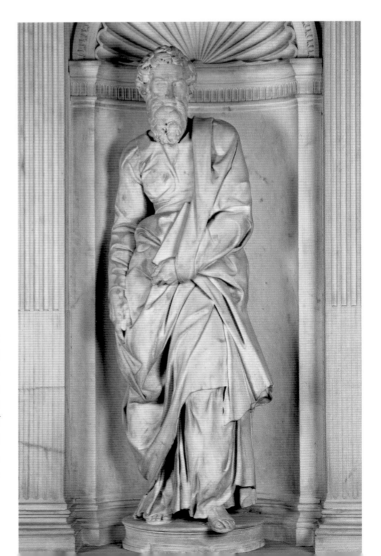

Piccolomini Altar, detail: *St Paul*

Michelangelo depicts a heavily bearded St Paul, an Apostle of Christ. He stands with his left foot forward, resting on a plinth. In his left hand he holds a book, wrapped in the folds of his cloak, his right arm to his side. He stares out toward the left of his vision. The stance of the figure bears a resemblance to the niche statues of Orsanmichele in Florence by renowned sculptors, including Donatello.

Piccolomini Altar, detail: *St Peter*

St Peter (died c. AD64) was the chief Apostle of Christ and the first Pope of the Christian Church. Peter is depicted with a short beard. He looks down toward his left. His expression is one of calm and serenity. In his right hand he holds the folds of his cloak; in his left hand he holds a book. This figure was retouched by Michelangelo after the sculpture was made by his assistant.

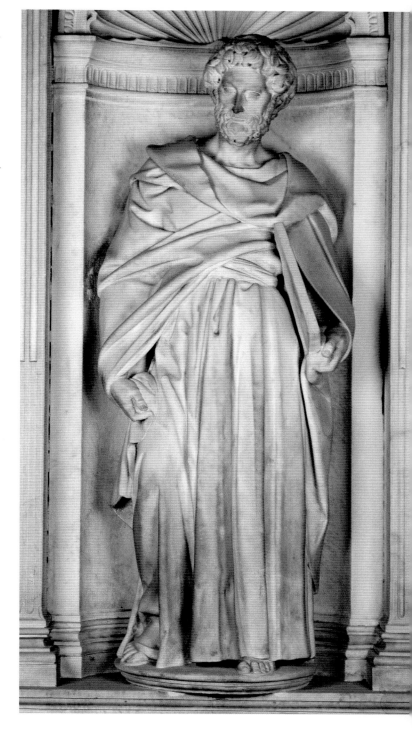

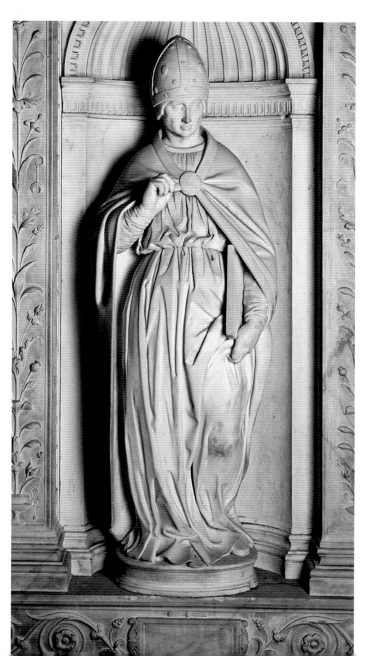

Piccolomini Altar, detail: *St Pius I*

Like St Gregory, St Pius I is an ecclesiastical saint. Counting St Peter as the first Pope, St Pius was the tenth (c.AD142–c.155). He is depicted in the *contrapposto* position. This statue (as well as the sculptures of St Gregory and St Paul) was designed by Michelangelo, but the work was carried out by Baccio da Montelupo.

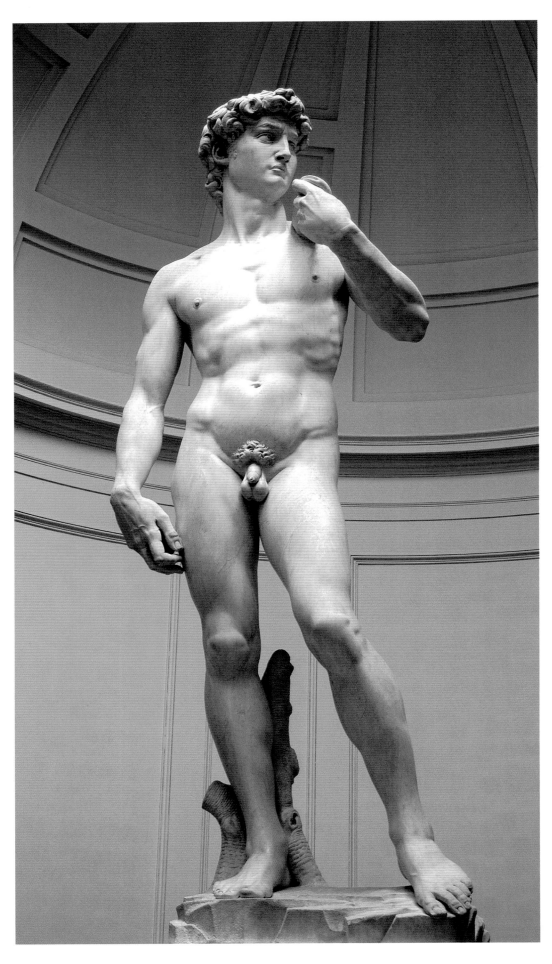

David, 1501–4, marble, Galleria dell'Accademia, Florence, Italy, 5.17m (17ft)

The marble sculpture of *David* depicts the young shepherd as he stands naked in preparation for battle with Goliath, who, we are told in the Bible, wears heavy brass armour. His left hand holds the slingshot, and his right hand holds the stone that will kill Goliath. Unlike traditional depictions of David, triumphant after his victory, Michelangelo chooses to portray him before the battle. The young man stands silent, naked, in preparation for one-to-one combat. He chooses not to wear the armour of the Israelites and clothes himself only with the divine protection of God. His face is turned in profile to the left, to view his adversary.

Study for *David* and various studies, pen and ink on paper, 1503–4, Musée du Louvre, Paris, France

By 1503, Michelangelo's sculpture of the figure of *David* for the city of Florence was placed outside the Palazzo della Signoria (now the Palazzo Vecchio). However, as his superb talent gained in recognition, he was approached to create other sculptures of David. Sketches like these of various figures, including David, illustrate how the sculptor worked toward his final designs.

Study for *David*, c.1501–4, pen and ink on paper, Musée du Louvre, Paris, France

The sketch includes a naked figure, probably a sketch for David, and a detail of an arm. The Bible narrative of the war between the Philistines and Israel includes the story of David and Goliath (1 Samuel 17: 55–58).

It describes the young shepherd boy David volunteering to fight the armoured warrior Goliath of the Philistines. David removes his clothes and prepares for combat, armed only with stones and a slingshot. Michelangelo depicts the young shepherd at the moment before his triumphant battle.

Study for *David* with his Sling, 1503–4, pen and ink on paper, Musée du Louvre, Paris, France

In this sketch of David with his sling, Michelangelo explores the various possibilities for the pose of the young shepherd holding a sling and a stone.

The *contrapposto* position of the lower body swivels the torso to create vitality and movement in the figure. The sketch illustrates how Michelangelo posed different positions for the arms and feet, and it may relate to other planned sculptures of the figure of David.

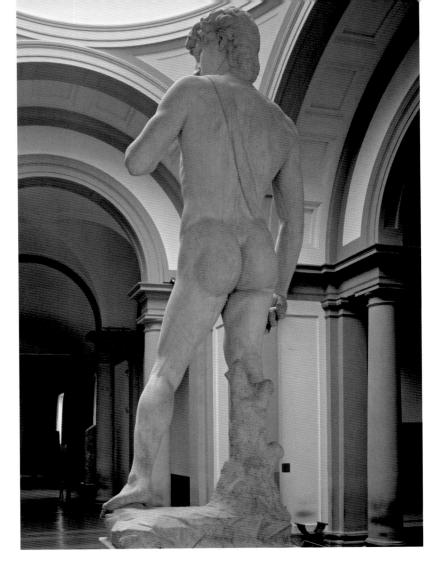

David – rear view

The muscular back of the young shepherd *David* is beautifully recorded. The strap of the slingshot falls across his back. The anatomy of the firm body reflects manual labour and youth. The colossal statue, originally placed in the Piazza della Signoria, Florence in 1504, was moved to an interior space in 1873. It now stands in the Galleria dell'Accademia in Florence.

David, detail of head from front

Michelangelo has created strong, firm facial features for David. The head of the youth is wreathed in curls, which fall to the nape of the neck. The frontal brow is furrowed and the eyes are sharply drawn and firmly focused on his adversary. The jaw line is strong and reflects the sculptures of antiquity, such as the *Apollo Belvedere*, which Michelangelo would have seen in Rome.

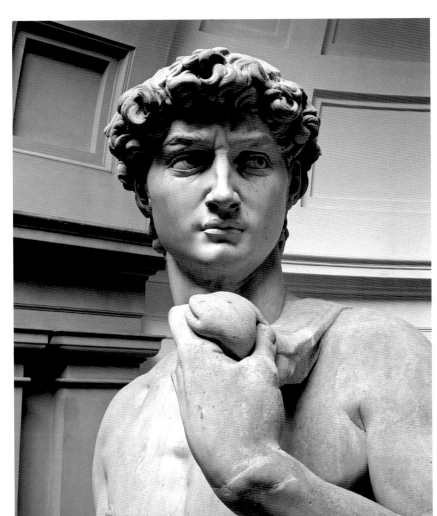

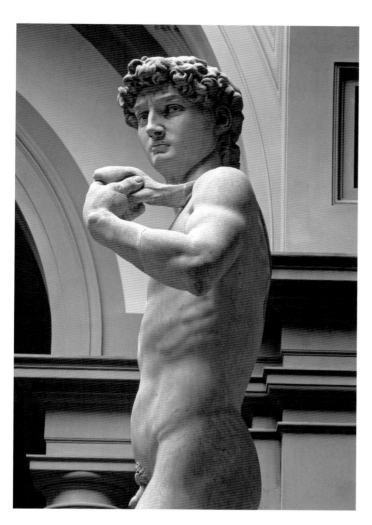

***David*, detail of side view**

The slim body profile is an example of Michelangelo's ingenuity when given the problem of an inferior piece of marble, which needed skill to work around its uneven shape. His adept use of perspective and the knowledge that the statue would be viewed from below allowed him to compensate for the irregularities in the marble. On 26 April 1527 the left arm of the statue was damaged and broken in three places by furniture thrown from a window of the Palazzo Vecchio, relating to the Medici fleeing Florence. Vasari collected the pieces. Duke Cosimo I de' Medici ordered its restoration in 1543.

***David*, view of torso, from below**

The view of the upper body of *David* highlights the taut muscles beneath the skin of the torso. The *contrapposto* stance of the hips accentuates the slim build and youthful physique of the shepherd boy. Michelangelo needed to create a narrow torso due to the shape of the marble, blocked out by a previous sculptor. Had the statue been placed above ground on the buttresses of the cathedral the problem would have not been apparent.

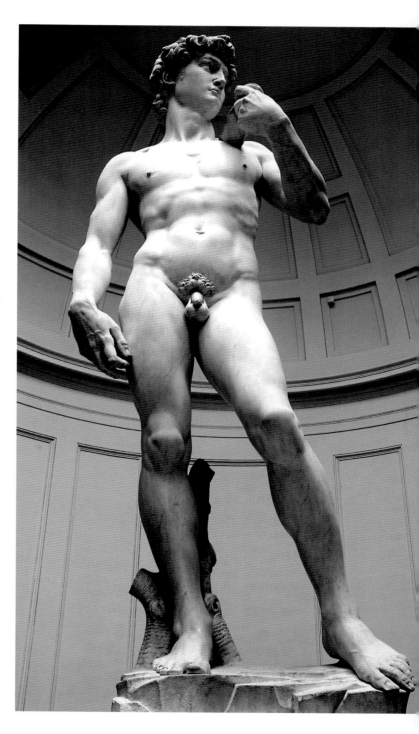

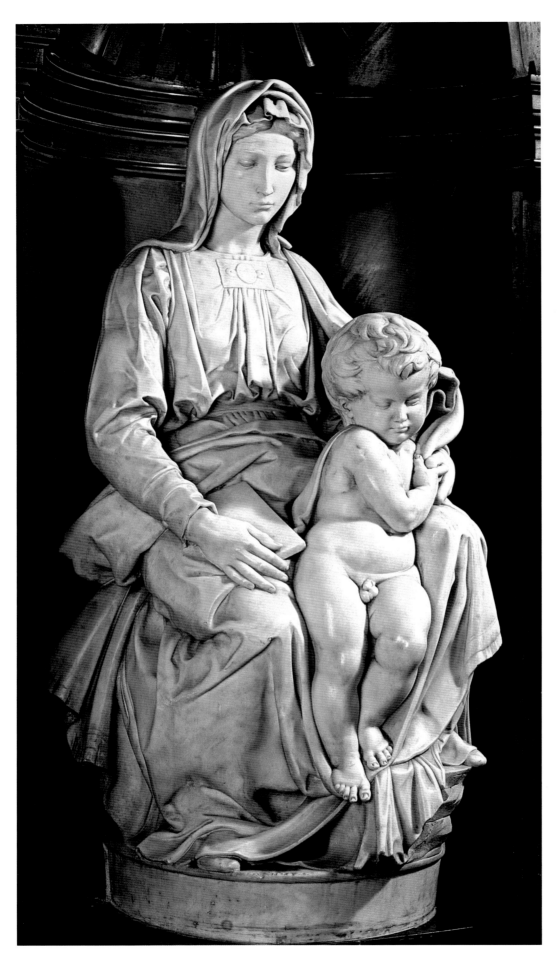

Madonna and Child
(*Bruges Madonna*), 1503–5,
marble, Notre-Dame,
Bruges, Belgium,
128cm (50in)

The freestanding marble *Madonna and Child* represents Christ's mother in draped clothing, seated with her left foot raised on a plinth. In her right hand she holds a book. Her young son leans against her, his left arm placed around her left leg. He stands naked, poised half-on, half-off the plinth. His right hand clutches her left hand for support. Both faces are in repose with eyes looking down. The hair of the Madonna is covered in drapery. Her young sweet face has a calm, sad expression. Her down-cast eyes suggest that the figure would be above eye-level. The work was commissioned by two Flemish merchants, Jean and Alexander Mouscron, for their family chapel in the Church of Notre-Dame, Bruges. It was sent to Bruges in 1506. Condivi mistakenly records it as a work in bronze.

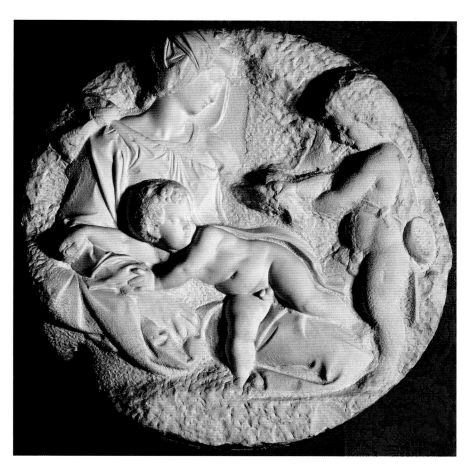

Madonna and Child with the Infant St John (Tondo Taddei), c.1503–6, marble, Royal Academy of Arts, London, UK, c.109cm (42.9in)

This unfinished circular marble sculptured relief was commissioned by the Florentine Taddei family. The sculpture depicts the seated Madonna in left profile. The naked Christ child at the centre reaches across his mother to hold her. Behind him, standing to the left, in right profile, is the infant St John, who holds out an object to give to the Madonna, possibly a goldfinch, a symbol of the human soul.

Virgin and Child with Infant St John (Tondo Pitti), 1503–6, marble, Museo Nazionale del Bargello, Florence, Italy, 85.8 x 82cm (33.5 x 32.3in)

This unfinished circular marble relief was commissioned by Bartolomeo Pitti, one of the senior patricians of Florence. Michelangelo carved the figures in high relief. He depicts the Virgin seated with her body facing to the left and her head turned toward the right. The infant Christ is naked and stands with his body resting against her knees and his right elbow on the open book in her lap. Her left hand supports his body.

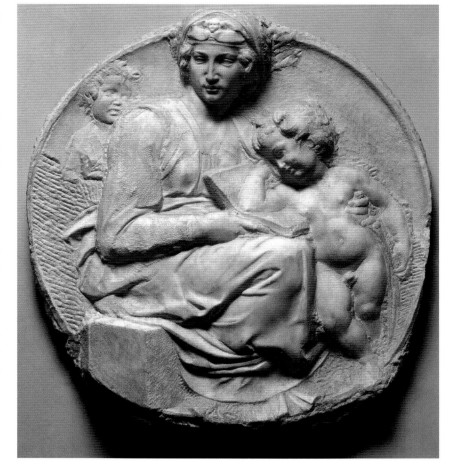

The Rebellious Slave,
c.1513–16, marble,
Musée du Louvre, Paris,
France, 209cm (82in)

The Rebellious Slave is a
counterpart to *The Dying
Slave,* both now in the
Louvre, Paris. The early
designs for the tomb of
Pope Julius II show many
more captive slave
sculptures. The number
diminished with each
contract. The two
created in 1513–16
remained but had to be
discounted in 1544,
proving too large for
the niches of the final
contract wall tomb.

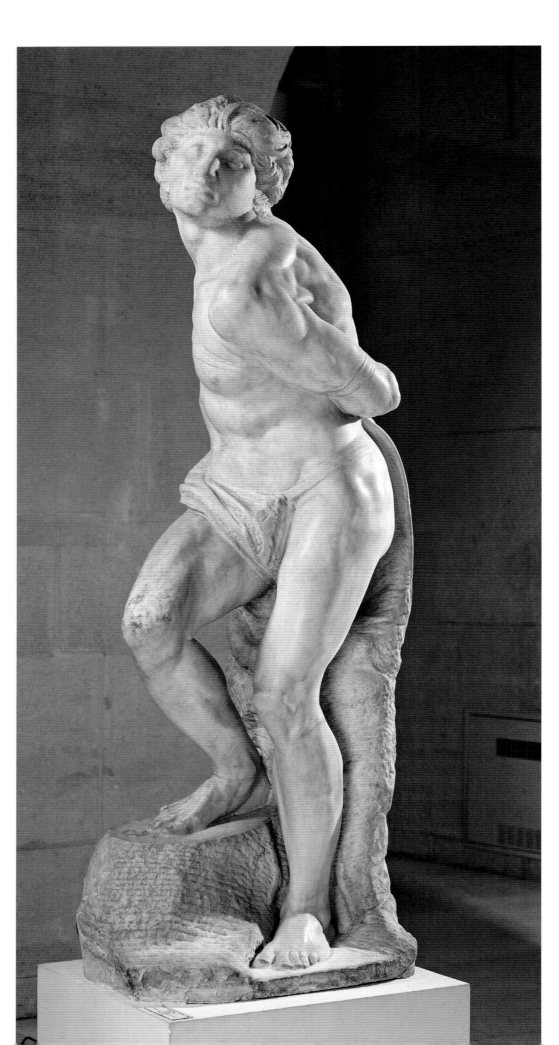

The Dying Slave, 1513–15, marble, Musée du Louvre, Paris, France, 229cm (90in)

This marble sculpture depicts a dying slave or captive prisoner. *The Dying Slave* is a symbol of the frailty of human life in its struggle against fate. The near-naked body twists and the head is thrown back, supported by the left hand. This statue and its counterpart, *The Rebellious Slave,* were carved for the Tomb of Julius II, in 1513–16. The figures were part of a group and, according to Condivi, intended to symbolize the Liberal Arts. In 1544, Michelangelo gave *The Rebellious Slave* and *The Dying Slave* to his good friend Roberto Strozzi. Michelangelo had stayed at the Strozzi palazzo as Roberto's guest, and was nursed through a serious illness. Four years after Michelangelo's death, Strozzi gifted the sculptures to Henri II, King of France. The finely sculpted fingers of *The Dying Slave* epitomize Michelangelo's gift for expressing human emotion. The fingers barely touch the body. Is it the moment of death? Is it the anxiety of awaiting death? Is it the realization of mortality? Michelangelo's attention to the details of a simple hand gesture shows the intention of the artist to bring the soul of the character to the surface.

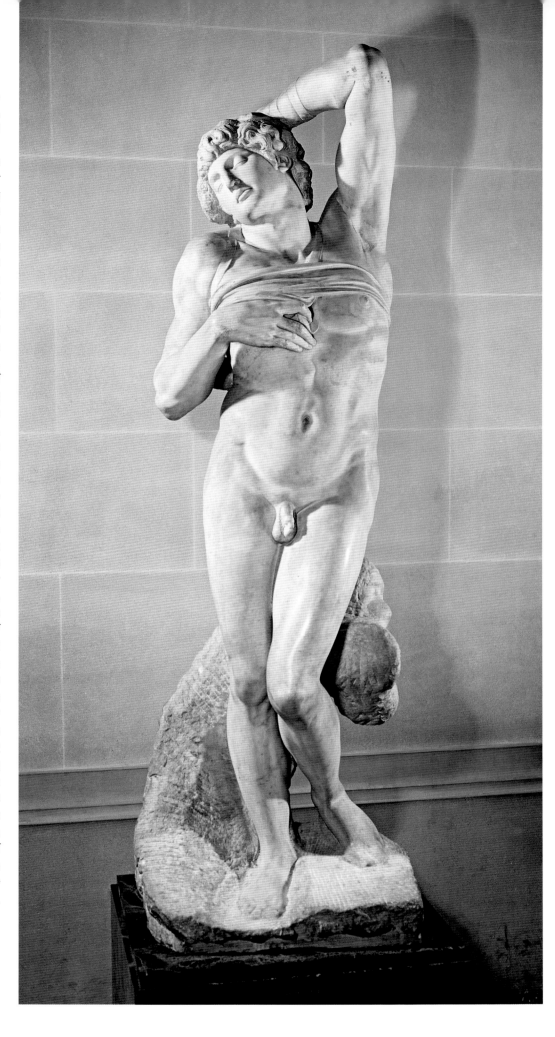

*Young Slave, c.*1520–34, marble, Galleria dell'Accademia, Florence, Italy, 256cm (100.8in)

Four over-life-size marble sculptures of 'captives', measuring 244–274cm (96–108 in), were planned for the tomb of Julius II in addition to the *Rebellious Slave* and *Dying Slave*, but remained unfinished, partially encased in the stone. They were part of the contract of 1516, which specified 22 sculptures to be produced. *The Young Slave*, part of the group, depicts the naked muscular body of a youth in the *contrapposto* pose, with his left arm covering his face, as if shielding it from the light.

*Bearded Slave, c.*1520–34, marble, Galleria dell'Accademia, Florence, Italy, 263cm (103.5in)

The bearded slave is a thick-set, muscular older man. He carries a heavy weight on his shoulders, and his head stoops toward his chest. This sculpture, one of the four that remain unfinished, was worked on by Michelangelo while he was in Florence.

Atlas Slave, c.1520–34, marble, Galleria dell'Accademia, Florence, Italy, 277cm (109in)

The mythological Atlas carries the world on his shoulders. Here the *Atlas Slave* depicts a naked male with a heavy load on his shoulders and back. The partially sculpted figure is retained in the marble block.

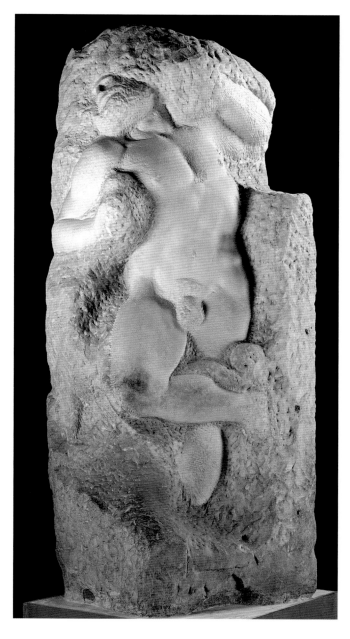

Awakening Slave, c.1520–34, marble, Galleria dell'Accademia, Florence, Italy, 267cm (105in)

The fourth unfinished captive depicts a male nude stretching up, standing with one leg crossing the other. The sculpture is only partly worked. Michelangelo worked on the sculptures in Florence during his contract for the New Sacristy in San Lorenzo.

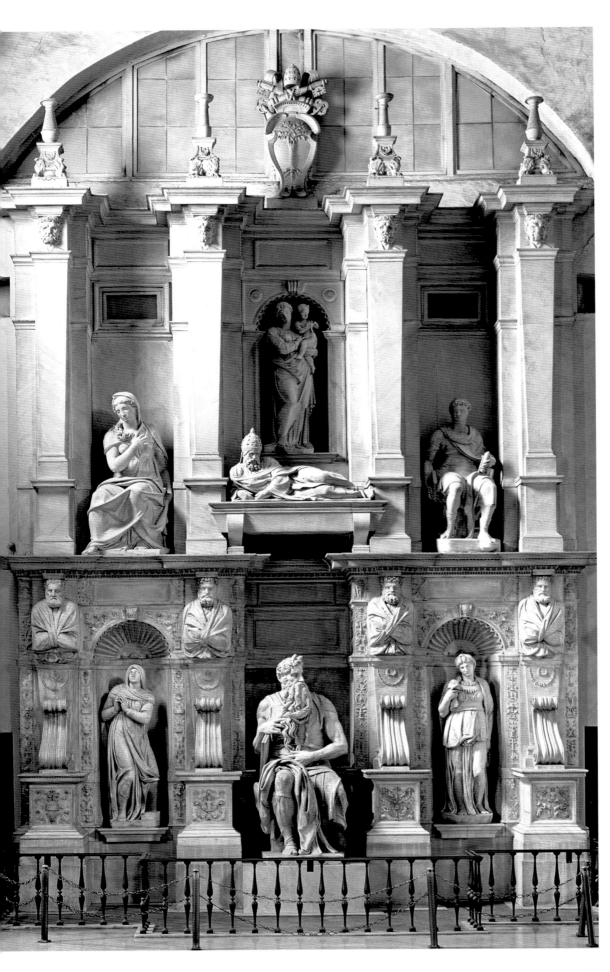

Tomb of Pope Julius II with *Moses* at centre, 1505–45, marble, San Pietro in Vincoli, Rome, Italy

The upper section of the wall tomb, created after the final contract was agreed, was to feature a figure of the Pope and below him the sculpture of *Moses*. For the lower section it had been planned to place *The Rebellious Slave* and *The Dying Slave*, but the niches proved to be too small and they were replaced with *Leah*, 'contemplative life', and *Rachel*, 'active life', made in 1542–5. *Rachel, Moses* and *Leah* complete the lower section of the wall tomb, a minor representation of the original plan for 40 life-size sculptures. The figures of Rachel and Leah are each placed in niches on either side of the main figure of Moses. The figure of Moses was planned for a different location in the original design.

Tomb of Pope Julius II, detail: *Moses*, c.1513–16, marble, 235cm (92.5in)

This remarkable sculpture portrays a strong, muscular Moses, seated, holding tablets of stone in his right hand. He sits facing forward, with the left foot placed slightly behind and the head turning toward the left. He is dressed in the antique style. His strength is illustrated in the raised veins highlighted on his arms, legs and hands. The head and face of Moses are wreathed with curls to the nape of the neck. He wears a long, heavily curled beard, which reaches down to the left hand at waist level. The eyes are piercing and stare ahead. The head is depicted with two small protruding horns, from an early Bible mistranslation of a description of his physique. The sculpture, acclaimed as a masterpiece, was hailed 'divine' by Vasari.

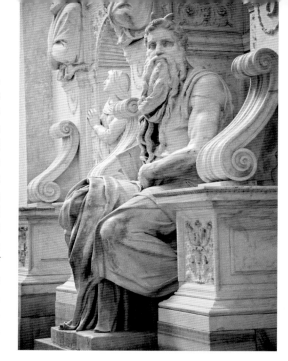

Tomb of Pope Julius II, detail: *Rachel*, c.1542–5, marble, 209cm (78in)

Rachel, the younger sister of Leah, represents 'contemplative life'. Michelangelo only refers to the sculpture by this name; it is Vasari who tells us that it is Rachel. Condivi considered it to be based on Dante's *Purgatorio*, cantos XXVII, XXVIII, and XXXIII. Michelangelo depicts Rachel with her head veiled, and face turned upward, hands clasped together in prayer. The 'contemplative' and 'active' life figures replaced the original 'captive' sculptures, which were too large for the niches.

Tomb of Pope Julius II, detail: *Leah*, c.1542–5, marble, 209cm (78in)

Two sisters, Rachel and Leah (Genesis 29:1–30), represent the 'active' and 'contemplative' life. Leah symbolizes 'active life' – the name used for the statue by Michelangelo in a letter of 20 July, 1542 to Pope Paul III. Michelangelo depicts Leah with a garland in her left hand and a mirror in her raised right hand. Condivi considered this sculpture to be modelled on Dante's description of Countess Matilda in canto XXVIII of *Purgatorio*.

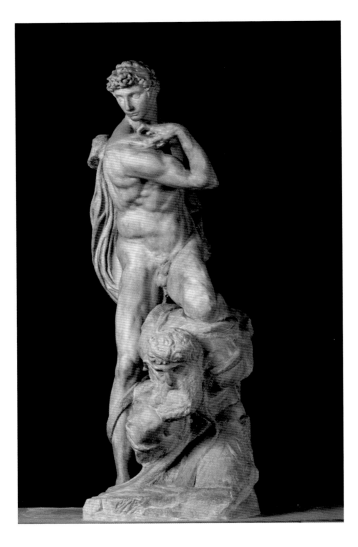

Victory, c.1520–34, marble, Salone dei Cinquecento, Palazzo Vecchio, Florence, Italy, 262cm (103in)

The two-figure *Victory* was possibly designed for the tomb of Julius II. The youth wears a wreath of oak leaves, a symbol of the della Rovere family. He stands over a crouching older man with his left knee pressed on to his back. The face of *Victory* is said to be modelled on Tommaso dei Cavalieri, a young friend of Michelangelo; the older man is a possible self-portrait of the sculptor.

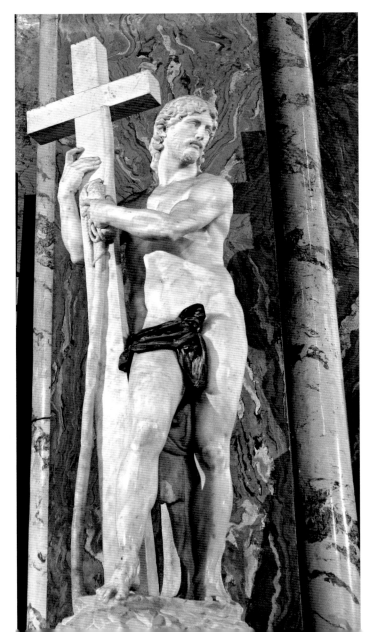

The Risen Christ, 1519–21, marble, Santa Maria sopra Minerva, Rome, Italy, 205cm (80.7in)

Commissioned in 1514, the freestanding marble sculpture was to be "a figure in marble of Christ as large as life, nude, standing, bearing a cross". Michelangelo began the sculpture in 1516, but a black vein was found in the marble and work on it was stopped. A new block of marble from Carrara replaced it. The second sculpture was completed by Michelangelo in 1521, assisted by Pietro Urbano, a pupil. A bronze 'loincloth' was later added to the sculpture.

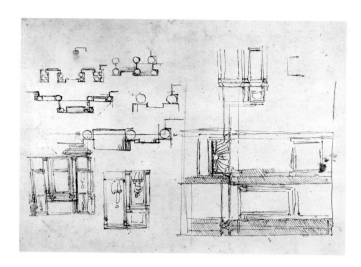

Studies for the Medici Tomb, *c.*1520, pen and ink on paper, Ashmolean Museum, University of Oxford, UK

Studies for the Medici Tomb in the New Sacristy of San Lorenzo, Florence *c.*1520, illustrate Michelangelo's thought processes. Here he considers the outer framework and inner decorative detail. However, the exterior walls of the building were in place before the final design for the tomb project showed that the interior space was too small for the memorial that he had planned.

Study for the upper level of the Medici Tomb, 1520–1, black and red chalk on paper, Ashmolean Museum, University of Oxford, UK

A study drawing for the upper level of the Medici tomb proposed for the New Sacristy in San Lorenzo, Florence. The centre and lateral tabernacles are evident, placed in an architectural framework. The commission of Cardinal Giuliano de' Medici, later to become Pope Clement VII, was for a memorial to four Medici and himself, but the space for it proved to be too small. The final decision was to place two tombs in the New Sacristy.

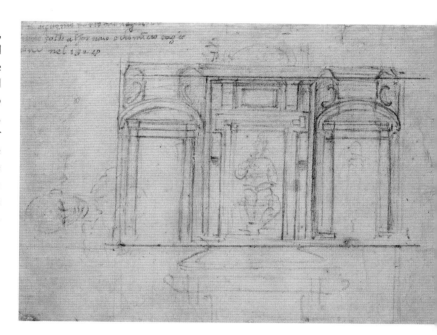

Study for the Magnifici double tomb, *c.*1520–1, dark brown ink on paper, British Museum, London, UK, 20.7 x 16.1cm (8 x 6.3in)

This is a study for the double tomb of Medici 'Magnifici' Lorenzo (d.1492) and his murdered brother, Giuliano (d.1478), in the New Sacristy. It illustrates a standing figure in each upper lateral section and a central figure drawn standing and seated. The drawing includes a statement from Michelangelo in Italian which translates as: *'Fame holds the epitaphs in position; it goes neither forward nor backward for they are dead and their work is still.'*

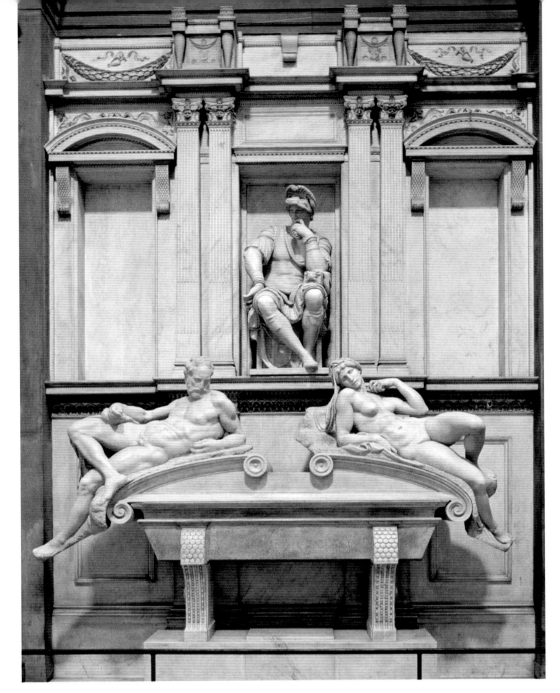

Tomb of Lorenzo de' Medici, Duke of Urbino, with *Dawn* and *Dusk*, 1520–34, marble, New Sacristy of San Lorenzo, Florence, Italy

The marble wall tomb of Lorenzo de' Medici, Duke of Urbino and the nephew of Pope Leo X, mirrors that of Giuliano, Duke of Nemours. The seated figure of Lorenzo is placed in an upper niche. Below it stands his sarcophagus. Resting on top are the symbolic figures of *Dawn* and *Dusk*.

Design for the Medici chapel tombs, 1520–1, black chalk and red chalk on paper, British Museum, London, UK, 21.9 x 20.8cm (8.6 x 8.2in)

The page illustrates Michelangelo's variations for the design of the ducal tombs planned for the New Sacristy. The design to the left illustrates the height of the sarcophagus at the centre. It creates a long sloping surface for the figures which are placed on either side. Two further sculptures are in place at the corners of the tomb structure. This design was not realized.

To the right above, a design for a sarcophagus includes niches in the architectural composition.

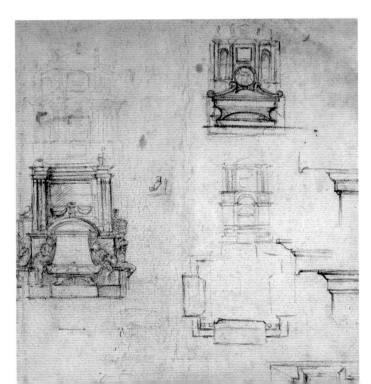

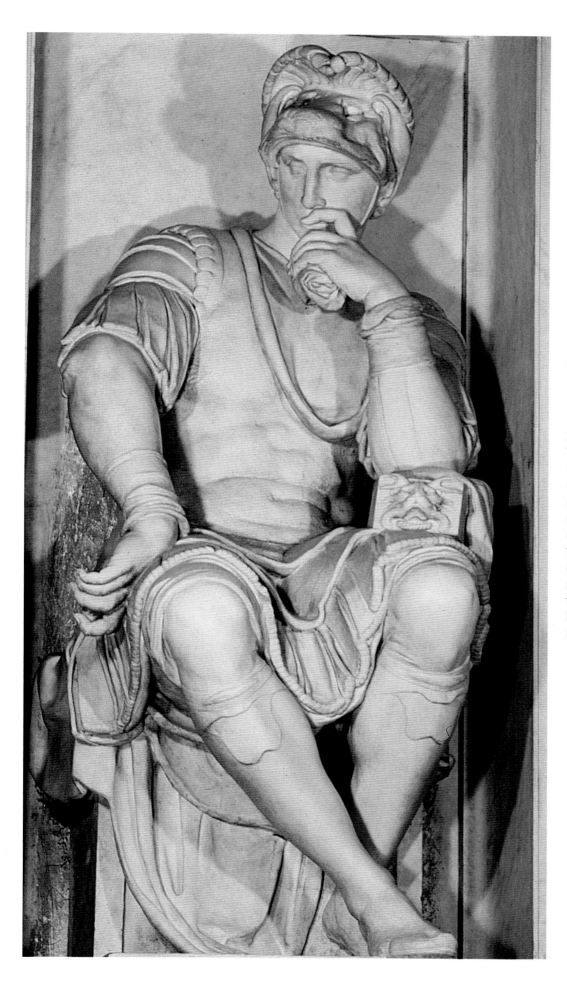

Tomb of Lorenzo de' Medici, Duke of Urbino, detail of *Lorenzo de' Medici*

The seated figure of Lorenzo de' Medici wears the symbolic regalia of a leader of the ancient Roman army. He sits in contemplation with one hand raised to his face. The sculptures of Lorenzo and Guiliano were idealized. This puzzled many who visited the chapel, expecting to see life-like depictions. In a letter dated 28 July 1544, one spectator, Niccolò Martelli, wrote to Michelangelo, asking why the sculptures bore little resemblance to Lorenzo and Giuliano. Michelangelo responded that in 1000 years it would not matter if they were a true likeness or not. Michelangelo's drawings of living people were accurate, and historians do see a likeness to Lorenzo and Guiliano, when compared to portraits of them when alive, but the overriding purpose for the sculptor was to create 'heroic' portrayals, linking the Medici to their Roman heritage.

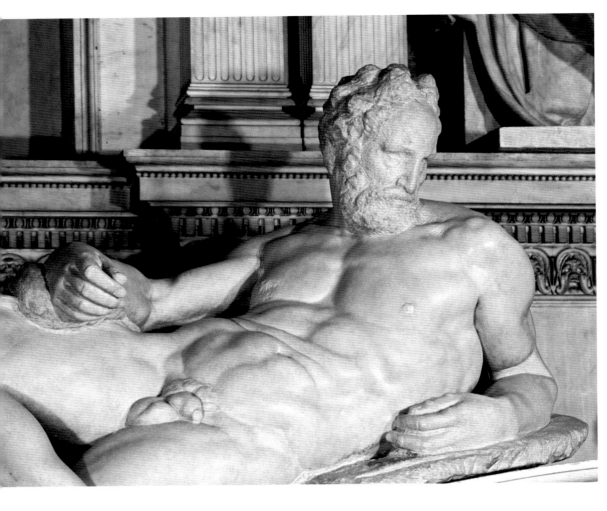

Tomb of Lorenzo de' Medici, Duke of Urbino, detail of head of *Dusk*

The head of *Dusk* remained unfinished when Michelangelo left Florence in 1534 to work in Rome. He did not return. The head of *Dusk* turns slowly across his muscular body. One can see similarities in *Dusk* and *Day* with the antique sculpture of the marble *Torso Belvedere* created by the Athenian sculptor Apollonius, 1st century BC, that was on display in the Vatican collection in Rome.

Tomb of Lorenzo de' Medici, Duke of Urbino, detail of *Dawn*

The female figure of *Dawn*, resting on the rounded lid of the sarcophagus, lies to the right of the broken pediment decoration. The naked figure lies back with the left leg hanging over the end of the sarcophagus and the right knee raised to balance her weight. She rests on her right elbow with her left arm raised toward her face. Like the other statues on the tomb, she has a muscular body.

Study for *Dusk*, pencil on paper, 1520–33, Ashmolean Museum, University of Oxford, UK

The preparatory sketch indicates how the four figures for the sarcophagi were planned in advance. The drawing shows a life model, in the pose of *Dusk,* lying on a sloping trolley.

Tomb of Lorenzo de' Medici, Duke of Urbino, detail of ornamental decoration, 1520–34

Ornamental decoration appears on the exterior sides of the marble sarcophagi of Lorenzo and Guiliano de' Medici. Michelangelo depicts a ram's skull, a rope festoon and a scallop shell. The artefacts could denote both Neo-Platonic and Christian symbolism, referring to birth, death and sacrifice.

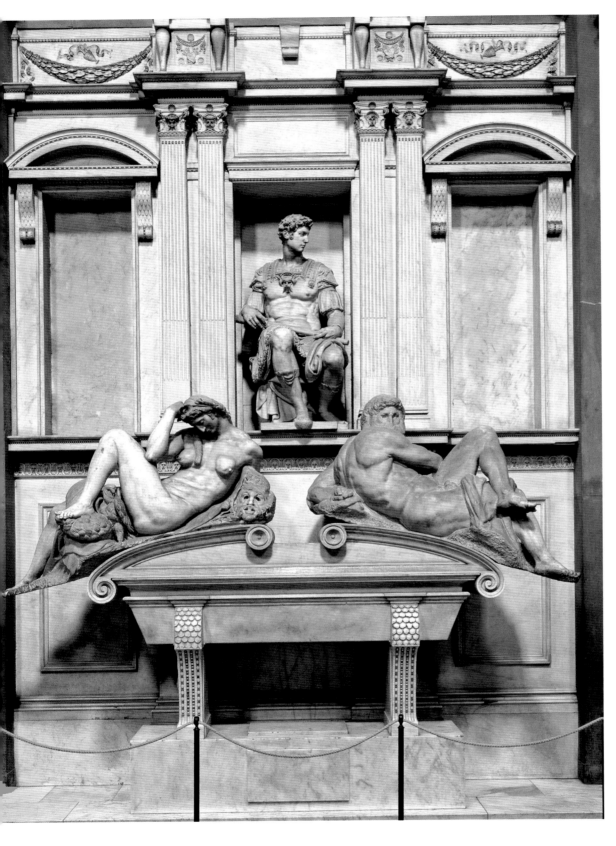

Tomb of Giuliano de' Medici with *Night* and *Day*, c.1526–32, marble, New Sacristy of San Lorenzo, Florence, Italy

The tomb of Giuliano de' Medici, Duke of Nemours, shows him seated in an upper level niche. He sits in a relaxed pose with one foot forward. He is dressed in a military breastplate of a Roman soldier of antiquity. Beneath the statue is Giuliano's sarcophagus, supporting the symbolic marble figures of *Night* and *Day*.

Tomb of Giuliano de' Medici, detail of *Night*

The female figure of *Night* lies languorously on top of the sarcophagus. Her body gleams. On her head she wears a diadem crown emblazoned with a crescent moon and a star. Her head is bowed. Her left leg is raised at the knee and its foot rests on a bound bunch of flowers. Her right leg stretches down. She is accompanied by a tragic mask and a small owl.

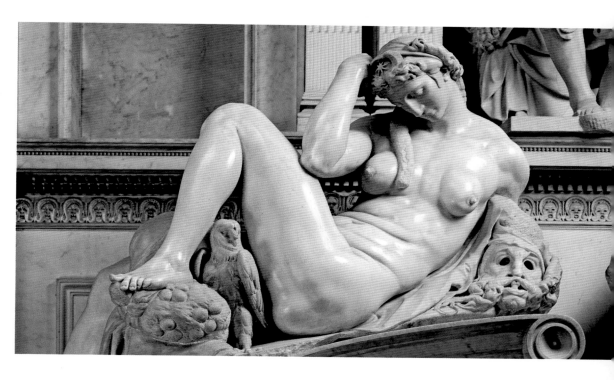

Tomb of Giuliano de' Medici, detail of the *Tragic Mask*

The tragic mask is squashed beneath the body of *Night*. It alludes to the darkness of night providing a cover for deception and vice, and the association of night with sleep and therefore death (since sleep imitates death).

Tomb of Giuliano de' Medici, detail of *Owl*

The small owl is located on the sarcophagus of Giuliano, accompanying the figure of *Night* as a symbol of her realm. His face is alert. His head swivels around to reveal a sharp beak. The feathers are clearly modelled, and he looks out at the observer.

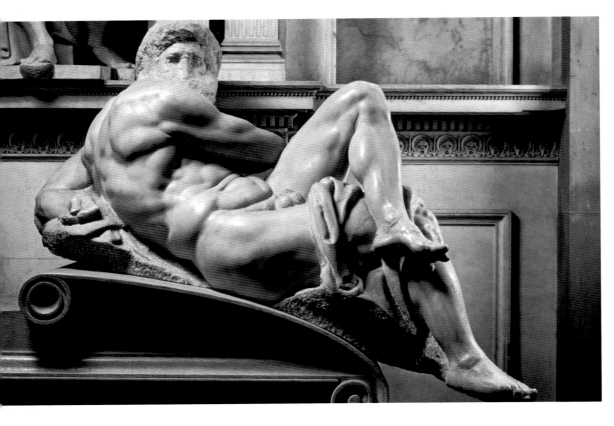

Tomb of Giuliano de' Medici, detail of *Day*

The figure of *Day* rests on top of the sarcophagus of Giuliano de' Medici. The sculpture of the heavily bearded nude male half sits up and looks around, twisting his torso, to view the onlooker. Michelangelo explained that the figures of *Day* and *Night* had symbolically taken Giuliano to his death.

Tomb of Giuliano de' Medici, detail of *Giuliano de' Medici*

The young duke is depicted as a Roman leader. He holds a baton in his right hand and a coin in his left hand, symbols of his role as a leader of a papal army. He wears a breastplate and armour. His elevated position in Florentine society is made clear through his mode of dress.

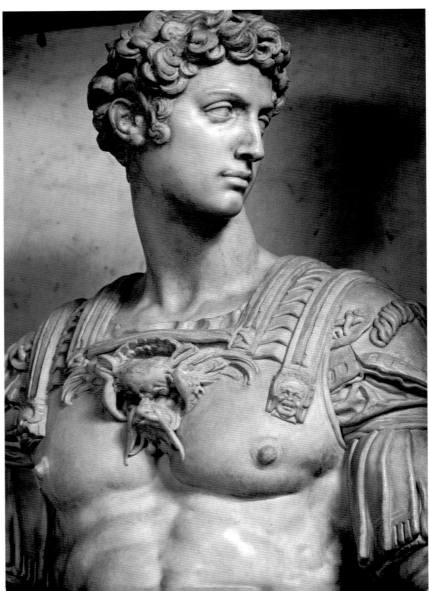

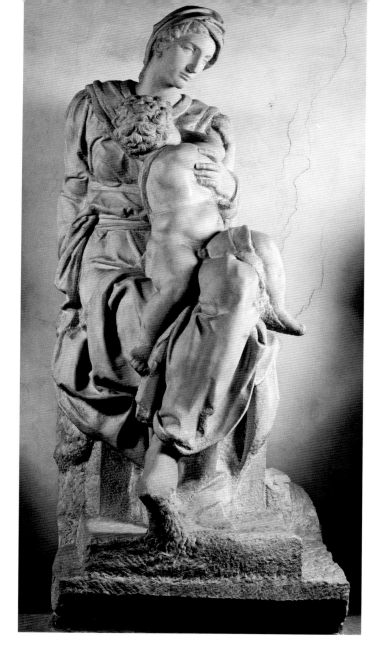

Madonna and Child (Medici Madonna), marble, New Sacristy, San Lorenzo, Florence, Italy, 229cm (90in)

The Madonna is seated. She holds the naked Christ child on her lap. He is balanced on her knee and turns his upper body around to face her, holding on to her arm. She holds on to him with her left hand. The face of the Madonna is sad and she looks away from her child, perhaps in contemplation of his fate. It was originally intended that the sculpture would be part of the Medici double tomb, which was cancelled.

The Madonna and Child flanked by Saints Cosmas and Damian, marble, New Sacristy, San Lorenzo, Florence, Italy

These sculptures were intended for the double tomb of the elder Medici, Giuliano and Lorenzo, which did not materialize due to lack of space. The figures of the younger Medici, seated in their wall tomb niches, look across to the sculpture figures, which are placed where it was planned the double tomb would be built.

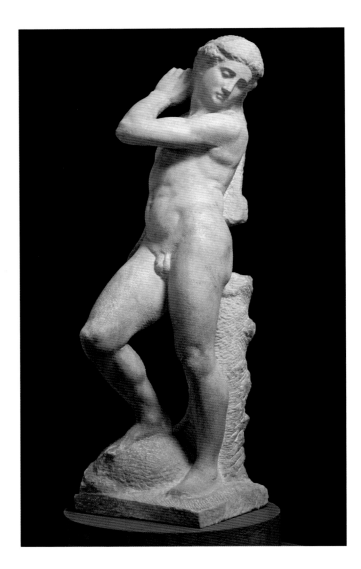

David Apollo, c.1530–2, marble, Museo Nazionale del Bargello, Florence, Italy, 146cm (58in)

This sculpture was created as an offer of appeasement to Pope Clement VII, after Michelangelo sided with the Republican fraternity of Florence against the Pope and the Medici family, during the siege of the city in August 1530. The naked *David Apollo* draws an arrow from his quiver with his left hand. The facial expression is contemplative. It is perhaps modelled on the sculptures of antiquity known to Michelangelo.

David Apollo,
side view

The bulge under the right foot was originally thought to be intended for the head of a slain Goliath. This led people to believe it was a depiction of *David*. Another view is that it is perhaps a figure of *Apollo* with either a slain python or a rock underfoot. It is difficult to ascertain, as the statue remained unfinished.

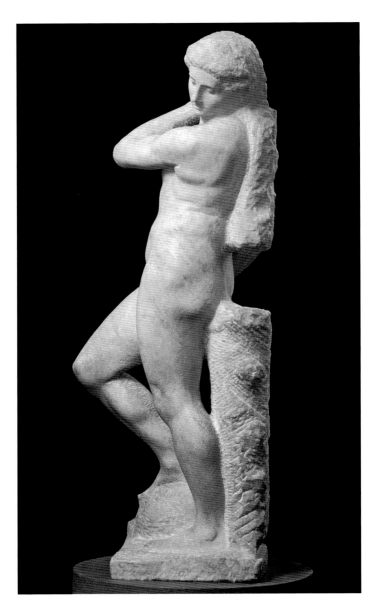

Crouching Boy, c.1530–4, marble, Hermitage Museum, St Petersburg, Russia, 54cm (22in)

It is considered that the exquisite marble figure of the *Crouching Boy* was intended for the Medici tombs in the New Sacristy at San Lorenzo. The work remained unfinished when Michelangelo left Florence in 1534. It may have been worked on by another artist.

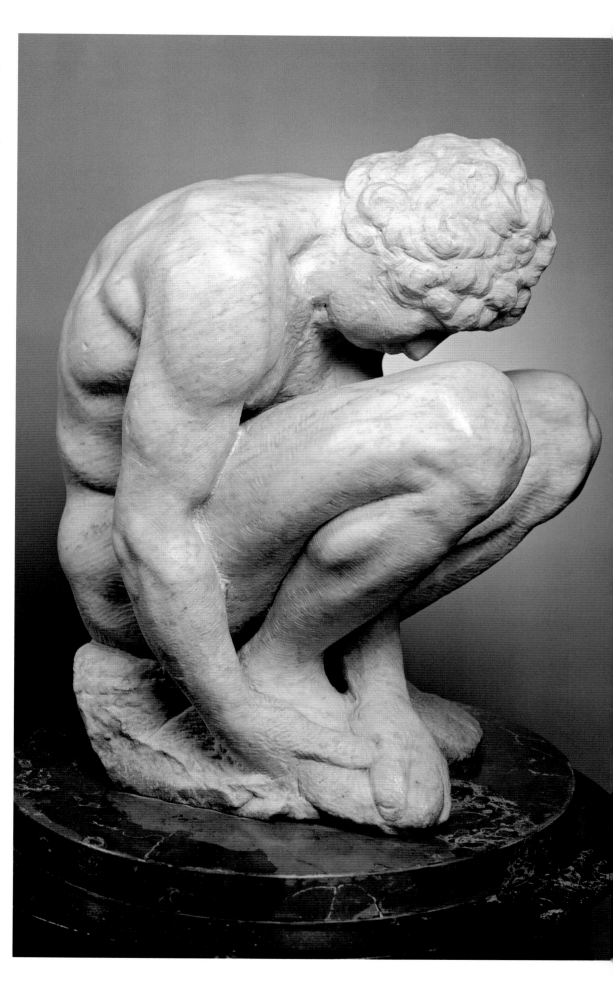

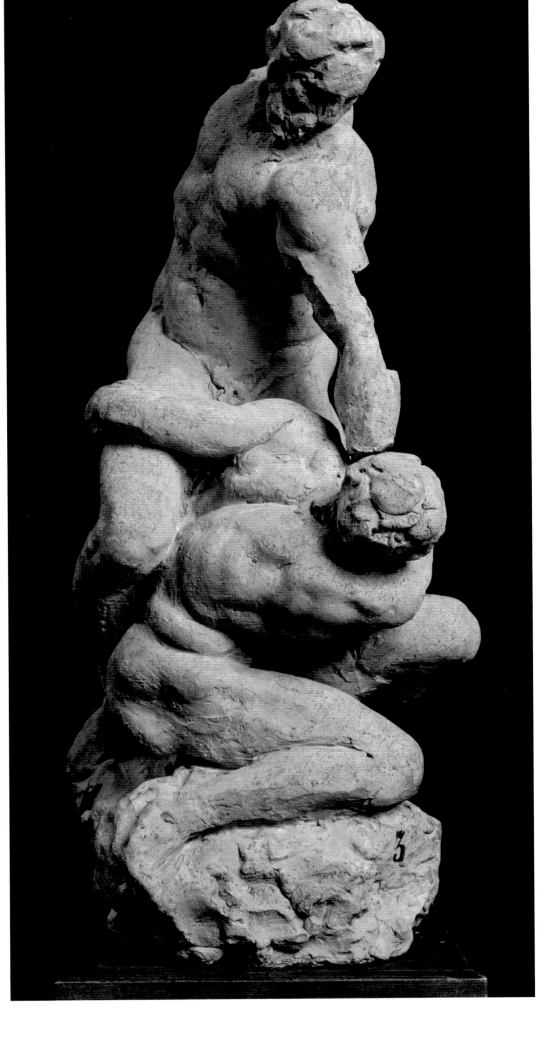

Hercules and Cacus,
c.1525–8, terracotta,
Casa Buonarroti, Florence,
Italy, 41cm (16.4in)

This small figure group in
terracotta is a depiction of
the mythological characters
Hercules and Cacus. Cacus,
a son of Vulcan, finding
Hercules asleep, steals his
cattle. When Hercules
awakes a bitter fight ensues
between the two. In Book
VIII of the *Aeneid*, Virgil
describes the scene, saying
that the force of Hercules's
body-crushing blows made
Cacus's eyes pop out.

Bust of *Brutus*, c.1540, marble, Museo Nazionale del Bargello, Florence, Italy, 74cm (30in)

The bust of *Brutus* depicts the Roman emperor Brutus (85–42BC). The portrait bust was the only one that Michelangelo ever made, and was unfinished. It was commissioned by Giovanni Fattucci on behalf of a Florentine exile in Rome, Cardinal Niccolò Ridolfi. The idealized portrait bust depicts Brutus in profile, staring ahead, looking to his left. There is a possibility that the statue was meant to represent the Florentine Republican faction, i.e. anti-Medici, which Michelangelo surreptitiously supported.

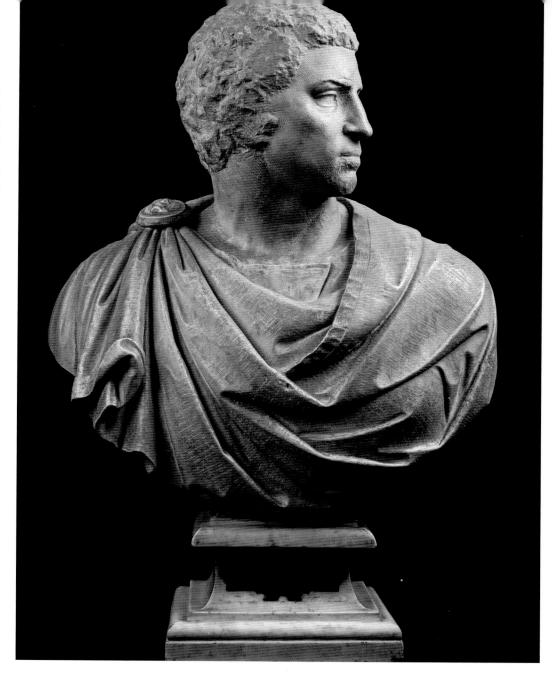

Bust of *Brutus*, detail of face

Giorgio Vasari referred to the marble bust of Brutus as a portrait inspired by classical precedent, namely an ancient cameo of Marcus Junius Brutus, a Roman political leader. Michelangelo's preparatory studies for figures for the *Last Judgement* in the Sistine Chapel include a likeness of the head of Brutus.

Florentine Pietà, c.1547–55,
marble, Museo dell'Opera
del Duomo, Florence, Italy,
226cm (89in)

This figure group, one of
Michelangelo's most
elaborate works, depicts
a Pietà (known as the
Florentine Pietà). The four
figures represent the dead
Christ; his mother the
Virgin Mary, seated; a
maidservant, kneeling; and
an upright figure of a man,
either Joseph of Arimathea
or Nicodemus. This figure
supports the body of
Christ. It is considered that
it may be a self-portrait
of Michelangelo.

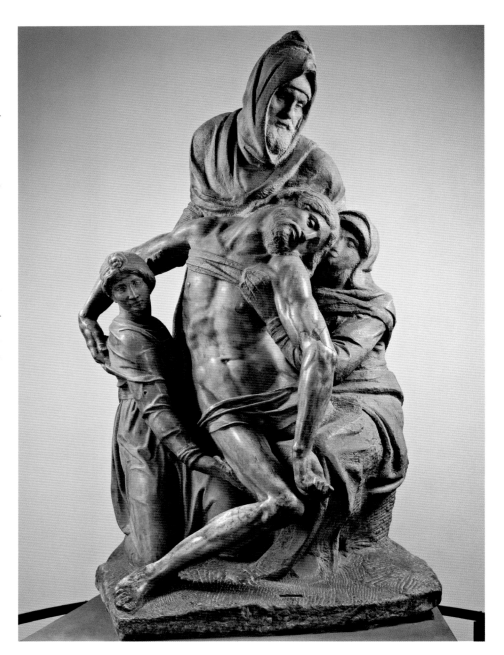

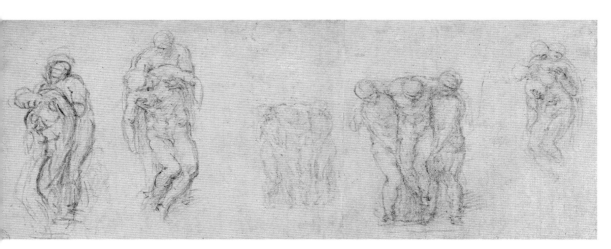

Studies for a *Pietà, c.*1540s,
black chalk on paper,
Ashmolean Museum,
University of Oxford, UK

The sheet of drawings
shows how Michelangelo
considered many different
ways to portray the Pietà.
The sketches may possibly
refer to the *Florentine Pietà*.

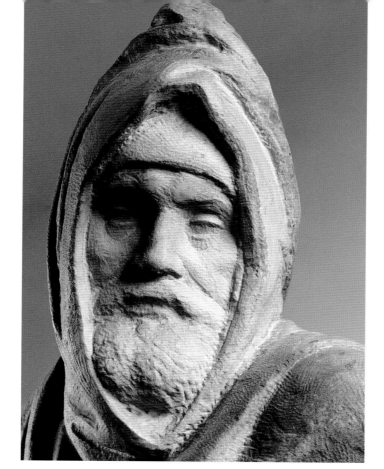

Florentine Pietà, detail: head of Nicodemus

This is possibly a self-portrait of Michelangelo as Nicodemus (or Joseph of Arimathea). The head is of an old man. The face is forlorn. The eyes look down to the Christ figure below.

Florentine Pietà, detail: head of Christ

A beautiful rendition of the head and face of the dead Christ, similar to Michelangelo's much earlier *Pietà* (1499), in St Peter's Basilica. Here, the head of Christ is tenderly supported by his mother's face. She presses her head and body into him, to support his weight.

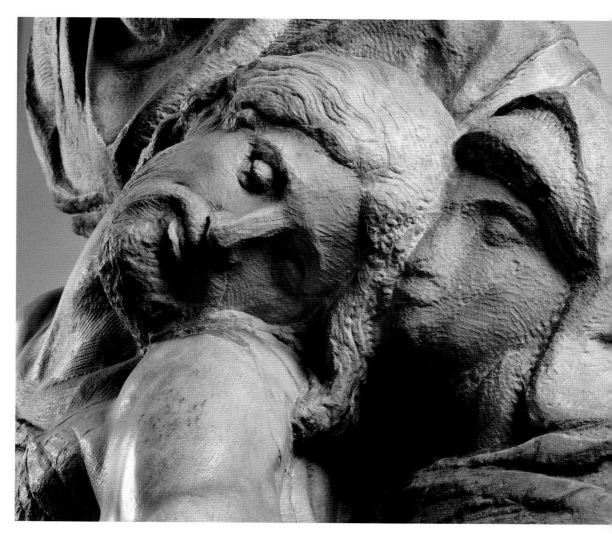

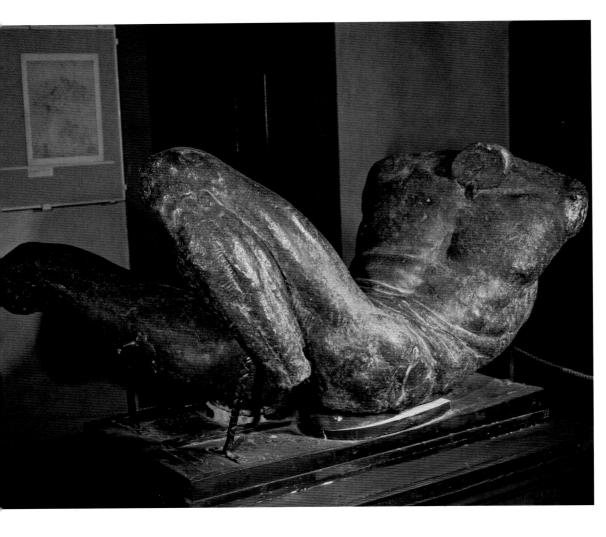

River God, c.1527, unfired clay, river sand, wire, mesh, and plant fibres, Casa Buonarroti, Florence, Italy, 65 x 140 x 70cm (25.6 x 55 x 27.6in)

River God is considered to be a preparatory model for a marble sculpture of a river god, one of four rivers to be personified in sculptural form, in the new sacristy of the Medici Chapel. The planned sculptures, two to lie at the base of each tomb, of Giuliano, and Lorenzo de' Medici, were only at the preparatory stage at the time of Michelangelo's departure for Rome. This particular 'river god' was intended to lie beneath the tomb of Lorenzo. Michelangelo has taken inspiration for the river god from the sculptures of classical antiquity.

Study for a *River God*, c.1525, pen and brown ink on paper, British Museum, London, UK, 13.7 x 20.9cm (5.4 x 8.2in)

A working drawing for a river god sculpture planned for the Medici tombs in the New Sacristy of San Lorenzo, Florence. On the drawing paper there is a short line of handwriting and 16 lines of dots and dashes. The drawing is inscribed with figure dimensions added by Michelangelo: '*u(n) b(racci)o e mezo*', '*braccia 3*', '*b(raci) a 2 e tre quarti*' and '*un braccio*' (the figure in profile to left); '*u(n) b(racci)o e 3 quarti*', '*b(racci)o uno e quarto*', '*b(racci) a 2 e 2 terzi*', '*braccia 3*' (the figure in profile to the right).

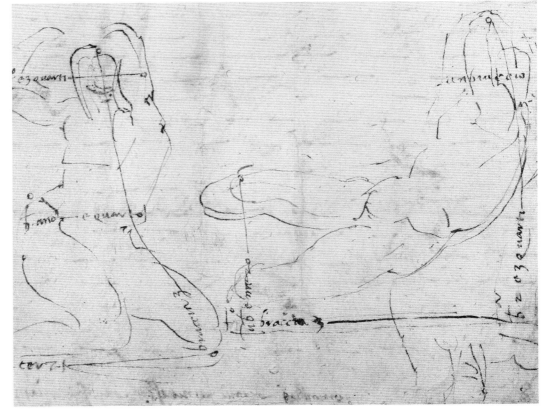

Rondanini Pietà, c.1564, marble, Castello Sforza, Milan, Italy, 195cm (77in)

This unfinished marble sculpture is referred to as the *Rondanini Pietà*. It is one of Michelangelo's last works. He is known to have been working on the sculpture shortly before his death. It portrays the emaciated body of the dead Christ held up by his loving mother. An arm from a previous figure remains to the right of the two-figure group. The barely visible details of the faces and heads of Christ and the Virgin Mary are placed close together. Many scholars have considered that while working on this sculpture Michelangelo was informed by medieval, Gothic sculptures, which leave much of the detail untouched, to add a spiritual strength to the work. There is no confirmation of this and it remains speculation.

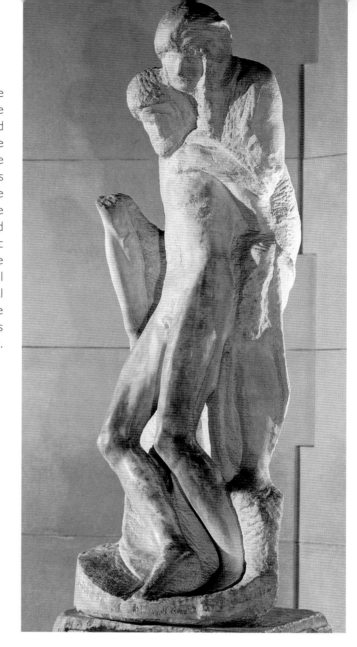

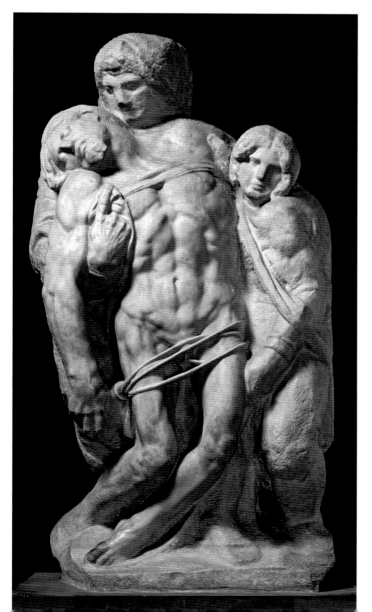

Palestrina Pietà, 1555, marble, Galleria dell'Accademia, Florence, Italy, 249cm (98in)

The stone used for the *Palestrina Pietà* is a piece of ancient Roman marble, taken from a cornice from the church of Santa Rosalia in Palestrina. This sculpture was originally attributed to Michelangelo, but historians now debate whether all the figures, or any of them, are his work.

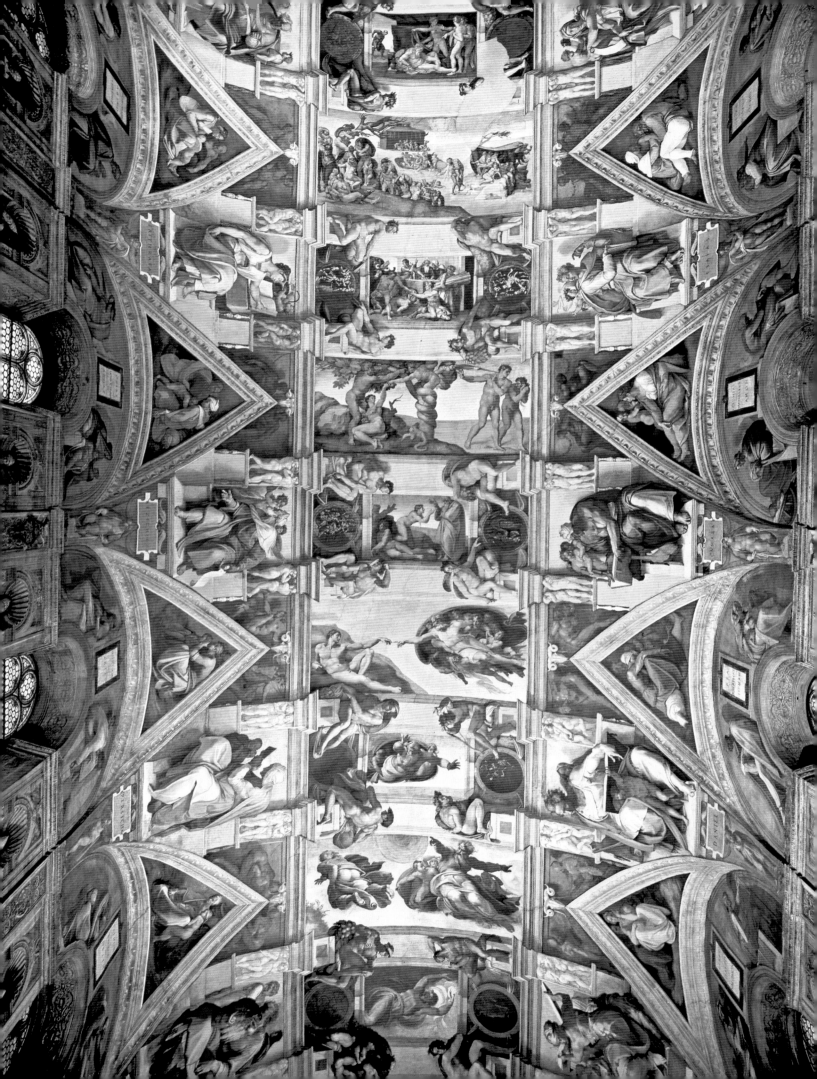

Paintings

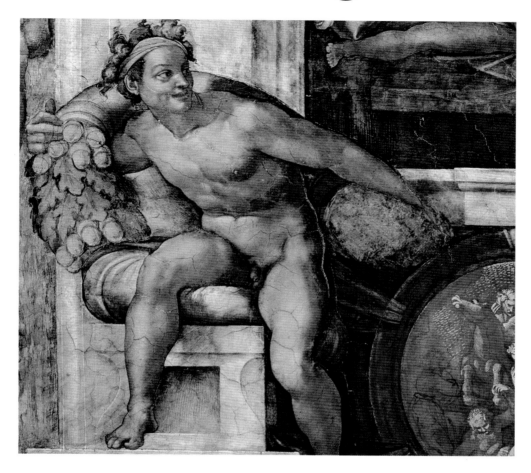

Michelangelo's first paintings were modest in size when compared to his first major work of art, created in fresco, on the ceiling and upper walls of the Sistine Chapel. After a difficult start, Michelangelo mastered the art of fresco painting on the damp ceiling and walls of the chapel, to create 300 figures in scenes from the Old Testament. The sculptural quality of the figures illustrated his desire to work as a sculptor rather than a painter. In 1538–41, a further commission from Pope Clement VII realized the *Last Judgement*, a vast altar painting in fresco, for the Sistine Chapel's vast altar wall. Michelangelo's figures now no longer represented the beauty of the classical ideal of humanity, but more of a realistic view. Two large-scale paintings in the Pauline Chapel illustrate Michelangelo's stature as an accomplished artist, portraying the conversion of Saul (St Paul) and the crucifixion of St Paul.

Above: An ignudo, *seated above the prophet Isaiah, Sistine Chapel ceiling.*
One of twenty nude males, placed in pairs, holding bronze-like roundels.
Left: Sistine Chapel ceiling (detail). Nine Old Testament biblical episodes are depicted on the central section of the ceiling. In total, the ceiling frescoes depict over 300 figures.

The Virgin and Child with St John and Angels (Manchester Madonna), c.1495–7, egg tempera on wood, National Gallery, London, UK, 104.5 x 77cm (41 x 31in)

This unfinished painting is accredited to Michelangelo. It depicts the Virgin, the young Christ and John the Baptist with four angels (two unfinished). Christ points to a passage in a book that the Virgin holds. The angels to her left are engrossed in the writing of a scroll they hold. The style of their sweet, sad faces, wreathed in golden curls, is reminiscent of the sculptures of antiquity, and the masterful paintings of the Florentine artists Sandro Botticelli and Filippo Lippi. The detail of the Virgin's drapery and the plinth mirror Michelangelo's sculptural work.

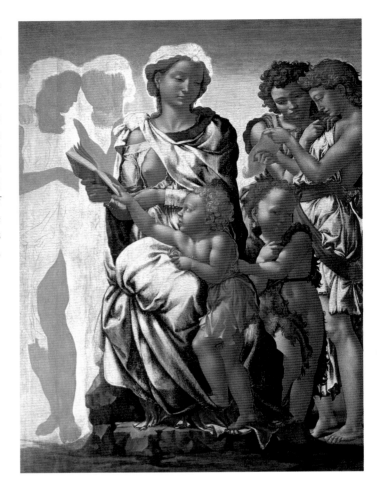

The Entombment, 1500–1, oil on wood, National Gallery, London, UK, 161.7 x 149.9cm (64 x 60in)

This unfinished painting depicts the dead body of Christ being carried toward his tomb. Apart from the figure of Christ, the other people in *The Entombment* are of ambiguous identity. The figures are possibly St John the Evangelist, depicted in red, with Nicodemus and St Joseph of Arimathea. In addition it is probable that the female characters are Mary Magdalene (bottom left, unfinished); the Virgin (in outline, bottom right); and a holy woman, Mary Salome (above right).

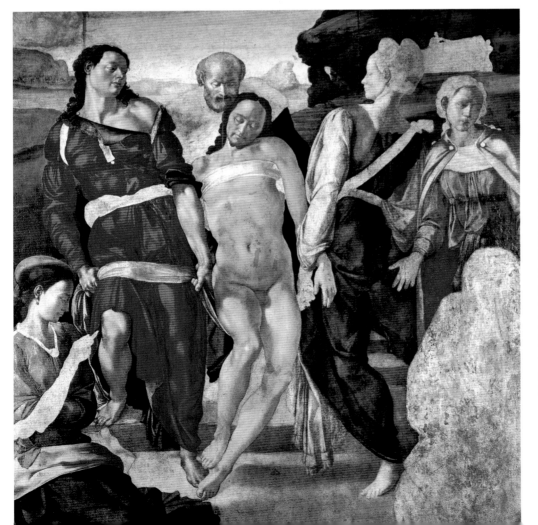

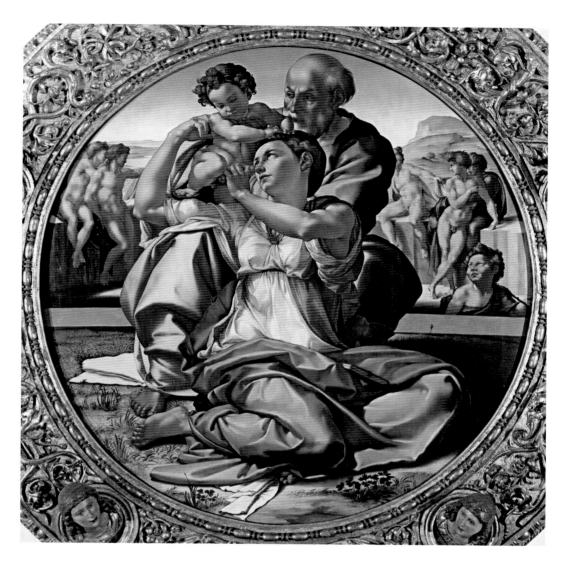

The Holy Family with the Infant St John the Baptist (Doni Tondo), c.1503–6, oil on panel, Galleria degli Uffizi, Florence, Italy, diameter 120cm (47in)

This strikingly colourful circular oil panel was possibly commissioned to celebrate the birth of Agnolo Doni and Maddalena Strozzi's first daughter. The Virgin, in pinkish-red gown, is seated on the ground. Joseph, in blue and gold, is seated above and behind her, holding the naked infant Christ on his knee. The Virgin twists around to reach up toward her son. The infant St John is depicted to the left of Joseph.

The Holy Family with the Infant St John the Baptist, **detail of central figures with young boys in background**

In the near background, the infant St John the Baptist, to the left of Joseph, looks up toward the family. Behind St John, in the rocky landscape backdrop, are two groups of naked youths, depicted standing and sitting, chatting to each other, oblivious of the Holy Family and the infant St John. Their inclusion is ambiguous but follows Michelangelo's interest in the sculptures of antiquity. The nude figure of a youth, to the left of Joseph (to the viewer's right), stands casually with legs crossed, leaning against another figure, with his left hand placed on a rocky wall. The youth resembles the *ignudi* (idealized male nudes) that Michelangelo later painted on the Sistine ceiling, 1508–12.

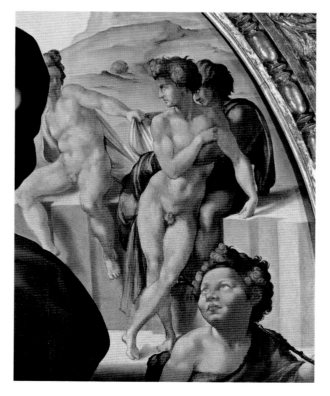

Study for the *Battle of Cascina*, *c.*1504–5, charcoal on paper, Gabinetto dei Disegni e Stampe, Galleria degli Uffizi, Florence, Italy

This preparatory sketch for the *Battle of Cascina* shows how accurately Aristotile da Sangallo copied the original cartoon, *c.*1542, when in Florence. The figures are depicted climbing from the river. They twist and turn, showing Michelangelo's interest in the classical figures of antiquity, his preferred style for works of sculpture. The cartoon was completed after making initial sketches and drawings, but the fresco for the Salone dei Cinquecento did not materialize.

Battle of Cascina (after Michelangelo), by Aristotile da Sangallo, *c.*1542, oil on panel, Holkham Hall, Norfolk, UK, 76.5 ×129cm (30.12 × 50.79in)

Michelangelo reached the cartoon stage of the *Battle of Cascina* (now lost), a work commissioned for the Salone dei Cinquecento in Florence and a companion piece to Leonardo da Vinci's *Battle of Anghiari*. Michelangelo's cartoon was viewed in Florence by invited artists, where Aristotile da Sangallo copied it. It depicts soldiers in the lull of battle, bathing in the Arno river. On hearing the battle alarm, they rush to dress and put on their armour.

Anatomic horse studies, 1504, pen and ink on paper, Ashmolean Museum, University of Oxford, UK

Michelangelo was a keen horseman. He studied the anatomy of horses closely as these drawings illustrate. The page is in two parts, and shows a detailed drawing of a horse from the right side. On the right-hand page are detailed sketches of the rear legs and back of two horses. Turned upright the right hand page includes a text. These sketches are considered to be preparatory drawings for the *Battle of Cascina*.

Nude study for the *Battle of Cascina*, c.1503–5, red chalk on paper, Galleria degli Uffizi, Florence, Italy

Another preparatory study for the *Battle of Cascina* that illustrates Michelangelo's remarkable understanding of human anatomy. The rear view of a nude male figure stretches his right arm toward the distance, twisting his body and accentuating the athleticism and strength of his muscular torso and limbs.

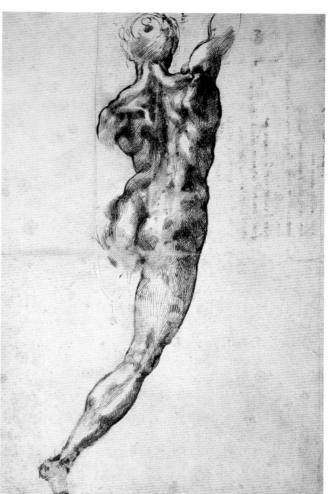

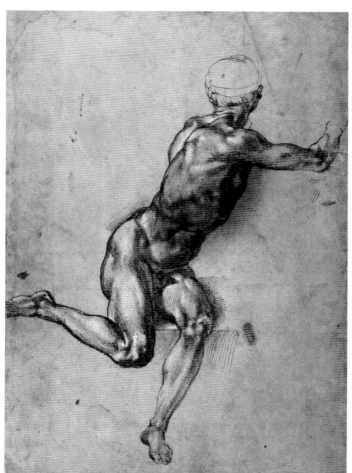

Study for a seated male nude twisting around, c.1505, pen and ink, grey and brown wash, heightened with white, over lead point and stylus, British Museum, London, UK, 41.9 x 28.6cm (168 x 114in)

The superb detail of this figure, particularly the cross-hatching in the drawing, shows Michelangelo's creative skill as a draughtsman. This life drawing is of a seated male nude, twisting around to the rear. It explores muscular movement in the body of an athletic man. The figure was intended to be the centrepiece of the *Battle of Cascina* fresco in the Salone dei Cinquecento, Florence.

Studies for figures on the Sistine Chapel ceiling, c.1508–12, pen and ink and pencil on paper, Casa Buonarroti, Florence, Italy

The larger figure drawing and the many smaller figure drawings that accompany it are figure studies for the many *ignudi* (idealized male nudes) planned for the Sistine ceiling.

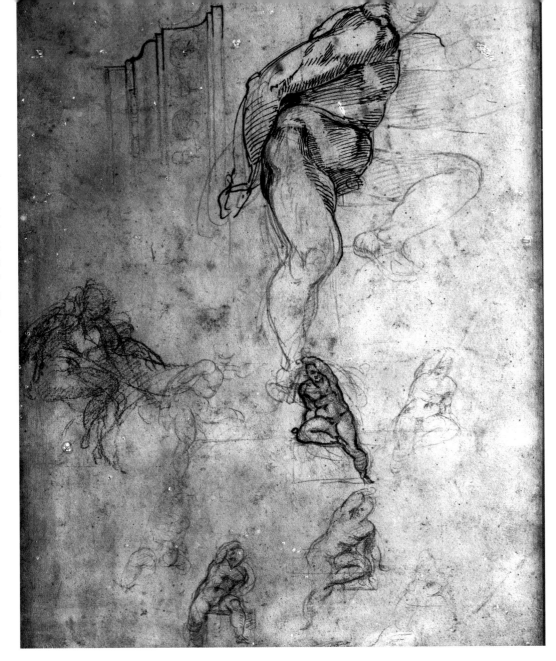

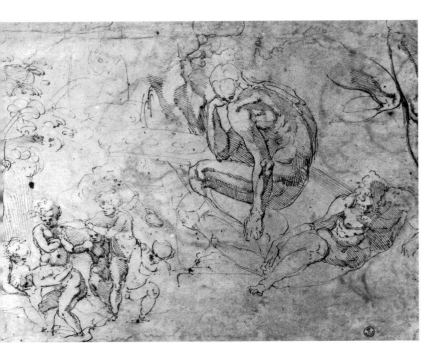

Studies of figures (*ignudi*), 1508–12, pen and ink on paper, Galleria degli Uffizi, Florence, Italy

The studies are drawings that relate to figures on the Sistine Chapel ceiling, particularly the *ignudi*. Here, one can see Michelangelo exploring many different poses for the seated figures.

Scheme for the Sistine Chapel ceiling, *c.*1508, pen and brown ink over leadpoint and stylus; black chalk, British Museum, London, UK

This is one of the two earliest studies of Michelangelo's plan for the Sistine ceiling. (The other is owned by the Detroit Institute of Arts, Detroit, MI, USA.) The drawing is considered to have been created soon after the contract for the Sistine ceiling was drawn up in 1508. The remaining section of the paper was utilized for studies of an arm and hand in black chalk.

Study for an Apostle, 1508–12, pen and brown ink on paper, Gabinetto dei Disegni e Stampe, Galleria degli Uffizi, Florence, Italy

This preparatory sketch is for one of the Apostles on the Sistine Chapel ceiling. The original agreement was for a series of Apostles surrounding the ceiling. Michelangelo, having completed the preparatory drawings and possibly the cartoons, was not pleased with the result. Pope Julius II then gave permission for Michelangelo to paint whatever he wished, which resulted in the whole ceiling being decorated.

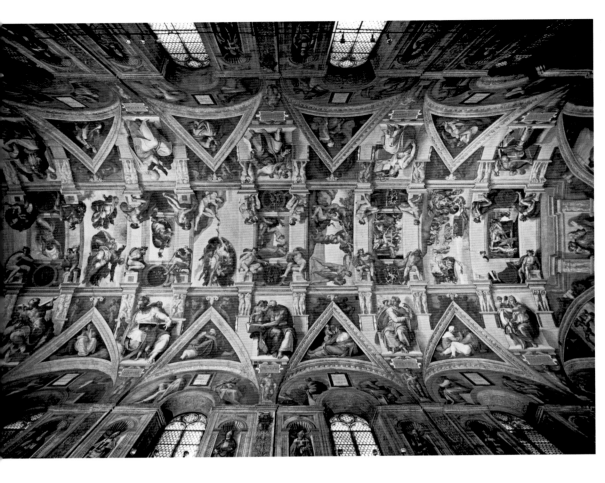

Sistine Chapel ceiling (nine sections of the story of the Old Testament), fresco, 1508–12

The complexity of Michelangelo's fresco decoration of the Sistine ceiling is displayed here. The upper level of the chapel contains six arched tall windows. Nine central rectangular sections illustrate the foremost narratives and personages of the Old Testament. Michelangelo began work on the fresco in 1508, taking four years to complete the task. In a ten-year programme, starting in 1989, the Sistine ceiling was cleaned and restored to remove centuries of dirt.

Sistine Chapel ceiling, first three sections from altar end

To complement the Quattrocento frescoes, which unfold from the altar end and illustrate the history of Moses on the left wall and the life of Christ on the right wall, Michelangelo begins his narrative at the altar end in rectangular sections, which illustrate a succession of stories from the Old Testament. The first triad consists of (from bottom) *The Separation of Light and Darkness, The Creation of the Sun, Moon and Planets,* and *God Separating the Land from the Water.*

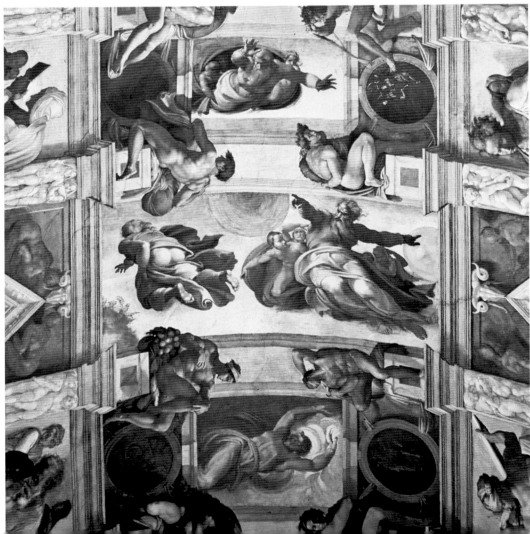

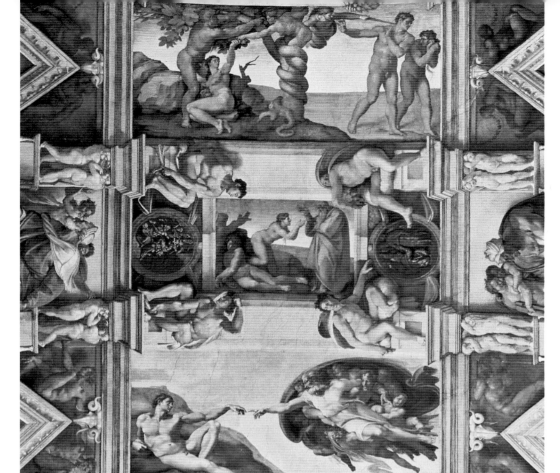

Sistine Chapel ceiling, middle three sections

The triad of the middle section, covering the near centre of the Sistine ceiling, shows *The Creation of Adam, The Creation of Eve*, and combined in one section, *The Temptation of Eve by the Serpent* and *The Expulsion of Adam and Eve from Paradise. The Creation of Adam* is the most recognized section of the whole cycle.

Sistine Chapel ceiling, bottom three sections

The third triad depicts events following the expulsion of Adam and Eve from the Garden of Eden. *The Drunkenness of Noah, The Flood*, and *The Sacrifice of Noah* are depicted from the eastern end, over the exit to the chapel, which juxtaposes *The Expulsion from Paradise* with *The Sacrifice of Noah.* It is known that some of the decoration in the chapel and minor figures of *The Flood* were completed by assistants of Michelangelo.

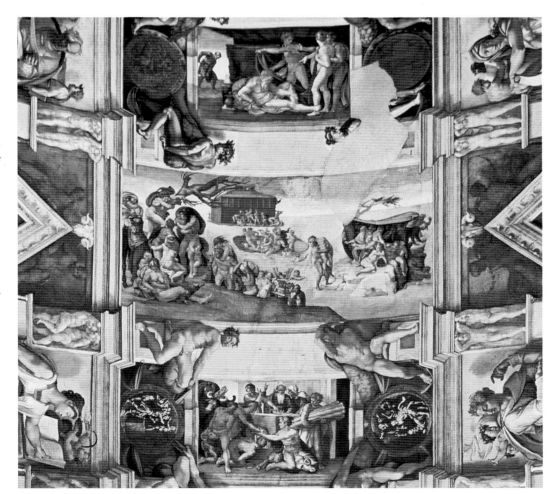

Study for Noah in *The Drunkenness of Noah*, 1508–12, charcoal on paper, British Museum, London, UK

In Michelangelo's depiction of *The Drunkenness of Noah* he is possibly referencing a Platonic reading of drunkenness as an outward symbol of the despondency of the soul. This sketch of Noah shows him to be a rotund figure with ample torso. The figure lies back, resting his weight on his right arm, with left arm outstretched.

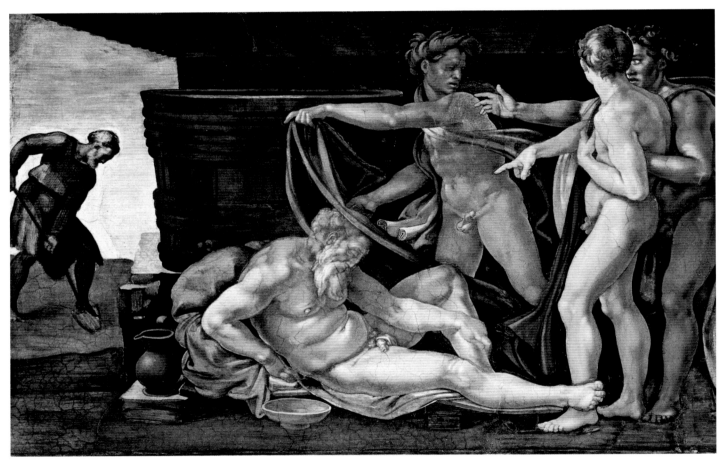

Sistine Chapel ceiling, *The Drunkenness of Noah*

The early Sistine scenes such as this one (1508–9) contain much more figurative detail than later ones. Noah, after the flood, is pictured to the left, tilling the vineyard. Then, the naked figure of Noah, inebriated from sampling too much of the wine from his vineyard, lies back, propped up on one elbow, his head lolling forward. Behind him is a giant wine vat. By his side are a pitcher and an empty drinking bowl. This version of Noah's drunkenness is similar to portrayals of the incident by Lorenzo Ghiberti (Porta del Paradiso, Florence) and Jacopo della Quercia (San Petronio, Bologna), both works that were observed by Michelangelo. Half-asleep, Noah's head hangs down on his chest. Noah's inebriation can be seen as an analogy for redemption; the wine as a symbol of the Eucharist, or communion. The three naked youths standing to the right of the figure of Noah are his sons. Their bodies retain a sculptural quality. The central figure, with his face turned away, is Ham. He points his finger with annoyance at his inebriated father, who lies in a stupor. Ham's two brothers, Shem and Japheth, restrain him from waking their father as they try to cover up the old man's nakedness. This episode, although first in the ceiling sequence (from the entrance), happened after the flood.

Sistine Chapel ceiling, *The Sacrifice of Noah*

Vasari mistook this scene as the sacrifice of Cain and Abel, but in fact the depiction is of the old man Noah, in red, standing behind the sacrificial flames. His wife stands to his left, looking toward him. Noah's sons and daughters-in-law gather around him to take part in the ritual. His young sons grab hold of the animals that are to be given in sacrifice to God. There is a sculptural quality to the figures of the three young men, the sons of Noah, who are depicted in a flurry of activity: lighting the fire, bringing forward the animals for sacrifice and carrying out sacrificial duties. Michelangelo shows them conversing with each other, their bodies twisting and turning toward and away from the viewer. It adds great depth and movement to the portrayal of Noah's sacrifice. In this scene one ram has been sacrificed and others are to follow. A son of Noah has straddled the beast and brought it to the ground. Its front legs are pinioned under his knees. The ram's head is forced back. Its eyes are open as it lies dying with throat slit, the blood trickling on to the earth. The faces, heads and bodies of the animals awaiting sacrifice display nervousness and fear. This can be seen in their bulging eyes and the anxious movements of their heads and bodies. One ram, seeing the sacrifice of another, struggles to get free from the grip of the young man who holds it. Michelangelo has portrayed the reality of death; each animal fears its fate and resists slaughter.

Sistine Chapel ceiling,
The Flood

This was the first and largest scene in the Noah series to be painted. In the centre distance Noah's large wooden ark is visible, with Noah and the dove. To the left and right men, women and children clamber to reach the safety of land. To the far right on an outcrop of rock, a makeshift shelter creates little protection for a group of people as the flood waters swirl around them. Their faces are full of fear and anguish. On the rock a naked older man is weighed down as he carries the pale, naked and lifeless body of a younger man (probably his son), but only the blameless, aboard Noah's Ark (the Church of God), will survive. To the far left an ass, in right profile, represents God's creatures. The figure group think they have reached the safety of higher ground. Children clutch at their mothers' bodies for protection from the wind and water. Men, women and children twist and turn to view the flood waters below them. Torment is etched into their faces. Chaos and turmoil are paramount.

Sistine Chapel ceiling, *The Flood*, detail: the Ark

Groups of people try to board the ark but will not survive. Around the ark the flood waters rise and people on board a small boat fight to keep others off as it capsizes.

Study of figures for *The Flood*, c.1508–9, pen and brown ink on paper, Gabinetto dei Disegni e Stampe, Galleria degli Uffizi, Florence, Italy

This brown ink compositional sketch illustrates Michelangelo's plan to include two major groups of people to the left and to the right in the picture frame.

The group to the left are climbing upward. The group to the right seem to be calling out. The figures are intended to illustrate God's wrath and deliverance.

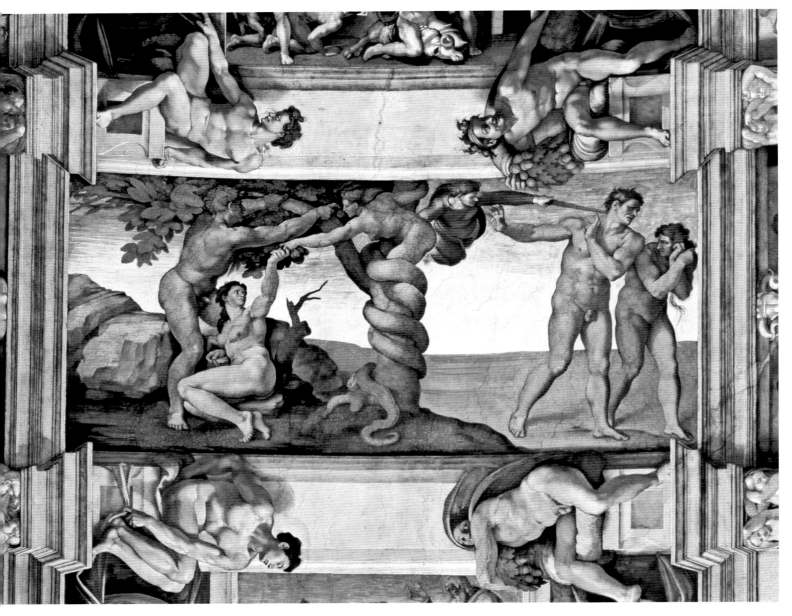

Sistine Chapel ceiling,
The Fall of Man and
Expulsion from Paradise,
with four *ignudi*

In the second triad one
large panel shows *The Fall*
of Man and Expulsion from
Paradise surrounded by
four *ignudi* (idealized male
nudes). It complements the
second large panel, *The*
Creation of Adam. Between
them a smaller panel, *The*
Creation of Eve, sits at the
centre of the Sistine
ceiling. *The Fall of Man and*
Expulsion from Paradise
carefully contrasts Adam
and Eve before and
after the fall of man.
Michelangelo divides the
picture frame. To the left
the temptation of Eve is
set in a colourful Garden
of Eden. Adam tends to
the Tree of Knowledge
while Eve lies back,
conversing with a
humanized serpent that
is coiled around the tree
as if growing from it.
The serpent hands Eve a
fruit to eat, yet God had
warned, "Ye shall not eat
of it, neither shall ye
touch it, lest ye die."
(Genesis 3:3) Eve looks
up toward the serpent and
takes the fruit. To the right
is the aftermath of the
'Fall'. An angel, a messenger
of God, sword in hand,
expels Adam and Eve from
Paradise (Genesis 3:23–24).

Study for Adam in *The Expulsion* (recto), 1508–12, charcoal on paper, British Museum, London, UK

This drawing is a study of Adam for *The Expulsion from Paradise*. It is a bulky figure striding forward. Michelangelo's depiction of Adam and Eve in *The Expulsion* mirrors the Brancacci chapel version of the narrative by the Florentine artist Masaccio (1401–28). Comparing the two, one can see that Michelangelo has portrayed the forlorn facial expressions and body language of despair, notable in Masaccio's work. This is surely homage to his predecessor.

Study for *The Fall of Man* (two sketches of the leg of Eve), 1510, charcoal on paper, Gabinetto dei Disegni e Stampe, Galleria degli Uffizi, Florence, Italy

This sketch is a preparatory drawing for the figure of Eve, in *The Fall of Man and Expulsion from Paradise*.

In the finished work Eve lies resting under the tree in the Garden of Eden. Her lower body faces toward Adam on her right, while her torso and head twist around toward the left to face the serpent. The sketch shows Michelangelo exploring the different possibilities for the position of the legs.

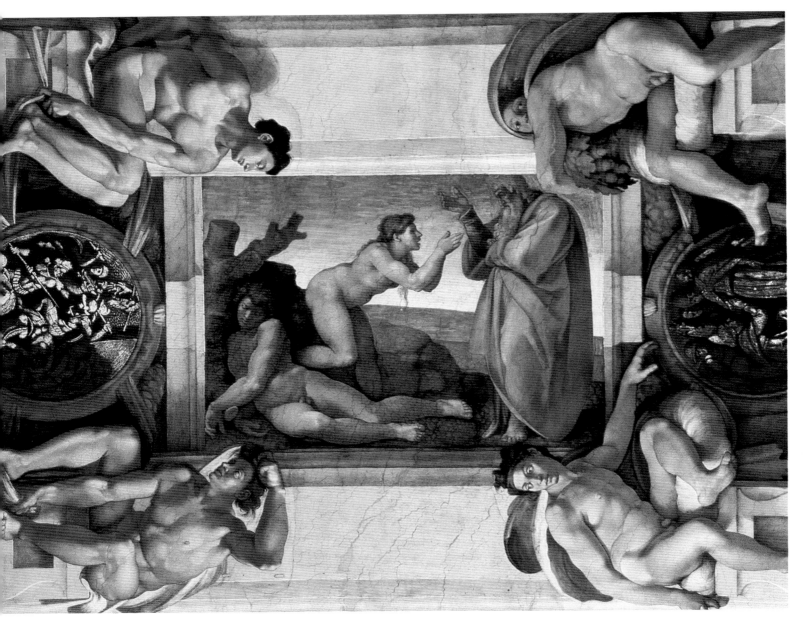

Sistine Chapel ceiling,
The Creation of Eve, **with**
four *ignudi*

The story of the creation
of Eve is narrated in Genesis
2:21–23: 'So the Lord God
caused a deep sleep to fall
upon the man, and while
he slept took one of his

ribs and closed up its
place with flesh. And
the rib that the Lord God
had taken from the man
he made into a woman
and brought her to the
man.' Michelangelo has
depicted the sleeping
Adam as Eve turns toward
the figure of God.

Sistine Chapel ceiling, *The Creation of Eve*, detail: ignudi and medallions

The five smaller ceiling panels, including *The Creation of Eve*, are framed with two medallions and four *ignudi*. This panel has the medallions: 'The Death of Nicanor' and 'Alexander the Great Adores the Name of God'. Michelangelo explained *ignudi* as idealized male nudes. The sculptural quality of their appearance bears a close relation to the marble *Belvedere Torso* created by the Athenian sculptor Apollonius, 1st century BC, which was part of the collection of Pope Julius II.

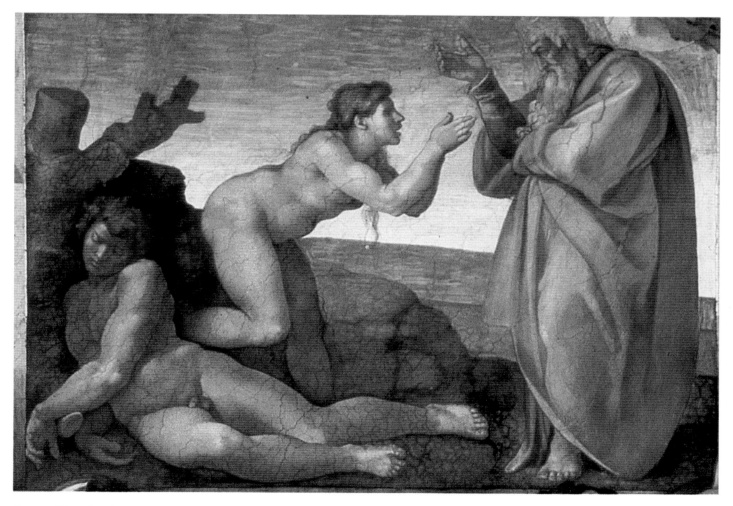

Sistine Chapel ceiling, *The Creation of Eve*, detail: figures of Adam, Eve and God

Three figures are placed close together, to accentuate their close relationship. In the background one can see the earlier fruits of God's labours: the land, the sea and the sky. The Bible explains that Adam and Eve were created as God's human reflection without sin. Genesis 2:18 reinforces Eve's role: 'Then the Lord God said, "It is not good that the man should be alone; I will make a helper suitable for him."' Eve's face is wreathed in long golden hair, which flows down her naked body. Her hands are clasped in supplication. She is in right profile with a facial expression of wonderment and awe. Eve looks up toward the figure of God. It is the moment of her creation. While Adam gently sleeps through the miracle, Eve's mouth is open as if in disbelief. She faces her maker, the magnificent figure of God.

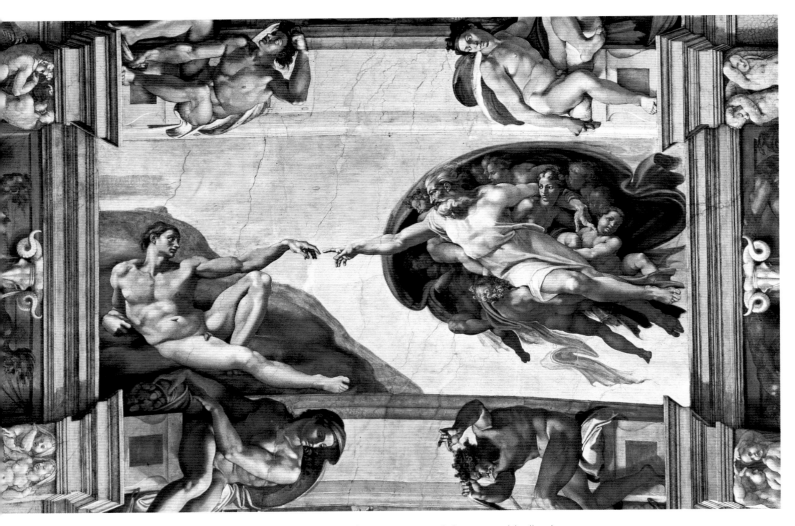

Sistine Chapel ceiling, *The Creation of Adam*

This depiction sublimely illustrates the meeting of the material and spiritual worlds at a single touch. Adam lies alone, while God speeds to Earth enveloped in a cloak of heavenly beings. He reaches out his hand to give life to Adam. The muscular arms and detailed hands of the figures of Adam and God illustrate Michelangelo's knowledge of human anatomy. The biblical text of God the Father creating Adam from the dust of the ground (Genesis 2:7), is notable for its simplicity. Here, Michelangelo depicts Adam as an idealized male. On Earth the newborn, fully formed man, lies back, with his right elbow holding the weight of his raised torso. His left arm balances on his raised left knee. Adam stretches out his hand to receive the gift of Life from the hand of God.

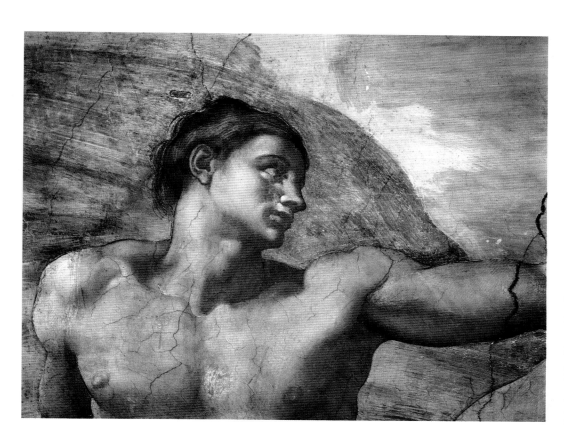

Sistine Chapel ceiling,
The Creation of
Adam, detail: Adam

The head and face of
Adam bear a resemblance
to those of Greek and
Roman sculptures of
antiquity, notably the *Apollo*
Belvedere (350–25BC),
by Leochares, in the
collection of Pope Julius II
in Rome. The idealized
male nude was foremost
in Michelangelo's design
for the figures and faces
of the young males. There
is a certain similarity
between Adam and his
planned sculptures for the
Tomb of Julius II, notably
the captives, now in the
Louvre, Paris.

Sistine Chapel ceiling,
The Creation of Adam,
detail: God

The figure of God the
Father is heavily bearded.
He wears flowing robes of
pinkish-red hue. The robes
would traditionally be a rich
royal blue, but the size of
the images of God in the
five panels of the ceiling
disallowed it. Azure was
expensive and used
sparingly by all artists.

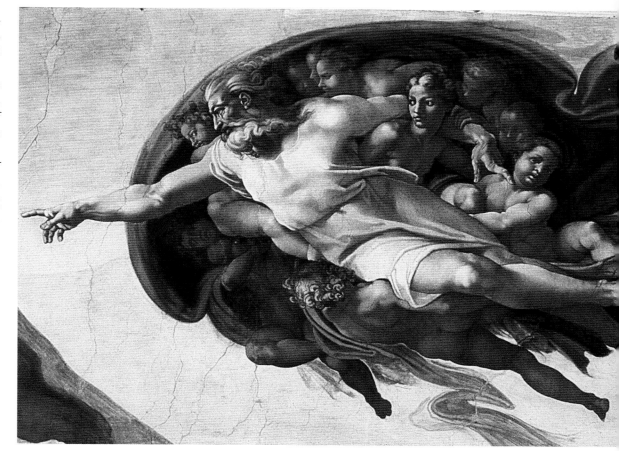

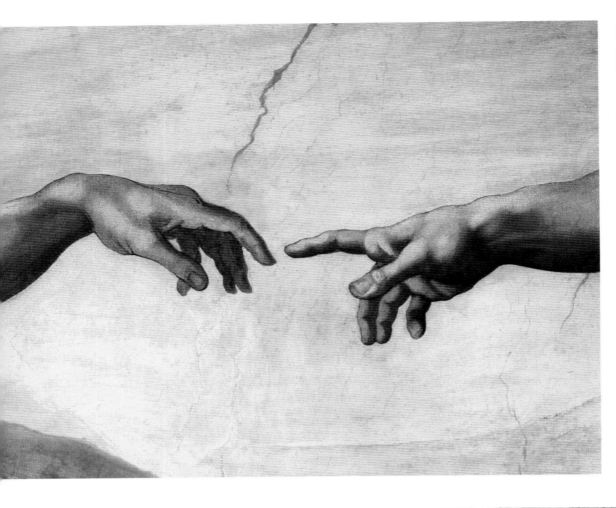

Sistine Chapel ceiling, *The Creation of Adam*, detail: hands of God and Adam

The most famous detail of the panel *The Creation of Adam* is the hand of God and the hand of Adam reaching out to each other. The image signifies the passing of the gift of Life from God to Adam.
The image has become far better-known than the rest of the Sistine ceiling; many who would recognize it are unaware of its source.

Studies of figures, including some from *The Creation of Adam*, 1508–12, pencil and red chalk on paper (verso), British Museum, London, UK

One of the many preparatory sketches for the Sistine Chapel ceiling includes studies of various figures, including those for *The Creation of Adam* panel. The figures would be sketched, often from a live model, and then worked up into a larger study for the cartoon sections. These would be used to transfer an outline of the work to the Sistine ceiling.

Study for *The Creation of Adam*, 1508–12, black chalk on paper (verso), British Museum, London, UK

This is a preparatory study for the figure of Adam. It illustrates a muscular torso and upper leg, similar in shape to the headless antique sculpture in marble, Apollonius's *Torso Belvedere*.

Study for Adam in *The Creation of Adam*, c.1510–11, red chalk on paper, British Museum, London, UK, 19.3 x 25.9cm (7.6 x 10.2in)

This study of the figure of Adam from *The Creation of Adam* panel illustrates Michelangelo's knowledge of human anatomy. He pays attention to the muscular form of the torso, arms and legs. This detail is lost when transferred to the fresco of Adam on the Sistine ceiling but is notably reproduced in Michelangelo's later works of sculpture.

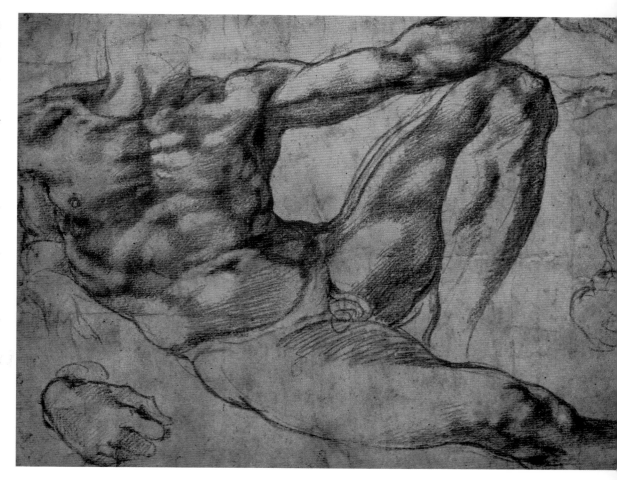

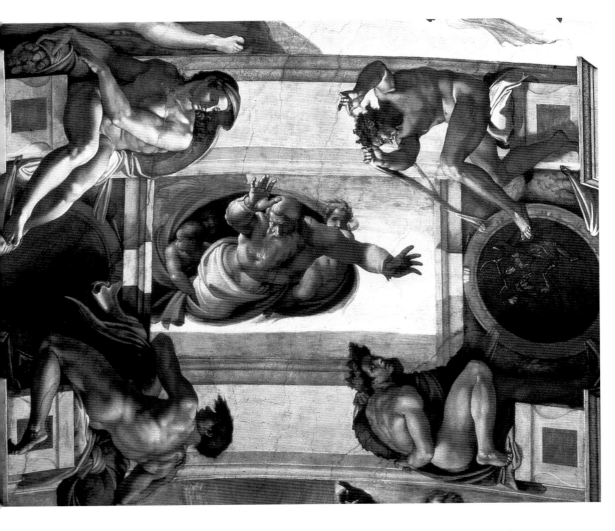

Sistine Chapel ceiling, *God Separating the Land from the Water,* with four *ignudi* and two medallions

The pinkish-red robes and mantle of the bearded figure of God envelop the picture space as he seemingly falls toward Earth and the occupants of the Sistine Chapel. Michelangelo uses the technique of foreshortening to depict God and the heavenly beings caught up in the swirl of his mantle. The arms of God are outstretched as he separates land from water (Genesis 1:6).

Sistine Chapel ceiling, *God Separating the Land from the Water,* detail: the figure of God

The figure of God is depicted with a full head of grey hair and a long, flowing beard. The aged face is compassionate and concentrates on the task of separating the land from the waters (Genesis 1:6). He hovers in mid-air, seemingly oblivious of the young heavenly beings that cling to his robes and his mantle, which swirls protectively around their bodies.

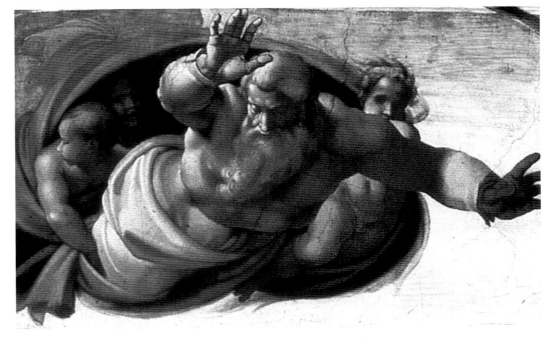

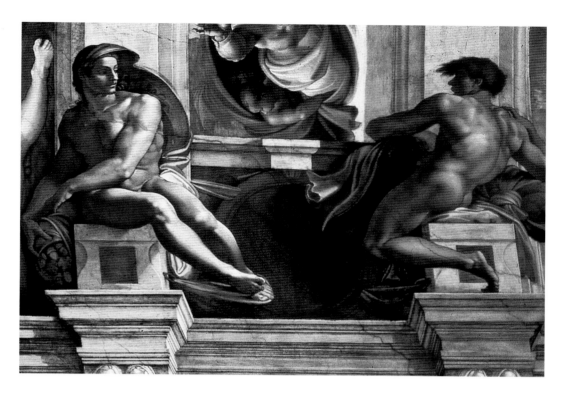

Sistine Chapel ceiling, *God Separating the Land from the Water*, **detail: two of the four** *ignudi*

The medallion centred between the two *ignudi* to the left of the figure of God separating land and water is blank. It is possible that it once contained an image of adultery and was subsequently cleaned.
To either side the images of two male idealized nudes are pictured swivelling their strong muscular bodies in opposite directions to each other, to add further movement to the image of God in the centre of the panel.

Sistine Chapel ceiling, *God Separating the Land from the Water*, **detail: two of the four** *ignudi*

Two *ignudi* to the right of the panel of *God Separating the Land from the Water* hold a medallion depicting the death of Absalom. Absalom, third son of King David of Israel, was killed during a skirmish against his father. One male nude crouches with his arm behind his back, and his foot on a pedestal. This figure and many of the *ignudi* figures are recreations of the sculptures planned by Michelangelo for the Tomb of Julius II.

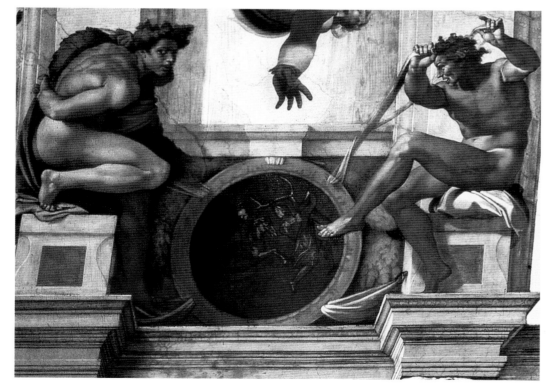

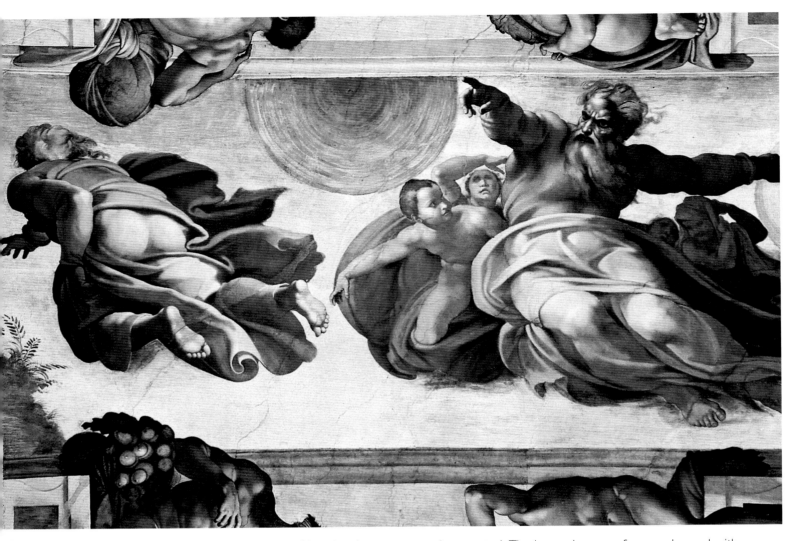

Sistine Chapel ceiling,
The Creation of the Sun, the Moon and the Planets

Michelangelo divides this scene with two views of God, depicted from front and rear. At centre-right God swirls with outstretched arms. Behind him shine an ethereal moon and a large yellow-orange sun that he has created. The heavenly angels hold on to the folds of his voluminous robes. To the left is the rear view of God. He hovers above the earth with one hand outstretched. Michelangelo uses foreshortening to emphasize the body and outstretched arms of God (to the right in the picture frame). It underlines the force and speed with which the figure moves through the Universe. The furrowed brow and piercing eyes, the head of grey hair and flowing beard, the muscular arms and commanding presence are all replicated in the sculpture of *Moses* (1513–16), created for the Tomb of Julius II.

Sistine Chapel ceiling, *The Separation of Light and Darkness*

This is an interpretation of Genesis 1:4–5, '…and God divided the light from the darkness…' Michelangelo's superb use of the technique of foreshortening allows the viewer to stand below the figure of God as he proceeds to separate light from darkness. The arms of God are raised above his head to create the firmament and the light-filled sky above. The tilted-back head, muscular torso and arms of the figure fill the panel. Michelangelo has illustrated a vision of God with his arms raised and torso twisted. The viewer looks up to the image of God creating the firmament and separating light on God's left, from darkness on his right. 'And God saw the light, that it was good. …And God called the light Day and the darkness he called Night.' (Genesis 1:4–5)

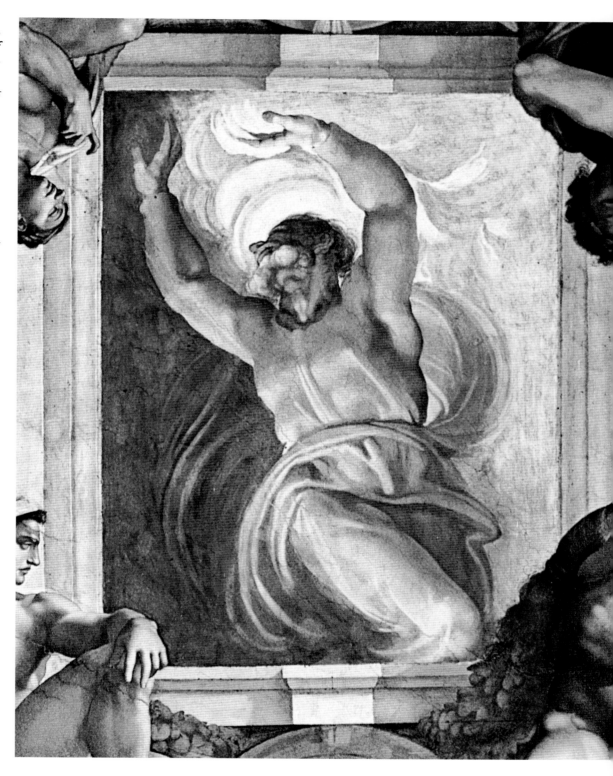

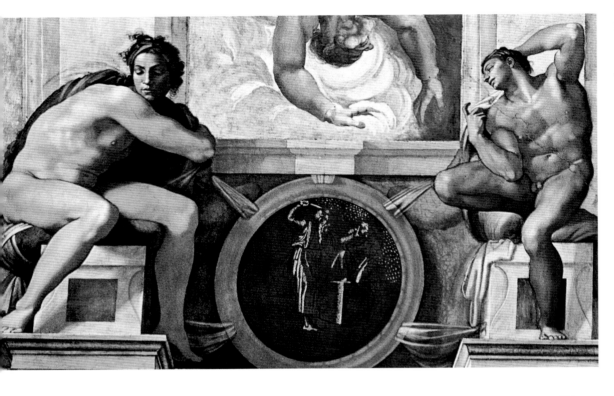

Sistine Chapel ceiling,
The Separation of Light and Darkness*, detail: two of the four *ignudi

Above the small panel of *The Separation of Light and Darkness* two *ignudi* sit either side of the painted bronze medallion. It depicts the sacrifice of Isaac by his father Abraham (Genesis 22:1–13). The male nude to the left of the medallion straddles his seat and leans forward, looking down. The male nude to the right leans back, in a pose reminiscent of Michelangelo's later work, the sculpture of *The Dying Slave*.

Sistine Chapel ceiling, *The Separation of Light and Darkness*, detail: two of the four *ignudi*

Below the small panel of *The Separation of Light and Darkness* two *ignudi* hold on to a bronze medallion with silk ribbons. The roundel depicts the Old Testament story of *The Ascent of Elijah*. The biblical narrative relates how and why the Prophet Elijah is carried up to Heaven in a whirlwind (II Kings 2:1–12).

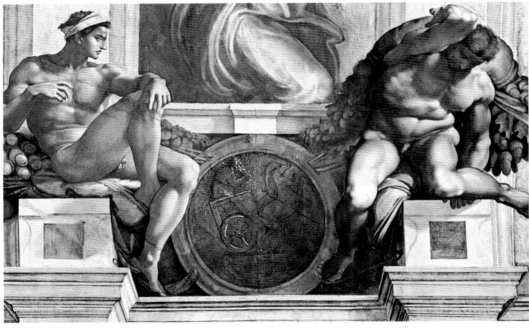

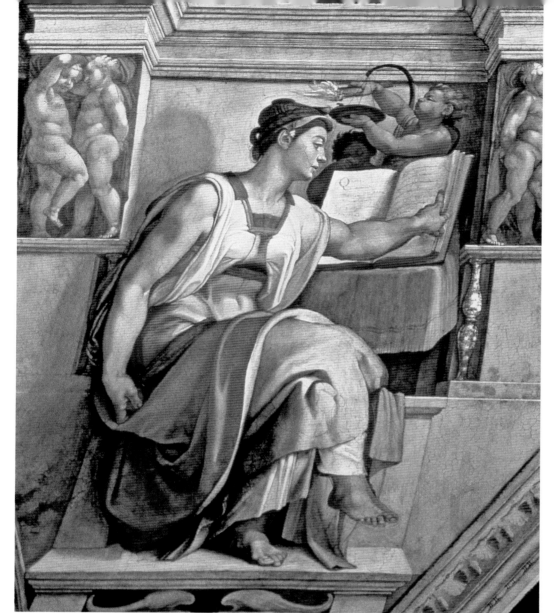

Sistine Chapel ceiling, *Erythraean Sibyl*

The meaning of the word 'Sibyl' relates to the Greek word *sibylla* (prophetess), a figure from ancient mythology. Sibyls were often depicted with open books. Their poetic prophecies were written in hexameter verse. On the Sistine ceiling twelve colossal figures of prophets and Sibyls (seven prophets of Israel and five Sibyls) are placed above and below the smaller panels of scenes from Genesis. *The Erythraean Sibyl* is placed below *The Sacrifice of Noah*. She sits back in a relaxed pose, her legs crossed. She looks aside to the open book on her small table and studies the pages. Behind the book on her table a cherub blows wind through his cheeks to fan flames to light the wick of her oil lamp. To either side of the scene, as part of the decorative trompe l'oeil 'wall frieze', Michelangelo depicts two pairs of plump sculptured cherubs, in mirrored poses.

Study for the robes of the *Erythraean Sibyl*, c.1509, charcoal with white highlights and brown wash on paper (recto), British Museum, London, UK, 38.4 x 25.8cm (15 x 10in)

This preparatory drawing illustrates the pose and the robes of the Erythraean Sibyl on the Sistine Chapel ceiling. The Sibyl, scarcely outlined, is seated, legs crossed, with her right side more visible. The folds of her clothing are drawn in detail. Vasari described a method used by artists to recreate the exact details of folded material. A cloth was submerged in wet clay, lifted out and arranged in folds on a figurine.

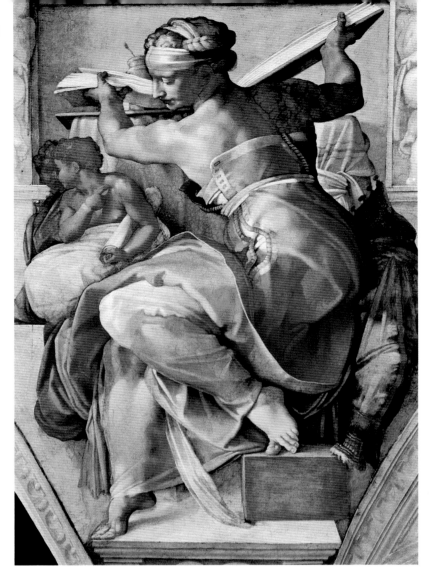

Sistine Chapel ceiling, *Libyan Sibyl*

The *Libyan Sibyl* is shown in rear view facing toward the architrave, her body turned to the right. She steadies her position and looks down below. Two cherubic attendants are seated underneath the large open book and one, with a scroll under his arm, points toward her. She raises her hands to lift the heavy book. The colours of her layered clothing are delicate shades of peach, grey, soft orange and blue. The careful detail of the clothing of the Libyan Sibyl is mirrored in her finely plaited golden hair and intricate headdress. Her face in profile is sweet and demure. Her arms, lifting the book of prophecies, are muscular, perhaps to show the strain of the position and the weight of the book.

Study of the assisting figure of the *Libyan Sibyl*, c.1512, red chalk on paper, Ashmolean Museum, University of Oxford, UK

A study for the figure to the left of the Libyan Sibyl. The upper body of the figure is youthful. Michelangelo has developed the muscular form in the drawing but omitted it from the painted depiction, where it has the body of a child, not a youth. This was perhaps to focus attention on the Sibyl and her action of either opening or closing the book behind her. On the same page, a drawing of the right hand of the Sibyl, and below, small studies for the 'slaves' of Julius II's tomb.

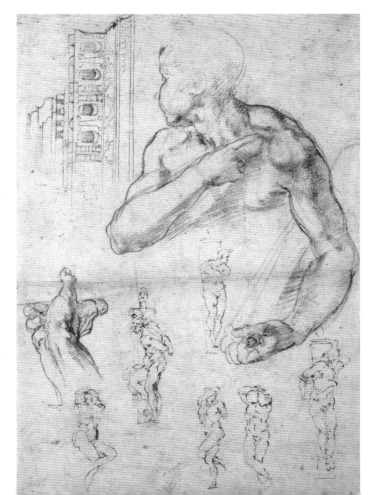

Sistine Chapel ceiling, *Delphic Sibyl*

In ancient Greece the Delphic Sibyl made prophecies within the sacred precinct of Apollo at Delphi. In contrast to the ageing figure of the Cumaean Sibyl the image of the Delphic Sibyl is one of youth and idealized physical beauty. She wears bright robes of green, gold and blue. She sits in her niche, her body facing right. Her attendant is engrossed in his reading. Of all the figures painted by Michelangelo on the Sistine ceiling the Delphic Sibyl was recognized above others for its stunning beauty. The folds in the blue headdress frame the delicate features of her youthful face. Her eyes are wide with apprehension. One interpretation is that she has read the prophecy of Christ's fate on the scroll she holds and turns away in disbelief, seeing a vision of what is going to happen.

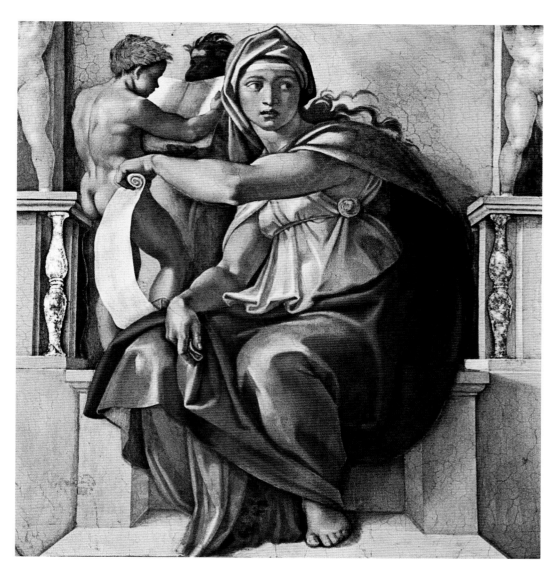

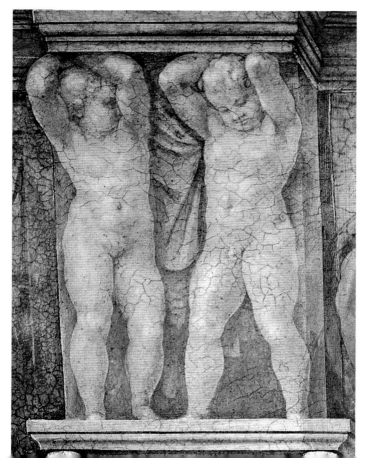

Sistine Chapel ceiling, *Delphic Sibyl*, detail: two sculptural cherubs holding up an architrave behind the Sibyl's left shoulder

Each Sibyl and prophet is placed seated in a trompe l'oeil marble niche of classical design. To the left and right of the figures are pairs of naked cherubs, posed in various stances, which relate to the sculptures of antiquity. Thus, the whole ceiling is a classical reference to the ancient buildings of Rome and an architectural framework to hold the figures. Behind the Delphic Sibyl the 'sculptures' are caryatids who hold up the architrave.

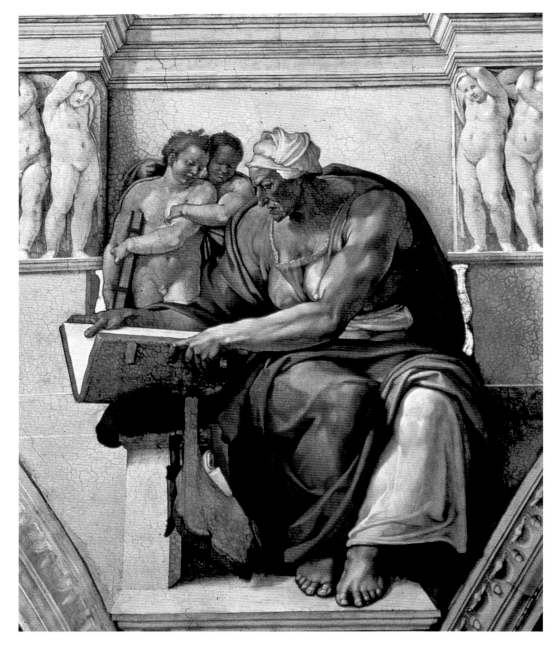

Sistine Chapel ceiling, *Cumaean Sibyl*

In her role as prophetess, the Cumaean Sibyl, foretold that Christ, the son of God, would be born of a virgin in a stable at Bethlehem. In Ovid's *Metamorphoses* a Sibyl from Cumae (Campania, Italy) guided Aeneas through the Underworld on his return from Troy to Rome. On the Sistine ceiling the muscular, man-like figure of the Sibyl sits above the central panel of *The Creation of Eve*. The Cumaean Sibyl is seated with her head turned to the right as she reads from her open book. She wears a close-fitting headdress. Her face is craggy and etched with age. Two attendants, one holding another book, stand arm in arm in her niche, looking over the open pages. Traditionally, the story is that the Roman king Tarquinus Priscus requested to buy nine books of her prophecies but thought the price too high. She destroyed three of the books and then three more, and quadrupled the price.

Study of a Sibyl, pen and brown ink; red chalk (the ground plan), 1508–10 or c.1520–25, British Museum, London, UK

This figure drawing may be considered to be one of the sketches for the Sistine Chapel ceiling. The heavy draping of the clothes and the positioning of the seated figure with attendant bears a similarity to the Sistine Sibyls. However, the figure is drawn over a red chalk ground plan of a rectangular room, and three sides have semi-circular niches. It is therefore also possible it was intended for the Medici's New Sacristy in Florence and created later on, c.1520.

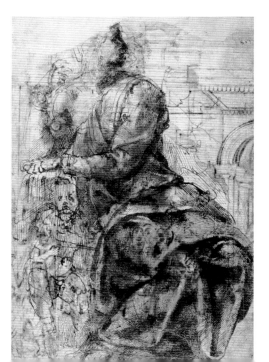

Sistine Chapel ceiling, *Persian Sibyl*

The Persian Sibyl flanks the centre panel depicting *God Separating the Land from the Water* and complements the Prophet Daniel on the opposite side. Both were recognized for their prophecies of the second coming of Christ. The old seer sits hunched in the niche, her upper body and head leaning inward. Her clothed attendants wait by her side. The head of the Persian Sibyl is wrapped in a pale-coloured cloth turban, which covers her hair. She is reading from a book, which is closely held up to her face. She reads intently and holds the book at an angle as if trying to catch the light to read the words on the page.

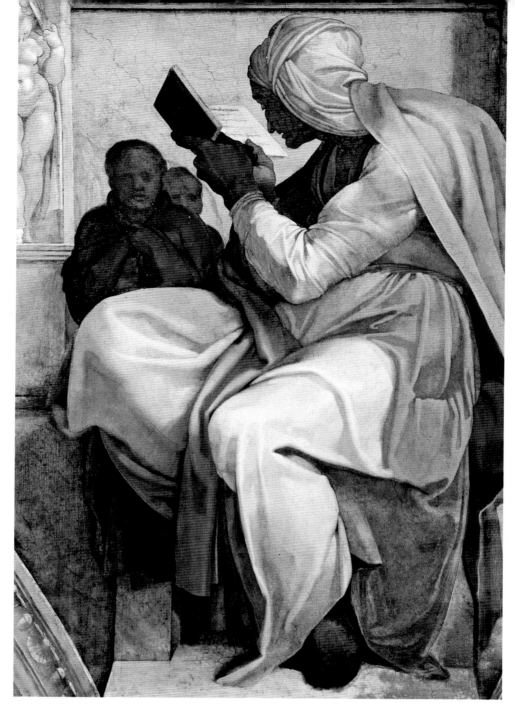

Study of a Sibyl, 1508–12, grey-brown and black chalk over stylus (the Sibyl); grey-brown chalk (the scheme); black chalk over stylus (the hand), British Museum, London, UK, 38.4 x 25.8cm (15.1 x 10.2in)

This drawing is on the reverse side of a study of drapery for the Erythraean Sibyl. The verso is a study of a figure seated to the right with legs crossed, looking down; there are putti, hardly discernible, to each side of the figure. In addition, there is a layout for the decoration of the ceiling of the Sistine Chapel, and a drawing of a left hand. The drawings highlight Michelangelo's working through his scheme for the Sistine ceiling, and the variation of position for each figure.

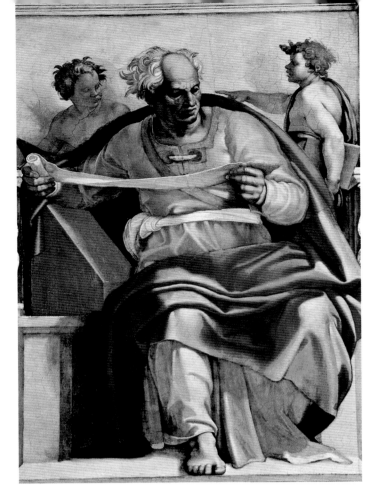

Sistine Chapel ceiling, *The Prophet Joel*

The prophet Joel is placed opposite the Delphic Sibyl and flanks the centre panel of *The Drunkenness of Noah*, at the entrance end of the Sistine Chapel. The prophet, named only once in the Old Testament, is shown reading from a long scroll, held out between his hands. He sits back on his throne within the niche. Joel, one of the earlier figures created by Michelangelo, is slimmer in shape than those painted after 1510.

Sistine Chapel ceiling, *The Prophet Daniel*

The heroic figure of the prophet Daniel fills the painted architectural niche. He sits with an open book propped on his knees, held there by an attendant standing beneath the book. Daniel, the prophet who foretold the coming of Christ, is depicted as a young man with red hair swept off his face. His stares down to his right, in deep thought. In contrast to his serious demeanour, the sculptural cherubs on the architrave dance and cavort.

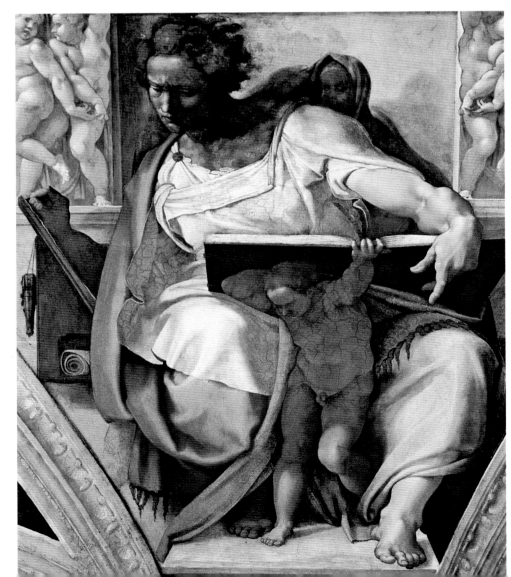

Sistine Chapel ceiling, *The Prophet Ezekiel*

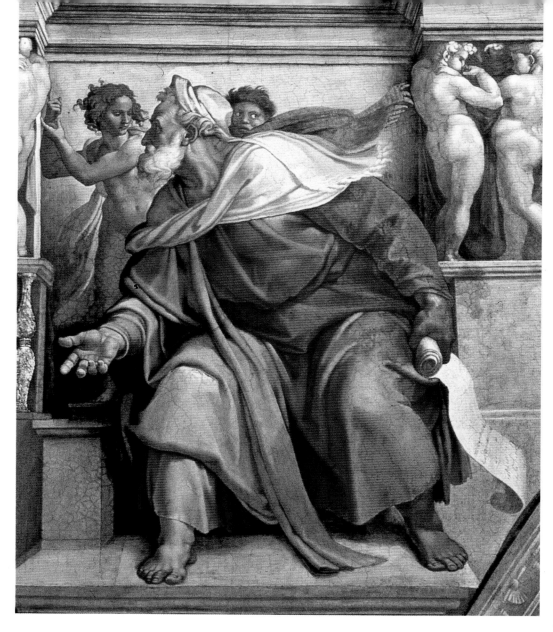

The prophet Ezekiel (active c.600BC) was a descendant of Joshua by marriage. The Book of Ezekiel describes him as a priest and Israelite exile. He was called to deliver God's prophecies. Seated, he holds a scroll in his left hand. His head and body lean to the right. The palm of his right hand faces upward, as if discussing an issue with the Erythraean Sibyl seated further away, to his right. Michelangelo depicts the prophet Ezekiel wearing a robe of red and mantle of blue. His head is in profile and shows an older man with a lively demeanour and sharp eyes. His grey hair is short and his beard white. A pale blue scarf swirls around his head and shoulders, as if caught by the wind, adding movement to the figure.

Sistine Chapel ceiling, *The Prophet Ezekiel*, detail: two sculptural figures 'holding up' the architrave behind prophet's left shoulder

Pairs of 'sculptures' of naked cherubs continue the architrave decoration. To either side, slightly above the head of Ezekiel, the small muscular figures lean into each other, facing the inner wall. Their posture mirrors the larger figures that are Ezekiel's attendants standing in the niche behind him. Michelangelo has used various stances to give the painted images a sculptural quality. The greater size of the figures toward the altar end is noticeable.

Sistine Chapel ceiling, *The Prophet Isaiah*

The prophet Isaiah (active 8th century BC) was politically motivated. He put his faith in divine intervention and advised leaders against war, warning of God's power to destroy the world (Isaiah 24:3). On the Sistine ceiling the seated, grey-haired Isaiah is placed opposite *The Erythraean Sibyl*. They flank *The Sacrifice of Noah*. Isaiah's face shows concern as he turns to listen to his young attendant who points to an event in the distance.

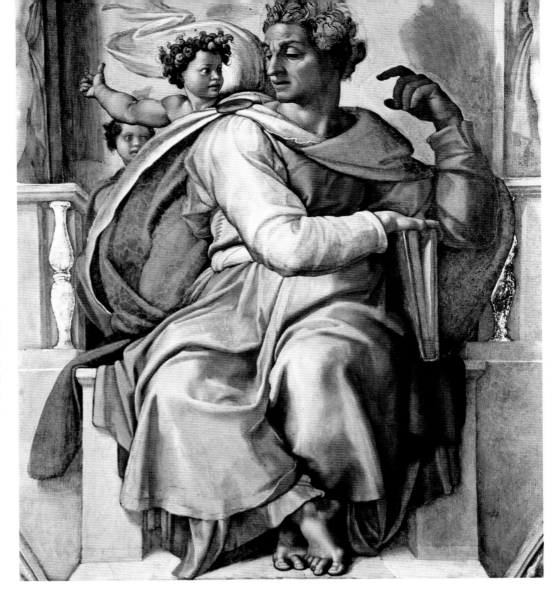

Study of head and hand of an *ignudo*, 1508–12, black chalk heightened with white, 30.7 x 20.7cm (12.1 x 8.1in)

This drawing is a study of the head of the *ignudo* positioned above left of the figure of the prophet Isaiah. In the painted version of this preparatory work, the *ignudo* was admired for his smiling face. In the drawing, the position of the head shows it turning toward its counterpart, the *ignudo* positioned above right of the prophet. On the same paper is a study of the *ignudo*'s hand.

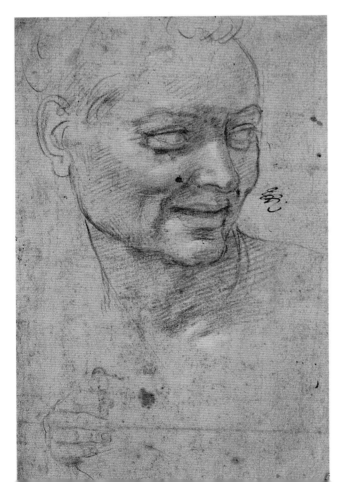

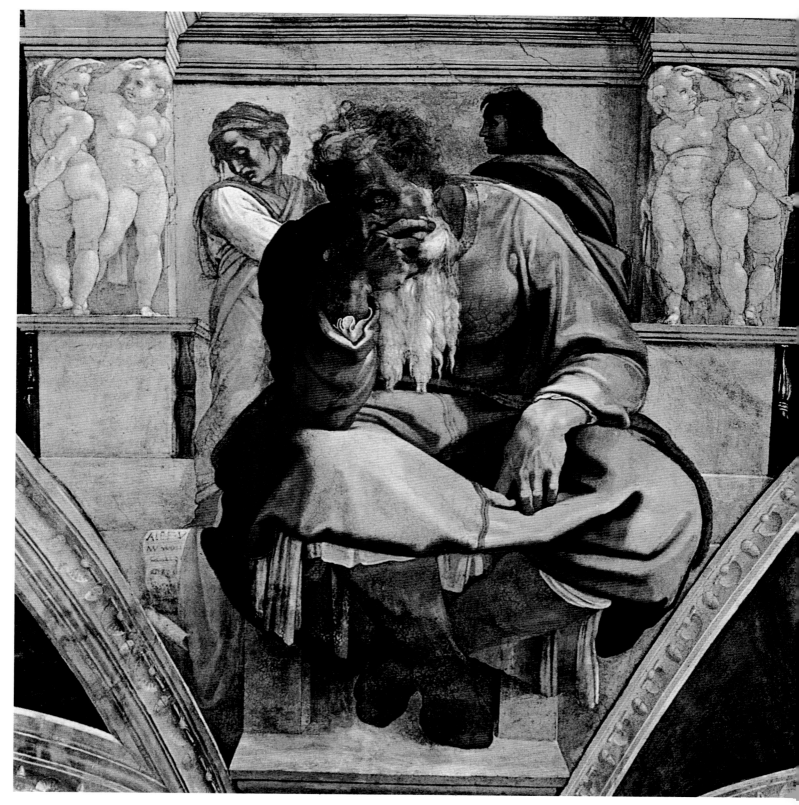

Sistine Chapel ceiling,
The Prophet Jeremiah

Jeremiah was nicknamed the 'broken-hearted' prophet as many of his predictions went unheeded. The Book of Jeremiah in the Old Testament holds his writings. On the Sistine ceiling the image of the prophet Jeremiah is considered to be a self-portrait of Michelangelo. The prophet is seated with his lower legs crossed. He leans forward with his right elbow on his knee and his right hand cupped to his chin. Beneath his grey hair and long white beard the sad face of Jeremiah looks dejected.

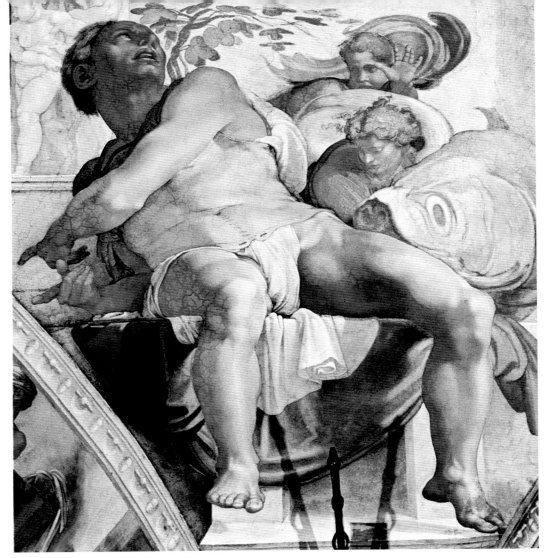

Sistine Chapel ceiling, *The Prophet Jonah*

The Book of Jonah narrates that the prophet, in order to avoid a command from God to preach in Nineveh, boards a ship that is involved in a violent storm. Considering himself the cause of the storm, he offers to be thrown overboard. He is swallowed by a giant fish and later spewed out to carry out God's wishes. Michelangelo depicts the hapless prophet looking up to God's firmament. He is accompanied by a large fish.

Study for a prophet for the Sistine Chapel ceiling, *c.*1508–12, pen and brown ink on paper, Gabinetto dei Disegni e Stampe, Galleria degli Uffizi, Florence, Italy

This drawing in brown ink on paper illustrates the outline of a figure, considered to be a preparatory sketch for one of the seven prophets depicted on the Sistine ceiling. The strong lines, dictating shape and posture, point to a general study, to help Michelangelo position the figures in different stances and add movement to the Sistine figures.

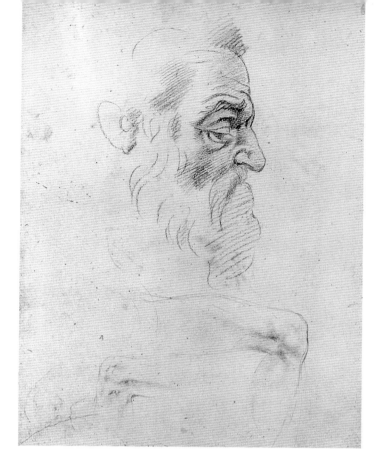

Study of a male head in profile, 1508–12, black chalk on paper, Gabinetto dei Disegni e Stampe, Galleria degli Uffizi, Florence, Italy, 43 x 28cm (17 x 11in)

A preparatory sketch for the head of the prophet Zechariah on the Sistine Chapel ceiling. The paper includes two smaller sketches of knees completed by another artist.

Sistine Chapel ceiling, *The Prophet Zechariah*

Positioned above the entrance to the Sistine Chapel, *The Prophet Zechariah* is possibly a portrait of Pope Julius II. Zechariah, dressed in green, orange and red, is depicted as an old man, seated in profile. He holds up a book and is reading from it. His two young attendants lean forward on his back and read the book over his shoulders. It is a fatherly image of the prophet (and Pope Julius).

Sistine Chapel ceiling,
Judith and Holofernes

The Old Testament narrates the story of Judith, who inebriated Holofernes, General of the Assyrian king Nebuchadnezzar, and while he slept, decapitated him, in order to save her city of Bethulia, which he was about to attack (Judith 13:1–10). Michelangelo depicts the sleeping guards to the left and the murdered Holofernes, sprawled across a bed to the right. At centre Judith and her maidservant cover the severed head (a possible self-portrait of Michelangelo).

Sistine Chapel ceiling,
David and Goliath

Michelangelo positions the two figures of David and Goliath at centre. The victorious David, a shepherd boy, is depicted straddling the fallen Goliath prior to the moment when he cuts off his enemy's head with a sword. The figures, presented one on top of the other, work surprisingly well in the confined space of the triangle, due to Michelangelo's use of foreshortening. The figures bear resemblance to his later sculpture *Victory*, c.1532.

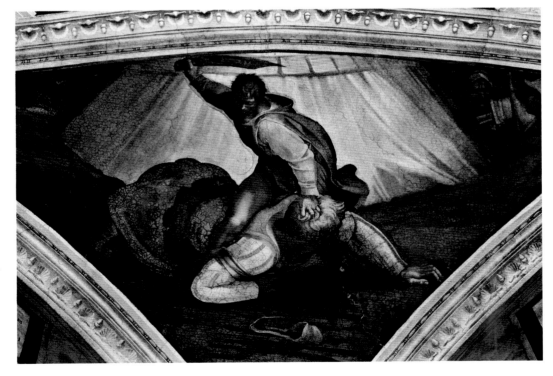

Study for the *Brazen Serpent*, red chalk on paper, Ashmolean Museum, University of Oxford, UK

The study shows two groups of people, one above the other. As two swarming masses they twist and turn to escape danger and death. The formation of the figure groups is similar to an earlier work by Michelangelo, the marble relief *Battle of the Lapiths and Centaurs*, c.1492. In both editions of *Lives* Vasari gives much praise to the finished work of *The Brazen Serpent* on the Sistine Chapel ceiling. Condivi, less enamoured, only briefly mentions it.

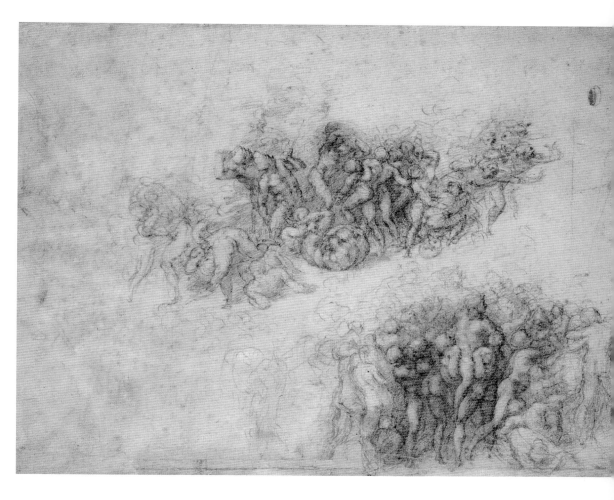

Study for the *Punishment of Haman*, c.1511, red chalk on paper (recto), British Museum, London, UK

The drawings on both sides of this paper are preparatory studies for the figure of the crucified Haman, to be depicted in a corner pendentive of the Sistine Chapel between the ceiling and the altar wall.
The figure study of Haman subsequently painted in fresco is a masterpiece of anatomical detail and proportion. This drawing includes studies of the leg and foot.

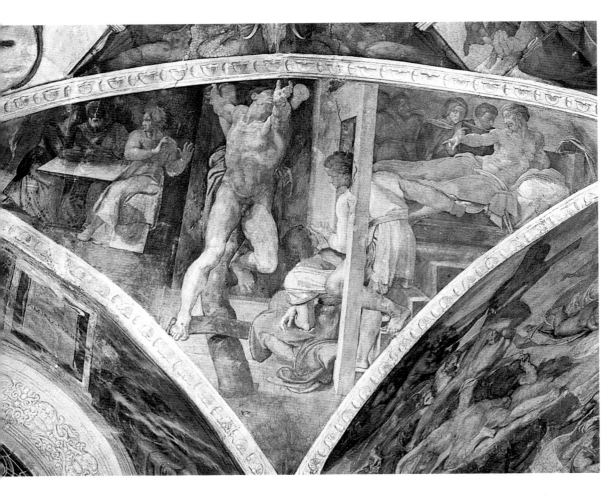

Sistine Chapel ceiling, *The Punishment of Haman*

In the Book of Esther (3–7) Haman, a Persian noble, plots to kill all Jews. The Persian king Ahasuerus hears of the plot from his wife, the Jewish queen Esther, and her cousin Mordecai. Haman is hanged from a tree. In Dante's *Purgatorio* (xvii: 25–30), Haman is crucified, nailed to a tree. It is the latter narrative that is illustrated here by Michelangelo. The three instigators of the crucifixion – Esther, Ahasuerus and Mordecai – are shown in the left background.

Sistine Chapel ceiling, *Ancestors of Christ: Boaz*

This detail is a possible depiction of Boaz. He is one half of a lunette that illustrates his young and beautiful wife Ruth and their infant child Obed. While Ruth cuddles her infant, having suckled him at her breast, the figure of a grizzled and hunched Boaz in right profile is striking in contrast. He is dressed ready to travel and holds a walking stick, the head of which is remarkably similar to his own face.

Sistine Chapel ceiling,
Ancestors of Christ:
David and Solomon

The lunette contains three
figures: an adult woman, plus
David and a young Solomon,
the ancestors of Christ. The
lunette is next to the spandrel
of the Jesse tribe. To either
side sit the Libyan Sibyl and
the Prophet Daniel. David
and Solomon were of the
Jesse family (Matthew 1:5–7).
The plaque between the
figures reads 'Jesse–David
–Solomon'. The figure seated
left, in oriental-style dress, is
probably David with a young
Solomon behind him.

Sistine Chapel ceiling,
Ancestors of Christ: Ahaziah

The future king Ahaziah
with his mother. Behind
them is depicted Joram
and another son.

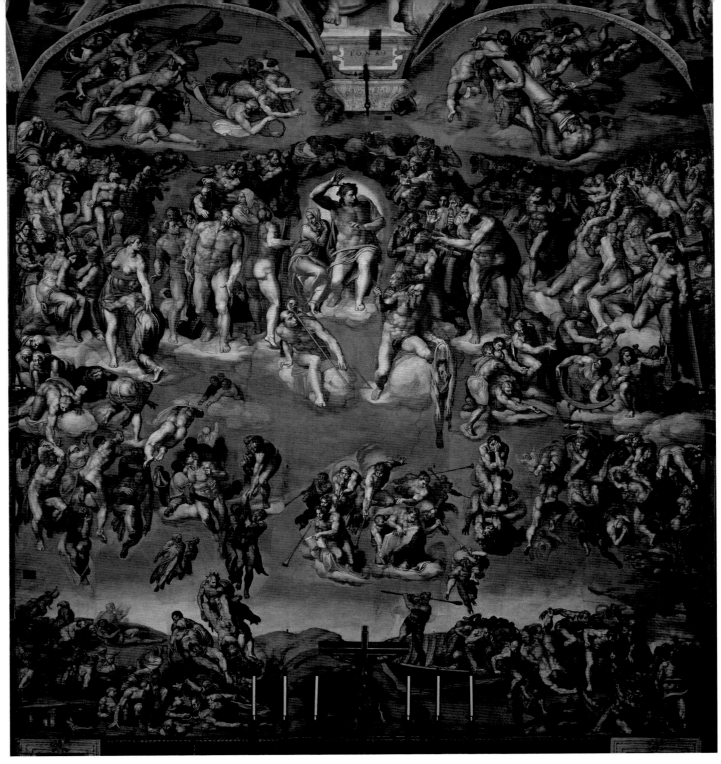

Last Judgement, 1538–41, fresco, Sistine Chapel, Vatican, Rome, Italy, 13.7 x 12.2m (45 x 40ft)

The *Last Judgement* on the altar wall of the Sistine Chapel complements the figurative decoration of the Sistine ceiling. The fresco depicts the day of judgement when all souls are examined. At ceiling level are two lunettes, followed by three lower tiers. The Last Judgement sequence begins at lower left and rises up to the figure of Christ, where it continues on the right side, downward. Christ stands at the centre, his mother to his right. He is surrounded by saints. The upper tiers on the left side of the fresco illustrate the righteous ascending to Heaven.

Above, in the lunettes, God's angels carry the symbols of Christ's Passion, including the wooden cross. In the right-hand lunette they struggle to hold the column of flagellation. To Christ's left, angels push the damned down toward Charon, Minos and the Underworld. At lower left the dead are seen to rise up, reawakened by the trumpets of seven angels, positioned lower centre, who call to them from all corners of the earth. The dead are to give an account of the deeds on which they will be judged. To the left the righteous continue upward toward Heaven. To the right the damned are pushed and pulled downward, toward the boat of Charon and the Underworld.

Study for *Last Judgement*, c.1538–41, pen and pencil on paper, British Museum, London, UK

Various sketches are extant which show the figurative development of the *Last Judgement* and the complexity of combining so many figures in one continuous narrative. This preparatory sketch illustrates one diverse group of figures that Michelangelo had planned to execute.

Study of figures for *Last Judgement* with signature, 1536–41, charcoal on paper (recto), British Museum, London, UK

This is a varied group of sketches for the *Last Judgement* that includes the authenticity of the signature of Michelangelo Buonarroti. Many sketches would have been made for this colossal work and many of them destroyed. Not every sketch would have been kept, but Michelangelo did sign some as gifts to admirers and some would have also needed a signature as proof that he had created them.

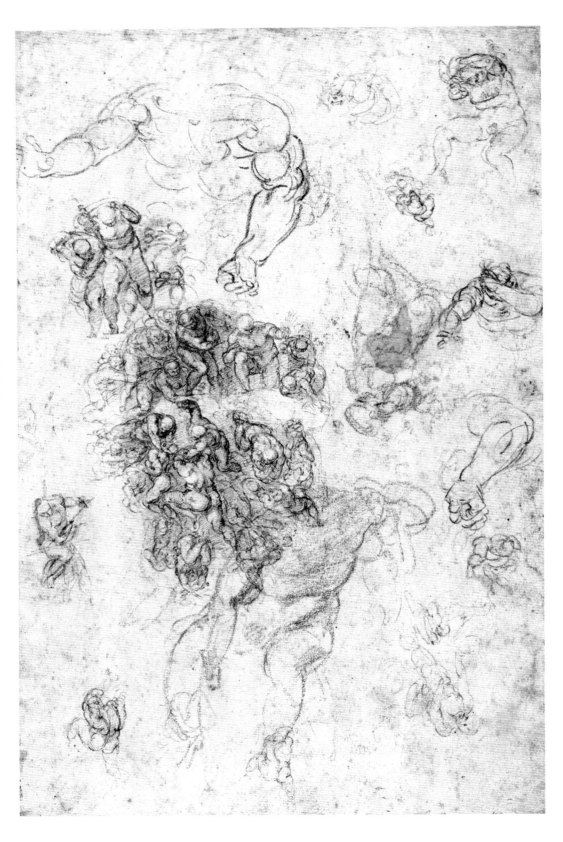

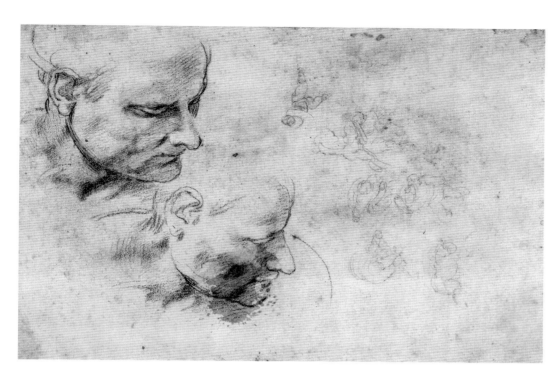

Study of a male head in two positions, *c.*1534–6, black and red chalk on paper, British Museum, London, UK

This sketch, studies of a male head in two positions, is a preparatory sketch for the cartoon sections of the *Last Judgement*. Two heads in right profile are drawn one below the other. The upper face is detailed. It is difficult to judge which figure head is in the finished work, but the drawing process is clear and an example of Michelangelo's method of refining the face and correcting the angle of each head.

Study for *Last Judgement* (crouching figure), *c.*1535–42, black chalk on paper, British Museum, London, UK

This is one of many figure drawings considered to have been created for various individuals depicted in the *Last Judgement*. The stance of the figure bears similarities to a sculpture of a crouching figure, by Michelangelo, originally intended for the New Sacristy of San Lorenzo, Florence.

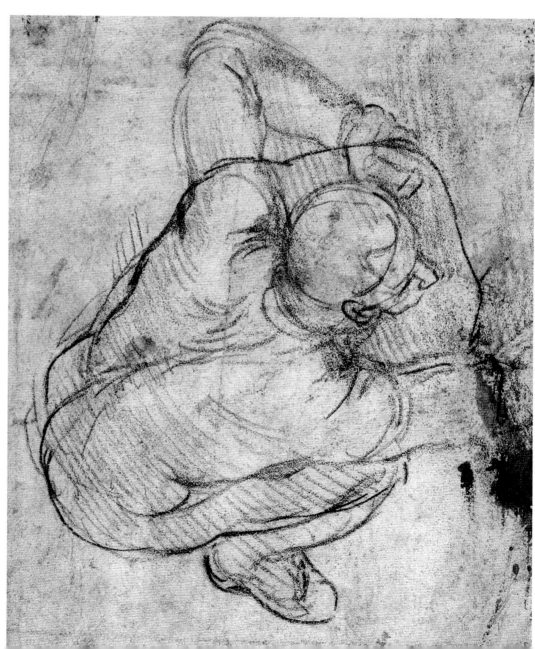

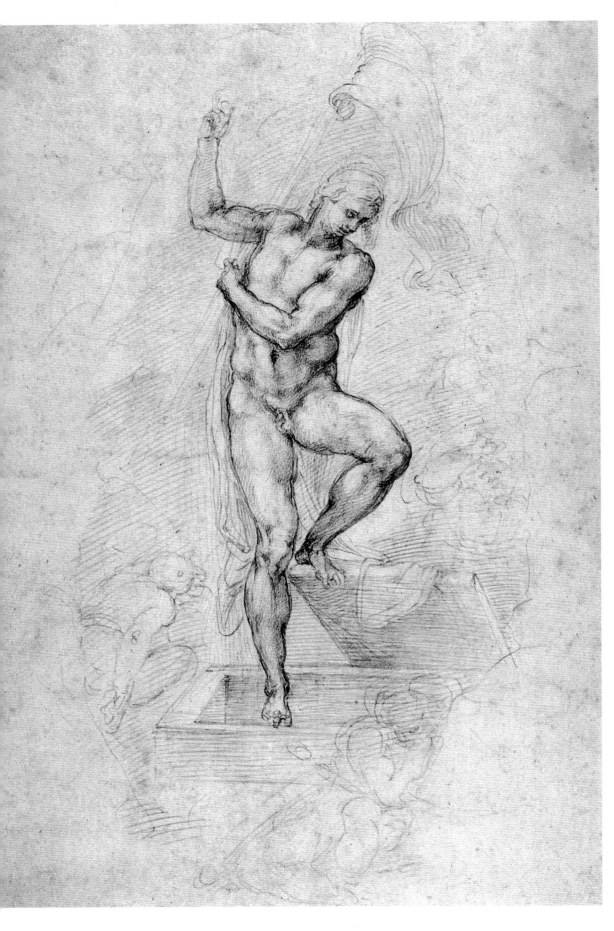

Study for the resurrection of Christ, *c*.1532, black chalk on paper, British Museum, London, UK, 40.5 x 26.9cm (16 x 11in)

Michelangelo depicts Christ framed within a mandola-shaped sepulchre. The naked figure of Christ emerges from the tomb. The left foot is placed on the open lid. His right arm and hand are raised and point upward. At the feet of Christ are figures of soldiers. In this study, one of several created for the *Last Judgement* fresco in the Sistine Chapel, Michelangelo has depicted the risen Christ, appearing from the sepulchre tomb with a banner in hand.

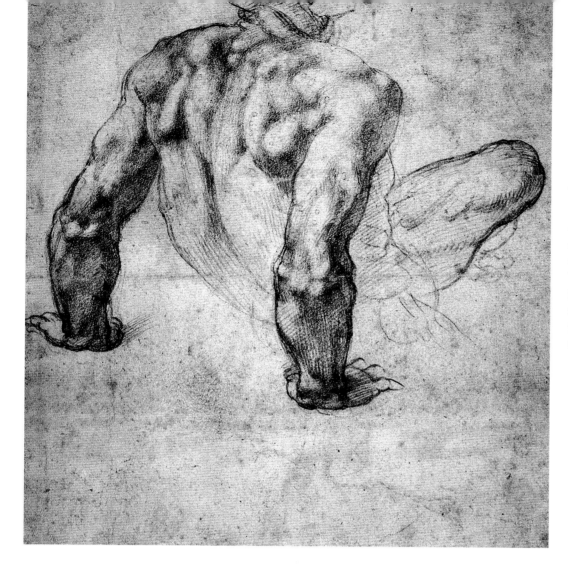

Study of a male nude seen from behind, *c.*1539–41, black chalk on paper (recto), British Museum, London, UK

This is a study for one of the souls emerging from a grave at the bottom left-hand corner of the altar-wall fresco of the *Last Judgement*. The study accentuates the muscular detail of the flesh and the weight of the body to be lifted by the strength of the arms.

Study for the arm of Christ, *Last Judgement*, 1535–41, black chalk on paper, British Museum, London, UK

The central figure of Christ in the finished fresco is muscular and bulky, a representation of Michelangelo's interest in depicting realism, and a reversal of his interest in the idealized male nude.

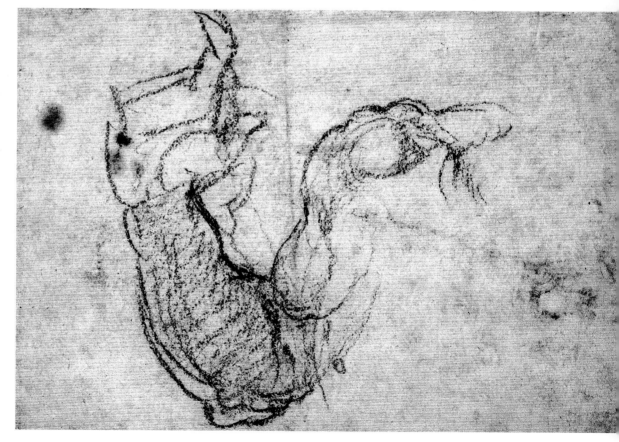

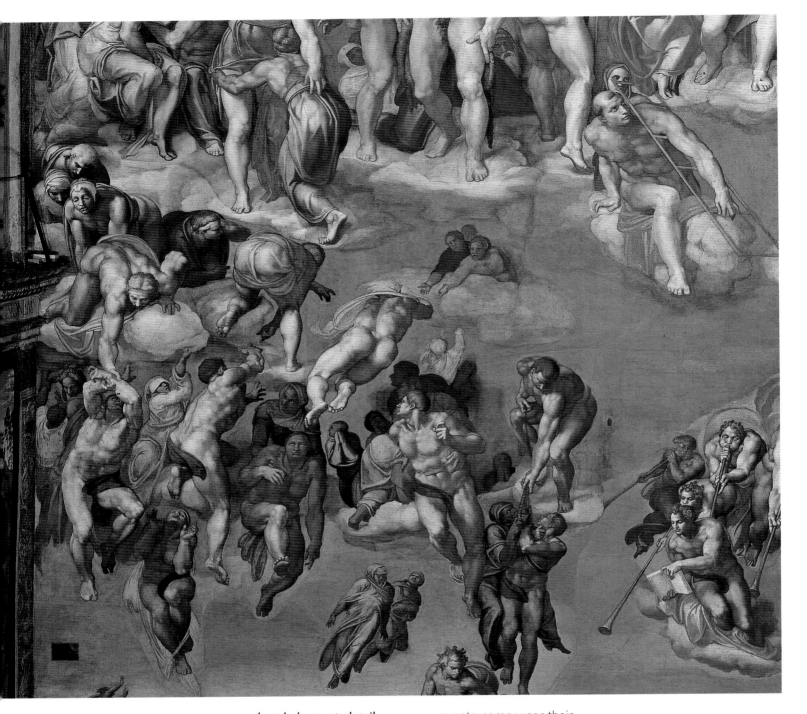

Last Judgement, detail
of the righteous drawn
up to Heaven

At lower and middle left
Michelangelo captures the
haphazard movement of
bodies as the righteous
are called to Heaven.
Some faces look fearful and
dazed, as if stupefied by
events; some wear their
funeral shrouds, some are
naked, some are in rags;
others, above them, help
to pull up those who have
been saved. The muscular
male nude figures, depicted
from every angle, have a
sculptural quality. The
foreshortened figures add
depth and movement.

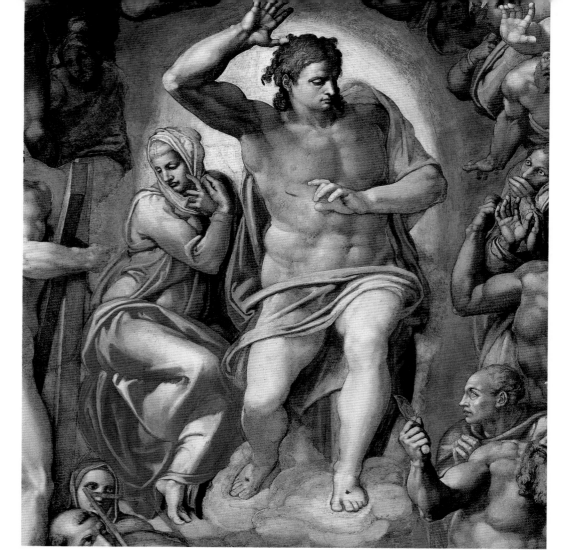

Last Judgement,
**detail of Christ and
the Virgin Mother**

Central to the *Last
Judgement* is the near-naked
figure of Christ. He appears
in a heavenly light. He has
a youthful appearance
and a muscular physique.
His right arm is raised
as he turns to his left to
admonish the damned,
descending to the
underworld. To his right sits
the figure of his mother
Mary, dressed in red and
blue. She keeps close to
him, staring out at the
scene of chaos around her.

Last Judgement, **detail of
St Bartholomew
holding his flayed skin**

St Bartholomew, one of the
twelve Apostles of Christ,
was flayed alive and then
crucified for his beliefs.
The saint is depicted old,
naked, bald and bearded.

He sits looking at the
instrument of his torture,
the flaying knife, which he
holds up in his right hand.
His flayed skin, held in his
left hand, droops below him.
The face on the skin is
considered to be a self-
portrait of Michelangelo.
It looks forlorn and weary.

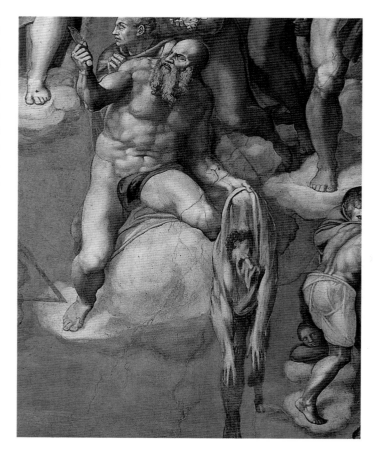

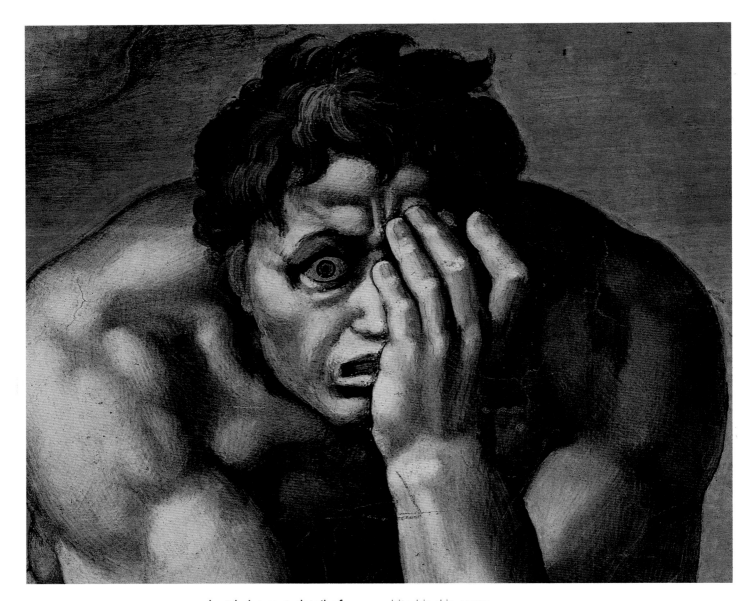

Last Judgement, **detail of one of the damned**

The fear of the damned is etched in the expression of this young man. His muscular body is of no use to him as devilish creatures bite his skin, wrap themselves around his body and pull him downward toward eternal damnation. He covers his face with his hand and then opens one eye to peer out at the scene laid before him.

Last Judgement, detail of
angels and archangels
with trumpets

According to the text in The
Book of Revelation (New
Testament), seven angels
with trumpets at their lips
will call the dead from the
four corners of the Earth to
rise up and be judged. In the
fresco the angels hover
below the figure of Christ in
Heaven and above the Earth
and the gloom of Hades.
They hold two books, one
of which is the Book of
Life, which will determine
the fate of the dead.

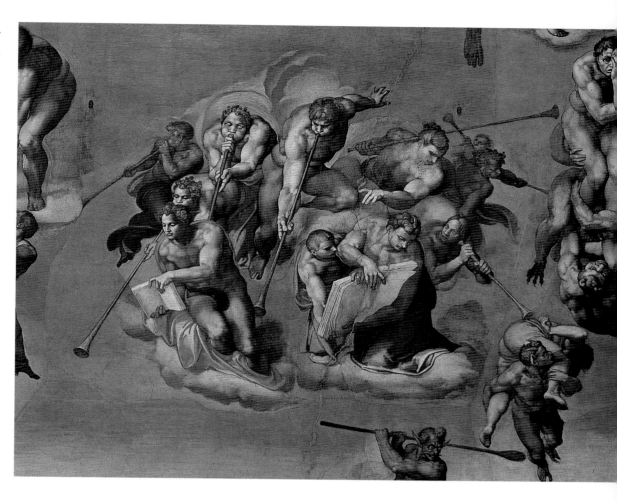

Last Judgement, detail of
Saints Blaise, Catherine
of Alexandria and Sebastian

Each saint is depicted with
the instruments of their
torture and martyrdom.
St Blaise holds two large iron
wool combs, used to rip the
flesh from his body before
he was beheaded. St
Catherine holds a piece
of the spiked wheel on
which she was tied.
After the wheel broke she
was beheaded. St Sebastian
holds the arrows that
were shot into his body.
Found to be still alive, he
was then clubbed to death.

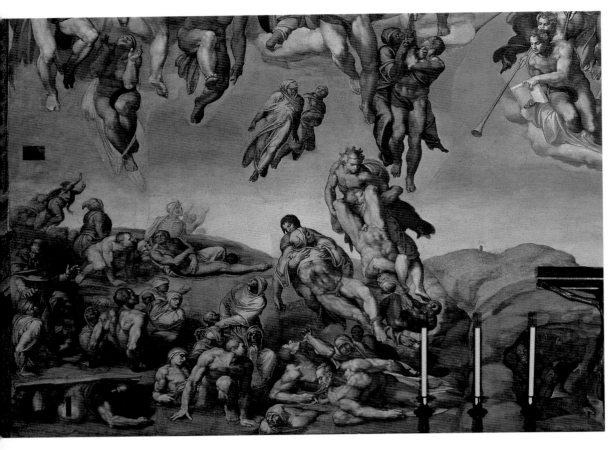

Last Judgement, detail of the resurrection of the dead

At lower left Michelangelo illustrates the moment when the dead are resurrected on the last day for their final judgement. The scene is murky, set in fields and cemeteries. The bodies of the dead are awakened by the angels' trumpets. Some stumble to their feet. Others are pulled from their graves. Their bodies are wrapped in various forms of clothing from funeral shrouds to rags; some are naked. They represent the living dead.

Last Judgement, detail of the boat of Charon

Michelangelo has taken his depiction of the boat of Charon from Dante's description in the *Inferno*. Charon the ferryman ferries the damned across the river Acheron in his boat, to deposit them at Minos's feet, at the entrance to the Underworld. Charon's repulsive features are accentuated in the greenish body, devilish face and over-sized muscular legs, thighs and arms. Such is his wanton cruelty that the damned can hardly wait to jump ashore.

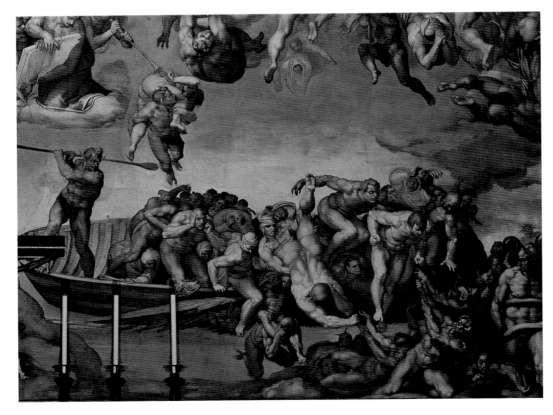

Last Judgement, detail
of the damned

To the left of the figure of
Christ (the viewer's right),
the damned descend to
eternal damnation. Angels
punch them and push them
downward, and the sinners
plummet toward the boat
of Charon, their one-way
journey to the Underworld
and everlasting torment.
Michelangelo depicts
the swarthy bodies of the
damned, some of which
are mauled as they are
pulled downward by
devilish creatures. Some
are carried down by devils,
to hasten their journey.

Conversion of St Paul (Saul), 1542–50, fresco, Cappella Paolina, Vatican, Rome, Italy, 6.3 x 6.6m (20.6 x 21.8ft)

This giant fresco depicts the conversion of the Roman soldier Saul of Tarsus, as he becomes St Paul, on the road to Damascus (Acts 9:1–9). En route to getting authorization from the synagogue to arrest the Christians, the crowd disperses in every direction. Saul's horse has bolted and one can see it rear up as an attendant reins it in. Some gather around Saul to aid him. They look up in disbelief at the beam of light which falls on the Roman soldier. One attendant covers his own body and head with a shield, for protection. Michelangelo creates a spectacular moment of chaos as bodies twist and turn.

Conversion of St Paul, detail
of the figure of St Paul

Saul falls from his horse.
His attendants rush to help
him. Saul is converted to
Christianity and receives the
name Paul, now St Paul.
In the fresco Michelangelo
depicts Saul at the moment
the light of God shines upon
him. His lifts up his head; his
face is panic-stricken.
He tries to cover his eyes
with his hand to shield it
from the light, which is
blinding him.

Conversion of St Paul,
detail of Christ and the
thunderbolt of light

Saul is struck down by a
blinding light delivered by
Christ who appears from the
heavens. The thunderbolt of
light in the shape of a
crucifix separates the picture
frame into light and
darkness. An aura of light
surrounds the descending
figure of Christ who flies
forward. His muscular body
is wrapped in robes.
His naked right arm
stretches forward toward
the figure of Saul, and his
left arm is held back to
calm the heavenly beings
around him.

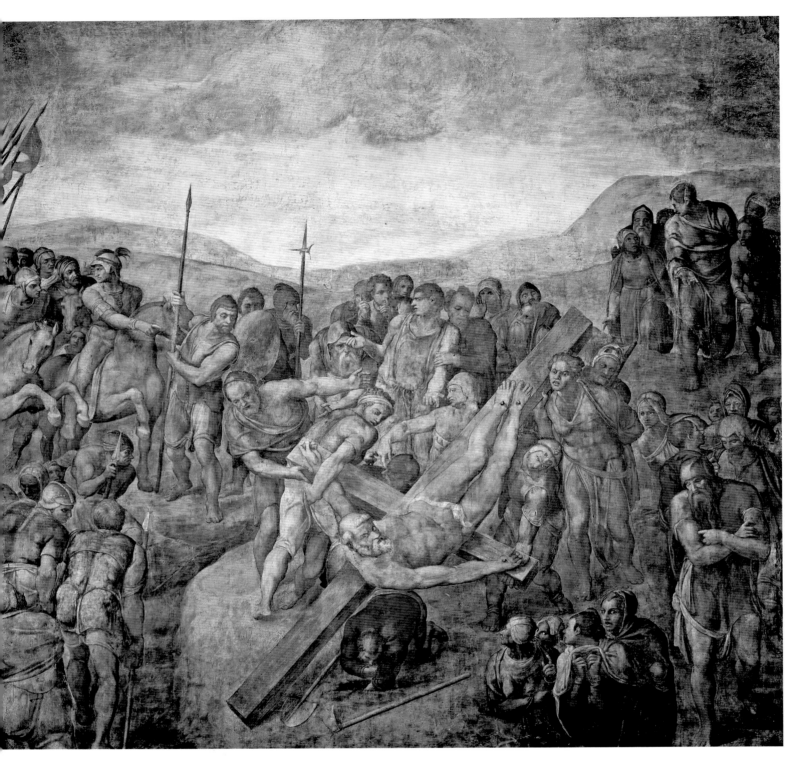

Crucifixion of St Peter,
1546–50, fresco, Cappella
Paolina, Vatican, Rome, Italy

Michelangelo depicts a
moment of realism as the
inverted wooden crucifix of
St Peter is positioned in the
ground. One man kneels
down to clear soil from the
hole. The spades used to
dig the hole are still visible
nearby. St Peter has been
nailed to the cross. The
soldiers prepare to pull
it up into position. The
crowds gather and hover
to watch the event.
Some look away in despair,
others eagerly watch with
interest. St Peter's head and
shoulders swivel around to
stare at us, the viewers who
observe the scene. Is his
expression one of anger?
His brow is furrowed and
his eyes are fixed ahead.
St Peter chose to be
crucified on an inverted
cross, not considering himself
worthy of being crucified in
the same way as Christ.

Crucifixion of St Peter,
detail of old man

The figure of an old man at
bottom right of the picture
frame walks with arms
folded. He stands passively
to the right of the cross of
St Peter. This is thought to
be a self-portrait of
Michelangelo. The artist was
in his seventies during the
production of the Cappella
Paolina frescoes. The body
language of the tall, muscular
figure is one of resignation.
He is present at the
martyrdom but takes no
part. The finely drawn face
of the old man looks down
sadly at the event taking
place. If this is a self-portrait
of Michelangelo, he
has depicted himself
troubled, resigned and
near despair. The Pauline
Chapel frescoes took a
period of eight years to
complete. During this time
he was taken ill, suffering
from kidney stones.
He also encountered further
problems over the contract
of the Julius II tomb.

Study for the *Crucifixion of
St Peter* depicting a group
of soldiers, c.1540,
charcoal on paper, Museo
Nazionale di Capodimonte,
Naples, Italy

This preparatory cartoon
depicts a group of three
soldiers. The same group
can be seen to the bottom
left of the finished fresco of
the *Crucifixion of St Peter*.
As the soldiers climb to
higher ground, barely
interested in the crucifixion,
their muscular youthful
bodies are clearly visible
beneath the clothing. One
young soldier turns back to
talk to another behind him,
and their torsos twist and
turn, bringing movement
to the scene.

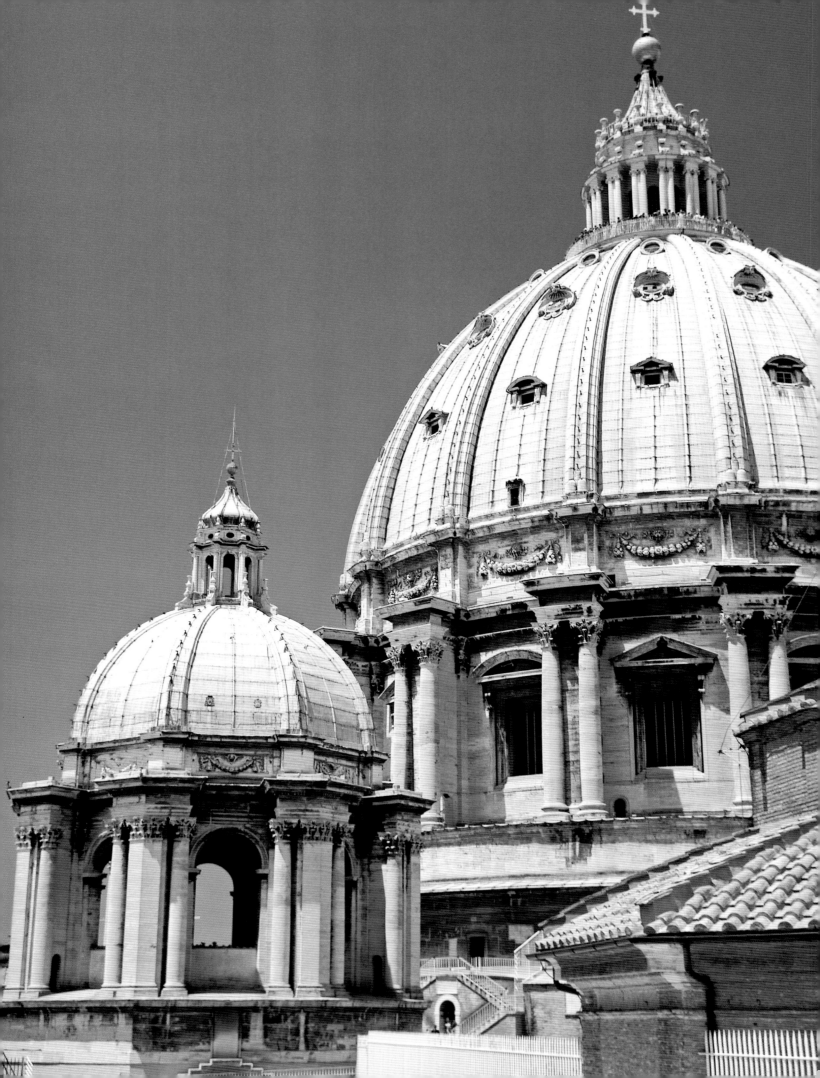

Architecture

Michelangelo's first major opportunity to practise architecture was given to him in 1514 by Pope Leo X, who commissioned a marble façade for the Medici parish church of San Lorenzo in Florence. Michelangelo's design was in the classical tradition but the plan was dropped on the pope's death. Soon afterward, a new Medici pope, Clement VII, commissioned a new sacristy and library for San Lorenzo, and it is here that one sees Michelangelo's inspired architectural compositions. The highest point in Michelangelo's career as an architect was achieved in 1547 when he became Chief Architect of St Peter's Basilica, Rome. He held the position until his death in 1564. He crowned the new basilica with a breathtaking dome, which, in the succeeding centuries, has come to represent the city of Rome.

Above: Study for a door with the papal arms above the pediment. Designed for the door between the vestibule and the Laurentian Library reading room, San Lorenzo, Florence.
Left: View of St Peter's Basilica, Rome. Its magnificent dome, copied worldwide, is a permanent testament to the architect who designed it.

Study of details of classical
architecture: architraves,
entablatures and columns,
c.1515–18, red chalk on
paper, British Museum,
London, UK, 27.9 x 20.8cm
(11 x 8.19in)

This drawing is
considered to show
preliminary outlines and
possible designs for the
commissioned façade
of the church of San
Lorenzo, Florence.

Study of details of classical
architecture, among which
is a column of the Temple
of Castor and Pollux in the
Roman Forum, c.1515–18,
red chalk on paper, British
Museum, London, UK,
27.9 x 20.8cm (11 x 8.19in)

The drawing reveals a
schematic representation
of the entablature of the
Temple of Castor, including
a section, possibly planned
for the façade of the
Medici parish church of
San Lorenzo, Florence.
The column to the left
is after a column and
architrave of the Temple of
Castor in the Roman Forum.

Exterior view of the Dome
of Santa Maria del Fiore
(Duomo), Florence, Italy

In 1516 Michelangelo created
new drawings for a proposed
gallery at the upper level of
the dome of the cathedral
of Santa Maria del Fiore, in
Florence. The large occuli,
which circle the dome, were
central to his design.

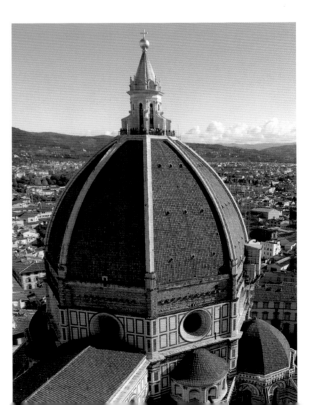

View of the cupola in the New Sacristy

Michelangelo created a domed roof for the New Sacristy, shown here from the interior room space. The dome is also visible on the exterior and is topped with a lantern designed by Michelangelo. Both the interior and exterior architectural form and decoration reference the earlier work of Brunelleschi in the Old Sacristy of San Lorenzo and the Pazzi Chapel in Florence.

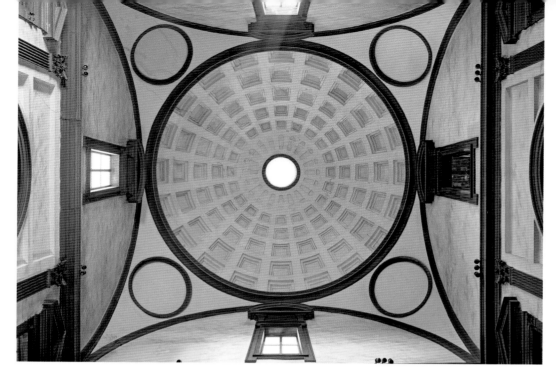

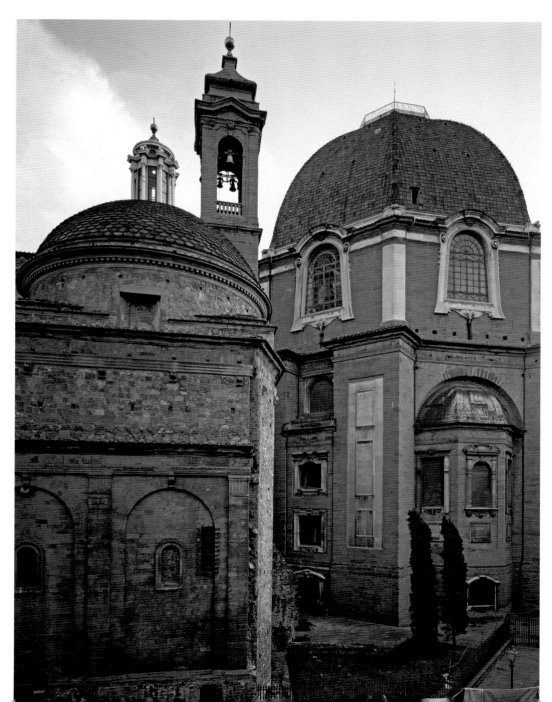

Exterior view of the Dome of the New Sacristy and the Chapel of the Princes, San Lorenzo

The exterior view of the dome (pictured left) of the New Sacristy, designed by Michelangelo, shows it to be saucer-shaped. A lantern circled with eight classical columns decorates the top. The dome is dwarfed by the much larger dome of the Chapel of the Princes (pictured right), designed by the architect Matteo Nigetti (1560–1649).

Design for a tomb, c.1521–34, red chalk on paper

In this drawing for a wall tomb one can see the beginnings of the final phase of planning. A figure is placed at the top of the architectural frame. In addition the leaning sculptures on top of the sarcophagus and the sculptures of river gods at ground level are visible. The sculptural programme adds movement and shape to the modular architectural framework.

View of the interior of the New Sacristy

It is only from behind the altar looking into the Sacristy that the whole architectural programme can be seen. This position unifies the entire concept, and is a view not possible from any other part of the inner room. From the altar end three marble sculptures are visible.

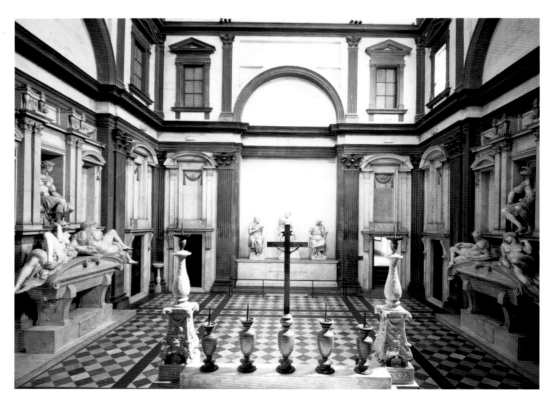

View of the interior of the New Sacristy

The original plan for a solid free-standing monument with four individual tombs decorating the outer framework on each side was dropped due to lack of space. A new plan proposed one double wall tomb (unrealized) and two single wall tombs. The altar was to face the double wall tomb. The architectural framework for the walls and the ceiling, shown here, sympathetically acknowledges the design layout created by Brunelleschi in the Old Sacristy.

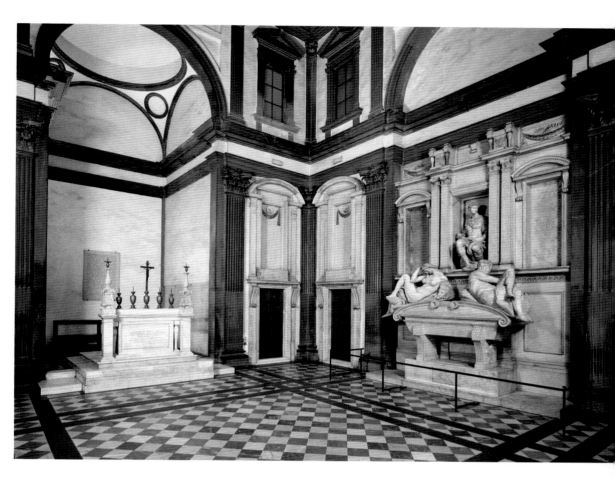

Decorative tabernacle (detail), New Sacristy, San Lorenzo, marble

In the architectural space of the new Sacristy, the wall tombs of Lorenzo and Giuliano de' Medici and the altar are flanked by decorative empty niche tabernacles, each with classical columns, an arched pediment and a decorative garland, which are suspended over the doors (not shown). The niches accentuate uniformity of design and emphasize symmetry and harmony within the architectural scheme.

Staircase in the entrance vestibule of the Laurentian Library

This remarkable triple staircase is situated in the entrance vestibule that leads up to the Laurentian Library on the first floor. Michelangelo intended the centre stair for dignitaries and the side staircases for lower ranks and servants. The result is an overpowering sense of architecture in sculptural form. The stair was built in 1559 by Bartolommeo Ammannati to Michelangelo's earlier design. The two side staircases, offshoots of the main stair, are more decorative than they are usable. Each abruptly terminates two-thirds of the way up to join the main stair. This focuses attention on the larger central staircase, leading up toward the grand entrance of the library.

Giant scrolls wall decoration, Laurentian Library vestibule

Two over-sized scrolls are joined to form the lower-wall corner decoration of the vestibule. The regular pattern of *pietra serena* paired scrolls, mirroring the paired engaged columns above, formed the decorative element of the lower walls.

Laurentian Library: entrance vestibule

A side view of the vestibule, which holds the Laurentian staircase, shows how it dominates the space. The staircase was not in place during Michelangelo's construction of the library and vestibule. The walls are decorated with an architectural framework, similar to the design of the New Sacristy. The upper-wall panels at first-floor level have blind tabernacle windows topped with alternating pediments. In the 1550s, Michelangelo (in Rome) sent his original drawings and terracotta model for the Laurentian staircase to Bartolommeo Ammannati in Florence. They cannot have discussed the project in any detail, for the staircase is made of granite. Michelangelo, on hearing criticism of the finished work, said that he had planned the staircase to be made of wood, to match the interior of the library. This would have perhaps created a less intrusive result.

Laurentian Library vestibule: detail of the side staircase

The side staircases in the vestibule include decorative detail borrowed from the classical language of architecture that has been manipulated to fit the design. Two elongated volutes (one pictured) are placed, one on each side, at the termination of the smaller stairs. Without the triple staircase the architectural framework of the room, which is spaced out over three levels, complements the architecture of the library.

Laurentian Library vestibule: frontal view of the staircase

The shape of the oval stairs on the central staircase was favoured by Michelangelo. The oval lozenge shapes seem to increase in size as they spill down, like a lava flow down a mountainside, from the grand first floor library entrance to the vestibule below. The stairs lead to the grand library entrance. Paired columns are placed on either side of the door, which is topped by a triangular pediment.

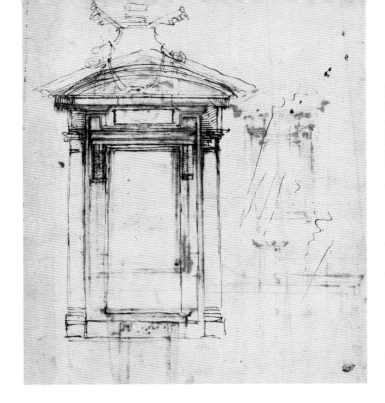

Design for the Laurentian Library door, *c.*1526, brown ink on paper over stylus; leadpoint (recto), British Museum, London, UK

This is a study for the Laurentian Library door, between the reading room and the vestibule. The sketch details a window frame with a double pediment and a coat of arms, based on the structure of an ancient triumphal arch. Michelangelo's design for the window frame is classical in its detail.

Study for the ceiling of the Laurentian Library, 1524, pen and ink on paper, Ashmolean Museum, University of Oxford, UK

This quickly drawn study for the Laurentian Library ceiling includes the placement of the pilasters (at the top edge) to correspond to the wooden beams of the ceiling and the decorative design for the ceiling.

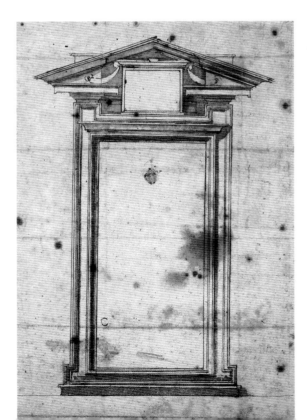

Drawing of a door for entrance into the Laurentian Library vestibule, 1526, pen, ink and wash on paper, Casa Buonarroti, Florence, Italy

Originally planned as a decorative tabernacle for the vestibule, the design was used for the entrance door from the vestibule into the reading room. Michelangelo took his inspiration from the architectural design of Roman antiquity to create original variations, which brought together the sculptural and architectural

elements of both the vestibule and the reading room. The door frame was designed to include a panel for an inscription, enlarged in later designs because Pope Clement VII wanted the dedicatory inscription in Latin, using around 100 words. Giorgio Vasari wrote, "Later Michelangelo sought to make known and to demonstrate his new ideas in the library of San Lorenzo; namely, in the beautiful distribution of the windows, the pattern of the ceiling and the marvellous entrance of the vestibule." *Lives,* 1550.

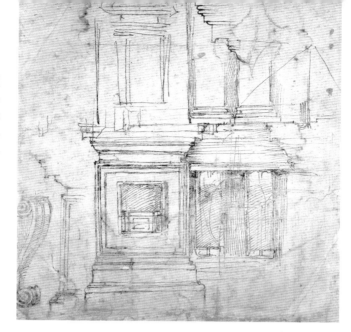

Study for architectural details of the Laurentian Library, 1525, pen and ink on paper, British Museum, London, UK

This design is close to the final scheme that was used for the library. The sketch details the architectural framework, the panels, columns and pilasters.

Laurentian Library: reading room

The central stair from the vestibule leads into the reading room of the Laurentian Library, built above a cloister in the convent of San Lorenzo. It is a long room with wooden reading desks on each side. Light pours in from the symmetrical rows of windows. The windows have decorative pilasters at either side, creating an architectural frame. The placement of the pilasters corresponds to the beams of the ceiling.

Reading-room wooden desks and seats, Laurentian Library

The design incorporates a seat-and-desk combination, which enables the user, seated at a comfortable distance, to place books in the light-filled space on the sloping display desk. The carved side panels of the desk and the ornamental volutes on the seat and desk add a sculptural quality and complement the wall of pilasters and window frames.

Drawing of the façade of Palazzo Senatorio

The Palazzo Senatorio (Senatorial Palace), in its central position on the Piazza del Campidoglio, links the Palazzo dei Conservatori to its right and the Palazzo Nuovo (now the Museo Capitolini) to its left. Michelangelo designed the building's façade, but the work was overseen by Giacomo della Porta, and from 1602 by Girolamo Rainaldi. The River Gods to either side of the central fountain represent the Tiber and the Nile.

Engraving of the Piazza del Campidoglio (source: *Antiquae urbis splendor*, Rome 1637, plate 157), 1610s, by Giacomo Lauro

The construction of the Piazza del Campidoglio on the Capitoline Hill was completed after Michelangelo's death. The older buildings received classical façades and a new building, Palazzo Nuovo, was built purely for the purpose of bringing symmetry and proportion to the open space. The bronze equestrian statue of Emperor Marcus Aurelius adds a focal point to the 'interior' room space. The Piazza del Campidoglio, planned from 1538, is situated at the heart of Rome's ancient city. The intention was to create a new civic space from what was then a derelict area. Michelangelo ingeniously linked the five road entrances of the hilltop site. The addition of classical façades to the three buildings sited in the piazza creates an open-plan harmony. The magnificent *cordonata* – the wide sloping surface made of stone – acts as a formal entrance and stairway to the open space.

View of the Palazzo Nuovo and equestrian statue of *Marcus Aurelius*

The trapezoidal shape of the Piazza del Campidoglio is contained by the façades of three buildings. The Palazzo Nuovo (a name originally given because the purpose of the building was undecided) has a two-storey façade that mirrors that of the Palazzo Conservatori opposite. The equestrian bronze statue of Emperor Marcus Aurelius provides a focal point. The statue's marble base was designed by Michelangelo, and its oval shape defines the whole piazza.

View of Rome: the Piazza del Campidoglio and the Cordonata, c.1742–50, oil on canvas, by Giovanni Antonio Canal (Canaletto), private collection, 87.5 x 138cm (34.4 x 54in)

The *cordonata* (wide sloping staircase) leading up to the Piazza del Campidoglio on the Capitoline Hill is a symbolic formal entrance to the sacred area of the ancient city and to the Roman Forum beyond. The piazza was drawn and painted by many artists who visited Rome, including the Venetian painter Canaletto. This painting illustrates the piazza from the *cordonata*.

Aerial view of the Piazza del Campidoglio, Rome

From above the enclosed 'open room' plan, created by Michelangelo to unite the diverse buildings and various foot and road entrances, can be clearly understood. This once derelict area, renewed by Michelangelo's plan, now links the ancient Roman Forum to the modern city of Rome. The geometric pattern on the surface of the piazza floor links the various elements of the hilly area to harmonize buildings, open space and the equestrian statue.

St Peter's Basilica, Rome: view of the dome

In 1546, Michelangelo, as Chief Architect of St Peter's Basilica, was continuing the design and construction work of a succession of architects who had worked on the project since 1505. His input, other than overseeing work in hand, was limited. He concentrated on the design of the main dome of the basilica. It was designed by Michelangelo and completed by Giacomo della Porta. From the top of the dome the height of St Peter's reaches to 136.5m (448ft). The dome measures 42m (138ft) in diameter.

Dome of St Peter's Basilica, 1694, print drawing, by Carlo Fontana, private collection

An exterior view of the dome and cupola of St Peter's Basilica drawn by Carlo Fontana c.1694 was published in his catalogue of drawings *Templum Vaticanum*. It shows the drum buttressed by pairs of attached columns, placed beneath the outer ribs of the dome. The double columns were in place (or being put in place) at the time of Michelangelo's death.

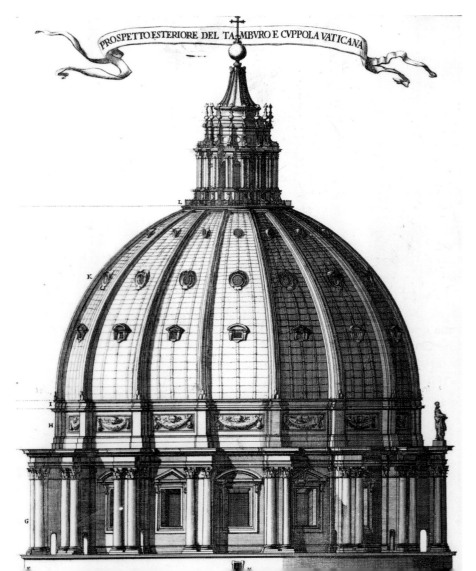

PROSPETTO ESTERIORE DEL TAMBVRO E CVPPOLA VATICANA

Model of the dome of St Peter's Basilica, c.1588–91, wood, Giacomo della Porta, Museo Petriano, Rome, Italy

From 1572, Giacomo della Porta continued Michelangelo's design plan for the dome. To aid his work he created a large wooden model of the dome, accurately based on the many drawings Michelangelo had produced for its construction. The dome of St Peter's was finally constructed by della Porta in 1588–91.

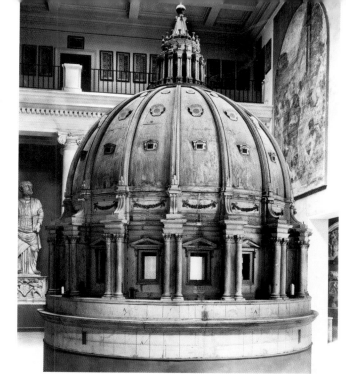

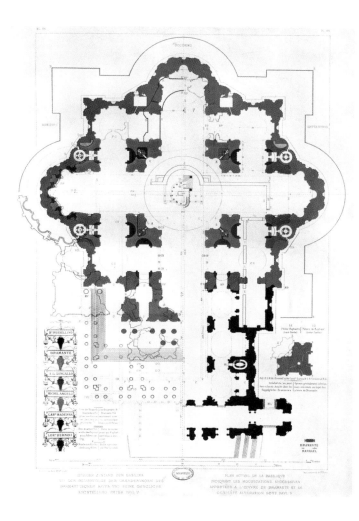

Plan of St Peter's Basilica, lithograph, French School (19th century), École Nationale Supérieure des Beaux-Arts, Paris, France

This complex ground plan reveals the stages of the design and construction of the new Basilica of St Peter's in Rome. The original idea for a church designed on a Greek cross plan would have left much of the basilica of the old St Peter's visible. The addition of a nave accommodated a larger congregation.

Plan of the drum of the cupola of the Church of St Peter's Basilica, pen and ink on paper, c.1546, Galleria degli Uffizi, Florence, Italy

On his acceptance of the post of Chief Architect of St Peter's Basilica, Michelangelo returned to the original design plan created by Donato Bramante. He removed much of the work created under his predecessor Antonio da Sangallo's supervision, destroying the southern ambulatory. He worked to a Greek-cross plan once more, which included a large dome at the central crossing.

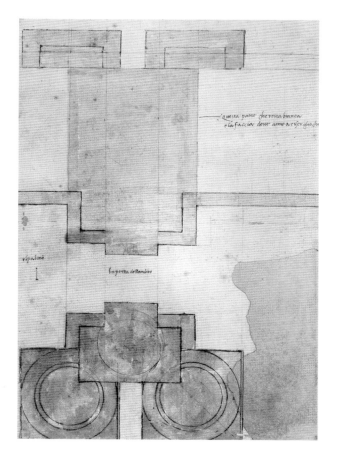

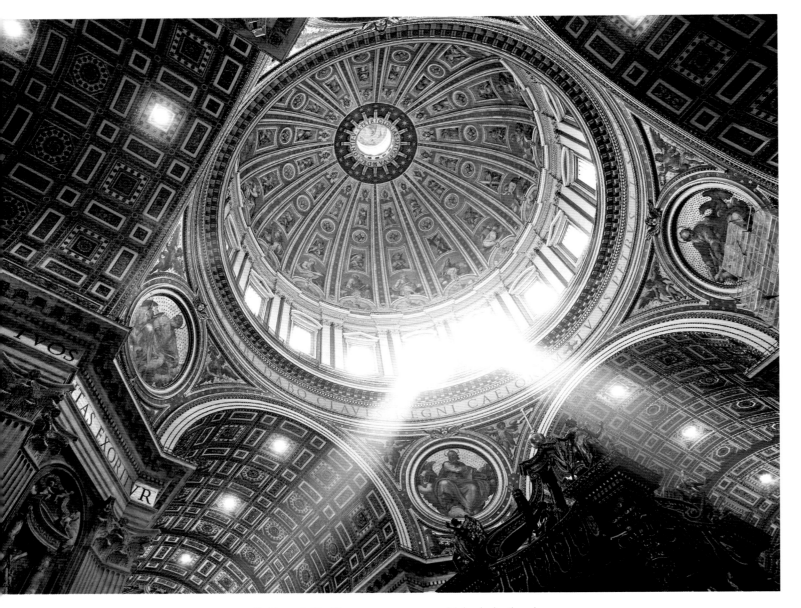

**St Peter's Basilica:
interior of the dome**

The spectacular interior of the dome of St Peter's Basilica was completed by Giacomo della Porta. The symmetrical openings, which circle the drum, allow light to pour into the interior space. The dome was designed with inner and outer shells of bricks, much like Brunelleschi's dome for the cathedral of Santa Maria del Fiore in Florence.

Study of the lantern for
St Peter's Basilica, c.1557,
black chalk, pen and ink on
paper, Ashmolean Museum,
University of Oxford, UK

The lantern tops the
exterior of the dome.
Michelangelo's drawing,
created c.1557, shows how
the lantern fits into the
inner and outer brick shells
of the dome structure.

St Peter's Basilica: view of the interior cupola

The interior of the cupola
of the dome of St Peter's
Basilica, rising above the
bronze *baldacchino*
created by the 'Baroque
Michelangelo' Gianlorenzo
Bernini (1598–1680) in
1633, continues to enthral
visitors today, much as it
did the Grand Tourists of
Europe. They viewed and
noted the ancient ruins,
and also took time to
study and wonder at
the art and architecture
of Michelangelo.

Palazzo Farnese, Rome, 19th century

Palazzo Farnese is three storeys high and thirteen bays wide. Four architects were involved in its design and construction, commissioned by Cardinal Alessandro Farnese (1468–1549). The initial design, created by Antonio da Sangallo the Younger (1484–1546), c.1513, was extended and embellished in 1534 when the Cardinal was elected Pope Paul III. A further redesign took place in 1541. Michelangelo became involved in the project in 1546. The palazzo has been the residence of the French Embassy since 1635.

Palazzo Farnese, Rome: inner courtyard

Michelangelo's designs for the inner courtyard centred on the façade and upper levels, continuing the work of Antonio da Sangallo the Younger. The façade of the inner courtyard is embellished with Doric, Corinthian and Ionic columns, used in ascending order on each level, informed by the decorative architectural design of the ancient Colosseum in Rome.

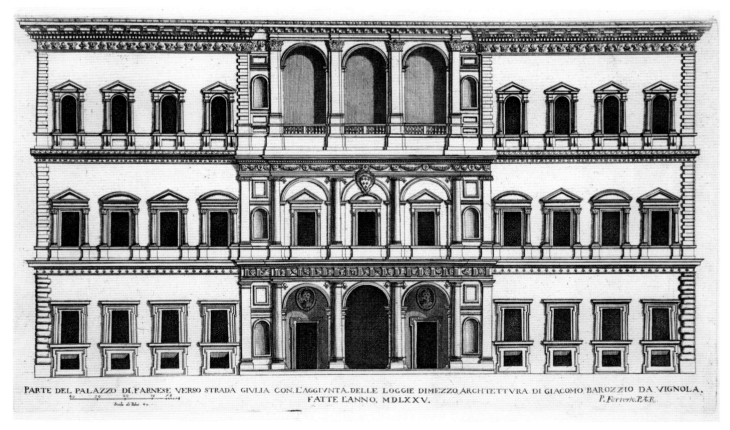

PARTE DEL PALAZZO DI FARNESE VERSO STRADA GIVLIA CON L'AGGIVNTA DELLE LOGGIE DIMEZZO ARCHITETTVRA DI GIACOMO BAROZZIO DA VIGNOLA. FATTE L'ANNO. MDLXXV.

P. Ferreria P.A.R.

Palazzo Farnese, engraving (from *Palazzi di Roma*, Part I, published 1655) by Pietro Ferrerio (1600–54) or G.B. Falda (active 1648–78), private collection

Michelangelo won a competition held *c*.1546 to design a cornice for the building and then, after Sangallo's death in 1546, he continued with the Farnese project.

His plan was to aggrandize the exterior façade with an impressive cornice on a colossal scale. He was also involved in the inner-courtyard design. After Michelangelo's

death the commission passed to Giacomo da Vignola (1507–73), followed by Giacomo della Porta. The project was completed in 1589.

Palazzo Farnese: lateral view of the façade

The angle of this photograph, giving a lateral view of the façade, highlights the colossal cornice that overhangs the building. Michelangelo designed the cornice in 1546. Its design acknowledges the cornice design of some of the buildings known to him in Florence, such as the Palazzo Rucellai (Leon Battista Alberti) and the Palazzo Strozzi (Benedetto da Maiano), and also references the buildings of ancient Rome.

Palazzo Farnese: detail of interior courtyard façade

The inner courtyard of the palazzo is one of the most impressive of all Renaissance palaces. The two lower floors and the arcades were built in line with Antonio da Sangallo's 1515 design. Later, Michelangelo altered the design of the balustrades and frieze at the first-floor level.

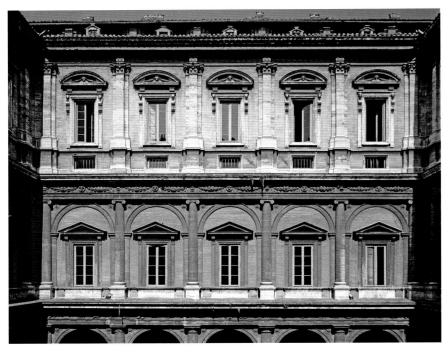

Palazzo Farnese: study for a window with triangular gable, c.1546, black chalk, wash, pen and ink, Ashmolean Museum, University of Oxford, UK

This is one of the extant studies drawn by Michelangelo in execution of the upper storey windows of the Palazzo Farnese. This sketch illustrates the detail of a window frame. Although none of Michelangelo's drawings show the third-storey construction, the design of the window frame in this drawing links it to the project.

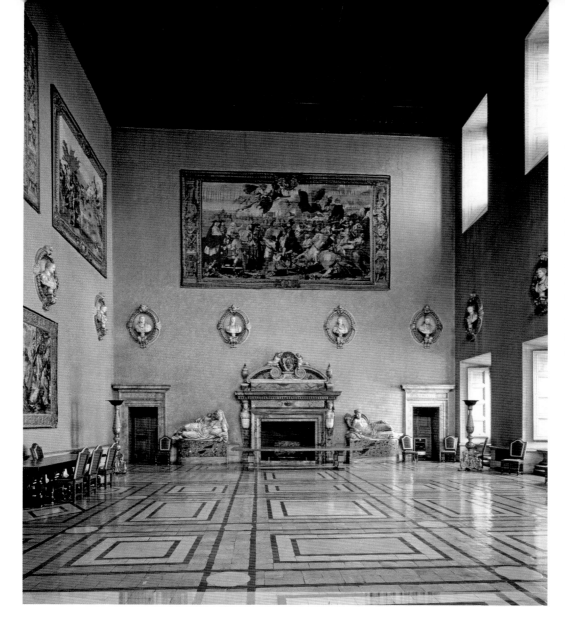

Palazzo Farnese: Sala delle Fatiche d'Ercole

The Sala delle Fatiche d'Ercole (Hall of the Labours of Hercules) housed some of the Farnese collection of antique sculptures. Much of the collection, including the Farnese *Hercules*, was taken to Naples by the Bourbon family in the 18th century. The wall decoration and the overall design of the hall mirrors the exterior classical design of the building.

Palazzo Farnese: the main corridor of the piano nobile

The simplicity of the classical design of the Palazzo Farnese is expressed in the main corridor of the piano nobile (first floor). While four different architects were involved in the design of the building complex, the essence of its classical roots is consistent. The wealthy Roman patrician Pliny the Younger (AD61/3–113), a witness to the eruption of Vesuvius in AD79, would have recognized much of the design as inspired by the architecture of ancient Rome.

Porta Pia, Rome (monumental exit from Rome)

The gatehouse is a monumental exit, not a defence barrier. Atypically it was the inner-city façade rather than the outer-city entrance that was given importance. Michelangelo considered the gatehouse in relation to the surrounding city walls and medieval streets. His design is a fusion of classical and medieval iconography. The central entrance of the gatehouse is ornamented with a classical arch structure, including rustication and a grandly embellished pediment. A Latin inscription within the pediment records the construction of the gatehouse and the Via Pia by Pope Pius IV. The arch is dressed with Tuscan Doric pilasters and extended capitals. Michelangelo was fond of using blind windows (window frames used for decoration) and they appear in many of his architectural works. The wall decoration of the New Sacristy and the vestibule of the Laurentian Library at San Lorenzo are notable examples. The most recognized are perhaps the blind windows created for the Palazzo Medici in Florence, to decorate a bricked-up entrance.

Santa Maria degli Angeli, Rome, façade

The Basilica of Santa Maria degli Angeli is contained within the ancient Baths of Diocletian, which date from AD306. Michelangelo was given the commission to convert the vast central hall of the ancient building into a church for the Carthusian monastery, which was situated on the site. Work began in 1563 and stopped in 1566.

Santa Maria degli Angeli, Rome, interior view toward the chancel, 1563–6

In 1561, Pope Pius IV consecrated part of the monumental halls of the Baths of Diocletian (AD306) as the new church and monastery of Santa Maria degli Angeli. Michelangelo was commissioned in 1563 to restore and refurbish a section of the interior space of the Baths to create the church. Due to continuing restoration in the 18th century, Michelangelo's original design was altered.

Studies for an architectural composition in the form of a triumphal arch, c.1516, black chalk with pen and brown ink on paper, British Museum, London, UK

Michelangelo created many architectural drawings based on the ancient Roman triumphal arch. One design was initiated for the New Sacristy memorial tombs for the Medici. However, a triumphal-arch plan for the monumental free-standing tomb of Pope Julius II, initially discussed with Michelangelo in 1505, was withdrawn in 1506, and barely realized in the completed wall tomb of 1545.

Studies for a monumental wall tomb, 1525–6, pen and brown ink on paper, British Museum, London, UK

A projected plan to create a double wall tomb in the choir of San Lorenzo was possibly intended for two Medici popes, Leo X (1513–21) and Clement VII (1523–34). This may have been taken from an earlier idea for a double tomb for the Medici brothers, Lorenzo the Magnificent (d.1492) and Giuliano (assassinated 1478), planned for the New Sacristy. The plan was abandoned due to lack of space.

Architectural studies, *c.*1560, black chalk on paper, Ashmolean Museum, University of Oxford, UK

The date of this drawing coincides with Michelangelo's design for the centrally planned church of San Giovanni de' Fiorentini, Rome, 1559–60. The commission was for a new church to replace an oratory used by the Florentine community. In 1560, Michelangelo was commissioned to design a chapel (Cappella Sforza) in Santa Maria Maggiore, Rome, for Cardinal Guido Sforza (d.1564).

Slight sketches of architecture and a small figure study (recto) and a fragment of a letter (verso), *c.*1518, pen and brown ink on off-white paper, 14.7 x 16.8cm (5.8 x 6.6in), Ashmolean Museum, University of Oxford, UK

The recto page of small architectural sketches includes a human figure and an octagonal building. A fragment of a letter in Michelangelo's handwriting (verso) can be seen through the page.

Architectural sketch with notes, c.1518, pen and ink, British Museum, London, UK

The paper shows a sketch for the lower section of the tomb of Pope Julius II. The writing is a directive from Michelangelo to his helper, the saddler Leonardo, in Florence, regarding the blocks of marble. His letter says that the marble for the façade has been cut and blocked, and he continues with instructions concerning where to find all the pieces.

Architectural sketch, c.1518, pen and ink, British Museum, London, UK

This is one of a series of drawings showing an octagonal structure, possibly part of a project for a memorial tomb structure.

A page of sketches
of columns and faces,
pen and ink and pencil on
paper, British Museum,
London, UK

Here Michelangelo has
sparingly used his paper,
to include sketches of
column bases and faces.

**Doric order from the
Theatre of Marcellus
(capital and entablature).
1515–18, red chalk on
paper, British Museum,
London, UK, 28.8 x 21.6cm
(11.3 x 8.5in)**

This freehand drawing
illustrates the antique Doric
order with capital and
entablature, identified as
part of the Theatre of
Marcellus, Rome (22–13BC).
Michelangelo repeats the
entablature's mutules detail
in the top right-hand
corner. This drawing is
the reverse page of the
drawing above, revealing
Michelangelo's close study of
ancient Roman architecture,
particularly capital and
entablature forms.

Studies for capitals, c.1517–18, brown ink on paper (recto), British Museum, London, UK, 27.4 x 21.3cm (10.8 x 8.4in)

These studies are for three types of ornate capital and a base. The top capital is of the Corinthian order; the lowest one of the Composite type. The centre capital is perhaps Michelangelo's own creation. In Greek architecture three capitals were in use: Doric, Ionic and Corinthian. The Roman architects added a Tuscan Doric and a Composite, to make the five classical orders of architecture.

Study of an Ionic capital and corner base, 1515–18, red chalk on paper, British Museum, London, UK, 13.3 x 21.2cm (5.2 x 8.3in)

Michelangelo's freehand drawing of an Ionic capital and base is considered to possibly be informed by Ionic capitals found in the Basilica of Santa Maria in Trastevere, Rome, which dates from the 4th century. The 12th-century interior of the church has 21 giant Roman columns and capitals, installed from various other buildings.

Study of decorative column capitals, 1515–18, red chalk on paper, British Museum, London, UK, 28.8 x 21.6cm (11.3 x 8.5in)

Michelangelo's freehand drawing of details of classical architecture illustrates ten decorated Doric capitals, of which three are in profile. This drawing is on the reverse page of the drawing below. At the time this drawing was created, Michelangelo was designing a façade for the church of San Lorenzo, the Medici parish church in Florence. Drawings and a model show the façade to be informed by Roman classical architecture. The antique Doric and Tuscan Doric capital was traditionally plain, without decoration.

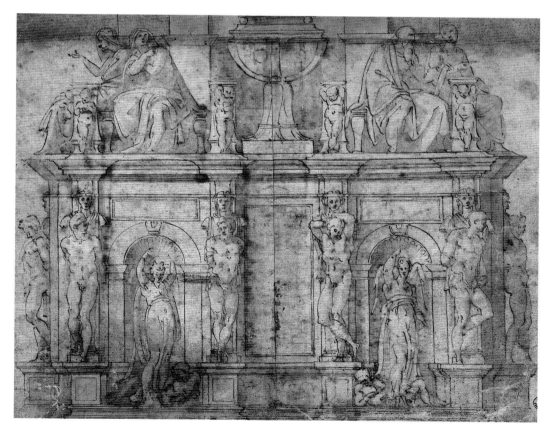

Tomb of Pope Julius II, 1513, pen and ink and wash on paper, Gabinetto Disegni e Stampe, Galleria degli Uffizi, Florence, Italy (copy by Aristotele da San Gallo of the now lost original drawing by Michelangelo)

The drawing illustrates the second version of the proposed tomb for Pope Julius II. The initial project was for a freestanding tomb with 40 marble sculptures. After spending about eight months in Carrara, choosing the marble, Michelangelo found that the pope had decided to defer the commission. After the pope's death in 1513, a new plan for the tomb was drawn up in agreement with Julius II's family.

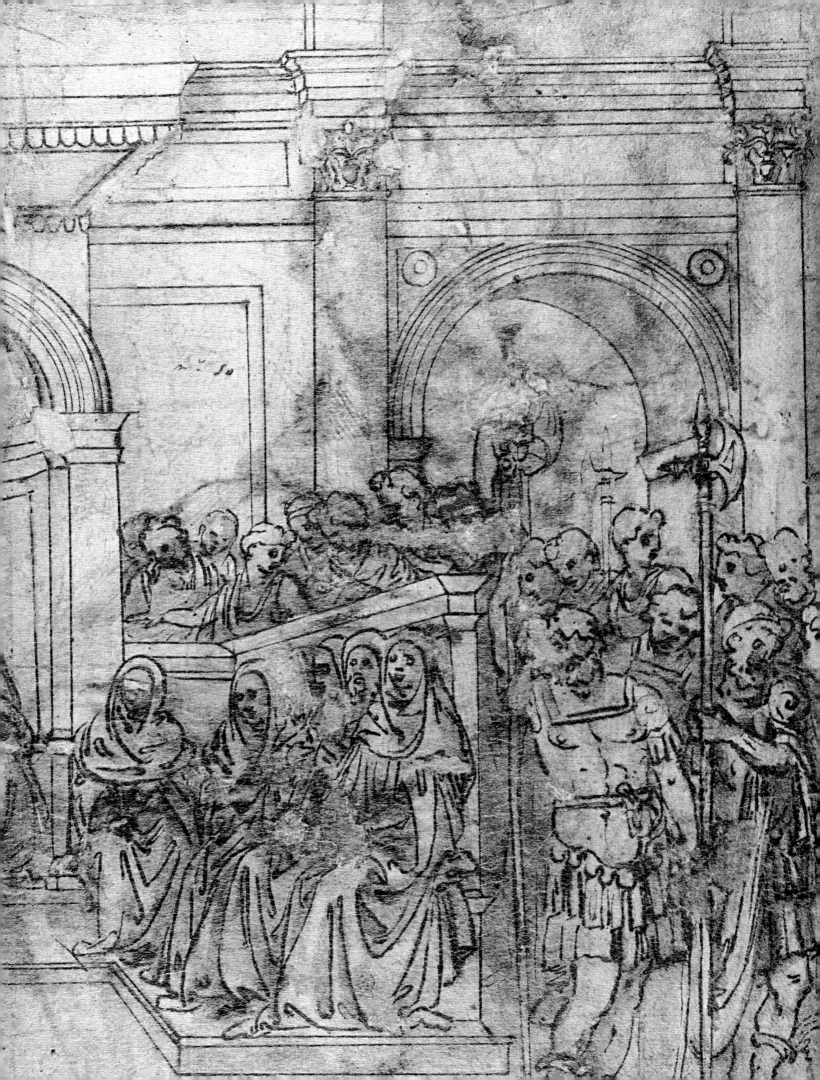

Selected Drawings

Giorgio Vasari, in his 'Life' of Michelangelo, relates that he burnt many of his drawings before his death, "so that no one should see the labours he endured and the ways he tested his genius, and lest he should appear less than perfect". The largest collection of his drawings in existence today is archived at Casa Buonarroti, in Florence. These drawings highlight the diversity of Michelangelo's work; his sketch method for building design; the thought-provoking religious portrayals, whereby Michelangelo, with a few masterstrokes of the pen, could create sublime devotional images; and his remarkable attention to detail for *teste divine*, special presentation drawings created as gifts for his friends. There are also drawings that explore Michelangelo's knowledge of ancient Greek and Roman myth, often used to disguise his own feelings, notably displayed in *The Rape of Ganymede* and *The Fall of Phaëton*.

Above: Head of a Woman. *This drawing may be linked to the depiction of Sibyls for the Sistine Chapel ceiling frescoes, 1508–12. Left: Part of a scene representing a Judgement, c.1520–5. An interior with a row of seated figures at the left and others, including guards or soldiers, standing behind, with a Roman triumphal archway beyond.*

Study of a youth beckoning, c.1504–5, pen and brown ink, black chalk, on paper (recto), British Museum, London, UK

Michelangelo's superbly detailed drawing of a youth is similar in its pose to the sculpture of the *Apollo Belvedere*, a marble Roman copy of a lost original in bronze by the Greek sculptor Leochares, which was among the collection of Pope Julius II, in Rome. Michelangelo was familiar with this work.

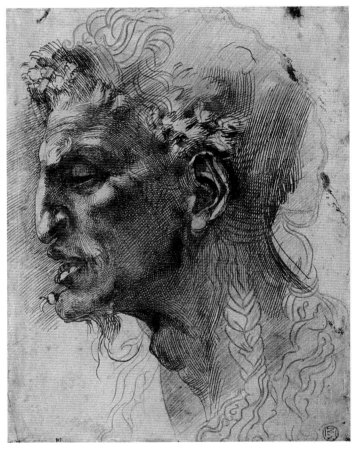

Study of the head of a satyr, c.1521, pen and ink partly over red chalk on paper (recto), Musée du Louvre, Paris, France

The faint drawing in red chalk is possibly the work of Antonio Mini, an assistant and pupil of Michelangelo. It is a profile head of a woman with plaited hair. On top of this is a detailed drawing of a satyr's head in left profile, finely composed with flaring nostrils and goatee chin hair.

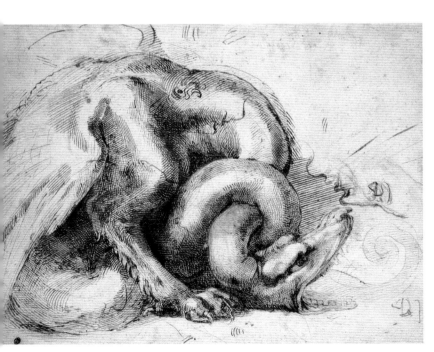

A dragon and other sketches, c.1525, pen and brown ink over black chalk on white paper, Ashmolean Museum, University of Oxford, UK, 25.4 x 33.8cm (10 x 13.3in)

The mythical dragon is often depicted as a large and scaly short-legged winged creature, given to exhaling fiery breath, while revealing its sharp teeth and talon claws. Michelangelo draws a stunning beast, bending its body low and curling its tail around its neck, and tilting the head up toward, perhaps, its approaching prey.

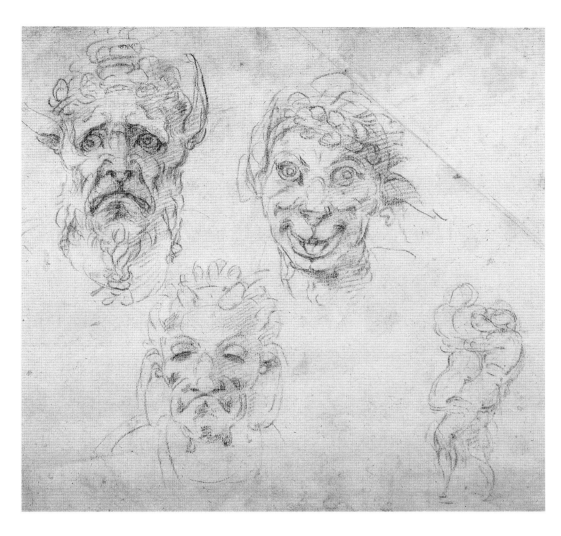

Sketch of satyr faces and two wrestlers (Hercules and Antaeus), c.1524–5, red chalk on paper, British Museum, London, UK

The three faces of satyrs, or grotesques, dominate the paper. They are perhaps tutorial drawings to aid Michelangelo's pupils or assistants. The satyrs have elongated animated ears, which reflect their expressions of displeasure, happiness and resignation. To the right, two wrestlers struggle. These are thought to be depictions of Hercules and Antaeus. Hercules is rendered in red and black chalk.

Miscellaneous sketches and a poem, c.1525, red chalk and pen and brown ink on paper, Ashmolean Museum, University of Oxford, UK, 28.8 x 42.7cm (11.3 x 16.8in)

These sketches include a horse and rider, vases, and several heads and faces. The poem, which runs down the left side, begins: *'Ohimè, ohimè! Ch'io son tradito'* ('Alas, alas! I am betrayed'). During the time the sketches were created, Michelangelo was in Florence, designing the New Sacristy in San Lorenzo for the Medici family.

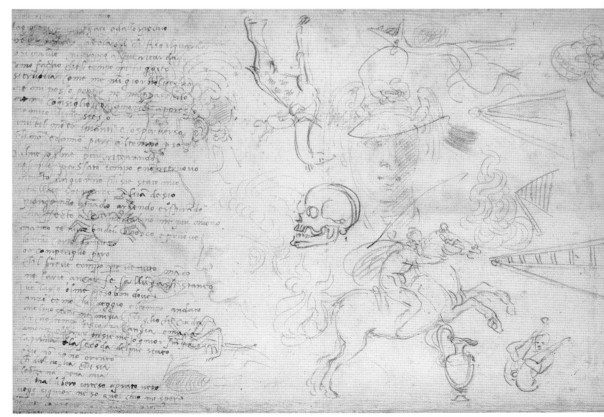

Studies for the head of *Leda*, c.1530, red chalk on paper, Casa Buonarroti, Florence, Italy

These studies for the head of Leda correspond to later copies of Michelangelo's original work (now lost). The head and the body

of Leda bear a close resemblance to the sculpture of *Night*, on the tomb of Giuliano de' Medici in the New Sacristy, San Lorenzo, Florence. The figure of Leda is erotic, as she actively pulls the swan close to her. The head of Leda is less erotic and more sensual.

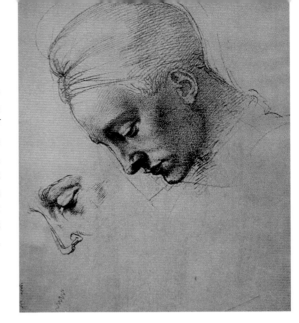

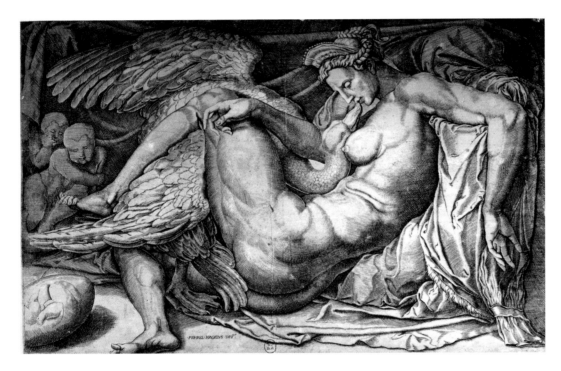

Leda (after Michelangelo), c.1540–50, engraving, by Jacobus Bos (born c.1520), Bibliothèque Nationale, Paris, France

In Greek mythology, Zeus, disguised as a swan, raped Leda, the daughter of the Greek king, Thestius. This engraving by Jacobus Bos is copied from Michelangelo's original work (now lost). The bodies of Leda and the swan (Zeus) are entwined. Several copies were made by various artists, proving the popularity of the theme and Michelangelo's depiction of the mythological story.

Figure studies and verse, 1503–4, black chalk (the man); pen and dark brown ink over traces of lead point (the putti); pen and light brown ink (the left leg and the sonnet verse); lead point (the fragments of a sonnet), British Museum, London, UK, 31.5 x 27.7cm (12.4 x 10.9in)

Front and rear studies of the figure of a young boy are drawn either side of a nude male, a possible study for the *Battle of Cascina*. There is also

a drawing of an outstretched leg. A sonnet verse is written on the page, which reads: *Sol io arde[n]do all ombra mi rima[n]go / qua[n]d el sol de suo razi el mondo spoglia / ogni altro p[er] piaciere p[er] doglia / prostrato in terra mi lame[n]to e pia[n]gho.* The text, written in 'old' Italian, translates: "I alone keep burning in the shadows / when the sun strips the earth of its rays / everyone else from pleasure and I from pain / prostrate on the ground and weep".

The Fall of Phaëton, 1533, black chalk over stylus on paper, British Museum, London, UK

This is a presentation drawing for Tommaso dei Cavalieri. It depicts the moment that Jupiter (Zeus in Greek mythology) hurls a thunderbolt to strike the chariot and horses of Phaëton, the son of Apollo, to save the Earth from Phaëton's wanton destruction. Phaëton, with his chariot and horses, falls to the ground. The story is told in Ovid's *Metamorphoses*. On the bottom of the drawing is a thoughtful note from Michelangelo to Tommaso.

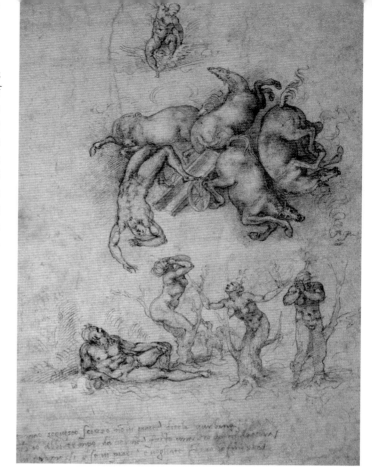

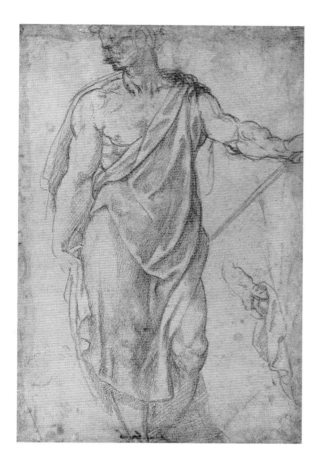

Sketch of a man holding a staff, red chalk on paper, Gabinetto dei Disegni e Stampi, Galleria degli Uffizi, Florence, Italy

This figure is drawn in the clothing of Roman antiquity. The body of the man is depicted with heavy, muscular legs and arms.

Study of three male figures (after Raphael), private collection

Michelangelo and Raphael were not close friends but each admired the other's talent. Raphael made drawings of the marble sculpture of *David* in Florence, Michelangelo drew a study of three figures by Raphael. In his fresco *The School of Athens* (1508–11), Raphael included a portrayal of Michelangelo as the ancient pessimist philosopher Heraclitus. Michelangelo is depicted with head down, as if in thought, leaning against a block of marble, writing on a sheet of paper.

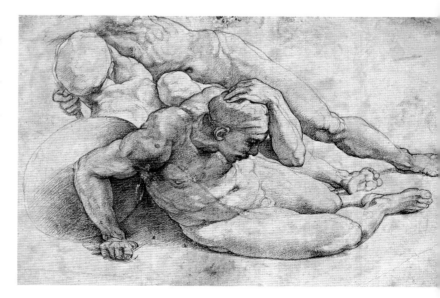

Study of the flagellation of Christ, 1516, red chalk over stylus, British Museum, London, UK

This is a preparatory drawing for an altar painting. It was intended for a chapel in the Church of San Pietro in Montorio, Rome. The Venetian-born artist Sebastiano del Piombo (1485–1547), known for his paintings in the Mannerist style, collaborated with Michelangelo on some commissions, such as this one for Pierfrancesco Borgherini, a Florentine banker of repute. The study depicts Christ bound to a column. His captors torture him.

Study of three crucifixions, c.1523, red chalk on paper, British Museum, London, UK

This study depicts the crucifixion of Christ and the two thieves. Michelangelo captures the moment that soldiers mount ladders to nail Christ to the cross. He looks up toward his left. The Y-shape of the cross accentuates the weight of Christ's body. The method of crucifixion differs between Christ and the other men. The families and followers of those to be crucified crowd around the bases of the crosses.

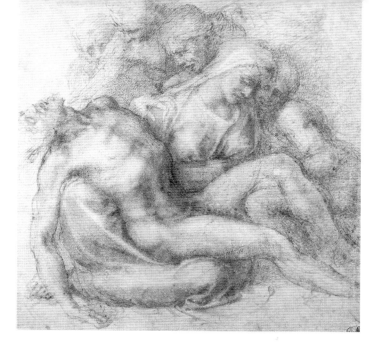

Study of the Lamentation over the dead Christ, c.1530–5, black chalk on paper, British Museum, London, UK

The stunning arrangement of the Lamentation over the dead Christ reflects Michelangelo's earlier marble *Pietà*, 1499, now in St Peter's Basilica. The Virgin is seated on the floor. The naked body of Christ lies across the lap of the Virgin.

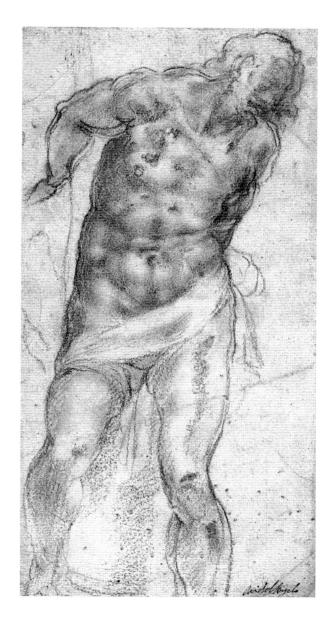

Study for a Pietà (the *Colonna Pietà*), early 1540s, black chalk on paper, Isabella Stewart Gardener Museum, Boston, MA, USA

Study of Christ at the Column, 1516, black chalk heightened with lead white over stylus, British Museum, London, UK

This is an enigmatic study of the suffering of Christ during his Passion. He stands, bearing the insults and crimes of his captors and torturers. Michelangelo depicts the muscular body of a young man in the prime of his life. The depiction of the head and arm movements highlights his suffering and pain.

The Madonna, aided by angels, supports with her own body the lifeless corpse of Christ her son. She looks upward to God. The study, in black chalk on paper, was created in Rome for Michelangelo's close friend Vittoria da Colonna.

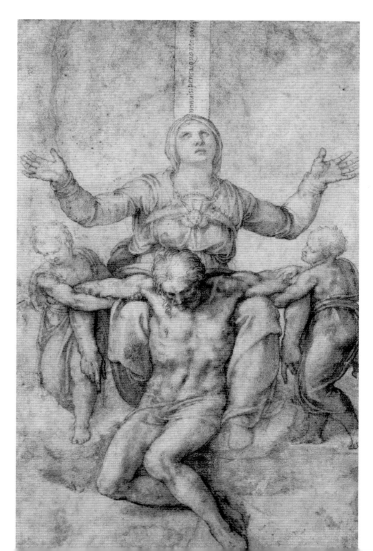

Study for the *Resurrection of Christ*, c.1532, black chalk on paper, Ashmolean Museum, University of Oxford, UK

This drawing shows many changes to the positioning of the arms and legs in this study for the *Resurrection of Christ*. The left arm is positioned bent at the elbow and drawn in; it is then placed above the head, pointing upward. The preparatory sketch is an excellent example of Michelangelo trying to formulate exactly the right positioning for the body, to illustrate the drama of the Resurrection of Christ.

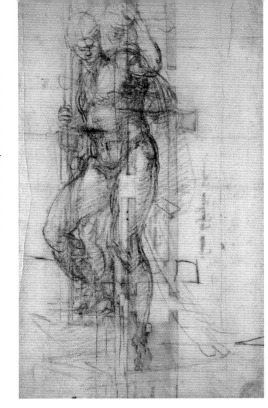

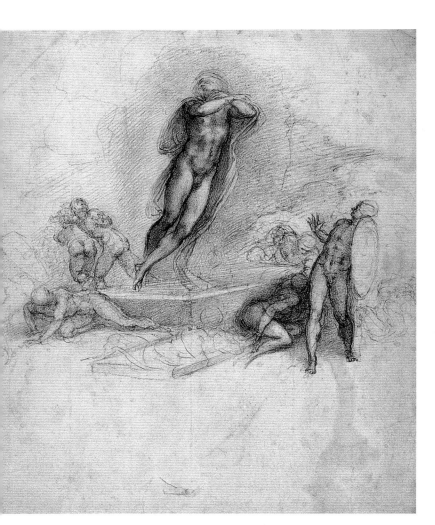

Study for the *Resurrection of Christ*, c.1532–3, black chalk on paper, British Museum, London, UK

This drawing depicts the Resurrection of Christ from his tomb. The naked body of Christ floats heavenward in Ascension, from the earthly stone sepulchre. Onlookers stand back in awe and fear and quickly disperse. A soldier, shield in hand, looks upward toward the ascending figure. This is possibly a preparatory drawing for an altarpiece in Santa Maria della Pace, Rome.

Study of a man about to strike with his right fist, 1540, black chalk on paper, British Museum, London, UK, 26.2 x 18.1cm (10.3 x 7in)

The figure above is a study for one of the angels in the group of the Seven Deadly Sins in the *Last Judgement* fresco on the altar wall of the Sistine Chapel. Below is a separate study of an outstretched right arm.

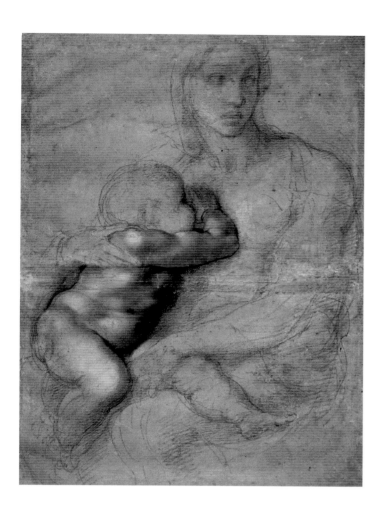

Study of a *Madonna and Child*, *c*.1525, black chalk, red chalk and white pigment on paper, Casa Buonarroti, Florence, Italy

This is a prepared cartoon on paper. Its proposed use is unknown. The image depicts the seated Madonna holding the naked infant Christ. She supports him with her right arm. Her left hand holds on to him, to balance him on her lap. He suckles her breast and clings to her. She looks away from him, to her left.

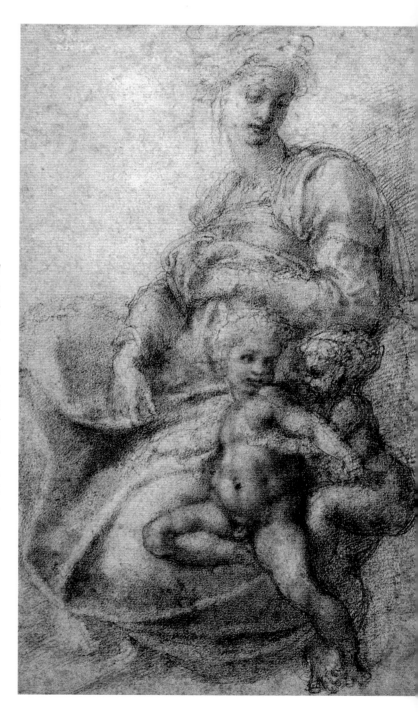

Study of the *Virgin and Child with the Infant St John the Baptist*, *c*.1530, black chalk on paper, British Museum, London, UK

The figure structure here places the Virgin seated at centre. Her body faces toward the right and her head turns to the left and down to observe her son, the Christ child, playing with the infant St John the Baptist.

**Study for a *Resurrection*,
c.1536–8, red chalk on
paper, Louvre, Paris, France**

Following Michelangelo's
completion of the Sistine
Chapel ceiling, Pope Julius II
considered a new altarpiece
for the chapel, depicting the
Resurrection. Michelangelo
created drawings of the
resurrected Christ but the
plan was abandoned. Later, in
the 1530s, Michelangelo
created preliminary drawings
for the altar wall of the Sistine
Chapel. The 'resurrected'
Christ is depicted soaring
upward from the open
sarcophagus, his tomb guards
react with surprise and fall to
the ground, stare in disbelief,
or turn away in fear.

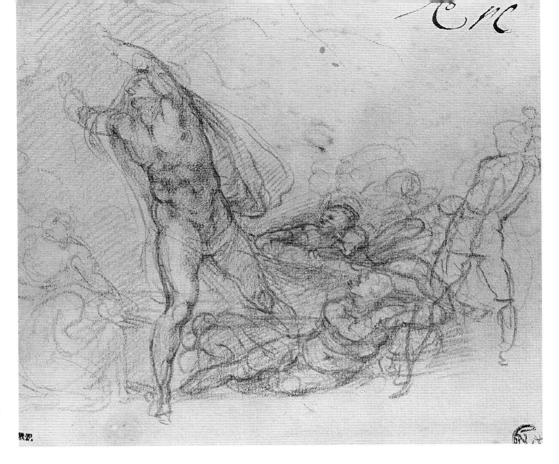

**Study of a dog, *c.*1525(?),
charcoal on paper, British
Museum, London, UK**

Attributed to Michelangelo.
This sketch of a dog,
particularly of the neck and
right foreleg, is comparable
to Michelangelo's fantasy
drawing of a winged
monster, c.1525 (Ashmolean
Museum, Oxford, UK).

**Study of a *Madonna and
Child*, 1530–4, pencil on
paper, British Museum,
London, UK**

This is a working drawing,
to fix the positioning of the
figures. The '*Madonna del
Latte*' (*Madonna of the Milk*)
was a familiar depiction in
art during the medieval and

Renaissance periods.
Here, Michelangelo seats
the Christ child on the knee
of the Madonna. The infant
suckles her right breast, his
tiny hands holding her firmly.
She is preoccupied. The
image reflects the unfinished
sculpture *Virgin and Child*,
c.1534, in the New Sacristy,
San Lorenzo, Florence.

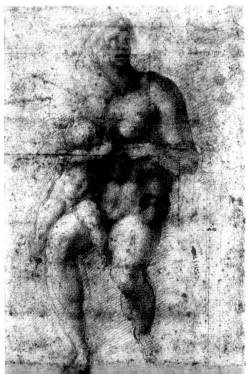

Studies of *Madonna and Child*, c.1522–6, pen and brown ink on paper; red chalk, British Museum, London, UK

The sketches on this paper are the work of Michelangelo and his pupil Antonio Mini (d.1533). The drawings are educational exercises, which depict the Virgin and Child. The studies by Michelangelo are in pen and brown ink; the copies by Antonio Mini are in red chalk. It is on this sheet of drawings that Michelangelo implored his pupil, 'draw, Antonio, draw, Antonio, and don't waste time.'

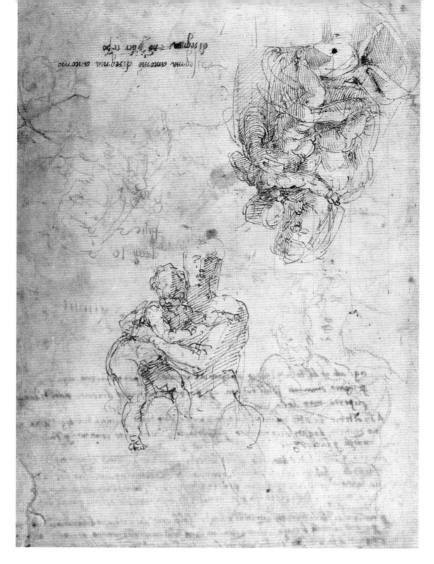

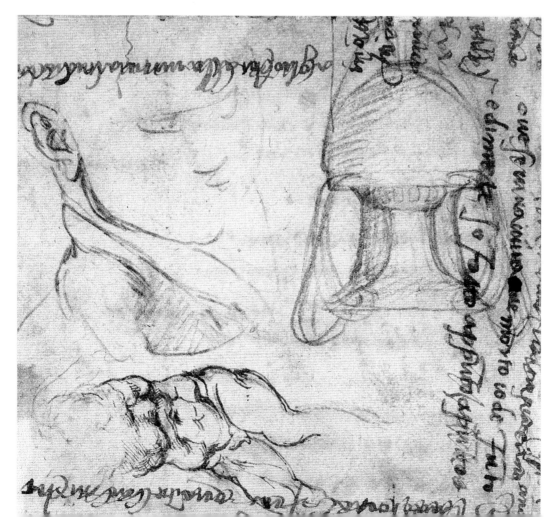

Page from a sketchbook with figure studies and notes, 1520–5, black chalk on paper, British Museum, London, UK, 12 x 12.7cm (4.7 x 5in)

The sketches include the head of a youth and a figure study of a male torso, which is partly gone over in pen, in the same ink as the handwriting, which is partly cut away. The page is inscribed with drafts of poems, some scratched out in a different coloured ink. Historians consider that the classical vase resembles vases used on the frames of the marble door-tabernacles in the New Sacristy, San Lorenzo, Florence.

Study for the *Virgin Annunciate*, c.1546, black chalk on paper (recto), British Museum, London, UK

The composition originally included a winged angel of the Annunciation. The study is now cut into two.

The study of the Annunciation links it to two works, one in the Cesi chapel in Santa Maria della Pace, Rome, and the other in San Giovanni in Laterano, in Rome. Here the Virgin is seen turning toward the angel (on the second sheet of drawings), who has taken her by surprise.

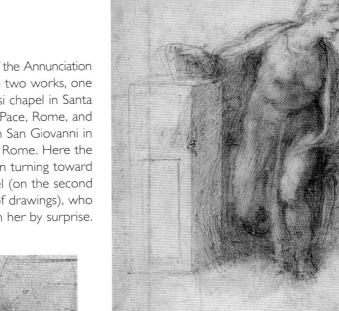

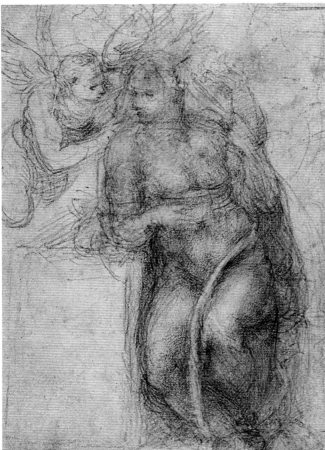

Study for the *Annunciation*, black chalk on paper, c.1547, British Museum, London, UK

A preparatory drawing of the Annunciation. The Virgin is seated. The angel of the Annunciation appears on her right. She turns her head to listen, as he whispers in her ear. It is a delicately drawn composition, which shows various positioning of the arm of the Virgin.

Study of a *Crucifixion with the Virgin and St John*, c.1550–5, pencil and chalk on paper, British Museum, London, UK

Michelangelo produced a steady series of religious figure drawings in the latter years of his life. His friendship with Vittoria Colonna, a devoutly religious woman, affirmed his own Christian beliefs. He was a deeply spiritual man, which he clearly expressed in his poetry. The essence of his religious understanding can be found in his poems, and in the crucifixion drawings and the Pietà sculptures produced at this time and up until his death.

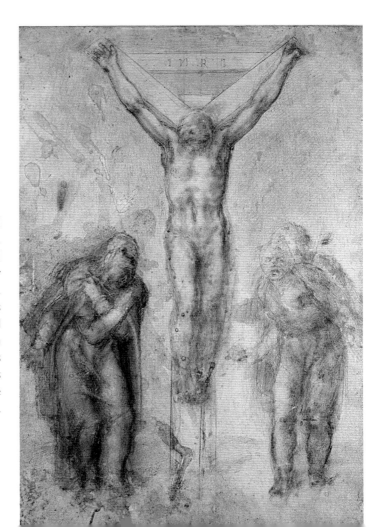

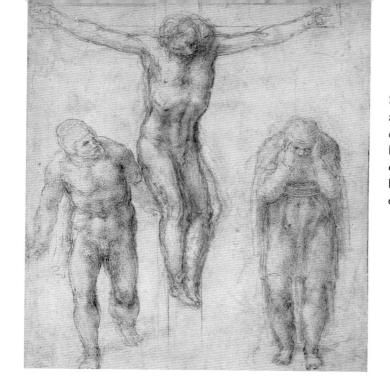

Study of the Crucifixion and two mourners, c.1555–64, black chalk, heightened with lead white on paper, Ashmolean Museum, University of Oxford, UK

This is one of a series of studies by Michelangelo that depicts the crucified Christ with two mourners. In this study there is a possibility that the two mourners, to either side of the figure of Christ, are intended to be the Virgin Mary and St John – although it is not clear.

Eight studies of children; a Virgin and Child; and a woman's head, c.1503–4, pen and brown ink (seven children), black chalk (other sketches), British Museum, London, UK, 37.4 x 22.8cm (14.7 x 9in)

Michelangelo scholars consider that the sketches are related to the marble roundel, the *Taddeo Tondo* (Royal Academy, London), that depicts the Madonna and Child and the infant John the Baptist, 1505–6.

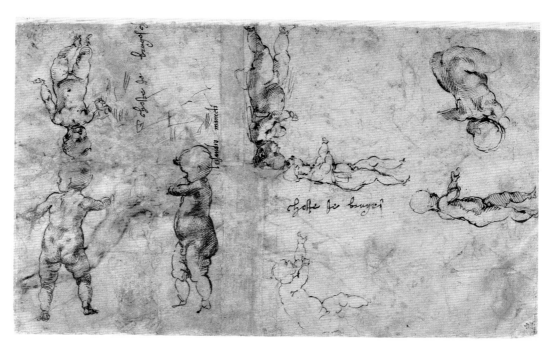

Study of a left arm and shoulder, sharply bent, c.1530, pen and light brown ink and black chalk over a stylus sketch, British Museum, London, UK, 16 x 13.4cm (6.3 x 5.3in)

This detailed study is a life-drawing of a male, which Michelangelo used for the marble sculpture of the female allegorical figure of *Night* on the sarcophagus of Giuliano de' Medici in the New Sacristy, San Lorenzo, Florence. Written in pen and ink, vertically between the thumb and upper arm, is the word '*uno*' (one), possibly referring to a unit of measurement.

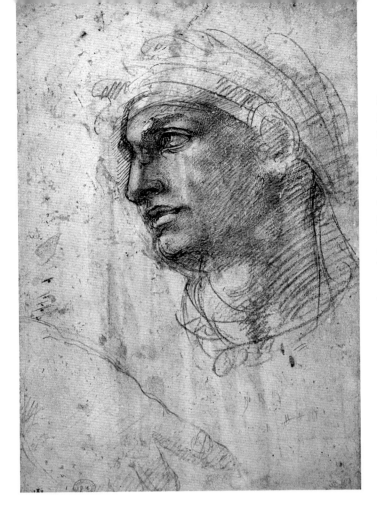

Study of a head, c.1508–10, red and black chalk and pen over metalpoint, British Museum, London, UK

This study is one of several created by Michelangelo as preparatory drawings for the male figures depicted on the Sistine Chapel ceiling. The pose of the head bears similarities to the heads of the *ignudi*.

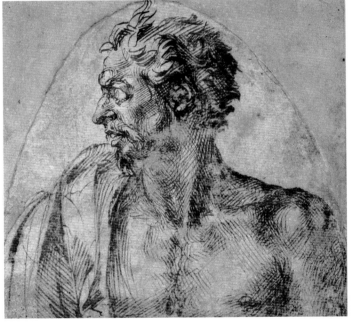

Study for the head of a man in profile, c.1501–5, pen and brown ink on paper, British Museum, London, UK

The paper has been cut to form an oval around the portrait of a man in profile, and later rejoined to form a square. The portrait is a detailed drawing of a man, possibly a study for a satyr, devil or Bacchus, with straggly beard and hair. His eye catches the light to give the figure a heightened sense of drama.

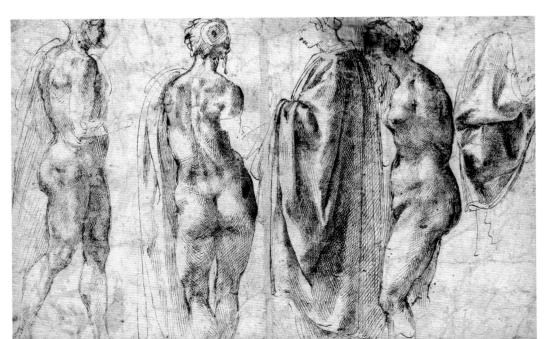

Study for five figures, 1496–1500, pen and ink, Musée Condé, Chantilly, France

To the left is a bearded male nude. The other finely drawn figures are of women, showing the side and rear views. One woman is clothed in a long robe and cloak. To the far right is a study of drapery in detail.

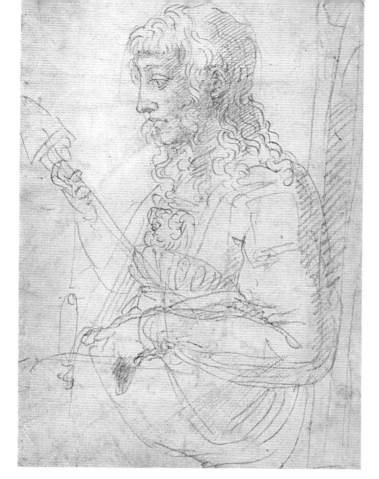

Study of a girl holding a spindle, *c*.1528–34, black chalk on paper, British Museum, London, UK

The young girl is seated in left profile. She holds a spindle for wool. She looks intently at her task. Her hair, in long ringlets, softly frames her face. She is dressed in a tunic with under-blouse.

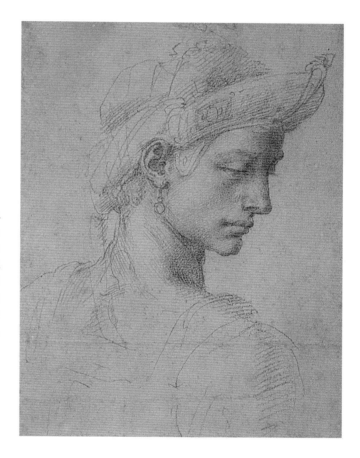

Study of an ideal head, *c*.1516, red chalk on paper, Ashmolean Museum, University of Oxford, UK, 20.5 x 16.5cm (8 x 6.6in)

The portrait is possibly a drawing of a young man, although the decorative jewellery would favour a female interpretation. The red chalk is carefully smudged on the face and neck to produce a soft, feminine portrayal.

Study of a young woman, *c*.1525, black chalk on paper, British Museum, London, UK, 32 x 25.6cm (12.6 x 10in)

A half-length study of a young woman, standing to the left, looking down. The drawing is possibly a *teste divine* drawing such as those which, according to Giorgio Vasari, Michelangelo created as gifts for his friends.

Study of a head, c.1511, red chalk on paper, British Museum, London, UK

Drawn in red chalk with an outline overdrawn with a stylus, the youthful head appears in three-quarter profile. It is possibly a preparatory sketch for one of the many *ignudi* on the ceiling of the Sistine Chapel.

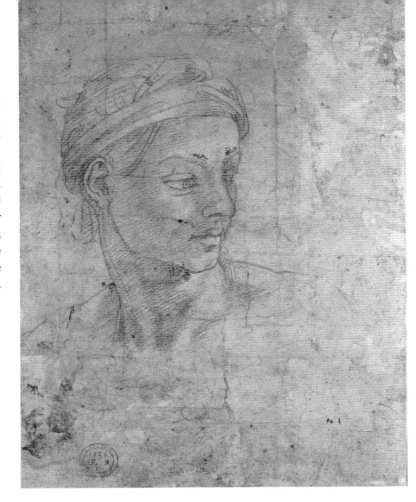

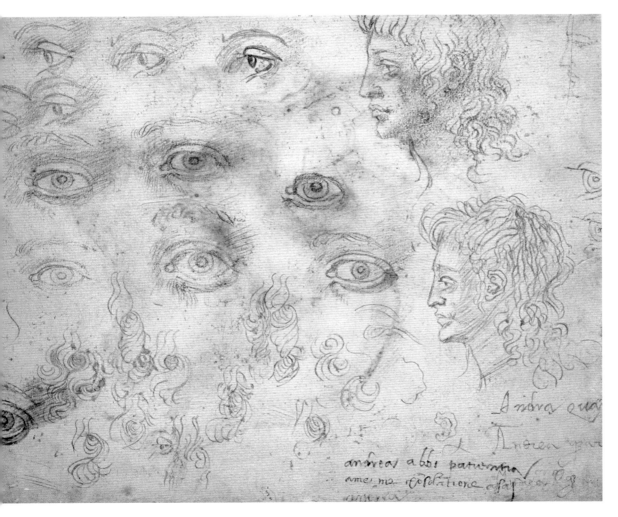

Study of two heads, eyes and locks of hair, c.1530, red and black chalk on paper, Ashmolean Museum, University of Oxford, UK, 25.4 x 33.8cm (10 x 13.3in)

This study sheet of two heads is one of several drawn by Michelangelo and his pupils Antonio Mini and Andrea Quaratesi. At the bottom right the drawing is inscribed in two different inks: "*Andra Quar…; Andrea qar; Andrea q; andrea abbi patientia / ame me chosolatione assai; andrea*". Michelangelo has written Andrea's name, and Quaratesi has copied it. Michelangelo added "*andrea abbi patienta*" (Andrea be patient), a possible reference to Quaratesi needing patience to learn how to draw. Andrea, or another pupil, has responded "*ame me [da?] co[n]solatione assai*" (this [gives] me great consolation).

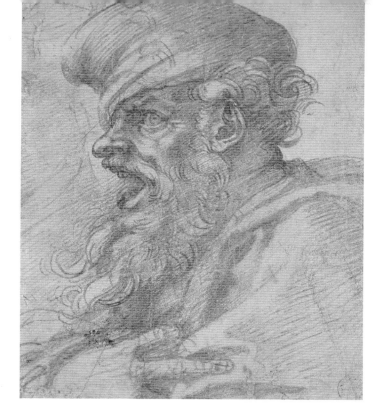

Study of the head of a bearded man shouting, *c.*1525, red chalk on paper, Ashmolean Museum, University of Oxford, UK

This finely drawn portrait, full of character, depicts the face of an old man who gawps open-mouthed. He stares wildly. The face is framed by facial hair and a long beard. His cap is pulled over to one side.

Study of a seated woman, *c.*1525, pen and brown ink over red and black chalk (recto), British Museum, London, UK

This study of a young woman seated is possibly the work of two artists: Michelangelo and his young pupil Antonio Mini.

It is considered that the under-drawing in red chalk was Mini's work, and the over-drawing in pen and ink, the work of Michelangelo. The young woman looks out toward the viewer. Her hair is carefully braided, and she wears an unusual tunic over a long shirt.

Study of a head (Marchioness of Pescara), 1525–8, black chalk on paper (recto), British Museum, London, UK

This study of the head of a young woman was perhaps intended as a presentation drawing for the person depicted. The young woman is drawn in left profile. Her hair is carefully braided and then woven through a close-fitting headdress, which is strapped under her chin. The soft detail of the socket of the eye, and the careful shading of the mouth and chin, make it one of Michelangelo's most delicate drawings.

Figure studies and a decorative emblem, c.1501–4, pen and ink and charcoal on paper, British Museum, London, UK

The studies illustrate sketches of male nudes, a Madonna and Child, and a decorative emblem at bottom right. The male figure study is possibly a design for an Apostle, one of 12 marble statues of the Apostles commissioned from Michelangelo in 1503. These were destined for the pier niches in Florence Cathedral. The unfinished St Matthew (Galleria dell'Accademia, Florence) was the only sculpture in the series that Michelangelo began, before abandoning the commission.

Two studies of a standing man with one leg raised, and a battle scene, 1501–4, pen and brown ink, some black chalk visible by saint's head, British Museum, London, UK, 18.5 x 18.1cm (7.3 x 7.1in)

Two sketches, one nude and the other clothed, of a standing man in profile are known to be studies for an Apostle, intended for the unexecuted commission mentioned above. If the drawing is turned 90 degrees, a battle scene is visible, possibly related to Michelangelo's commission to paint the *Battle of Cascina* (1504) for the Salone dei Cinquecento, Palazzo della Signoria, Florence.

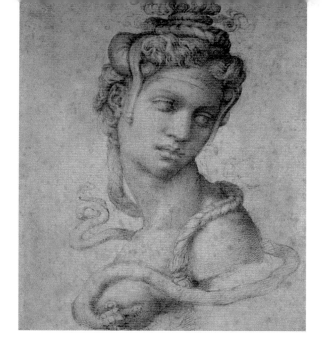

Head of Cleopatra,
c.1533–4, black chalk on
paper, Casa Buonarroti,
Florence, Italy

This presentation drawing
of Cleopatra was owned by
Tommaso dei Cavalieri.
It fell into the hands of Duke
Cosimo I de' Medici and
eventually became part of
the Michelangelo collection
at Casa Buonarroti, in
Florence. The drawing is
an idealized portrait of
Queen Cleopatra. Her
beautifully braided head
turns toward the left. Her
eyes are downcast. An asp
moves around her bare
shoulders, its fangs biting
into her left breast.

Zenobia, Queen of Palmyra,
c.1520–5, charcoal on
paper, Gabinetto dei
Disegni e Stampe, Galleria
degli Uffizi, Florence, Italy

Queen Zenobia,
Empress of Palmyra (ruled
AD240–c.247), claimed to
be a descendant of Dido,
Queen of Carthage. Upon
the death of her husband
King Septimus she became
ruler of the Syrian Empire.
Michelangelo depicts her
here in three-quarter
profile, bare-breasted. She
wears her hair elaborately
braided. This is possibly a
presentation drawing.

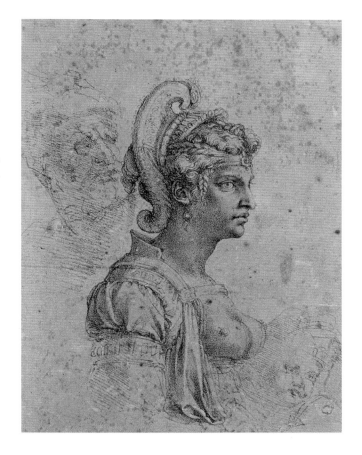

Study of a man shouting
(known as *The Damned*
Soul), *c.1525–34*, charcoal
on paper, Gabinetto dei
Disegni e Stampe, Galleria
degli Uffizi, Florence, Italy

This study of a man shouting
was a presentation drawing
for a young man, Gherardo
Perini, who was one of the
life models at Michelangelo's
studio. They met in 1522.
The sketch has familiarly
become known as 'The
Damned Soul'. A windblown
cloak frames the face of the
man who screams out.
His eyes bulge as he shouts
into the wind. The three
small circles at lower right
are Michelangelo's mark.

Designs for architectural capitals, smaller studies and handwriting, 1501–5, pen and brown ink (the studies for the capitals first sketched in leadpoint), British Museum, London, UK, 18.5 x 18.1cm (7.3 x 7.1in)

Historians remain undecided on the purpose for the designs for architectural capitals. At this time Michelangelo was commissioned to create 15 sculptures for the Piccolomini altar in Siena, but records only mention a contract for statues, not architectural decoration. More evidence is needed to support the supposition that the capitals are designs for the lower storey of the tomb of Pope Julius II.

The Dream of Human Life, c.1533–6, black chalk on paper, Samuel Courtauld Trust, Courtauld Institute of Art Gallery, London, UK

This is probably a presentation drawing, intended as a gift. The allegory of *The Dream of Human Life* is not fully explained. The young man in the foreground is seated. He rests on a globe. He has been asleep, awakened by a winged angel sounding a trumpet. Some of the deadly sins – Gluttony, Lust, Covetousness, Anger and Sloth – are identifiable around him.

Studies of heads, 1508–12, red chalk on paper (verso), British Museum, London, UK

The sketches and studies of various heads are drawn in no particular order but show an investigative touch, searching for character detail in the faces.

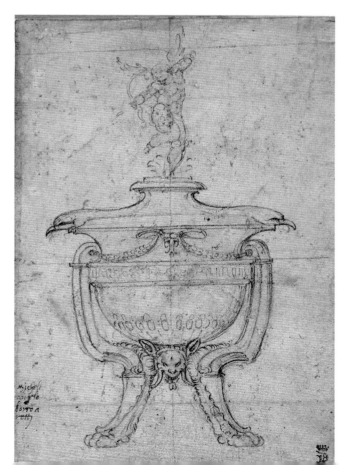

Design for a salt cellar, 1537, black chalk on paper, British Museum, London, UK

This is one of two works designed for Francesco della Rovere (the other a horse to be cast in bronze), both perhaps peace offerings for the delay on the completion of the tomb for Pope Julius II. The salt cellar had feet designed as animal paws. Upon these lay the highly ornate body of the salt cellar, chased with festoons and foliage. This superior design was a grand peace offering on a small scale.

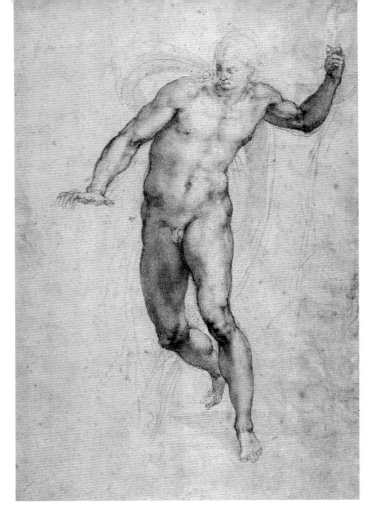

Study for a risen Christ, 1532–3, black chalk on paper with stippling over stylus under-drawing, British Museum, London, UK, 41.2 x 27.2cm (16.2 x 10.7in)

A nude figure depicting the risen Christ stands to the front, with his left hand raised and drawn back. Michelangelo gives great attention to the muscular form of the body, accentuating the thighs and torso. The drawing is one of several created by Michelangelo to depict the figure of the risen Christ.

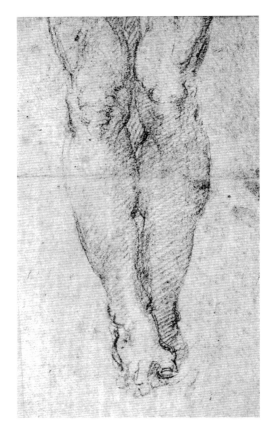

Study for a crucifixion, c.1557, black chalk on paper, British Museum, London, UK

Attributed to Michelangelo, this simple drawing is a detail of the lower legs of the crucified Christ on the cross. Michelangelo created many drawings of the Crucifixion dated c.1550–60.

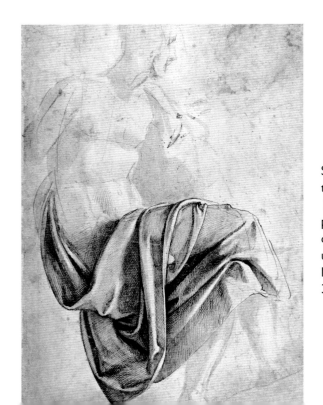

Study for the drapery of the *Erythraean Sibyl*, 1508–12, brown wash and pen and dark brown ink over a black chalk under-drawing, British Museum, London, UK, 38.4 x 25.8cm (15 x 10.2in)

The study of the Erythraean Sibyl, designed for the Sistine Chapel ceiling, shows her seated with legs crossed. The precise detail of the drapery is rendered through the practical method of dipping cloth in wet clay, and then arranging the material in folds on a model.

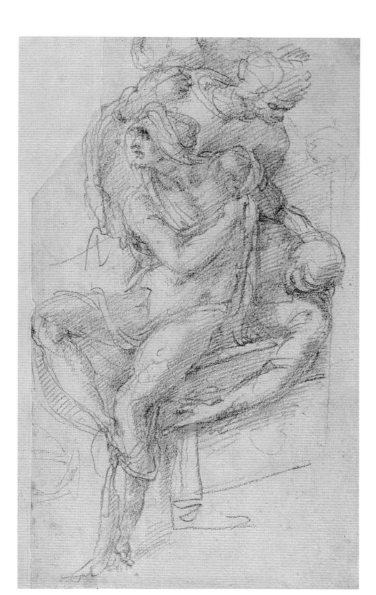

Figure studies for *Lazarus*,
1516, red chalk on paper,
British Museum,
London, UK,
25 x 11.8cm (9.8 x 4.6in)

The naked figure of Lazarus
is seated on a sarcophagus,
supported by two figures.
The page of drawings
includes studies of a left
foot and, bottom right, a
sketch of a right shoulder
seen from above.

A study for *The Raising of
Lazarus,* 1516, red chalk
on paper, British Museum,
London, UK

A study of Lazarus, naked,
seated on a sarcophagus,
supported by two figures.
This drawing is related
to a large altarpiece
commissioned by Cardinal
Giulio de' Medici for the
cathedral at Narbonne.
The painting *The Raising
of Lazarus* (now in the
National Gallery, London,
UK) was undertaken in
1517–18, by Sebastiano
del Piombo. It was based
on the drawings by
Michelangelo. The reverse
side of this drawing
depicts the same scene
with a slight change in
the placement of the
figures. The biblical
narrative relates how
Lazarus, a dead man, is
brought back to life
through the word of Christ.

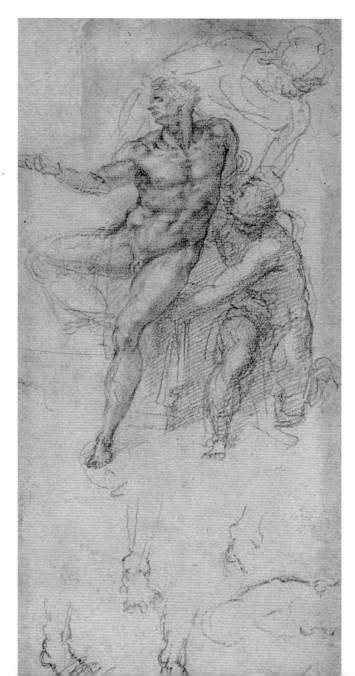

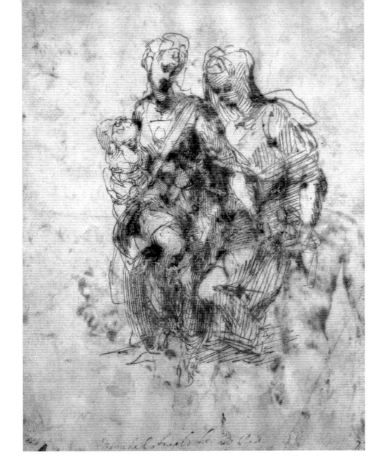

Study of the Virgin and Child with St Anne, *c*.1502, pen and brown ink on off-white paper, Ashmolean Museum, University of Oxford, UK, 25.7 x 17.5cm (10 x 6.9in)

The drawing is inscribed lower centre: '*di Michel Angelo di Bona Roti*'. Possibly a copy by Michelangelo, after the full-size cartoon of *Virgin and Child with St Anne*, *c*.1499–1500, by Leonardo da Vinci.

Two studies of grotesque heads, 1526, red chalk on paper, Museo Horne, Florence, Italy

Michelangelo possibly drew grotesque heads as a source of amusement for his pupils, and for them to copy as an exercise. He is known to have commented that *grotteschi* should be a draughtsman's source of "variation and relaxation of the senses".

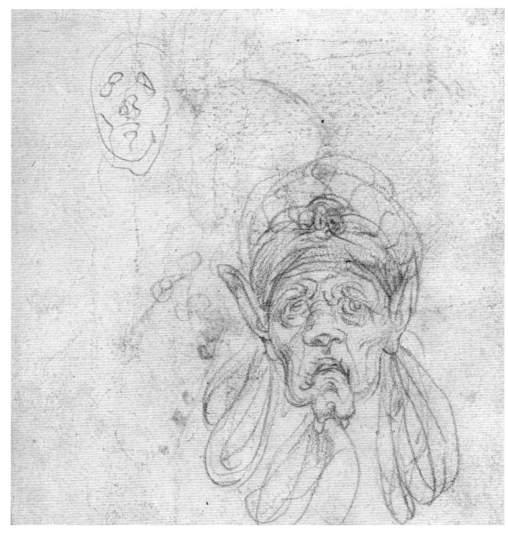

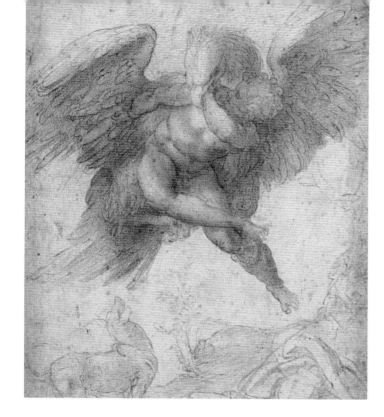

The Rape of Ganymede, c.1532, black chalk on paper, Gabinetto Disegni e Stampe, Galleria degli Uffizi, Florence, Italy, 36.1 x 27.5cm (14.2 x 10.8in)

In Greek and Roman mythology Ganymede is a shepherd, the son of a king of Troy. The myth relates that Ganymede was seduced by Zeus (Jupiter in Roman mythology). In Ovid's *Metamorphoses* 10: 152–161, the god transformed himself into an eagle and swept up Ganymede to carry him to Mount Olympus. In Michelangelo's drawing Jupiter/Zeus is depicted as an eagle with wings outspread in flight, capturing the moment when Ganymede is taken.

Head of a bearded man turned slightly, 1531–3, black chalk on paper, British Museum, London, UK, 38.6 x 24.6 cm (15.2 x 9.7 in)

The large drawing of a head of a bearded man is possibly a study for the head of a prophet or saint. Historians suggest that the head could be a preparatory study for Saint Cosmas or Saint Damian, patron saints of the Medici, and linked to the New Sacristy, in San Lorenzo, Florence. Other historians debate this and suggest a link to the *Last Judgement* fresco in the Sistine Chapel, Rome.

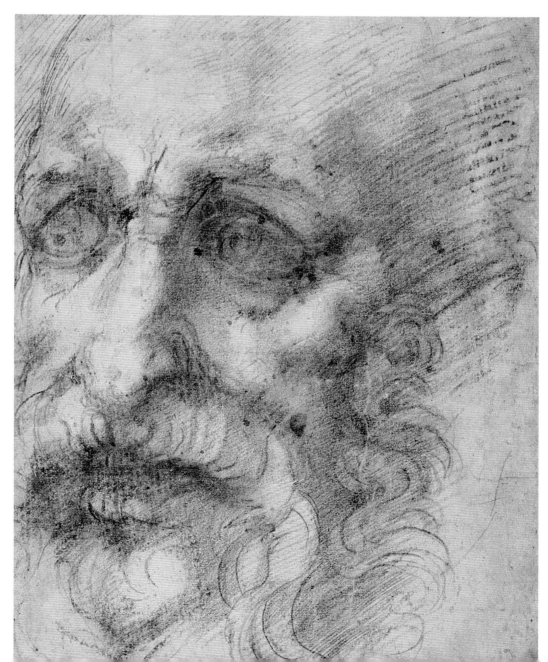

INDEX

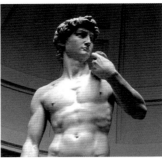

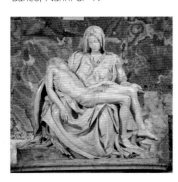

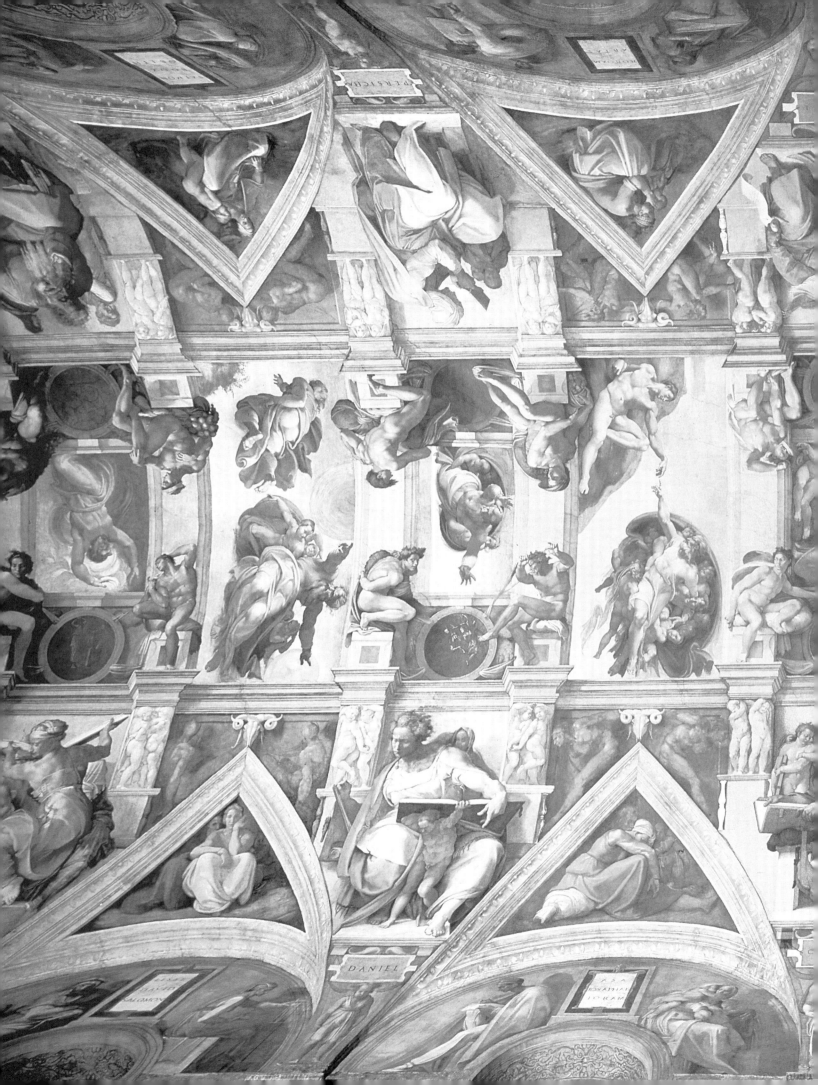